Jonathan Jones is the art critic of the *Guardian*. He appears in the BBC television series *Private Life of a Masterpiece* and gives talks at the Tate and other galleries. In 2009 he was a judge for the Turner Prize. Jonathan lives in London with his wife and daughter.

Further praise for *The Lost Battles*

'A story of rivalry, political intrigue and conspiracy . . . Beautifully produced . . . the book is beguilingly written' Mary Hoffman, *Guardian*

'A superb account of two of the Renaissance's greatest geniuses . . . There is sensuous finesse in Jones' descriptions . . . A fine, daring book' Peter Conrad, *Observer*

'Splendid . . . An eloquent and compelling view of these supreme artists, up close and personal' Martin Gayford, *Mail on Sunday*
★★★★★

'A compelling story . . . gripping' Keith Miller, *Sunday Times*

'In any form of art, the idea of Homeric rivals going head to head in a clash of skill and daring is almost irresistible . . . Jonathan Jones weaves a rich and intricate story . . . *The Lost Battles* is full of colourful incident and detail, both historical and artistic . . . Jonathan Jones writes with engaging passion about the art that Leonardo and Michelangelo did complete' *RA Magazine*

'An engaging story . . . Reveals the insults, egos and formal competitions that separated these two giants of the 16th century art world' *Artists & Illustrators Magazine*

THE LOST
BATTLES

Leonardo, Michelangelo and the Artistic Duel
that Defined the Renaissance

Jonathan Jones

**SIMON &
SCHUSTER**

London · New York · Sydney · Toronto

A CBS COMPANY

First published in Great Britain by Simon & Schuster UK Ltd, 2010
This paperback edition published by Simon & Schuster UK Ltd, 2011
A CBS COMPANY

1 3 5 7 9 10 8 6 4 2

Simon & Schuster UK Ltd
1st Floor
222 Gray's Inn Road
London
WC1X 8HB

www.simonandschuster.co.uk

Simon & Schuster Australia
Sydney

PICTURE CREDITS
Text: p6 Getty; p32 Alinari Archives; p38 Corbis; p121 Bridgeman;
p132 Getty; p152 Alinari Archives
Plates: Getty – 1, 3, 5, 11, 15
RMN – 2
Corbis – 4, 6, 7, 12
Alinari Archives – 8, 9, 13
Bridgeman – 10, 14

A CIP catalogue for this book is available
from the British Library.

ISBN: 978-1-41652-605-6

Typeset in Baskerville by Ellipsis Books Limited, Glasgow

Printed in the UK by CPI Cox & Wyman, Reading, Berkshire RG1 8EX

For my daughter Primavera

CONTENTS

Introduction 1

PART ONE Genius in the Streets 1503-4

One The Insult 9

Two The Fame Machine 31

Three Heroics 55

Four Stoning David 70

Five The Ascent of Art 90

PART TWO The Art of War 1504-5

Six Bloodstains 117

Seven The Genius in His Study 131

Eight Naked Truth 150

Nine Master of War 169

Ten The Raid 187

Eleven The Great Swan 206

Twelve Hell's Mouth 221

PART THREE The Lost Battles 1506–Present

Thirteen The Good Citizen 247

Fourteen School of the World 265

Fifteen Prisoners 281

Notes 302

Bibliography 330

The Works of Art 338

Acknowledgements 353

Index 355

INTRODUCTION

The candles cast a dancing light on flayed skin and exposed sinews. Leonardo da Vinci takes his knife and scrapes away more flesh from the arm, trying to make sense of the chaos revealed by his knife. With his left hand he executes a rapid sketch. As dawn breaks, the first rays of the sun catch the waxen face of the dead man. Bells in the hospital chapel ring for early-morning Mass.

This is the image of his own life that Leonardo paints in a passage in his notebooks on the vocation of the anatomist. Introducing his subtle, tender, yet precise drawings based on his own dissections of human bodies, he points out the originality and value of this new kind of anatomical art:

> And you, who say it would be better to watch an anatomical demonstration than to see these drawings, you would be right, if it were possible to see all the things the drawings demonstrate in the dissection of a single body, which with all your intelligence you will not see, nor get knowledge of more than a few veins . . . as one single body did not last long enough, it was necessary to proceed bit by bit with many bodies, until I had completed the research; which I did twice in order to see the differences.

Beyond all these practical barriers lie emotional and psychological ones: 'And if you should have a love of such things, you might be stopped by your disgust, and if that did not hinder you, then perhaps by the fear of spending the night hours in the company

of those dead bodies, quartered and flayed and terrifying to behold.'[1]

It is the last sentence that arrests you. Leonardo created his beautiful anatomical drawings under the most harrowing circumstances. He spent his nights among the dead, contemplating their eviscerated flesh, struggling with his own horror. How did he ever embark on such a strange adventure?

Leonardo had a lifelong interest in anatomy – he had a lifelong interest in all aspects of human existence, and in all of nature – but the great drawings he made of dissected bodies were begun in 1508 as work fizzled out on one of the most ambitious projects he ever undertook. If that project failed – *if* – then it gave life to what is in some ways Leonardo's greatest body of work. You only have to compare his drawings of heart valves, facial muscles, the brain and the sinews of an arm with the harsh, gory prints in the slightly later work of the first modern anatomist, Vesalius, to see how miraculous Leonardo's eye was. His studies of the human frame are at once scientifically meticulous and artistically exceptional: each pen stroke aches with wonder. On timeworn yellow and blue sheets of paper, he touches into rich life shades and nuances of bone and muscle. Veins hang like the roots of a plant, the interior of a heart resembles a cathedral. Profound love of creation pulses in these drawings. Out of his nights of horror, Leonardo reveals a deep poetic admiration for the human creature.

At the same moment, another artist is daring just as much, for an equally enduring reward. Michelangelo Buonarroti climbs a wooden ladder to the platform he has built on wooden rafters slotted just beneath the Gothic vaulting of the Sistine Chapel in Rome. It is 1508 and he is starting the work of his life: to paint the soaring ceiling of the pope's personal place of worship. Within months Michelangelo will dismiss his team of assistants and turn his labour in the chapel into a solitary struggle to impose a vision of humanity's place in the cosmos onto this lofty interior. As

Michelangelo plants his feet firmly on the wooden boards to start to fill the empty vault above him, he is just as conscious as Leonardo of his own heroism. His enterprise in the Sistine Chapel is a cruel physical trial. Only a young and fit man could take on such a thing – while Leonardo is fifty-six years old in 1508, Michelangelo is thirty-three. In the kind of coincidence he relishes, it is the age of Christ when he endured the cross. As he forces his tired body to keep its balance day after day, raising his leaden arm to brush bright colours onto the fictional heavens above, Michelangelo comes to see his labour as a strange torture, a ritual of pain. In a poem he describes what it feels like to stand on the scaffolding with his head bent back, his arm raised and his face covered in paint:

> Beard to the sky, I feel my brain
> on my hump, I have the breast of a harpy,
> and the brush constantly above me
> makes, as it drips, a rich pavement of my face.[2]

It's tempting to speculate that he actually wrote these lines on the scaffolding, for as he looked down at the floor far below he would have found his image of a 'rich pavement' – the chapel has a brightly coloured pavement of particoloured marbles, a kaleido-scopic mosaic like Michelangelo's own paint-spattered face. It was observed by a nineteenth-century art historian that Michelangelo portrayed creation no fewer than five times on the chapel's ceiling, as God divides light from darkness, makes the sun and moon, hovers over the waters, gives life to Adam and creates Eve.[3] It is as if he was depicting his own creative genius in the vault of the heavens.

These two titanic talents were leaping to new heights of ambition and courage in 1508. They were working heroically – daring the dark, braving the heights. It is one of the great moments in cultural history, the epoch of the High Renaissance. In the hands of

Leonardo and Michelangelo in the early sixteenth century, the art of the Italian Renaissance becomes fully conscious, lucid and complete.

The anatomical studies of Leonardo and the painted ceiling of Michelangelo could not seem more opposite in nature. As Leonardo draws tiny scientific images of dissected organs in fragile notebooks, Michelangelo paints huge figures on a vault at the heart of papal power. Yet a rivalry between the two artists lies just beneath the surface of these works. Leonardo in making the greatest drawings anyone has ever created of the dissected human form proposes to outdo Michelangelo's renowned sculptures of the nude body – to improve on the younger man's muscular nudes by looking deeper, exposing the inner fabric of muscles themselves. Meanwhile, on a colossal scale in the Sistine Chapel, his younger rival paints his answer to Leonardo's notebooks with their teeming imaginative wonders. The image of the book is unavoidable on the Sistine ceiling. Michelangelo portrays prophets and sibyls opening gigantic tomes: with its many layers of fiction and decoration, his complex painting resembles a vast illuminated text. It is a history of the cosmos, the book of time. From a religious perspective that is the opposite of Leonardo's materialist science, it sets out to eclipse the older man's intellect as well as his art.

These rivalries and parallels come of intense mutual observation. When Leonardo and Michelangelo worked simultaneously on science and cosmology in the years just after 1508, they were rebounding from a competition that deeply affected both their lives. This book is about that extraordinary stand-off between two of the supreme artists of all time.

The climax of the Italian Renaissance was not reached in a healthy dialogue of great minds. It was the outcome of savage, merciless rivalry. In the 1490s Leonardo and Michelangelo both, independently, developed a new kind of classical art, more lucid than any previous Italian attempt to revive the style of ancient

Greece and Rome, and more eloquent in its capacity to make monumental statements. But what forged this new art into the full grandeur of the High Renaissance – the brilliant age that lasted from 1504 to the 1520s, when Michelangelo designed his Laurentian Library in Florence – was a brutal confrontation between them.

In 1503 Leonardo was commissioned to paint a mural of a famous historical episode, the Battle of Anghiari, in the Great Council Hall of the Palazzo Vecchio in Florence. In 1504, as he was planning his painting, his junior, Michelangelo, was invited to paint a rival work, *The Battle of Cascina*, in the same room. It became a competition to discover which of the two was – in the words of Piero Soderini, the republican head of state who commissioned the pictures and launched the competition – 'the greatest artist in the world'.

The confrontation in the Great Council Hall made Florence, said an eyewitness, 'the school of the world'. It was a spectacle that drew artists from all over Italy and beyond to admire the heights of ingenuity to which Leonardo and Michelangelo were driven by their rivalry. Out of it came a new idea of 'genius' – of the artist as an enigmatic original – in which we still believe today. It was in this competition that artists were first fully and openly recognised not as artisans doing a job of work, but as godlike creators of the new.

The Renaissance is an important moment in history not just because it gave us so much beautiful art, so many fine works of literature, so many great buildings. It is important because, as the Swiss historian Jacob Burckhardt argued in 1860 in his classic work *The Civilisation of the Renaissance in Italy*, this culture gave birth to the modern individual.[4] The self striving for fulfilment is a Renaissance invention that still describes our lives. There is no clearer evidence of its genesis than the contest between Leonardo and Michelangelo.

This drama takes us to Florence, cultural capital of the Renaissance world, to behold outrageous egos in collision. It is a

spectacle of sublime ambition and low cunning, of great minds and petty dislikes, of genius stepping off its plinth to live among the flawed passions of a city of flesh and blood. The newborn modern self is about to take the stage in all its agony and ecstasy.

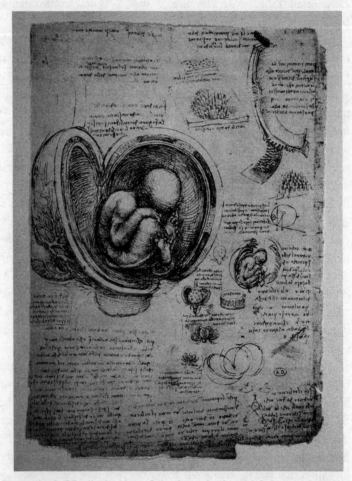

Leonardo da Vinci's drawing of the foetus in the womb is one of the most iconic images of the human being in art and science. Its biological realism contrasts with Michelangelo's portrayal of God giving life to Adam.

Part One

GENIUS IN THE STREETS
1503–4

One

THE INSULT

In the autumn of 1504 Leonardo da Vinci made an inventory of his wardrobe. He had to leave Florence on a military mission, and so he stored some of his most precious possessions in two chests at a monastery, one of which contained his books. But if his reading material offers insights into his mind, his handwritten description of the contents of the other box gives us a uniquely intimate glimpse of his physical existence.

Leonardo wrote his clothing inventory in a notebook (known today as Madrid Codex II) which he carried around with him from 1503 to 1505 and filled with notes that abound with insight into his life in Florence in those years. His inventory brings us disconcertingly close to the very skin of this Renaissance dandy:

One gown of taffeta
One lining of velvet that can be used as a gown
One Arab cloak
One gown of dusty rose
One pink Catalan gown
One dark purple cape, with big collar and hood of velvet
One gown of Salaì laced à la française
One cape à la française, that was Duke Valentino's, of Salaì
One Flemish gown, Salaì's
One purple satin overcoat
One overcoat of crimson satin, à la française
Another overcoat of Salaì, with cuffs of black velvet

One dark purple camel-hair overcoat
One pair of dark purple tights
One pair of dusty-rose tights
One pair of black tights
Two pink caps
One grain-coloured hat
One shirt of Reims linen, worked à la française[1]

This is an exquisite's costume chest. Not the least striking of its contents are four garments specified as *di Salaì* – meaning that Leonardo's clothes were mixed up with those of his workshop assistant Salaì. In the sixteenth century it was said this Salaì 'was most attractive in grace and beauty, having beautiful hair, ringed and bright, in which Leonardo delighted much'.[2] Salaì first joined the workshop as an apprentice in 1490, when he was ten; his master was shocked to find the boy an accomplished thief, taking money out of his own and friends' purses, and bitterly summed up the kid's personality as 'thief, liar, obstinate, glutton'.[3] But by the early 1500s Salaì – whether or not his character had improved – was the unquestioned leader of Leonardo's workshop, and people who needed to speak to the absent-minded genius found themselves dealing with this young man whose curly hair and slightly podgy face (that's gluttony for you) make him look in drawings by Leonardo like a decadent young Roman emperor. The list of clothes reveals how close they were: there's even an alteration where *di Salaì* was added later, as if there were some dispute over who owned what.

Yet the garments ascribed to Salaì are far more conventional than Leonardo's own clothes. The gown of grey Flemish cloth and coat with black velvet cuffs that belong to the youth could have come straight out of numerous sixteenth-century portraits of stylish men, such as the disdainful individual in black portrayed by Lorenzo Lotto in 1506–8 against a white curtain that emphasises his severe dress.[4] When Salaì went around in clothes that

were obviously expensive yet muted in hue, he was showing fashionably restrained good taste. Leonardo by contrast dressed almost exclusively in pink and purple, a delicate palette that harmonised with his own paintings. It was as if he was a character escaped from a fresco.

Surely this was a deliberate badge of professional identity – wearing colours that might have been mixed in his own workshop. Leonardo believed in painting as a vocation, an ethos, a way of life. The painter, he exulted, 'sits in front of his work well-dressed and moves a very light brush with lovely colours, and is adorned with clothes as he pleases . . .'[5] He mentions the painter's excellent clothes and freedom of dress twice in this passage, which also stresses that painting is the manipulation of colour. In fact Leonardo's taste in dress was of a piece with his aspirations as a painter. From his very earliest works, one of his overriding fascinations is with how oil paints can reproduce the transparencies and opacities, folds and twists, brightness and darkness of textiles. Among the first drawings that can be ascribed to him are studies of drapery which convey not just the weight of cloth as it hangs in mountainous creases, the shadowy valleys between folds, but the very grain of the woven fabric. In his youthful *Annunciation*, both Mary and the angel are decked out in garments of almost curdling richness and a colour range of great complexity and power. Mary has blue skirts which turn into a robe covering her right shoulder, a glow of gold satin at her elbow and over her midriff, and, beneath all this, a red dress with pale purple belt and collar. The angel wears a white tunic tied at the arm with a violet ribbon, a drapery of green, and long, dark red robes. It is as if they are waiting patiently while Leonardo drapes them according to his fantasy – for Mary's blue skirts are not really skirts at all but an enormous cloth he has arranged on her shoulder and legs, spreading it over a chair arm whose form becomes an enigmatic bulge.

From the clinging dresses of goddesses carved on the pediment

of the Parthenon in fifth-century BC Athens to the precious work of Leonardo's teacher Verrocchio with its ribbons fluttering in the air, textiles swag the history of art. Yet no one has ever painted clothes quite as consummately as Leonardo. If he does have predecessors, they are the Gothic painters of fifteenth-century Germany and the Netherlands. The massive capaciousness of Leonardo's draperies, the apparently arbitrary spreads and redundant quantities of cloth, resemble the heavy fabrics of Northern European art. There are rewards for the curious eye in watching him pour deep shadows down valleys of satin, weaving mysterious daydreams and conjuring phantom forms in an art that begins by dwelling on powerfully coloured, ornately folded draperies and evolves to encompass the most gossamer of translucent gauzes.

This evolution is apparent in the first and second versions of his composition *The Virgin of the Rocks*, which he first painted in the 1480s and then recreated in a picture still unfinished in 1506. The earlier version has an angel swathed in bright, bulky red and green satin; the angel in the later painting wears a sleeve whose gold-embroidered tracery floats on transparent layers of light-filled, colourless material gradually forming into a white creaminess. It is a stupefyingly intricate effect – precisely the type of challenge Leonardo sought as a painter, although how much of this second version is by his own hand will never be certain. In *The Virgin and Child with Saint Anne*, which he worked on more or less to the end of his life, he again gives the Virgin a semi-transparent filigree sleeve. Having learned from the Gothic-tinged training of his youth in 1460s and '70s Florence to depict draperies with a crisp attention to their folds, he became in his maturity obsessed with the ambiguous semi-transparency of gauzes and veils.

That is how Leonardo hangs clothes on women and angels. Women appear in far more of his surviving paintings than men do – four portraits of women exist by him. Even Ginevra de' Benci, who posed for one of his earliest and plainest paintings in

about 1474, sports a black velvet scarf that contrasts sensually with her simple brown dress and pale skin. There's only one portrait of a man, a young musician whose costume isn't especially interesting or well-preserved.

There is, however, one painting by Leonardo that is full of male figures nobly robed. The *Last Supper* started to rot and flake the second he set down his brush for the last time in the monks' canteen of the convent of Santa Maria delle Grazie in Milan in 1497/8. Restorations and repaintings over the centuries added layer on layer of glue and pigment to try and preserve what people thought – long after living memory was lost – the work must have looked like. The most recent (perhaps quixotic) restoration pared away these later layers to get as close as possible to the 'original' paint.[6] The fragmented result is infinitely paler and drier than any of its creator's better-preserved paintings, with scarcely a hint of the low-toned ambiguities he loved. While this makes it hard to interpret the appearance of the clothes, it is apparent that he arranged the men's robes as freely and sculpturally as he layered satins and gauzes on his female models. At the far end of the table on our left, Bartholomew stands up from his seat in shock at Christ's revelation that one of the disciples will shortly betray him; the heavy green robe over his thin blue tunic gathers in a bunch on his shoulder and hangs in the air, defying gravity as impossibly as the crinkly satin garments that float unsupported in Leonardo's later *Virgin and Child with Saint Anne*.

Look more closely at the same disciple, and his clothes become even more similar to those of Leonardo's women. What is the green drapery I've called a robe? It falls in a mass onto the table, bunches extravagantly on Bartholomew's back and is piled around his lower body. It is just as wilful and gratuitous as the voluminous skirts of the Virgin in Leonardo's youthful *Annunciation*. All the disciples at his table are just as artfully clad. What is the garment slung over one shoulder of the feminine-looking John, seated at Christ's right hand? It is simply a loose cloth, there at the painter's

whim and as pink as the clothes in his own wardrobe. Further along the table, James Minor's crinkly shift is also pink.

Long before he painted this heroic and tragic scene, Leonardo drew the portrait of an executed criminal. He was still in his twenties when, in December 1479, he stood in the high, narrow courtyard of the Palace of the Podestà – today's Bargello Museum – in Florence and recorded the appearance of a hanged man in a few perfect pen strokes. Bernardo di Bandino Baroncelli swings, in Leonardo's drawing, from a rope that inclines to the left in a gentle pendulum motion. The dead man's hands are tied behind his back and his legs hang limply. The terrible thing is the face. Its eyes are dark voids, already looking like the empty sockets of a skull. The skin, Leonardo suggests in a couple of lines, is discoloured. There are clear signs of rot and postmortem decay on this face, the only part of Baroncelli's body that is naked.

The rest of the body may be equally emaciated and skeletal, but it looks more alive, more human, because every part of it except the face is concealed by clothes. Bernardo di Bandino Baroncelli was hanged in Florence in the last days of 1479 for his part in a conspiracy that had ended the life of Giuliano de' Medici, brother to the city's ruler Lorenzo the Magnificent. Baroncelli plunged the first dagger into the victim, but while his fellow-conspirators rapidly suffered horrible retribution, he escaped to Constantinople. When he was finally dragged back from the Ottoman city, he was hanged still wearing the Turkish coat and slippers in which he had disguised himself.

Leonardo dwells on the assassin's exotic clothes, already a bit big for the corpse, which shrinks within their bulk. He captures with his pen the soft folds of a long coat, the distinctive bobble buttons on its collar, and its fringe of fur. He records the executed assassin's slippers and skullcap and tights. In a note written as a column next to the swaying body, he gives precise descriptions of each garment:

A little tan cap
A black satin doublet
A black jerkin with a lining
A Turkish jacket lined
with foxes' throat fur,
and the collar of the jacket
covered with velvet stippled
black and red;
Bernardo di Bandino
Baroncelli;
black tights.[7]

Even though this was written a quarter of a century before Leonardo's inventory of his own clothes, the mature artist's list contains a peculiar echo of the youthful drawing, which lingers with such fascination on the dress of a hanged criminal.

Among the clothes Leonardo placed in a chest for safekeeping in 1504 he mentions 'One cape à la française, which belonged to Duke Valentino; of Salaì'. 'Duke Valentino' was the name by which contemporaries knew Cesare Borgia – son of the pope and commander of the papal armies – who cut a terrifying path through central Italy in the first years of the sixteenth century as he conquered one small city state after another in his drive to build an empire for his notorious family. Borgia had menaced Florence itself; his men perpetrated atrocities in its countryside. To most Florentine citizens in 1504, his name was diabolical; a diarist called him 'this serpent'.[8] But for Leonardo, this murderous prince was apparently as darkly seductive as the hanged assassin had once been. Why else dress Salaì in Valentino's old clothes?

* * *

It is no small thing to be able to list the exact clothes a particular human being wore in everyday life half a millennium ago. The 1504 inventory of Leonardo's wardrobe is the next best thing to

possessing the clothes themselves. It is an archaeological fragment that allows us to reconstruct one part of his physical being, to see what he wore as he walked the streets of Florence. In fact his notebooks teem with odd physical details of his life. Sometimes there will be a list of groceries, or calculations of household expenses. All such glimpses of his daily existence delight. But the inventory of his clothes is special because it lends startling substance to one of the most amazing, even embarrassing, anecdotes that sixteenth-century gossips told about him.

* * *

The book is a lovely thing to hold in your hand, like touching a pebble worn smooth by the sea. A creamy-white binding, flattened and honed by time, swings open to reveal paper whose yellowed edges and soft textures tell its age. It breathes out its four and a half centuries (and more) when you open it, as when an ancient attic is unlocked and the trespasser coughs on dust. The slippery, leathery paper leaves a smell on your hands – not unpleasant. Each page is printed in thick black type. The title page is designed like a fantastic window, with robed women supporting a marble pediment upon which play little winged boys, holding between them a shield emblazoned with six spheres. Through the window, beneath the shield, we can see a walled city in a hilly landscape, dominated by a vast cathedral dome and a formidable fortress.

In the time-stained sky above the city framed by the window are the book's title and author:

LA TERZA ET
ULTIMA PARTE
DELLE VITE DE
GLI ARCHITET-
TORI PITTORI
ET SCULTORI
DI
GIORGIO VASARI
ARETINO

It has been printed and reprinted many times in many languages; there are currently at least three rival popular editions in English, but this is how it first appeared in the world in 1550. The wondrous artefact we're admiring in the rare-books room of a great library is the very first edition of the sixteenth-century artist Giorgio Vasari's extravagant, gargantuan literary masterpiece *The Lives of the Architects, Painters and Sculptors*.

One of the most productive crafts in Renaissance Italy was storytelling. Before Spanish and English writers invented the novel, there were Italy's *novelle* – brief tales, tragic or comic, assembled in generous, expansive collections in a genre whose timeless classic is the fourteenth-century Florentine writer Giovanni Boccaccio's bawdy masterpiece *The Decameron*. Shakespeare was to get some of his most famous plots from these Italian story collections: *Romeo and Juliet* and *Othello* started their lives in Italian books of *novelle*.[9] What might have happened, you wonder, if, in addition to the tales of Matteo Bandello in which the original tragic narrative of Romeo and Juliet can be found, Shakespeare had known Vasari's tales of murderous rivals and star-crossed lovers? Vasari's book is so rich in narrative that it sometimes seems less a history than a collection of *novelle*. Although it is full of sensitive descriptions of works of art and acute critical observations, and has a serious argument to make about the progress of culture, its facts are mixed with fiction to a riotous degree.

Vasari's 'Life of Leonardo da Vinci' is his most intoxicated, and intoxicating, parable of genius, a mythic tale whose hero is superhumanly intelligent. Vasari's tone is rhapsodic, the man he evokes magical – 'marvellous and celestial', *'mirabile e celeste'*,[10] was this boy born in 1452 in the country town of Vinci, in the hills to the west of the great art capital that was Florence. One day when he was still a teenager, Vasari tells us, Leonardo was asked by his father, Ser Piero da Vinci, to turn a twisted piece of wood into a shield as a favour for a peasant who worked on the family estates. First Leonardo got the roughly shield-shaped wood

smoothed to a convex disc. Then he went out into the country-side to collect the strangest-looking animals he could find: beetles and butterflies, lizards of all shapes and sizes, bats, crickets and snakes. He killed these animals and took them to his private room, where he started to dissect them and select components of their bodies – wing of bat, claw of lizard, belly of snake . . . Leonardo took no notice of the growing stench as he worked on these dead animals, stitching bits of them together to create a composite monster. He also added something extra, by means Vasari does not explain, for the monster he made 'poisoned with its breath and turned the air to fire'.[11]

Once Leonardo had created his monster, he sat down to paint its portrait on the round shield. Finally, he invited his father to see the result. The painting was so realistic that when the door opened on the teenager's darkened room, it looked as if he had some hideous living creature in there that belched fire. Ser Piero was terrified: his son was delighted, for this was the desired effect.

Vasari tells how, after Leonardo completed his apprenticeship in Verrocchio's painting and sculpture workshop, the young genius went to Milan to play for its ruler Ludovico Sforza on a grotesque-looking lyre of his own invention. Later he relates how Leonardo made a robot lion to greet the King of France that walked forward then opened to reveal a cargo of lilies, and how sometimes for fun he would inflate a pig's bladder like a balloon, pumping it up until it filled an entire room. You might take these to be tall tales. But Leonardo really did move from Florence to Milan in 1481/2, working there for Ludovico Sforza until 1499; he really did make a robot lion; and he wrote in his notebooks about how to create bizarre effects such as an explosion inside a room.

Leonardo's death offers Vasari a final folkloric image of fame. In 1519, having left Italy to end his days as painter to the French court, the old artist was visited on his deathbed by the king. While

the monarch was with him, '. . . a paroxysm came to him, the
messenger of death; on account of which the King having got up
and taken his head in his arms to help him and favour him, in
order to ease his pain, his spirit, which was so divine, knowing it
was not possible to have a greater honour, expired in the arms of
that King, in his seventy-fifth year'.[12]

If Vasari's image of the death of Leonardo is poignant, his
explanation of how it was that such an eminent Florentine ended
his days not just far from Florence but outside Italy itself is one
of the most extravagant claims in his entire book. It seems that
Leonardo had a potent enemy: their rivalry bordered on vendetta:
'There was very great disdain [*sdegno grandissimo*] between
Michelangelo Buonarroti and him; because of which Michelangelo
departed from Florence for the competition, with the permission
of Duke Giuliano, having been called by the pope for the façade
of San Lorenzo. Leonardo understanding this departed, and went
to France . . .'[13] Of all the anecdotes in Vasari's 'Life' of Leonardo
this is the most tantalising.

Vasari was not the first writer to tell tales about Leonardo's
strained relationship with Michelangelo. Anecdotes about artists
were part and parcel of the storytelling culture of Renaissance
Italy. This goes back ultimately to the ancient Roman author Pliny
the Elder, who included anecdotes about famous Greek artists in
his *Natural History*.[14] Boccaccio himself includes a funny story
about the painter Giotto in the *Decameron*.[15] One of the earliest
accounts of Leonardo was written by the novelist Bandello, who,
having as a novice monk at Santa Maria delle Grazie in Milan
in the 1490s witnessed the painting of the *Last Supper*, introduces
Leonardo as a character in his *Novelle* and even has him narrate
a tale of his own, about the amorous friar and painter Filippo
Lippi.[16]

Rumours of some vicious, irreconcilable enmity between
Leonardo and his younger contemporary started to circulate in
Italy in the first half of the sixteenth century. Such a feud was

bound to interest a culture in which ritualised *vendetta* was prac-
tised as readily by artists as by aristocrats. The autobiography
of the Florentine sculptor Benvenuto Cellini is full of stories
about his rivalries, grudges and brutal acts of revenge.[17] This
was a fiercely competitive world and also one obsessed with
honour, with the public image of you and your family, which
could not be sullied by insults or slights.[18] Vasari tells tales in
which artists do not merely try to outdo one another, but even
in one case commit murder out of professional jealousy.[19] The
story that the century's two greatest artists loathed each other
found a ready audience.

In the 1540s – that is, before the publication of Vasari's *Lives* –
an anonymous Florentine author compiled a manuscript collec-
tion of reminiscences about artists that anticipates Vasari's
comment on the geniuses' mutual 'disdain'. This writer, known as
the Anonimo Magliabechiano, tells how Leonardo was walking in
Florence

> by the benches at the Palazzo Spini, where there was a gathering
> of gentlemen debating a passage in Dante's poetry. They hailed
> Leonardo, asking him to explain it to them. It happened that just
> then Michelangelo passed by and one of them called him over.
> And Leonardo said: 'Michelangelo will explain it to you.' It seemed
> to Michelangelo that Leonardo had said this to mock him. He
> replied angrily: 'You explain it yourself, you who designed a horse
> to be cast in bronze but couldn't cast it and abandoned it in shame.'
> And having said this, he turned his back on them and left. Leonardo
> remained there, his face turning red.[20]

A precious clue testifies to the reliability of this tale – a striking,
physical clue. It seems that the Anonimo's informant had an excel-
lent visual memory of Leonardo, for his story of the insult at the
Palazzo Spini is preceded by a detailed pen portrait of
Michelangelo's victim in what must have been about 1504:

'[Leonardo] cut a fine figure, well-proportioned, pleasant and good-looking. He wore a pink [*rosato*] cloak . . .'[21]

A pink cloak?

Let's cast our minds back to that clothes chest in the monastery. In the inventory of its contents, the predominant colours in his wardrobe are pink and purple. The colour terms *rosa* and *rosato* recur so often that it's safe to say this was the colour you were most likely to remember Leonardo wearing if you'd seen him around Florence. Among the items he mentioned were:

Una gabanella di rosa seca [one dusty-rose-coloured gown]
Un catelano rosato [one rose-pink catalan cloak]
Un pa' di calze in rosa seca [one pair of rose-pink hose]
Due berette rosate [two rose pink caps][22]

Leonardo's rosy clothes were memorable – so memorable that an eyewitness accurately recalled their hue forty years later, along with bitter words exchanged between famous men in the street.

* * *

The clothing inventory that Leonardo left in Madrid Codex II gives a good story the colour of an authentic eyewitness account. It is not a second-hand bit of information retold years later, but a note from Leonardo's hand that puts him in pink clothes, just as the witness remembered, that day in front of the Palazzo Spini.

The Spini is a formidable survivor, an urban castle with crenellated battlements which glower on the swanky shopping street that is today's Via Tornabuoni. At once toweringly Gothic and discreetly elegant, its façade bowed and twisted by the irregularities of the medieval city and perforated by arched windows that glisten with wealth, in the twenty-first century the Palazzo Spini is home to an eminent fashion house, its tough stone mass the perfect foil for displays of blue and yellow patent leather shoes. It was outside this building that Michelangelo insulted Leonardo.

The triangular space to the north of the palazzo is the kind of Italian urban setting, formed naturally in the course of time by a gathering of mighty façades closing off a little piazza, that feels like a purpose-designed theatrical stage. Florence specialises in such superb sets for impromptu street theatre. On a summer night, mopeds are parked here, lovers sit close together on marble ledges. Walk southward past the palace and you come to the River Arno, where, in the summer dark, teenagers perch dangerously above the black waters on the stone pontoons of the Ponte Santa Trinità, savouring the eerily beautiful midnight view of the Ponte Vecchio, its freight of ancient craftsmen's workshops sparkling in the velvet dark.

In the early 1500s there was a public space outside the Palazzo Spini where citizens sometimes congregated. The gatherings were all male. In Italian cities 500 years ago the only time respectable women were seen on the street was during their early-morning walk to church. The rest of the time, the drama of civic life was masculine. To taste its flavour, look at Leonardo's *Last Supper*. All the men here, like the 'gathering of gentlemen debating a passage in Dante's poetry' that day in front of the palazzo, are passionate and argumentative. They make their emotions visible through hand gestures. When the great German poet and dramatist Johann Wolfgang von Goethe wrote about the *Last Supper* in the early nineteenth century, he compared the disciples' gestures with the hand signals people still used for emphasis on Italian streets in his day.[23]

In his play *Mandragola*, a grittily real comedy of city life set in 1504 although first performed in 1525, Niccolò Machiavelli has a character go looking for someone in all the obvious places: 'I've been at his house, on the Piazza, the Market, the Spini Works [*Pancone delli Spini*], the Loggia of the Tornaquinci . . .'[24] The Spini was one of the places where people gathered, where urban life happened, where a bad penny might turn up. He also mentions Tornaquinci, a nearby corner where five streets meet, in fact just a brief walk further north on Via Tornabuoni. One of the most

vivid records of everyday life in Renaissance Florence is the diary of Luca Landucci, an apothecary who kept a shop at Tornaquinci. One day in February 1501 he came out of his shop to watch a blistering scene. Two convicted murderers were being driven through the streets of Florence

> . . . on the cart, being tormented very cruelly with pincers all through the city; and here at Tornaquinci the stove for heating the pincers broke. And not much fire being seen, and with it failing to flame, the officer, threatening the executioner, made him stop the cart, and the executioner got off and went for charcoals to the charcoal-burner, and for fire to Malcinto the baker, and took a pot for the stove, with which he made a great fire. The officer yelled constantly: 'Make it scorching'; and it was as if all the people wished to do them great harm without pity. And the boys wanted to assassinate the executioner if he didn't torture them well, for which reason they [the condemned men] screamed most terribly. And all this I saw here at Tornaquinci.[25]

The style of theatre that took place on the streets of a Renaissance city was bloody and extreme. Without having to leave his own shop, Landucci saw a drama of intense physical suffering, terror, hate: prisoners' flesh being torn from their bodies with hot pincers, an officer roaring at his underling, a mob on the verge of taking the law into its own hands.

It's not the Florence you see today, looking down from the hill of San Miniato just outside the city walls. The skyline, to be sure, is remarkably unchanged. All the landmarks that dominate the vista of Florence on a bronze summer evening are the same today as on old maps: the slender pink, white and green ribbon of Giotto's Campanile, the tall, sloping roof of Santa Croce, the spire of the Badia, the tall watchtower of the fortified Palazzo Vecchio brown and fierce near to the glowing river, and, at the heart of everything, the Cathedral dome, that white-ribbed terracotta imitation

of the vault of heaven itself. The city lies there in the warm air like a set of jewels, and it would take an insensitive soul to resist a romantic sigh. But this beauty was always in tension with a gory, visceral, earthy everyday life of conflict, individualism, competition, violence.[26] Today the street life of Florence is genteel and touristy – half a millennium ago it was far more vital. What has vanished is the human past. What we fail to hear as we contemplate the beauty of Florence are the screams of prisoners having their flesh ripped off with hot pincers.

The row between Michelangelo and Leonardo that day at the Palazzo Spini was as typical a scene of this world as the spectacle of public torture. Giving – and replying to – insults was a Florentine obsession. The entire Sixth Day of Boccaccio's *Decameron* consists of stories about 'those who, tried by some graceful witticism, have roused themselves to make a prompt riposte, escaping loss, danger or scorn'.[27] The heroes of these stories demonstrate superior wit and mental agility by thinking up a reply to their verbal attacker: a brilliant comeback that turns the insulted victim into the witty victor. Leonardo shared this admiration for the barbed reply. Indeed in the Codex Madrid II, which dates from the time of his confrontation with Michelangelo, he tells his own story about a man who was insulted: 'Someone once told off a man of worth for not being legitimate. To which the man replied that he was legitimate according to the conventions of the human species and the laws of nature. But that his accuser on the other hand according to nature's laws was a bastard, because he had the habits more of a beast than a man, while by the laws of men he could not be certain of being legitimate . . .'[28] Here Leonardo imagines the insulted man replying with devastating force. There is surely a personal animus in his calling the unnamed accuser the real *bastardo*, who behaves more like a wild animal than a man. It sounds as if he himself endured the insult and now is replying in fantasy. Who can have been hateful enough to upbraid Leonardo da Vinci for being illegitimate, as in truth he was, for Ser Piero had conceived

him out of wedlock while sowing his wild oats with Caterina, a farmer's daughter?

Once again, Leonardo's recorded thoughts and feelings tantalisingly strengthen the lurid narratives of the first biographers. And his imagined reply is curious. Who had 'the habits more of a beast than a man'? Leonardo penned an attack on the characters of sculptors which contains a personal caricature of the most famous one he knew:

> Between painting and sculpture I find no difference, except that the sculptor undertakes his works with greater strain of body than the painter, and the painter undertakes his works with greater strain of mind, which is proved to be true because the sculptor in making his works does so by force of arm and of percussion to wear away the marble or other stone and uncover the figure enclosed within, which is a most mechanical exercise often accompanied by great sweat, compounded with dust and turning to mud, with a face all pasted and floured with marble dust that makes him look like a baker, and he is covered with tiny fragments, so he seems to have snow on his back, and his house is dirty . . .[29]

This text only appears in the Codex Urbinas, a manuscript compiled from Leonardo's writings after his death by his pupil and companion Francesco Melzi. There is consequently every chance that it was written late and refers directly to the person it seems to portray – Michelangelo Buonarroti. Sculpture did not always mean chipping away marble to reveal an image – in the Verrocchio workshop where Leonardo trained, bronze and terracotta were used as well as stone – but it is how Michelangelo defined it. There's a suggestive fit between this image of the Michelangelesque sculptor as a dusty mechanical who lives like a pig and the reply of an insulted man that his accuser has bestial habits.

The insults are flying thick and fast, now. We have put Leonardo outside the Palazzo Spini in his rosy clothes in about 1504, victim

of Michelangelo's scathing verbal onslaught. But what did Michelangelo say, exactly, and how did Leonardo respond? He may indeed have said, as the Anonimo claims, 'You explain it yourself, you who designed a horse to be cast in bronze but couldn't cast it and abandoned it in shame,'[30] or he may have said something still more vicious. He may have called Leonardo a bastard. In fact the answer is there in the Anonimo's manuscript, for it seems there was more than one meeting, more than one insult. On another occasion, Michelangelo challenged his enemy this way: 'And those capons of Milanese really believed in you?' The manuscript states that he uttered this insult *volendo mordere Lionardo* – 'wishing to bite Leonardo'.[31]

So there stands Leonardo da Vinci speaking to the gathering of Florentine citizens outside the Palazzo Spini in his rose-coloured cloak, and perhaps in rosy cap, too.

In the Romantic Age and after, there was huge demand throughout Europe for scenes from Renaissance history. The nineteenth-century painter Lord Leighton, in a picture so admired in its day that it was bought by Queen Victoria after a triumphant exhibition at the Royal Academy in London, visualised Vasari's story of how an altarpiece by the medieval master Cimabue was carried aloft through the streets of Florence by a grateful populace. Leighton's imagined medieval Tuscans in their tights and headresses march before a view of the hill of San Miniato that was meticulously observed from life.[32] Just as in such works, by now we have assembled enough details of costume, setting and character to imagine our own history painting of the meeting in the heart of Florence of the city's two most eminent artists of all time. Leonardo, an immaculately turned-out and handsome man in his early fifties with long hair and pink dandified garments, stands with the crowd of dignified gentlemen in their red and black robes in front of the tall, harsh Palazzo Spini. Michelangelo remains some distance off – a man who has not yet turned thirty, with messy black hair, a lump of a nose. We can picture the expression

on his face as he utters his biting words; to reconstruct it we need only contemplate the sculptor's youthful self-portrait, in which a fierce boy stands with his right fist clenched at his side (it originally held a sword or dagger) and a face of concentrated rage. Deep incisions cleave his brow above eyes that glare unforgivingly. Moral outrage grips this face, intensity transfigures it. He is a rebel, an avenger, a martyr.

Michelangelo carved his self-portait into a little marble figure of St Proculus in a church in Bologna in 1494–5. Proculus had been a Roman soldier who had taken the side of the Christians during their persecution in ancient Bologna: this violent revolutionary hero, this justified killer, had turned his weapon on a Roman official and died for his heroic crime. Michelangelo gave the soldier-saint's face furious life – it is hard not to see this as an act of empathy and identification. For proof that it represents the young Michelangelo's formidable self-image, though, you have to look down from his face to his feet. Why does the young man have leather boots on? Ancient Romans, as Renaissance artists knew, wore sandals or, in the case of soldiers, open-toed *caligae*. St Proculus, however, has these boots of soft hide that enclose his feet cosily. They are made for comfort rather than style; it seems strange that a sculptor would have chosen to give a heroic figure such unflattering footwear. The decision to clad St Proculus in snug, unaesthetic boots is a startling act of realism. But what is its meaning?

Fifteen years later, in 1509–10, when Michelangelo was in his mid-thirties, a rival artist portrayed him. Raphael was working on a wall painting of a gathering of ancient Greek philosophers, known as *The School of Athens*, in a room of the Vatican palace for Pope Julius II. Meanwhile Michelangelo was at work for the same employer in the nearby Sistine Chapel. Raphael wittily included Michelangelo in his mural, brooding massively, leaning his head in his hand while he scribbled poetry on a sheet placed on the stone block beside him. His face is cast down in introspection

beneath his unkempt black hair. This man is a stern, unyielding, dark presence among the graceful Greeks. He is emotional while they are rational. His powerful knees are naked beneath his short, shapeless purple tunic. On his feet are soft, comfortable, style-less boots.

When Vasari's *Lives* was published in 1550, most of the artists whose stories it tells were dead. One whose life is heroically told in its pages was, however, very much alive. Michelangelo's 'Life' is the last, and the biggest, in Vasari's first edition. It is more than that: it is the book's logical climax, for in Vasari's eyes Michelangelo's works represented the summit of artistic endeavour. Vasari was fascinated by the 'celestial' Leonardo, but reserved his ultimate praise for Michelangelo. Born in 1475, this Florentine sculptor, painter, architect and poet was to live an epic life, dying in 1564, just short of his ninetieth year. When Vasari wrote his biography Michelangelo was still in the midst of his works, an old man with a young man's energy. Vasari tells his story as a great adventure – how Michelangelo trained as a boy in the Florentine workshop of Domenico Ghirlandaio until he was spotted by the ruler of Florence, *Il Magnifico*, Lorenzo de' Medici, while trying to carve a head in Lorenzo's sculpture garden. How he amazed everyone with his youthful sculptures of Bacchus, the *Pietà* and David until Pope Julius II asked him to design his tomb. Michelangelo fell out with the pope and fled Rome, but their reconciliation led to his painting the Sistine ceiling, a work unrivalled by any artist, living or dead. Michelangelo is simply the greatest artist in history, declares Vasari – he is nothing less than a gift from God.[33]

Michelangelo read this and was ambivalent. Having sent Vasari a poem praising him for bringing so many dead artists back to life, he got his own pupil Ascanio Condivi to take a break from making paintings based on Michelangelo's drawings in order to write an official life of his master.

Condivi's *Life of Michelangelo*, published in 1553, set out to correct errors in Vasari – and to overturn facts Michelangelo didn't like,

such as Vasari's entirely accurate claim that he had been Ghirlandaio's apprentice. What makes it fascinating is the sense that Condivi is closely reporting Michelangelo's own opinions and memories. One of the glimpses of his master that Condivi imparts concerns his favoured footwear: 'In more robust days, many times has he slept in his clothes and with the ankle boots [*stivaletti*] on his legs that he has always worn on account of cramp, from which he has suffered constantly, as much as for any other reason.'[34] So Michelangelo had 'always' worn *stivaletti*, just as he does in Raphael's painting, and just as St Proculus does on the shrine in Bologna. The boy in short, soft boots that Michelangelo carved in 1494–5 is indeed a self-portrait – a symbolic, expressive portrait that acknowledges his own nature, for which the word *fiery* would be a pathetic understatement. Pope Leo X, who as the son of Lorenzo the Magnificent had known Michelangelo in his youth and apparently didn't wish to have him around too much when he became pope, said he was '*terribile*', terrifying and sublime.[35] The young man's face in Bologna holds the promise of trouble. You sense that he will always find a cause that justifies his fury. It is marvellous, this fury. It is moral, we intuit – it is righteous. He will always see his enemies as moral inferiors.

Say all this, and think about what you've said, and the most startling fact about this early work becomes apparent. It is one thing to say that Michelangelo portrayed his own anger, his own moral disdain in the figure of St Proculus. What is astonishing, and unprecedented in the history of art, is the fact that he wished to disclose his emotional self. Michelangelo is the first creator in history – certainly in the visual arts, surely in all the arts – to comprehensively, insistently do this. His works mirror his self in a radical and extreme way that makes them inseparable from their maker – when you look at a Michelangelo you feel the presence of his body working the stone, stretching up to paint the vault.

This new and magnificent conception of his relationship to his

work, perfectly encapsulated in the figure of St Proculus, means that Michelangelo's emotions are still visible to us. Even something as intangible and elusive as his dislike of Leonardo da Vinci has resisted the oblivion of time.

Two

THE FAME MACHINE

The antagonism between Leonardo da Vinci and Michelangelo Buonarroti did not arise out of thin air. It was not that dapper Leonardo disliked young Michelangelo's scruffy appearance, or that the avowedly celibate Michelangelo frowned on the older man's confident parading of young assistants in front of everyone's eyes − or rather, it was not only these personal differences. The tensions that exploded at the Spini were sparked by competition. It would have been miraculous had the two men liked one another, for in 1504 the two greatest artists of the Renaissance became direct rivals.

Pull back from the two men standing there yards apart, one turning away in contempt, the other blushing; broaden the view until the old palace of the Spini no longer forms a backdrop to an intense encounter, but is simply a big brown cube surrounded by smaller pink and white boxes, and further back again − until it takes time to identify it among the hundreds of buildings that stuff the city walls of Florence on both sides of the Arno. The political centre of this walled city was to the east of the Spini, along narrow, dark streets overshadowed by tall medieval houses. Eventually a path opened out onto the great space of the Piazza della Signoria, the ceremonial public square of Florence, where crowds met to acclaim leaders and threaten trouble. Above its pink tiles with their white grid design growled the government building of the autonomous city state that was Renaissance Florence.

Everyone just called it 'the Palace'. No one doubted which

Palazzo you meant; the most potent building in Florence was not to be confused with one of the classically inspired residences rich families kept building for themselves. No matter how many cornices the Strozzi, Rucellai or Pitti put on their rooftops, their great houses would never be as central to the life of the city as the stronghold of state that soared over the salmon-pink piazza, its slender square watchtower crowned with a bronze lion balancing on a ball. Made of rugged, irregular blocks of stone whose sheer quantity becomes a poem of force, on what was a precise rectangular ground plan before it encroached eastward to form a more mystifying shape, the serious defensive intentions of the Palazzo della Signoria were apparent from the fact that it had only the narrowest of barred windows on its lower floor. Its massive walls were perforated by secret passages and hidden escape routes, its upper windows with their elegant arches notorious as the openings from which not a few traitors had been launched to their deaths.

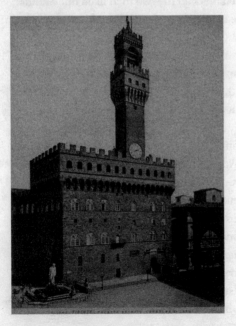

The government Palace of Florence – known since the later sixteenth century as the Palazzo Vecchio – has kept its medieval appearance. This architectural conservatism reflects the building's emotional significance as the beating heart of the Florentine city state

A bronze woman stood guard outside its arched doorway at the start of 1504. Donatello's *Judith* glowed yellow and reflective on her undulating marble column, raising a curved sword that resembled a Turkish scimitar. Her head was covered in a heavy cloth and her figure wrapped in a long, loose dress – all bronze. Her eyes had no pupils and her face seemed blank and mask-like, impassive, as she firmly gripped her victim, the sleeping drunkard Holofernes, by his mass of twisted hair, one long finger of her powerful hand hooked over the locks she pulled back from his forehead. Holofernes, his body as passive as if he were already dead, hung from her strong hand, his head twisted grotesquely on his trunk, his arm swinging and his legs dangling off the cushion he rested on as he waited, half-buried in her dress, for her to bring down the blade and decapitate him.

Donatello's *Judith* could tell you a thing or two about the history of Florence.

To the north of the Piazza della Signoria, past the Cathedral, on Via Larga (today's Via Cavour), was the one house that for fifty years had threatened to displace the Palace as the true centre of power in this small but arrogant polity. Now it stood despoiled, its owners in exile. Cosimo de' Medici had commissioned his townhouse to a revolutionary design from the architect Michelozzo in the 1440s: behind its deliberately restrained façade – whose precisely shaped stone blocks were smooth to connote civilised ways on the upper storeys, rusticated to communicate strength at street level – was a luxurious and spacious inner world that for a while stood fair to become the court of Florence. A chapel fit for a king was adorned by Benozzo Gozzoli's pageant-like *Procession of the Magi*. An *Annunciation* by Filippo Lippi decorated a doorway. Antonio Pollaiuolo's *Hercules* raged on the walls and Cosimo's grandson Lorenzo the Magnificent kept Paolo Uccello's *Battle of San Romano* in his bedroom – among the other treasures of this private house that outdid for taste and probably for comfort any monarch of the day. In its courtyard stood

Donatello's statue of Judith, together with his bronze *David*. Both
bore patriotic inscriptions identifying the Medici with the cause
of Florentine freedom.

The wealth of the Medici came from banking; their fortune was
made when they won the pope's account.[1] Cosimo il Vecchio trans-
lated money into influence to make himself, by 1444, the effective
ruler of a city that nevertheless still considered itself a republic.[2]
On his tombstone Florence acknowledged him as '*Pater Patriae*',
'Father of His Country'. The triumph of the Medici was a crafty
political achievement. Alliances and loyalties were nurtured,
largesse distributed, ballots rigged – and enemies who couldn't be
bought ruthlessly crushed. Part of the game was to flatter repub-
lican illusions. Florence had grown from not much to become a
great city in the thirteenth century. In Northern Europe at this
time strong monarchies were unifying what would eventually
become nations, but Italy lacked central authority. The Papacy
and the Holy Roman Empire fought for dominance, but neither
ever achieved it, instead dividing cities into pro-Papal Guelf and
pro-Imperial Ghibelline factions, adding to the bloody lottery that
was medieval urban life.[3]

Guelf or Ghibelline, the one constant in Italy's political and
social history was the city. The Mediterranean world has a propen-
sity for cities that can be traced back into prehistory. Italy's can be
small or large, but they are never provincial because each sees itself
as a little world apart, even today, with all the cultural confidence
and communal self-respect that implies. In the Middle Ages, cities
created their own governments and their own little empires. Tuscany
threw up a particularly dazzling constellation of neighbouring city
states: Pisa, Siena, Lucca, San Gimignano, Arezzo – and Florence.[4]
In paintings of the landscape of Tuscany, these warring commu-
nities were portrayed as fortified enclosures crowded with houses
and towers on rival, rounded hilltops. The most seductive of all
medieval visions of city life is a wall painting in the Palazzo Pubblico
in Siena. Ambrogio Lorenzetti's *Allegory of Good Government* depicts

Siena as a colourful cluster of pink houses and soaring towers inside walls dividing it from its surrounding countryside, its *contado*, where peasants happily toil to provide it with everything it needs. On the city streets people are so happy they dance in a circle in front of shops laden with food. This is all the result of good government, and the best government, medieval Italians tended to believe, was a republic. In a republic all citizens had a say in the running of the state and all in principle might be called to hold office. In Florence, to be a political citizen you had to be male, over thirty and have at least one ancestor who had held office. But there were so many offices, all with comparatively brief terms of appointment, that most families who'd been settled long in the city were led by men who were *cittadini*.[5]

The antithesis of republican liberty was tyranny, the rule of one individual. In most Italian city states in the course of the Middle Ages, tyrants took over. Wealthy families were happy to have a despot secure their property. By the early 1400s Florence was almost alone in maintaining its republican freedom, fighting a bitter war against the Visconti, despotic rulers of Milan, to defend it.[6] Cosimo de' Medici and his successors emerged as de facto hereditary rulers of Florence without appearing to end its republican tradition because the Palazzo della Signoria remained the seat of government, separated from their house, and because they supported and shared the rhetoric of republicanism. Donatello's *Judith* stood witness to this: she had originally done her killing in the courtyard of the Medici house above fierce inscriptions, put up by the potent family, hoping that '. . . citizens . . . might return to the republic'.[7]

In proclaiming their own love for the Republic, the Medici masked their destruction of Florentine freedoms. There were difficult moments, but for most of the fifteenth century their hegemony was complete. Then it crumbled overnight. The *Judith* saw it, felt it. When the Medici fell in 1494 she was physically dragged from the Medici courtyard and placed outside the Palazzo della Signoria, a symbol of revolution.

When Lorenzo de' Medici died, still only in his forties, in 1492, he was succeeded as *capo* of Florence by his son Piero. Unfortunately Piero lacked finesse, intelligence and cunning. In 1494 the King of France invaded Italy, crossing the Alps with an army equipped with cannons. The French cannons were invincible. One Italian city after another fell as the French headed southward to contest the crown of Naples. As they entered Tuscany, the hapless Piero rode out from Florence to cut a deal, without consulting the Palace. His attempt at flamboyant diplomacy had the disastrous result of surrendering important fortresses and allowing the French to give Pisa its freedom from Florentine rule. Returning home, Piero found the bells of the Palace ringing to call the people to arms against him. He and his brothers fled. Suddenly the Republic actually was a republic.[8]

There was instant debate about what to do next. Some patricians wanted this republic to be carefully managed with methods like those the Medici had used. Others argued for broadening the government. The most influential voice turned out to be that of a prophet who got his political advice straight from God.[9] For years now in his sermons in the Cathedral, the terrifying preacher Girolamo Savonarola had denounced tyrants and the abuse of wealth. Rich, tyrannical Lorenzo nonetheless promoted him to be prior of the city's Dominican monastery, San Marco. Savonarola's sermons were more than merely fiery; he claimed he was able to speak directly with God, who informed him of future events.[10]

The French invasion in 1494 seemed to vindicate Savonarola's prophecies. He'd spoken of a 'great scourge' coming into Italy – and here it was. He'd spoken of a sword, and here it was. Savonarola's audiences now accepted him not just as an eloquent man of God but as an authentic prophet. This gave him extraordinary power. As the city's political elite debated what to do after expelling the Medici, he spoke for God – and for the People, the *Popolo*, who loved him. He said he agreed with those who argued for establishing a Great Council, an assembly of all citizens. There

was such a thing in Venice, and the divinely harmonious Venetian constitution seemed good to him.[11]

Savonarola's word – God's word – was law. The Great Council was born. It was not really like its Venetian equivalent because Venice was an aristocratic society with a rigorously limited citizen body. In Florence, shopkeepers and craftsmen suddenly found themselves entitled to approve taxes and elect officials alongside wealthier citizens in the Great Council.

Revolutions eat their children – this one burned its father. Savonarola's preaching became too divisive, and by 1498 not everyone believed he was a true prophet. He kept denouncing Pope Alexander VI, repeating terrible rumours about the pope's Borgia family from the pulpit, all but calling him an Antichrist.[12] His followers, scathingly nicknamed by their enemies *Piagnoni* – Weepers, Cry-babies – went around in pious adolescent fraternities burning 'vanities'. He even spoke of giving women a political voice – for women were among his most devoted followers. Cynical anti-Savonarolan factions arose. With the pope threatening reprisals and the Republic breaking apart, the Palace ordered the monastery of San Marco to be attacked. After a brief, riotous siege Savonarola was arrested and brought to the Palace, where he was tortured until he confessed that he was not a genuine prophet. He and his two closest lieutenants were then taken out onto a wooden platform erected on the Piazza della Signoria, shriven by priests who'd come specially from Rome, and led along a pier that jutted at an angle from the north-west corner of the Palace to a scaffold towering above the tightly policed crowds. The three men were hanged until they were dead and then a great fire was lit beneath them. It was kept blazing until their charred skeletons fell from the scaffold, and still longer, until there was nothing left but ashes. The ashes were carefully collected and taken to the Ponte Vecchio, where they were scattered into the Arno to prevent anyone retrieving relics. Even so, some people waded weeping into the river to try and skim the black dust off its surface.[13]

With the ground still warm in the middle of the Piazza della Signoria, the Florentine Republic, still in no mood to welcome back the Medici, lurched from crisis to crisis as it tried to protect its liberty in an Italy descending into chaos. The French invasion of 1494 turned out not to be a passing storm, but one of those events that define an age. Great changes followed. One fatal consequence for Florence was the rebellion provoked by the French of its subject city Pisa near the mouth of the Arno. Pisa proved agonisingly difficult to reconquer, and by 1504 Florence had been at war with its Tuscan neighbour for a decade. This was just one of the wars of Italy. By the time the entire cycle of conflicts ended, the very idea of the city republic would lie in ruins.

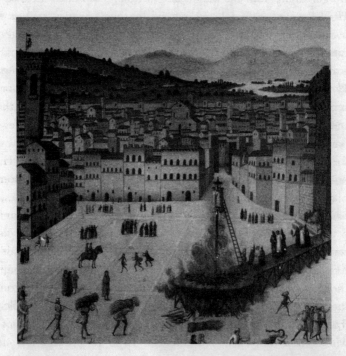

The execution of Savonarola in 1498 left Florentine citizens stunned and anxious. It was hard for the Republic to overcome this burning memory

* * *

Florence at the beginning of the sixteenth century was a republic
bereft. It had driven out the Medici and executed Savonarola.
With the former it extinguished a glamorous court, with the latter
a countervailing force of religious charisma. Its moderate new
government faced a timeless dilemma: how to make the middle
course exciting. Keeping the Republic free from a return to Medici
rule yet also safe from the tyranny of religious fanaticism was a
tricky course. How to give compromise a glorious face? That was
the dilemma confronting Piero Soderini, the Republic's new head
of state, and his counsellor Niccolò Machiavelli.

The defence of liberty is not what the name Machiavelli suggests.
For five centuries it has been synonymous with political ruthless-
ness and skulduggery; in Italy the heirs of Machiavelli might
appear to have been Mussolini and the Mafia, and all over the
world, to this day, he lends his name to cynical and manipulative
behaviour. There is even a school of primate research that claims
to discern 'Machiavellian' – that is, thoroughly competitive and
ruthless – social traits in chimpanzees. Machiavelli is infamous not
for his actions but for his words. A few years after his death in
1527, his books *The Prince* and *The Discourses* were published. Brief,
brilliantly phrased and deliberately shocking, *The Prince* was soon
translated into all the major European languages and remains a
thrilling read to this day. It disturbs and provokes because it appears
to offer, with disarming candour, advice to a ruler on how to
bamboozle and gull ordinary people and isolate, weaken and if
necessary kill rivals and enemies. Its longer companion volume
The Discourses was if anything still more shocking to early readers
because it coolly analyses religion as an opiate of the people.
Machiavelli was once as notorious for his atheism as he still is for
his Machiavellianism.[14]

In Elizabethan England the spy and dramatist Christopher
Marlowe popularised Machiavelli's ideas, having him appear on

stage to speak the prologue to his violent play *The Jew of Malta* (c. 1590). Shakespeare seems to have discovered Machiavelli through Marlowe and, within a year or so of Marlowe writing *The Jew of Malta*, had the tyrant Richard III swear to outdo the ruthless Florentine, boasting anachronistically that he would 'set the murderous Machiavel to school'.[15] The real Machiavelli was as fascinating as the stage monster the Elizabethans made of him, and a lot more complicated. His attraction to the amorality of power was real, and without it his writings would not live as pungently as they do. But closer readers discover the subtleties and ambiguities of his thought, the richness of what he is really getting at. If his words are much more nuanced than the caricature of an evil counsellor might lead you to expect, his life was practically the direct opposite of the fictional self he invented in his books.

Machiavelli wrote *The Prince*, *The Discourses* and several more works including comic plays while in forced retirement after the complete failure of a career dedicated to defending and preserving the Florentine Republic. Far from advising a prince, he got his political experience as Second Chancellor of the Florentine Republic and secretary to its military committee, the 'Nine of War'; he was a civil servant fired by the idea of republican government. He first came to office after the death of Savonarola in 1498, when he was twenty-nine, but his golden moment was the election of Piero Soderini in 1502.

Florence was edgy. The elite wanted to weaken the popular government established in 1494 and to present a more authoritative face to the outside world. Everyone envied Venice, the changeless maritime jewel of European states, whose republican constitution had endured for centuries. The stability of Venice owed much to its unique office of an elected duke, or doge, a role that combined the dignity of regal ceremony with the equality of a citizen among citizens. Florence decided to ape this institution by creating its own doge, known as the Gonfalonier, or Standard-bearer for Life, and Soderini, an adept politician from a respected family,

won the election. One of the ways in which he quickly proved his suitability for the job was by singling out the young Machiavelli as one of his most trusted agents and advisors. Machiavelli soon became a leading voice in the affairs of the Florentine Republic.

Politics in sixteenth-century Florence was a man's world – from ruling right down to citizenship itself. There was a stir when, shortly after Soderini moved into the Palazzo della Signoria, his wife, Argentina Malaspina, went to live there with him. 'It seemed a very new thing to see a woman inhabit the Palace,' the diarist Luca Landucci observed wonderingly.[16] Machiavelli's correspondence with male political friends is full of dirty jokes and machismo, and when he was away on political missions his wife, Marietta Corsini, was often the last to get a letter. But in 1503 a woman changed the course of Florentine political history.

* * *

The woman who won Leonardo his commission to paint a great work for the Florentine Republic is both mortal and goddess, lover and mother, smiling archaic personage and merchant's wife. Her pose has an eternal inevitability, as if she contained within her a serpentine column, revolving heavenward in a perfectly calibrated spiral: this effect of torsion means that she is in energetic motion even as she sits still in her chair. The relief of shadow on her strong features gives her feminine beauty a masculine counter-life. She is a hall of mirrors, a shrine of paradox.

The crowd presses towards her, and to study her for any length of time you must hold fast to a position jammed against the crash barrier in front of the glass box inside which the Louvre displays its most famous treasure. The *Mona Lisa* dwells in a painted atmosphere so thick she might be suspended in tinted liquid. Reality melts in her world. Mountains dissolve, roads wind to nowhere. Soft rocks sink into primeval seas. The power of this painting owes a lot to the strangeness and universality of its landscape, which feels like some kind of summation, some kind of conclusion about the nature

of life on earth. At the heart of that conclusion sits a woman resting her left hand on the arm of a chair turned almost at 90 degrees to the surface of the picture, while her right hand spreads out gently on top of the left wrist, fingers fanning over a coppery sleeve. Bones and muscles and veins lie just beneath the translucent, glowing wax of those hands. The same hypnotic accuracy sculpts the smooth contours of the face that rotates towards us. Beneath her high, bright forehead the perfect symmetrical arcs of her brows graduate as precisely as if they'd been calculated to illustrate some geometrical theorem, curling superbly into the long perfection of her nose. Her lips are cool pink against the warmth of her skin, their clarity as still and eternal as fixed stars. The tautening of the muscles at their corners into a smile is sweetly life-giving.

Her portrait is drawn with shadows. The darks that deepen her features are so bold you can lift them off and reproduce them as a black template. A single stream of shadow starts at the corner of her eye and flows calmly under her rounded eyebrow, into the recess between eye and nose, right down the side of her nose and over her mouth, where it meets the ocean of shade that laps on her cheek. This dramatic yet exact use of shade deepens the *Mona Lisa*'s beauty by giving her superbly made features still greater fullness, smoothness and symmetry; then it mutates into something more tantalising. The shadow on her cheek grows darker until it descends into a black mystery between her head and her hanging coils of brown hair; the blackness below her right cheek is deeper still, almost resembling a cavern or grotto that metaphorically connects her body with the mountain landscape beyond.

The shadows that swarm the *Mona Lisa* have the effect of diminishing the distance between foreground and background. The colours of the landscape bring it forward as her shadows draw her back. This optical effect heightens the psychological and poetic sense that somehow she contains grottoes and rocky recesses within her. The tenebrous voids that darken her beauty make us unconsciously recognise that we cannot interpret this as merely a portrait

with a landscape in the background. The vista beyond her, with its coiling road, arched bridge, rocks, rivers, lakes, mountains and sea, is as much part of her as she is part of it.

The *Mona Lisa* – '*Mona*' or '*Monna*' being short for '*Madonna*', the reverent way to title a married woman in sixteenth-century Florence – started life as a portrait commissioned by Francesco del Giocondo, a textile manufacturer and merchant who had business dealings with Leonardo's notary father. But the picture of Francesco's wife that Leonardo showed his fellow citizens that autumn must have looked very different from today's unfathomable mystery. She must have looked like a real woman.

'What was the relationship of a living Florentine to this creature of his thought?' asked the Victorian critic Walter Pater in 1873.[17] It's still a good question. Leonardo worked on the *Mona Lisa* for years – perhaps until close to the end of his life. He never let the painting go, never handed it over to Francesco and Lisa del Giocondo. The poplar-wood panel was with him in France when he died. Leonardo's long and loving work – that and the smoke of time – created the dream picture we see today. It is impossible, as the aesthetically intoxicated Pater rightly divined, to see this as a 'portrait' in any normal sense. As her obscurities deepened and her landscape ramified, so Lady Lisa was transfigured into a being of myth and fable. Yet Leonardo's rhapsody really did start out as a portrait of a 'living Florentine', and what amazed the first people who saw the picture was its brilliant verisimilitude.

'In this head anyone who wanted to see how art has the power to imitate nature, could easily understand it; for here were counterfeited all the minutiae that it was possible with subtlety to paint . . . the eyes had the lustre and moisture always seen in life . . .'[18] So wrote Vasari in 1550. He praised the curve of the eyebrows, the graceful nose, the mouth that 'seemed, in truth, to be not colours but flesh'. The use of the past tense is significant. Vasari hadn't himself seen the painting, by then in the French royal collection at Fontainebleau, and relied on older Florentine artists' memo-

ries of it. They remembered the name of Lisa Gherardini del Giocondo, an otherwise obscure name that has only recently been rediscovered in the archives, confirming his identification of her: they remembered how in the pit of the woman's throat, if you looked long enough, you'd see 'the beating of the pulse'.

If we want to try and see the woman they remembered, the real Lisa Gherardini del Giocondo whose lifelike portrait became an instant icon in Florence in 1503, perhaps we should start by looking at Maddalena Strozzi Doni. In about 1506 the young Raphael, who came to Florence from his native Umbria to learn from the latest works of Leonardo and Michelangelo, was commissioned to paint portraits of Maddalena and her husband, Agnolo Doni, which hang today in the Pitti Palace in Florence. This wealthy couple – she belonged to the powerful Strozzi clan – collected art, and Raphael gratified them with a visual game to delight the trained eye. He painted Maddalena with a shadow of the *Mona Lisa* on her. It's not just that she adopts the same pose as Leonardo's model, turning towards us in her chair. She also crosses her hands in the same position. Most startling of all, the deep, clean shade that sculpts Lisa del Giocondo's bone structure is reproduced along Maddalena's brow and nose.

Because it was painted so early in the life of Leonardo's masterpiece, Raphael's picture tells us what the *Mona Lisa* looked like before the older master's imagination had finished transfiguring a living Florentine into a fantastic being. It shows what survives in today's painting from the very first sessions in the Giocondo household in the spring of 1503. We can see that Lisa must have actually held that pose, the pose Maddalena would imitate – hand over hand, turning to her side while seated in a *pozzetto* chair (called a 'little well' because of its low, rounded back) – her eyes looking over to the left at Leonardo.

So that's how she sat, holding the pose with infinite grace. Women in Florence were trained to look beautiful, after all. In drawings and paintings by Leonardo and by Sandro Botticelli, you

see models wearing, for the artist's benefit, extraordinarily complicated hairstyles, the time needed for the elaboration of which suggests something of the boredom of women's lives in this city that did so much to create the Western idea of beauty. Lisa's family, the Gherardini, came from the Chianti hills, but the wine of wealth had long since gone sour, and her marriage, at sixteen, to the silk manufacturer and dealer Francesco del Giocondo was economically an upward move that is quietly symbolised in the painting, for she wears a transparent veil of raw silk that glosses her hair in the very stuff of Giocondo's wealth.

* * *

'Leonardo da Vinci could not have portrayed you better,' wrote one Luca Ugolini to his *compare* – his co-father, a term of intimate social bonding – Niccolò Machiavelli on 11 November 1503. While Machiavelli was away in Rome observing the election of a new pope, his wife gave birth to a son. With raw wit, Ugolini was assuring Machiavelli that there was no danger he had been cuckolded because the baby was his spitting image – the child looked as like its father as a portrait by Leonardo looked like its sitter. It would seem that within months of the first drawings being done, the *Mona Lisa*'s fame had reached the managers of the Florentine state.

And so it hung there, a stray, indirect allusion to what might be the *Mona Lisa* in Machiavelli's correspondence, until the announcement by Heidelberg University Library in 2008 that it had discovered something amazing. In the margin of its early printed volume of the ancient Roman Republican politician Cicero's *Familiar Letters*, in handwriting believed to be that of Agostino Vespucci, who worked closely with Machiavelli in the Florentine Chancellery, a note about Leonardo mentions the *Mona Lisa* directly.[19] Dating his comments October 1503, Vespucci says Leonardo is working on a picture of 'Lisa del Giocondo'. It's a vindication for Vasari, whose identification of this painting as a portrait of the wife of Francesco del Giocondo was never until now universally accepted as simple

truth – after all, he has such a reputation for making things up.

Nor is this the only claim in Vasari's 'Life of Leonardo da Vinci' that Agostino's comment substantiates. The *Mona Lisa*, says Vasari, brought Leonardo's fame in Florence to fever pitch. He started it after returning from his long sojourn in Milan, where he had attempted to cast a colossal bronze horse and succeeded in painting the sublime *Last Supper*. On his arrival back in Florence, he dumb-founded people with a cartoon – a full-sized drawing for a painting on many sheets of *cartone*, the largest sheet of paper manufactured in Renaissance Italy – showing a group consisting of the Virgin with her mother, Anne, the infant Christ and the young John the Baptist. This lost work must have resembled Leonardo's only surviving cartoon, which hangs in the National Gallery, London, and depicts a similar composition.[20]

If you look at the National Gallery's cartoon, you can clearly see how rectangular *cartone* sheets were stuck together to create the vast drawing surface. On the soft paper, Leonardo has used black chalk to create a group of figures born of shadow. The Virgin Mary and Anne sit in an arrangement so peculiar it takes you a while to under-stand that Mary is sitting on her mother's lap. Their legs, under sculpturally massive robes, are immense. The grouping of two figures so close together has the power of some massive fragment of marble statuary. This monument comes to spontaneous life in the childish energy of Christ and St John, as the little future Baptist with his curly hair and soft, round face looks up at Christ, who, though but a baby, blesses him. Mary looks down tenderly and happily at this scene. Her mother points heavenward and, also smiling, gazes at her daughter out of a face of cavernous revelation. Anne has profound shadows under her throat and shading that finely maps every muscle in her face. Most imposing of all, she has recesses of darkness for eye sockets, into whose ashen pits you have to stare to make out her eyes at all.

The London cartoon was probably drawn a year or so before the one Vasari describes, which he says was exhibited at the

Santissima Annunziata, one of the holiest churches in Florence. People flocked to see it as if going to a festival: it amazed not only artists, but all the people of the city. Leonardo soon followed up this triumph with the even greater success of the *Mona Lisa*. His miraculous portrait captivated the entire Republic:

> And this work by Leonardo had a smile so pleasing that it was a thing more divine than human to see; and it was held a marvellous thing, since it did not differ from life.
>
> Through the excellence of the works of this most divine artificer, his fame had grown so much, that all persons who delighted in art, indeed the entire city, desired that he would leave them some memory. And it was being argued everywhere that he should be commissioned to do some notable and great work, by which the public might be adorned and honoured by the great intelligence, grace and judgement that were known in the works of Leonardo. And between the Gonfalonier and the great citizens it was decided, the Great Council Chamber being newly built, that he should be given some beautiful work to paint; and so Piero Soderini, then Gonfalonier of Justice, allocated him that room.[21]

There's no doubt that this happened: records of payments and even a contract survive for the mammoth project Leonardo now took on.

What's new about the recently discovered annotations by Vespucci is their confirmation that the commission was related to the *Mona Lisa*, just as Vasari said. In the letter to which Vespucci appended his comments, Cicero, writing in the first century BC, describes a painting of Venus by the ancient Greek artist Apelles. No work by Apelles survives, but classical writers call him the greatest painter of all time. The old authors make him sound radical and brave: he once won a contest with another artist in which they merely painted lines on a board, a work so revered – says Pliny the Elder – that it was in the Roman Imperial collection on the Palatine

until destroyed in a fire.[22] In his letter, Cicero also stresses the aesthetic boldness of Apelles. He says that in one of his paintings this master meticulously delineated the head and shoulders of Venus, but left the rest of her form '*incohatam*', 'unfinished'. Beside this passage in the margin of his copy of Cicero's letters, Vespucci wrote 'so does Leonardo da Vinci in all his pictures'. He gives examples: Leonardo is working on two unfinished pictures, 'the head of Lisa del Giocondo and Anne the mother of the Virgin'. In other words, when people first saw the *Mona Lisa* in Florence in 1503, it was an unfinished sketch, perhaps an uncoloured cartoon, like his design of St Anne. This isn't surprising since he'd probably only begun it that spring. And Vespucci adds, 'we will see what he does in the Great Council Hall . . .' Writing from within the Palace itself in October 1503, he confirms that Leonardo is preparing to decorate its grandest and most daunting space.

* * *

The best place to comprehend that space today is from outside the Palazzo Vecchio, as the old Palazzo della Signoria has been known since the later sixteenth century. The pink tiles of its piazza have been replaced with blue-grey cobbles, on which crowds of visitors mill and horses waiting to give expensive carriage rides leave their droppings. Café terraces and a luxurious accretion of statues added in the later sixteenth century – Cellini's bronze *Perseus* raising the green head of snake-haired Medusa and Giambologna's frozen white contortion of Sabine women beneath the stately arches of the Loggia, goat-legged satyrs disporting themselves around Bartolommeo Ammanati's *Neptune Fountain* close to where a plaque marks the site of Savonarola's death – have transformed what was, in 1504, an austere, pristine space. But even today it is imposing, and the façade of the Palace has scarcely changed at all, whatever conversions went on within. This is in itself meaningful: a building that dates from the fourteenth century has been maintained in its original Gothic appear-ance as a manifest sign of the endurance of traditional Florentine

values. The bell tower still soars, the windows still look like it would be quite natural to hurl somebody out of one. Along the north wall, there is a visible change in the stonework. It becomes more raw. You can clearly see a break where what must originally have been a separate building was added on, its slanting roof much lower than the tall fortress it adjoins. You can also see, on the undressed façade, where it was later extended upward, towards the lofty heights. The archaeology of the Great Council Hall is plainly visible here: it is a separate hall built onto the eastern side of the original palace, and at some point its roof must have been raised.

It is far more difficult to discern this room's history from within. In the vast Hall in a silvery light you walk past twisted, violent marble people. A nude Florence holds Pisa in chains at her feet. Hercules fights a whole series of enemies. A Michelangelo youth stands astride an older, bearded man. Chairs are set out between the statues for a concert or meeting; the Palazzo Vecchio is still the seat of Florentine local government and this is a functioning hall, with a lectern on the raised ceremonial platform called the Udienza. Scalloped recesses and marble prelates dignify this chilly platform, conceived as a shrine to the Medici family. High above, the ceiling is heavily impressive, a system of immense gilt beams framing oil paintings of the Medici and allegories of Tuscany, including a homage to the vintages of the Chianti hills. You get the impression that above this false heaven you would find royal apartments: only by taking the 'secret tour' into the attic space, an ancient, dusty labyrinth of wooden beams supporting the ceiling's grandiosities beneath a simple slanting roof, can you see that in essence this hall is a simple shed. On its long, high walls innumerable soldiers fight and die. Armoured men raise blazing torches to attack Siena by night. A warrior rushes to dress as the Florentine army swarms into Pisa. Hosts of cavalry raise scything swords. Muscles, chain mail, a palette of bright orange, glowing green and violet.

The frescoes, allegory-laden ceiling, display of sculpture and raised galleries of this epic room date from the mid-sixteenth

century, decades after Leonardo worked here. There is no sign of his mural among the works by lesser painters, but the visitor is likely to find assorted technological items and scaffolding along the walls, scanning for his lost work beneath the later frescoes. However, you don't need hi-tech instruments to get closer to the past of this room. The floor is a sea of dark red tiles, like an ancient blood stain. They transport the imagination to a moment when the Hall was new, when it was lower and darker than it is today, and bare plaster walls waited to be filled with images. The creator of the Great Council Hall still haunts it: a beak-like nose, a glittering eye, a stentorian voice linger in the room's shadows.

In 1494, when Florence threw out the Medici, the voice of Savonarola called for the new Republic to be truly popular. It had to invest power in a Great Council of all its citizens. When this democratic institution was created, there was the immediate problem of finding a space to accommodate so many. Savonarola had the answer: he called for a special hall to be built for the new assembly. Architects and craftsmen, fired by faith, worked with a speed the Savonarolans dubbed miraculous. Angels must have helped, it was said, for the Great Council Hall was ready by 1496. Its construction had taken just nine months. The plain coffered wooden ceiling was far lower than today, but the ground plan was the same. Roofing and flooring a first-floor chamber on such a scale were no mean feats.[23]

It opened with a Mass, held by Savonarola's lieutenant Fra Domenico da Pescia, for this was to be a sacred space, formally consecrated as if it were a chapel. Savonarola preached here to the Great Council. Naturally this holy place of the People needed to be ornamented with fine seating and works of art. In 1496 an order went out for anyone hiding treasures looted from the Medici during the revolution to hand them over 'to honour and orna-ment the new great hall in honour of the Florentine People'.[24] The Hall honoured the People and it in turn needed honours.[25]

After Savonarola's death, the humble citizens who admired him

watched his ashes float away on the river, but did not forget his words. The shopkeeper and Great Council member Luca Landucci recorded that on a festival day in 1500, 'at the door of the Signori was placed a Christ of very beautiful relief, as if it appeared we wished to say, "We do not have any other King than Christ". I believe that this was a divine permission, because many times Fra Girolamo said that Florence had no other King than Christ'.[26] Soderini's government had an instant way to preserve an image of continuity with the idealism and passion of Savonarola's Republic and so please the People: decorating and dignifying the Great Council Hall. So in June 1502 it commissioned another representation of Christ, this time a marble statue, to stand above the wooden loggia where Soderini and other governing executives – the Signoria – sat. In the same sanctimonious spirit, Filippino Lippi had been commissioned to paint a religious altarpiece for the Hall shortly after Savonarola's death – the symbolism was obvious.[27] Even as it burned his body, the Republic was using public art to stress faith and fidelity. The Hall was in short not just bricks and mortar: it was the physical expression of the Republic, a sacred manifestation of the Florentine People itself. Machiavelli understood this well. Years later, after the Great Council Hall was closed for political reasons, he gave some advice to Pope Clement VII on how to govern Florence with consent: 'It remains to satisfy the third and final class of men, who are all the universality of the citizens . . . and therefore, I judge that it will be necessary to reopen the [Great Council] Hall . . . Without satisfying the many, you cannot have any stable republic. Nor will the great mass of Florentine citizens be satisfied, if you don't open the Hall: therefore, if you want to make a republic in Florence, open this Hall . . .'[28] Both Machiavelli and Soderini knew that Savonarola had left them a secret weapon. Simply by giving the Great Council Hall its due, the managers of the Republic could reassure humble citizens of the integrity and sanctity of their policies.

* * *

Leonardo da Vinci, at this time, was famous among the entire citizen body of Florence. His exhibition of a cartoon at the Annunziata drew crowds as if it were a carnival. His portrait of Lisa del Giocondo was patently the most lifelike record of a person anyone had ever seen. Portraits were revered in Florence as simulacra of the living and relics of the dead. After Lorenzo de' Medici survived an assassination attempt, he had lifelike models of himself placed all over the city; in a negative expression of the same impulse, portraits of conspirators were painted in public places to denounce, identify and curse them. Families kept death masks of ancestors in their houses and, if they could afford to, paid for realistic portraits. Domenico Ghirlandaio's picture of an old man with a misshapen nose looking down at his beautiful grandchild is a touching example.[29]

Leonardo, by the early 1500s, was rarely finishing any of his paintings and avoiding commissions wherever possible so that he could concentrate on scientific research. In Mantua, meanwhile, the brilliant, beautiful Marchioness Isabella d'Este was assembling an erudite art collection. She was determined to have a work by Leonardo to go with her paintings by such contemporaries as Giovanni Bellini and Lorenzo Costa; specifically, she wanted her portrait painted. Isabella wrote to one of Leonardo's previous portrait subjects, Cecilia Gallerini, asking to see her picture;[30] she hosted Leonardo in Mantua and sat for a drawing. Yet he evaded all pleas to work it up into a painted portrait and never gave Isabella a work of art.

Soon after this, as we have seen, he took on a portrait not of a princely ruler or court beauty, but of the wife of a Florentine citizen. Not only that, but he worked fast enough to impress people within months of starting on the *Mona Lisa* in 1503. The explanation is unavoidable: he was deliberately honouring Florence and its citizens. He wanted to make a quick impact, to give the city his calling card. Look closer at the painting and patriotic suggestions rise from its mists. The landscape of rocks and river and distant sea is a fantastical version of Tuscany – compare it with

the plainer Lombard landscape in the *Last Supper*. Sitting in front of this landscape, Lisa del Giocondo identifies the city with its surrounding region. Her pose is patriotic, too: she sits elegantly and modestly, the pious, polite wife of a sturdy citizen. Compared with the bohemian courtly manners of the artist's much more dynamic painting of Cecilia Gallerini, who holds a pet ermine as she looks sharply out of the picture, the *Mona Lisa* is respectably bourgeois. Only her smile hints at subversive secrets.

Leonardo set out to awe and enthuse the Florentine people with a simple, beautiful picture of one of their own. Today, the *Mona Lisa* is the prisoner of fame, glimpsed between camera flashes in the Louvre like a celebrity on the red carpet. It's tempting to imagine this intense fame must be a modern phenomenon, some bizarre byproduct of the reproduction of images – as Marcel Duchamp joked when he drew a moustache on a postcard of the Louvre's top star. But in reality this painting solicits the crowds. It is the great Renaissance inventor's one machine that still functions – a fame machine. He painted it to get attention, and succeeded beyond all imagining.

In the autumn of 1503, the fame machine seduced its original intended audience. Florence was impressed. Hearing the enthusiasm ('Leonardo da Vinci could not have done a better portrait . . .') the Republic's canny leaders invited him to the Palace. He agreed to paint a mural in the Great Council Hall that would satisfy the People.

Soderini and Machiavelli were astute patrons. The Republic was a weak, threatened entity, a small city state trying to preserve ancient ideas of liberty in a Europe of empires and potent monarchies – and yet here they were, commissioning an ambitious work of public art from the most famous artist in Italy. In October 1503 Leonardo collected the keys to an old hall off the cloisters of Santa Maria Novella in Florence where he was to be provided with a living and working space gratis by the Republic.[31] There, his task was to design a picture worthy of the dignified communal meeting room that was the Great Council Hall.

That all the painting and sculpture commissioned for the Hall up to that time had been religious fitted in with the traditional decor of communal palaces throughout medieval Italy. In the Public Palace in Siena, government officials were reminded of the sacred nature of their responsibilities by Simone Martini's painting of the Virgin enthroned in heaven. In ethos, there was no difference between this fourteenth-century fresco and the altarpiece of the Virgin and saints commissioned for the Great Council Hall from Filippino Lippi in 1498. Leonardo, however, embarked on the room's first secular decoration. Out of his discussions with Soderini came an idea for a narrative painting on a vast scale that would tell the history of the famous Florentine military victory at Anghiari, which had taken place on 29 June 1440.

Machiavelli's junior Agostino Vespucci, who watched Leonardo's discussions with Soderini and noted that 'we will see what he does' in the Great Council Hall, was delegated to transcribe an account of the battle from the old Florentine chronicles. In this official history of the Battle of Anghiari compiled for Leonardo's reference – it survives among his notes[32] – there remains a piety towards the religious origins of the Great Council Hall. In a nod to the simple citizens who mourn Savonarola, it stresses a moment of spiritual vision on the eve of battle. On that early summer morning as the enemy approached, says Vespucci's account, the patriarch who represented the Papacy at the battle addressed the army of Florence this way: 'Having spoken he prayed to God with joined hands and a cloud appeared from which Saint Peter emerged to talk to [him].' The ordinary, pious citizens of the city would undoubtedly be moved by this portrayal of a heavenly helper in the sky cheering on the Florentine army; it was a way for the government to pay homage to the power of talking to God that had enabled Savonarola to build the Great Council Hall in the first place. In its initial conception, Leonardo's *Battle of Anghiari* was to be a pious history that would help erase the bitter popular memory of an inspired leader's ashes floating to oblivion on the swirling waters of the Arno.

Three

HEROICS

In time it became his habit to leave the marks of his chisel on his works, the only signature most of them bear, as if his living, breathing, straining actions were fossilised in the chipped, unpolished surface of the marble. Entire works look like this, unfinished conundrums. Others are divided in their nature, with beautiful lifelike limbs and anguished faces bursting from a storm of curved cuts in rumpled overhangs and pillars of stone raw as it came out of the mountain. But there are no marks on the perfect youth. No chisel-wounds, no drill-scars blemish the form it took Michelangelo three years to release.

'*Luna*' is what the Romans called Carrara, whose marble is as white as the moon's shining disc. The block Michelangelo stood in front of in 1501 had come from the quarries years before, had been 'badly begun' by a semi-competent sculptor in the busy work-shops of the Cathedral and then left there unwanted for forty years. The tools with which Michelangelo proposed to hew this massive lump of stone into a human shape were hammers and chisels, rasps and files and scrapers and a wooden bow like an archer's whose string you could pull back and forth to rotate a drill. With this simple technology he had to excavate slowly into the 13-foot-long marble slab, negotiating the clumsy damage done by its previous assailants, hoping his labour would not be wasted and that he would find the perfect limbs, the breathing sternum, the keen gaze within. The work was dusty, sweaty, back-breaking and secret, done behind partitions in the Cathedral workshop so

no one could spy on his measurements with the dividers, or watch him drill heart-shaped pupils into the statue's stone eyes.

It is impossible to picture this labour as you approach the statue today in the Accademia Gallery in Florence, inconceivable, really, how he got from toil to miracle. Other works by Michelangelo may call attention to the struggle of creation – you walk towards the tall hero down a long avenue, almost like the sacred avenues of prehistoric sites, of unfinished bodies striving to be liberated from formless stone – but David is as absolutely himself as are any of the people walking around his plinth under the semi-spherical vault of an immense niche.

Stand far back, and his outline is a sharp drawing, as if Michelangelo had confidently mapped the shape in the air with pen and ink. The face, turned almost 90 degrees to look to the left, with its massive triangle of a nose, its mountain outcrop of an overhanging brow and florid hair flying out into space, forms a scintillating profile. The proportions of the body, from this distance, are mathematically graceful. The measurement from the hair on the head to the fusillade of hair above the penis appears – to the eye – identical to that from genitals to toes. You can not only see but almost feel the weight of the body gracefully shifting onto its right foot as the figure easily inclines its left knee forward, rolling its ribcage on top of its stomach to move its centre of gravity.

As you approach, this harmonious silhouette stays in your mind yet also dissolves into glances and momentary impressions. The ridges and tensions of the immense chest high above you – the *David* is more than twice the height of a living person, still higher because of the tall plinth – drink in nuances of shadow, so that, if from a distance he resembles an outline drawing, up close David is richly shaded, the belly button a pool of darkness, the nipples and ribs collecting delicate grey-greens. At his side hangs his gargantuan right hand, out of proportion you suddenly realise, not just in scale but in the mesmerising, exaggerated attention to

detail the sculptor lavished on it: those veins throbbing in the marble, those knobbly knuckles and the wrinkled skin on the vast thumb. Once you recognise the strangeness of this hand, the beautiful body Michelangelo has carved becomes still more alive in your understanding. This, you start to comprehend – although actually you sensed it from that very first view along the avenue – is not some chilly, perfect nude. It is not complacent in its proportions and harmonies, but mobile, active, keen-eyed. The hand is the most radical instance of a quality that all the *David*'s parts possess: they are separate and slightly at odds with each other, like characters in a play. The statue may be finished as a work of art, but what it portrays is unfinished: a body still growing and changing. David contradicts himself even in his grace, because to be alive is to be contradictory.

* * *

Even as Lisa del Giocondo posed for Leonardo da Vinci in the spring of 1503, Michelangelo Buonarroti was bringing to completion his own charismatic masterpiece. Florence was presented simultaneously with two of humanity's supreme works of art.

The Buonarroti were a poor but old Florentine family, proud of their gentility, and looked down on painters and sculptors as 'rude mechanicals'. Michelangelo's father and uncles were upset that as a boy he wanted to be an artist. They tried to beat this socially disastrous inclination out of him. He was to prove them wrong about the social standing of artists, very quickly, in a spectacular way. When corporal punishment failed, his family got him an apprenticeship with the leading Florentine painter Domenico Ghirlandaio. At the time, Ghirlandaio was taking on his masterpiece, a cycle of wall paintings narrating the life of the Virgin, in the church of Santa Maria Novella. But master and apprentice didn't hit it off – at least, Michelangelo refused to credit Ghirlandaio, whom he remembered as an envious man, with helping or influencing him in any way, even as we have seen to the point

of denying he had ever been an apprentice (thus provoking Vasari to produce in evidence an agreement signed by Ghirlandaio and Michelangelo's father in his second edition of the *Lives*).

Michelangelo found a better place to learn art. Lorenzo de' Medici had established an informal academy of sculpture in Florence, in a garden near the monastery of San Marco. Michelangelo joked that he imbibed his feeling for stone with the milk of his wet nurse, a stonecutter's wife in the quarrying village of Settignano outside the city. When he and his friend Francesco Granacci went along to the garden at San Marco where Lorenzo kept a collection of ancient Greek and Roman sculptures and encouraged young artists to study and copy them, his instant, natural talent for working marble with a chisel became obvious. This gifted, daring boy was particularly fond of one work there, an ancient marble head of a faun, a strange old creature's face worn away by time. It delighted him and he set out to copy it. Michelangelo managed to carve a good copy of the head, but he did more than that. The original was so worn and damaged that it had no mouth: Michelangelo gave *his* faun a laughing mouth full of teeth. One day Lorenzo visited the garden. Struck by the quality of the new head, he was astonished to see how young its creator was. But he teased Michelangelo, saying, 'Oh, you have made this faun old and left him all his teeth. Don't you know that in oldsters of such age some are always missing?'[1]

It seemed an eternity to the shamefaced Michelangelo until *Il Magnifico* went away and he could get his chisel and chip out one of the faun's upper teeth, even making a hole as if it had been removed at the root. When Lorenzo returned the next day he laughed at this, but then, thinking about the promise of the boy's work, decided to take him into his own household. He told Michelangelo to go and 'tell your father I wish dearly to speak with him'.[2] Michelangelo's father was given an office in the Customs House, and his son went to live in the Medici Palace on

Via Larga while he perfected the art of sculpture in the garden up the road.

Well, this is how Ascanio Condivi tells the story, and it must be how Michelangelo told it to him. It has a fairy-tale feeling so vivid that in the twentieth century the Medici sculpture garden at San Marco was debunked by self-consciously scientific art historians as a 'legend'.[3] More recent research has vindicated this 'legend'. One pupil in the garden, years before Michelangelo, was Leonardo – it is mentioned in his notebooks.[4] And a letter written in 1494 mentions Michelangelo the sculptor 'from the garden'.[5] So there really was such a place, Michelangelo did study there, and his own art and writings prove how much he was shaped by the culture that surrounded Lorenzo the Magnificent.

Condivi says that Lorenzo allowed no hierarchy at his table. First comers sat where they liked – sometimes the young Michelangelo would sit near Lorenzo and his closest advisers. He became particularly friendly with the poet and Humanist Angelo Poliziano, one of the true talents of the age, a star intellectual. Michelangelo told Condivi that the older poet became a mentor to him as an adolescent sculptor, always 'spurring him on' and telling him stories from classical mythology. He also remembered how Lorenzo would show him gems and cameos in his study.[6] Lorenzo was himself a poet, not as brilliant as Poliziano but not far off – and he was the poetic model Michelangelo chose to emulate throughout his life. *Il Magnifico* wrote melancholy, pensive lyrics and so did Michelangelo, as here, where, burning with love, he addresses the young nobleman Tommaso Cavalieri:

> That which in your beautiful face I long for and contemplate
> is badly understood by human intellects
> for he who wishes to know it must first come to death.[7]

The poetic atmosphere of Lorenzo's court haunts such lines. But Michelangelo's education ended when Lorenzo de' Medici died in

1492. Grieving as for a father, the young sculptor still got work from *Il Magnifico*'s son Piero, but it was scarcely the stuff of high art: he was asked to carve a snowman in the courtyard of the Medici Palace.

One day, Cardiere, a musician in the household, told the young sculptor a hair-raising story. The previous night, said this man, he'd been visited by Lorenzo's ghost dressed in a torn black shroud over his naked body. The spectre had told him to warn Piero that he would soon be driven from his home and would never go back. Too scared to tell Piero, the musician met Michelangelo with a harrowed look the next day. Lorenzo's shade had returned in the night and hit him about the head for failing to do as it asked. Cardiere finally caught up with Piero, on a hunting outing as usual, and delivered the warning. Although Piero and his friends ridiculed the poor man,[8] Michelangelo took the ghost seriously, leaving Florence for Bologna on the eve of the 1494 invasion and the Medici family's fall.

In fact it was too hot for him to stay in Savonarola's Florence. He would later say that he admired the prophet and could still, as an old man, remember the exact sound of his voice.[9] But a sculptor whose favourite theme was the male nude was not likely to get a lot of business in a city dominated by a preacher who denounced art as a sensual 'vanity'. And it wasn't just art Savonarola persecuted: he tightened the laws on homosexuality. Religious Michelangelo was, but the artist and the human being were inextricably sensual.

After a brief return home from Bologna, he headed for the feasts of the south. Rome was starting its rebirth. Ancient statues were literally rising from the ground, excavated easily in the gardens of cardinals and aristocrats. As for sensuality, Pope Alexander VI – Rodrigo Borgia – presided over wild parties at the Vatican, to put the tales of orgies and prostitutes that contemporaries told about the Borgia court at their mildest. Some of the stories must be true, for the pope sired one, possibly two –

traditionally three – children while in office.[10] In 1501 Agostino Vespucci wrote to Machiavelli from Rome that he'd been told at least twenty-five women were brought into the Vatican palace every night to enliven the evenings of high-ranking clergy, and this, he said, was in addition to the pope's own permanent harem.[11]

Michelangelo, serious, angry, virtuous, was an incongruously moral visitor to this city, but he was no dullard: he had bought his ticket to Rome with an act of wit. Egged on by Lorenzo di Pierfrancesco de' Medici – the leader of the lesser branch of the family who were spared exile and expressed their support for the new Republic by calling themselves Popolani – he played a joke on the art collectors of Rome who were so besotted by the city's subterranean classical legacy. Just as he had amazed *Il Magnifico* with his ability as a boy to copy an ancient head of a faun, now he deliberately faked an 'antique' statue of Cupid. Michelangelo carved the little figure as if asleep and made it look as if it had just been dug out of the ground. Then it was sent to Rome, where it was sold to Raffaele Riario, Cardinal San Giorgio, for 200 ducats. When the cardinal realised what had happened, he sent an emissary to Florence to find out the true provenance of the 'ancient' *Sleeping Cupid*. Instead of being punished, Michelangelo was invited to Rome to live in Riario's household. After arriving there in June 1496, the sculptor wrote home to Lorenzo di Pierfrancesco that he'd spent his entire first day looking at Roman statues with the cardinal. Afterwards, in the cardinal's new house, '. . . he asked my opinion of the things I had seen. I told him what I thought; and certainly I judged them beautiful things. Then the cardinal asked me if I had enough spirit to make something beautiful. I replied that I might not make such great things, but he would see what I could do. We have purchased a piece of marble for a life-like figure; and on Monday I will begin work.'[12]

Michelangelo's *Bacchus* is the life-size marble figure he created. It has a lot in common with his lost pastiches of ancient art, the *Faun* and the *Sleeping Cupid*: it too is a kind of pastiche, or even a

parody. The smooth, glassy body of Bacchus deliberately imitates not only the strengths of the statues he had been shown by the cardinal but their weaknesses too. Visit the Capitoline Museum in Rome, or the Vatican, or any old collection that has its share of classical nudes, and you will see many works that are, in the end, a bit routine in their smooth beauty. The statuary being excavated in 1490s Rome was not all of it marvellous. Sculpture in ancient Rome had been decoration for rich people's houses, its style established centuries before and now virtually mass-produced. The 'classical' style we still recognise today, with its lifelike faces and well-proportioned limbs, its gracious marriage of realism and the ideal, came into being in ancient Greece in the fifth century BC. It then continued, taken up by Rome, until the rise of Christianity; a millennium after the fall of the Roman Empire it was revived in Renaissance Italy. But the examples of ancient statuary Michelangelo could see in Rome were in effect mass-produced copies of lost Greek originals.

In one of his letters, Cicero complains to his friend Marcus Fabius Gallus, who had bought too many statues for him: 'Bacchantes indeed – where is the place for them in my house? . . . For I am accustomed to buy statues I can display as if in a public hall, to decorate a place in my palaestra. Mars indeed – what kind of statue is that for me, a teacher of peace? I rejoice there was no statue of Saturn – I would have thought those two together had got me into debt!'[13] Cicero cared about the meaning of the statues he put in his house – and, light-heartedly, the astrological significance of Mars and Saturn. But there's not much reverence for the work of art as an exalted revelation in his practical talk of where to put the damn things, and that almost utilitarian concept of sculpture is all too visible in lesser works of ancient nude statuary. In his great *Bacchus* the young Michelangelo mimics the very particular look of statues he saw in Roman collections and we can see in the Capitoline today – the sleek surface, the use of an extraneous support (in this case a young faun who

sits on a tree stump behind Bacchus, munching at the grapes in a folded cloth in his hand – but just to describe that detail is to notice how he transfigures his materials). Even as he mockingly reproduces the pose of a Roman statue, he enriches it: the faun is such a strange, devilish creature, his face a horned mask of wickedness as he eats the grapes, each of which in its individual roundness is captured as a little stone sphere, in cascading abundance; the cloth that connects, in a comically complicated way, Bacchus, the grapes and the faun, is amazingly soft and mobile in appearance, anticipating all the flowing stone draperies of Baroque art; and this comedy of forms reaches a dazzling climax in the figure of Bacchus himself. His pose is not so smooth, after all. The god of wine is drunk: his perfect nude body rolls about, teeters on its waxy legs, the chest sloping back, the right arm curiously unfettered in its drunken delusion of grace.

It could so easily be described as if it were a big joke – like the *Sleeping Cupid* – but no beholder of Michelangelo's *Bacchus* has ever wanted to laugh. A travesty it may be, but it is seriously unsettling. The wine god's head, with round little grapes in bunches in his hair, lolls grotesquely on his neck: this is the twist that transforms a mimicry of classical art into something new in the world. Suddenly something real is happening. This is not a coy figure of a drunken god, but an intimation of some great spiritual dislocation. Bacchus is a being divided – his head is not at one with his body. His violent jerk of the neck is truly jarring; you feel it. The face, moreover, is a mask, an oval that repels the gaze, with eyes that wander wildly, ecstatically. Their little pupils roll to the right, as Bacchus tilts his head in disorganised abandon.

Florentine artists had started painting mythical worlds when Michelangelo was a child. Botticelli's mythological paintings were groundbreaking essays in a new genre of art that would become the great palatial decor of the sixteenth century, taken to poetic heights by Titian and Correggio. Yet in sculpting Bacchus it is as if Michelangelo blew myth apart and made it his own, as if he at

once entered into the being of Bacchus and assimilated the delirious god to some aspect of his own experience. This is no more an illustration of myth than it is a mere pastiche of classical sculpture. It is significant that Michelangelo starts with the generic and the received. In beginning a sculpture, the stone carver works on a raw block; yet here Michelangelo works on a cultivated tradition. His material is not only stone, but the genre of the classical nude itself. Out of that he exposes something that throws off the anchors of genre, narrative and anecdote. It becomes pure object and at the same time pure idea, an image that, as soon as you perceive it – that madly lolling head on the beautiful body – roots itself permanently in your consciousness. What has Michelangelo done? What magic has liberated Bacchus from the mortality of genres and myths?

There is a permanent ambiguity to Bacchus' expression, or rather his mask. His drunkenness can also be seen as a rapturous, an exalted loss of self. The frenzy that blinds him might be the *furor* of creativity in which – as the fifteenth-century Florentine thinker Marsilio Ficino explained in his commentaries on Plato – that Greek philosopher said the genius works.[14] The strange, jarring face of Bacchus might be experiencing 'divine frenzy', a psychic journey into the unknown, to self-dissolution. This is not some funny statue of a drunk – this is the most serious image of intoxication in art. It breathes danger. It breathes youth.

Michelangelo is the first artist who had a youth. That is, he is the first artist whose works seem to express his youthful experience of life – the first artist to become personal enough to express the passion, energy, ambition and risk with which he seethed in his twenties. He was twenty-two when he began *Bacchus*. It has a craving for danger in it – whatever he learned about 'divine frenzy' from the Florentine *philosophes* does not come out here as intellectual commentary, but as lived experience. Michelangelo may even be telling us what it's like to get drunk, in Rome, far from his family's eyes – or to indulge and risk wilder passions than a

tipple. There's fear, too: the faun nibbling at the grapes is a little devil; the face of Bacchus looks from another point of view deprived of vitality and sensitivity, stunned, opaque and lost: it looks mad and evil.

*　　*　　*

Which is where the face of the *David* is so different. If the *Bacchus* portrays a being cut dangerously loose from the bounds of perception and thought, a mind slipping into the freedom or the death that is unreason, the face of the *David* is absolutely conscious of everything. David is pure alertness. He is pure will. Bacchus' head is disjoined from his body. Every part of David is fluently in sympathy; he is a great chorus of voices, singing separately and yet in harmony. He is a community, a city, in one figure. But every nuance of his flowing form is subordinate to that great head, its eyes fixed in concentration where the eyes of Bacchus roll aimlessly. In carving the *Bacchus*, Michelangelo had shown a body that is a dead, lumpen thing violently brought to life by the unbalance of a grotesquely animated head: life, the kick of it, is discovered here through shock, and it is in an ecstasy close to undoing, to final oblivion, that energy is discovered. When he returned to Florence after the death of Savonarola to take on the challenge of a great block of stone in the Cathedral workshop, Michelangelo did the absolute opposite: instead of a soul disintegrating in ecstasy or intoxication, losing itself in a perilous night of unreason, he set out to depict a soul so conscious of its own body and its place in the world that body and world became mere instruments of the imagination.

First, however, he took the journey he'd begun with the *Bacchus* to its awful conclusion. There is a quality of heedless adventure in the works he undertook in the sensual Rome of the Borgias. When he was commissioned to carve a *Pietà*, a statue of the dead Christ supported in the arms of his mother, he completed the voyage into the psychic underworld he began with the *Bacchus*. He imagined dying.

Michelangelo did not 'depict' the dead Christ. The young man's body, naked except for a loincloth, that sprawls in Mary's vast robed lap, its head slumping back, the thin, bony legs a touching picture of disarrangement, is Michelangelo's most extraordinary work of pure realism. The body is seen with terrible candour in its failure, its death: the ankle bones sticking out, the flaccid mass of the exposed throat, the small but lethal wounds − a slash, a hole − and that gut-wrenching softness of the shoulder under which Mary holds it with her strong hand. It's a work to twist the heart by making you see death: the exquisitely natural touches Michelangelo gives the bereft flesh, the dimples and long toes, the twist of the neck, the slender arm with its nail-hole in the hand, are so utterly truthful. He shows how much more powerful a calm naturalism can be than the gross excesses of Gothic sculptures of this moment of grief. The effect is absolutely to exact pity, to wrench compassion. But that is because Michelangelo arouses your imagination. He does not portray a dead man with cool precision: while it can be mistaken for realism, this sculpture is not realistic at all. It is an ordeal of the imagination. The emotional power lies in the eerie, relaxed clarity with which the artist shows himself what it would be like to be dead: to be the man in Mary's arms. It hits you, pricks you, the recognition of the fact of death: a fact Michelangelo has made himself know from the inside. After drinking with Bacchus, here he sleeps.

* * *

In Florence he woke up. The *David* is a gaze with a statue attached. As confessions, this series of three works − *Bacchus*, carved in his early twenties; the *Pietà*, when he was still under twenty-five; *David*, begun when he was twenty-six − chronicle a journey of the psyche. Michelangelo flirts giddily with madness and death before rising to his full height, a stone in his hand, defying the world. His Roman statues dare to fall towards oblivion: they are perilously intro-spective, and their enduring universal truth comes of the insights

of that introspection. The power of frenzy; the terrible sleep, the soft finality, of dying. David faces the world like Michelangelo himself, who has come back from the edge, renewed.

The creation of the *David* was like a ritual and Michelangelo's early career like a tribal initiation. The young man goes out into the forest – in this case Rome – and has epic nocturnal adventures: he loses his old identity as he encounters fabulous monsters. Where an initiate might have to hunt in the forest, Michelangelo subjects himself to the drunkenness of Bacchus, the deathly sleep of Christ. And then he returns to his community, but before reintegrating into a new life there he must endure one last ordeal.[15] It is the Ordeal of the Giant. Out of the rock he must liberate a figure: out of the broken, dead block he must produce life. He carved the *David* in secret, behind a wooden pallisade, before finally revealing his first truly adult work in the workshops in 1503. When the artists of Florence met to speak about it in January 1504, many were tender, respectful. It was as if they understood how personal a thing this was.

The gaze of David, ever-watchful, is Michelangelo's coming to terms with the world. The young artist who has – at least in his imagination – been to the edge of madness and death, of dissolution, now produces from raw matter a form that is supernaturally coherent. This is his discovery of form.

* * *

It is also his entry into the political world – the city and the republic. The Gonfalonier Piero Soderini saw the public power of Michelangelo's *David* when it was still emerging from the block. Soderini, evidently, was keen-eyed. Michelangelo always acknowledged this early support. Condivi, echoing his master's voice, called the Gonfalonier the sculptor's 'great friend'.[16] Even before he was confirmed as the Republic's head of state, Soderini was excited about the marble figure Michelangelo was carving. In 1502 he asked the young man to create a second work that orbited it – a

bronze statue of David to give as a present from the Signoria to a French diplomat. Michelangelo told Condivi that it was because Soderini wanted him to display prowess in every art that he challenged him – for the first time in his life – to make something in bronze. Yet this was also an emphatic way of pushing Michelangelo towards political art.

Donatello's bronze statue of David was taken, like his *Judith*, from the Medici courtyard after the family's fall in 1494. The Medici had inscribed its pedestal with one of their republican slogans, reminding the people of how a boy defeated the 'tyrant' Goliath and calling on the citizens of Florence to defeat their enemies just as bravely.[17] David was an archetypal hero for a republic. Defying the gigantic Philistine warrior armed only with his slingshot, he epitomised the triumph of the weak over the strong just as in a republic the people overcome would-be tyrants. Donatello's statue found in this hero a triumph too of youth and beauty: nude except for his disc-shaped helmet and ornate greaves, his David is truly a boy, cockily displaying the hairy head of the human monster he's brought down beneath his foot.

Soderini challenged the young Michelangelo to rival this masterpiece that now stood in the Palace, having been brought there, like the *Judith*, because its republican meaning was so potent. Michelangelo's sculpture is lost, but a design for it survives, and it is a direct response to Donatello: David stands nude with his foot on Goliath's head, his body eloquently drawn back in victorious pride. Beside the drawing is a detailed study of David's right arm, and to the right of that two lines of Michelangelo's strong and spiky handwriting: 'David with a sling and I with a bow. Michelangelo'.[18] The 'bow' he means is the sculptor's bow drill; he is drawing a parallel between a tool he used in his struggle with the vast block of marble and the slingshot David used to bring down Goliath. When the shepherd-boy David, in the Book of Samuel, proposed to fight the Philistine champion 'whose height was six cubits and a span', he was offered the king's own armour:

And Saul armed David with his armour, and he put an helmet of brass upon his head; also he armed him with a coat of mail.

And David girded his sword upon his armour, and he assayed to go; for he had not proved it. And David said unto Saul, I cannot go with these; for I have not proved them. And David took them off him.

And he took his staff in his hand, and chose him five stones out of the brook, and put them in a shepherd's bag which he had, even in a scrip; and his sling was in his hand: and he drew near to the Philistine.[19]

Michelangelo's line, '*Davitte colla fromba e io coll'arco*', with his signature emphatically placed beneath it, acknowledges that in his labour to reveal a beautiful figure within the immense, badly blocked-out slab of marble, he had come to identify himself with the young hero. It also commits his art to a political mission. Michelangelo is a citizen-soldier, armed with genius. In Leonardo he is soon to find his towering opponent.

STONING DAVID

There is another *David*, drawn on a sheet of paper that survives in the Royal Library, Windsor. In many ways it is a perfect copy of Michelangelo's statue. The hero stands in the same pose, his weight on his right leg, his chest sliding over to shift his balance, his right arm hanging at his side and his head turned in profile. When you sit in the panelled Victorian Gothic study room above the trees of Windsor Great Park and hold this drawing in white-gloved hands, what you are studying is Leonardo da Vinci's direct response to the work of his younger contemporary Michelangelo, drawn when the *David* was first shown to the world in 1504.

It is unmistakably the *David*. Leonardo must have been deeply impressed by the statue to draw its muscles so precisely. The drawing's right arm, for example, is dimpled and tapered in exactly the same places as the arm of the marble figure; the torso mirrors the statue even more scrupulously, its ribs and muscles and the slope of the shoulders all as carved by Michelangelo. With his consummate draughtsmanship Leonardo even captured patterns of shadow, the lights and darks that play on the statue's richly nuanced surface.

The idea of perfect, ideal proportion is a theme that fascinated Leonardo. He expressed it in his own famous nude design for a 'Vitruvian Man', a naked male figure stretching out his arms in two alternate poses within a square transposed onto a circle, making himself into a shape like a star. This diagram illustrates the ideas of the ancient Roman writer Vitruvius, who argued that

the standard of beauty in architecture and art originated in the proportions of the human body. Given Leonardo's preoccupations, it is no surprise that in his drawing of Michelangelo's *David* he got the ratios of distance between belly button and genitalia, between genitalia and head and feet, exactly as they are in the statue itself, as if analysing its quantifiable beauty.

But when you look at the loins of Leonardo's *David*, you notice something very odd.

Among the anatomical features of Michelangelo's *David* is a stone penis that rests on stone testicles amid a corona of stone pubic hair. Compare this feature with Leonardo's drawing and you encounter a strange metamorphosis. In Leonardo's sketch, it cannot be seen at all. It is effaced by a daub of bronze-coloured ink. This fig-leaf splash connects to a bronze belt around the statue's hips. The hero has been emasculated.

To understand Leonardo's graphic attack on the *David*, we have to take another look at Donatello's *Judith*, raising her *falchione* sword in her right hand outside the Palazzo Vecchio. With her glazed eyes she seems intoxicated by her duty to kill. The First Herald of the Florentine Republic, a certain Messer Francesco, shuddered when he saw her – or so his words imply. You can see him flinching and shaking his head when he speaks, first of all the speakers, to a committee meeting held in Florence on 25 January 1504. Donatello's bronze statue fills him with dread and revulsion, he confesses. Messer Francesco knows what he's talking about, for his office of Herald makes him Florence's public censor of symbols. It seems to him, he says, that Donatello's statue, for all its associations of the humble overcoming the proud, is not an appropriate image to stand right outside the gate of the Palace as a sign of the Republic. For 'the Judith is a deathly sign, and it doesn't seem right, when our emblems are the cross and the lily; and it doesn't seem right that the woman kills the man, and above all it was set up under an evil constellation, for from then to now things have gone from bad to worse: it was then we lost Pisa'.[1] It is time to

replace this statue's black magic, its witch-like woman slaughtering a man, with something white in its magic, male in its significance and – presumably – benign in its horoscope. There is only one candidate. Michelangelo Buonarroti's new statue of David, now 'as if finished' in the Cathedral workshop, should take the *Judith*'s place at the political heart of Florence.

Messer Francesco's passionate words were the first to be spoken at this extraordinary meeting, which brought together some of the greatest figures in the history of Western art, together with many lesser-known craftsmen, on a winter's day in Florence. Specialist committees, or *pratiche*, of citizens were an established part of the city's political tradition; they were convened to advise on decisions rather than to vote, and served to build consensus informally.[2] The purpose of this one, which took place in the premises of the Operai del Duomo – the Cathedral works – in the shadow of the red and white dome, built as it had been with cranes and scaffolding that emerged from these very workshops, was to advise on an 'appropriate and acceptable location' for Michelangelo's marble man. Freed the summer before from its hiding place behind wooden screens, the immense statue stood for all the speakers to look on as they came together that day in the workshops where everything was pale with marble dust, where fragments of angels and prophets lay around unfinished or removed from the cavernous Gothic edifice next door. Everyone was doubtless wrapped up against the freezing cold. That winter was so chilly that a couple of weeks after this meeting the Arno would freeze solid in the centre of Florence, marooning the stone pontoons of the Ponte Vecchio in a white iron world. It was a day for Leonardo to wear his purple cape with the wide lapels and velvet hood, or his heavy coat of crimson satin.

All of the artists had been summoned to the meeting by the consuls of the Arte della Lana guild and the officials of the Operai. Blowing on their hands and warming up at the fireplace – a city in winter, as Leonardo observes in his notebooks, has a permanent

cloud of smoke above it from all the hearths[3] – were Leonardo's old friends and rivals: Sandro Botticelli, Filippino Lippi and Giuliano Sangallo, all three ageing now, Sandro nearly sixty, Filippino to be dead within months, the proud architect Sangallo massively powerful even as he aged, his family dominating military architecture and palace-building with their easy mastery of classical rules and strong technical abilities, his masterpiece the Strozzi Palace the city's newest, most impressive exercise in luxury tempered by gravitas. Giuliano's brother Antonio was there, too, and the younger architect Simone del Pollaiuolo, nicknamed *Il Cronaca*, who had overseen the Strozzi in its final stages. *Cronaca* was a relative of the Pollaiuolo brothers, renowned painters; another artistic dynasty of Florence was represented by Davide del Ghirlandaio, yet another by Andrea della Robbia, of the family whose painted ceramic sculptures gave such life to the city's streets. Two lesser participants that day, the goldsmith Michelangelo Bandinelli and fife-player Giovanni Cellini, themselves had sons who would become famous artists. All were gathered both as artists and as Florentine citizens to advise on a matter of great importance to their community.

One outsider was the painter Pietro Perugino, from Umbria, who had recently been seen as the most cutting-edge artist at work in Florence – until, that is, the full genius of Leonardo struck the city on his return in 1500. Francesco Granacci, a young friend of Michelangelo's, was there. So were the goldsmith Andrea il Riccio, the painters Cosimo Rosselli and Lorenzo di Credi, and the miniaturist Attavante. Leonardo knew them all, even the lesser lights. The previous summer he'd lent Attavante four gold ducats.[4]

Giovanni Cornuola, Biagio d'Antonio Tucci, Guasparre di Simone, the goldsmith Ludovico, the master-embroiderer Gallieno, the jeweller Salvestro, Chimenti del Tasso and the woodcarver Bernardo di Marco della Cecca sat down to the meeting alongside the more famous artists. At the very edge of the group lurked the eccentric and brilliant painter Piero di Cosimo, admired for

his peculiar pictures of centaurs and forest fires, notorious for his antisocial ways which reputedly included living entirely on boiled eggs, being afraid of the chanting of monks and loving to stand outside in heavy rain.[5] In the transcript of the meeting he is recorded as speaking last, as if he had to be cajoled to say anything. He too was a friend of Leonardo.

One of the most curious people invited to this meeting might seem to have been the clockmaker Lorenzo della Volpaia. What, we might ask, did a horologist have to do with art? That we wonder is proof of the mental distance between us and Renaissance Florence. Volpaia was renowned for the great astrological clock he had created for Lorenzo de' Medici. It was a wonder of the city and also an important scientific asset of the state: in 1504 it stood in the Hall of Lilies in the government Palace, a crucial civic resource in planning wars, votes, even the placement of statues. Instead of merely keeping time, Volpaia's *Clock of the Planets* had dials showing the signs of the zodiac and the planets Saturn, Jupiter, Venus, Mars and Mercury – not simply lumps of stone in space, according to the culture of the Renaissance, but celestial beings and astral powers whose positions determined events on earth. The phases of the moon, the timing of eclipses – every consideration of significance in the casting of a horoscope was catered for by the clock's complex motion. This great mechanism was simultaneously evidence of the modernity of Renaissance Italy[6] – signifying as it did a developing consciousness of space and time – and of a web of beliefs that to us may seem outlandish. The clock reflected magical beliefs which included but also went beyond astrology. According to Marsilio Ficino, who translated magical writings attributed to the fictitious ancient Egyptian sage Hermes Trismegistus, the planets signified powerful supernatural forces, and the Hermetic magus could perform 'natural magic' by calling down their powers.[7]

The reason Messer Francesco's fearful opening speech has survived, along with everything else said at the meeting that

January day, is that it was all meticulously recorded, *verbo ad verbum* – word for word – by an assiduous clerk. The transcript transports us into a world where the first thing to be said, in considering where a new statue should stand, had to do not with artistic style or physical practicalities, but with magic. Donatello's *Judith* had been erected on the Piazza della Signoria under an 'evil constellation'. Since then everything had gone wrong. Astonishingly, the First Herald blamed the statue for the rebellion of Pisa and the bloody, apparently unwinnable war to get this nearby city back under Florentine rule.

Messer Francesco's denunciation of Donatello's *Judith* is an expression of magical thought. The spectacle of a woman killing a man even summoned up the terror of witchcraft that was so much part of this world. Judith had charmed and seduced Holofernes, and then killed him. Yet Donatello's statue does not portray her as seductive in any conventional way. She's all wrapped up in her robes, her face a rapt mask. The man she holds by the hair is paralysed and helpless, in a stupor. If not drunk, might he be under a spell?

Messer Francesco was right, of course. Judith in art is a curiously ambiguous figure – a heroine but also an embodiment of male nightmares. In Gustav Klimt's knowing modern *Judith*, painted in Freud's Vienna, she is explicitly an erotic goddess intoxicated by her own sexual power. In sixteenth-century Europe, however, the insights of Freud and Klimt lay far into the future. Women were profoundly excluded from power and authority. They were not citizens of Florence; they did not belong to the Great Council. So what the First Herald said of the *Judith* connects Donatello's sculpture with the darkest terrors of a society of absolute inequality. From the fifteenth to the seventeenth century, thousands of women were tortured and killed in Europe for the crime of witchcraft. Most were poor, older women, a fact that amplifies the witch-like character of Donatello's figure because, in the swathing, un-erotic robes the artist gave her as if to insist on

her virtue, she looks like a peasant of indeterminate age. Perhaps one reason so many artists – such as Lucas Cranach in Germany – loaded their Judiths with finery and stressed the biblical assassin's beauty was to avoid any association with this stereotype, so vivid in German painting in particular. But in Italian art there are subversively open acknowledgements that Judith might be some sort of enchantress. The most shocking of all was painted by Caravaggio in late sixteenth-century Rome. His Judith is in the middle of decapitating a man who looks up at her out of shining, agonised eyes: in Caravaggio's nightmare Holofernes is conscious as he is killed. But if conscious, why can he not resist? Has she put him under a spell so that he lies there unable to stop her cutting through his arteries towards his spine? Here Judith's servant is portrayed as an old crone – the stereotype of a lower-class witch.[8]

At least one of the artists who listened to the First Herald's disturbing words was himself a master of this theme. In Botticelli's painting of Judith, the heroine and her servant are neither simple virtuous women nor sinister crones. As they walk home, the servant carrying a man's severed head, they may well have something of the occult about them – but it is inspiring rather than evil.

Botticelli in 1504 was old and no longer fashionable. He came along to the meeting as an eminent craftsman and was one of the first artists to speak, but his works were no longer defining the look, the mentality, of Florence as they had twenty years previously. Still, the memory of his masterpieces perfumed the air. A few years older than Leonardo, he had come into his golden age in the 1470s and 80s, the time of Lorenzo the Magnificent. Refined and highly educated, in some ways Lorenzo had resembled the sophisticated children of nineteenth-century capitalist dynasties who rejected commerce for a life of culture: he had no time for the Medici bank, source of the family's wealth, and all he understood about money was how to spend it. But he was also a good fighter, who beat all-comers at a famous joust held on the Piazza Santa Croce, and a brilliant politician. He spent freely but with a

political purpose – to consolidate Medici prestige – commissioning or inspiring his friends to commission works of art which gave Florence an atmosphere of civilised grace unrivalled in fifteenth-century Europe.

In his *Adoration of the Magi* (circa 1475), Botticelli portrayed himself in orange robes looking proudly – even arrogantly – out of a company that consists of portraits of the Medici and their close associates. While the dead Cosimo the Elder and Piero the Gouty pose as Magi, and Lorenzo looks down sensitively and strongly, thinking, his brother Giuliano – doomed to be stabbed to death by conspirators in Florence Cathedral – stands with Angelo Poliziano leaning sleepily on his shoulder as the poet talks to the philosopher Pico della Mirandola, who argued that all religions are compatible and promoted the magical traditions of Hermeticism and the Jewish Kabbalah.[9] In this powerful high-cultural company Botticelli cockily displays his own philosophical-looking figure as part of Lorenzo's intellectual court with its occult interests; he too is a magus like Pico della Mirandola.

Much later, in 1500, when he inscribes a prophecy on a painting, it is written in Greek by 'I, Alessandro'. So Leonardo da Vinci was not the only Florentine artist with a passion for ideas.[10] In his 'Life of Botticelli', Vasari sniffs that pretension made the artist write a commentary on Dante.[11] In fact Botticelli illustrated every canto of Dante's *Divine Comedy* in drawings which rival Leonardo's notebooks.[12] He also painted, in the 1490s, a perfect archaeological reconstruction of the most famous lost painting of the ancient world, the *Calumny* by Apelles, based on textual descriptions. But for all these intellectual achievements, it is as a mystical weaver of impossible worlds, a visualiser of the invisible, that Botticelli rightly remains one of the world's favourite painters. His famous mythological paintings – *The Birth of Venus, Primavera, Pallas and the Centaur, Venus and Mars* – gave the ancient gods new life to walk, or waft, abroad among the young men and women of Florence.

Botticelli's world, in his paintings of the late 1470s and the

1480s, is a young, erotic, beautiful world. It's the world of tournaments, parties, picnics and carnivals in which Lorenzo and his friends existed. It is also a magical world. In *Venus and Mars*, probably created to decorate furniture in a palace bedroom, the goddess of love, in a diaphanous robe, props herself on one arm, calm but very much awake, while her lover, the war god Mars, lies, nude and asleep, beside her. In their woodland bower, cheeky little fauns play with the slumbering slaughterer's lance and helmet. Venus' elegant clothes stress her power over the nude man: her beauty has literally enchanted him. Mars lies under a spell, a benign spell, and it seems plausible (if unprovable) to see this painting as a talisman, a literal attempt to call down the influence of Venus according to principles of natural magic.[13] Its very crispness and solidity – its crystalline quality – have something enchanting and transformative about them. You feel better for seeing it. You feel benevolently influenced.

Botticelli's pacifying goddess has achieved some celestial effect: his Venus is the planet as well as the pagan personage, and the forces at work in this painting are the secret operations of spirit. It's a benign version of the sinister power of women the First Herald saw in Donatello's *Judith*. Florentine natural magic worked by using materials associated with the desired planet – the right music, the right food; why not looking at the right painting? Talismans and incantations were above all supposed to conquer 'melancholy'.[14] Botticelli's paintings are among the best cures for melancholy anyone has ever painted. They exude joy – and that joy is presided over by Venus, both the goddess of love and, as Ficino claimed, one of the happy, vital, fortunate planets that can defeat Saturnine melancholy.[15]

In *The Birth of Venus* she floats over the green sea, the inexplicable way in which her shell-boat clears the water, blown by wind gods who float in the air, itself suggesting some divine phenomenon. Everything is so firm and clear in Botticelli's world – the faces so limpid, the eyes so sharp – and yet there's a complete

mystery to the way in which the figures move through space, most purely expressed in the simple but ineffable flight of Venus over the waves. She comes towards you; the effect of joy is infectious; the gloom of Saturn disintegrates. In Botticelli's *Primavera* Venus rules a woodland gathering of gods and spirits. There's a new joy in the world – spring, the rebirth of nature. Venus, the goddess of generation, rules the time of renewal, the new Golden Age. Mercury raises his wand heavenward, connecting the earth with the celestial powers, literally reaching between one reality and another. Airy spirits populate the glade: the Graces dance, a blue Zephyr chases the nymph Chloris, who transforms into Flora with her dress of flowers. At once a hymn to spring, representation of the pantheon of Venus and transfiguration of the May dances that were part of Florentine high and popular culture, it's pointless trying to finally fix the meaning of the enigmatic *Primavera* and futile to deny that its feeling is supernatural.[16]

The sheer reality of spiritual beings in Botticelli's art populates Florence with occult forces. When he paints a centaur, the centaur is real, solid, alive; the blue Zephyr blowing among the trees in the *Primavera* is a personification of a demon. The world was self-evidently full of demons, spells and planetary forces; there was no better theory available to explain how it worked. The difference between Florence and any village of the day where similar beliefs flourished[17] was simply that Florentine philosophers and artists, and none more enduringly than Botticelli, granted these superstitions beauty and grace.

The Botticelli who came to the meeting on 25 January 1504 was absolutely the same man as the young magus who'd painted talismans of Venus, despite the fact that in 1494 he had discovered a new guru. Savonarola attacked the 'vanities' of sensual art and yet the sensual artist Botticelli became his devoted follower, says Vasari in his 'Life of Botticelli', and there is dramatic visual proof of this. Savonarola's books – cheap pamphlets relating his prophesies, interpreting the Bible, advocating personal prayer –

were copiously illustrated with woodcuts including some that antic- ipated paintings Botticelli had yet to create. For example, his later painting *The Agony in the Garden* has a spiked fence and mound that match the same features in a woodcut of this scene in a Savonarola pamphlet. The painting is a deeply original composition, almost painfully personal to behold. In other words, he designed the woodcut.[18]

Botticelli's devotion to Savonarola was in fact not a violent break with his magical paintings of myth, for prophecy was another variety of the occult. The spell Savonarola cast over Florence is the ultimate proof of the city's hunger for the supernatural. Here was a man who spoke to God, and God told him the future. Everyone accepted that his foretelling was proven true by events. Men and women alike went to stand, in crowds segregated by sex, in the Cathedral and be shaken by his revelations.[19] This was divination by another name: another way of making contact with the supernatural. As Machiavelli wrote, the city's credulity revealed a primitive stratum beneath all its sophisticated ways: 'The people of Florence do not appear to themselves to be either ignorant or crude; nevertheless the friar Girolamo Savonarola convinced them he spoke with God.'[20] The rise of Savonarola did not mark the end of Florence's magical beliefs. Rather, it was the apotheosis of Florentine superstition.

At the moment of Savonarola's death, Botticelli was one of the diehard Weepers who felt like strangers in their own city. He bravely asked a member of the Signoria, to his face, to justify Savonarola's cruel death. In 1500 he wrote on his painting *The Mystic Nativity* his own prophesy of the Last Days and the imminent end of the world, to be replaced by a New Heaven and New Earth. He believed the visible world, on that cold January day as everyone discussed Michelangelo's statue, to be on the very edge of disso- lution. The angels were about to come down to the city and embrace and kiss mortals while the Devil would be driven down into the depths.

Botticelli quietly disagreed with the caricature of Judith as a 'deathly sign'. Michelangelo's statue would stand well outside the Cathedral, he said, on the steps up to it at the right-hand side near the Campanile, 'with a Judith at the other corner'.[21]

*　　*　　*

Leonardo da Vinci sat doodling on a piece of paper. While the first speakers gave their opinions, he was drawing a great, hulking man with a beaky profile, a tremendous chest pulsing with shadows. He gave his sketch of the *David* a sling and a stone, and eyes that somehow were more stupid, less alive than those of the glaring giant in whose thrall everyone was speaking. It was an insidiously cruel caricature – at once true to the statue's physical power and denying something about it. Leonardo refused to acknowledge the youth of the *David*, let alone admire the figure's vitality. His drawing transforms the alert hero into a muscleman, a thug. Leonardo was looking at the statue towering there and deliberately refusing to accept its claims for itself, to see the movement of spirit in that body.

As the artists and craftsmen began to give their opinions – What's wrong with the buttresses of the Cathedral, asked the woodcarver Francesco Monciatto? Hadn't the statue actually been commissioned to go up there on top of the building? His mind was not really made up, Monciatto confessed[22] – the haunting words of the First Herald of the Republic hung in the air. Where had it come from, his denunciation of Donatello's *Judith*?

It had come from the Palace, as would become clear in retrospect. Piero Soderini wanted Michelangelo's statue for the city, for the state. The potent masculinity of the statue was its virtue. It stood colossally nude. Its stone phallus rested on immense stone testicles. Here was a man, and nothing but a man. Freed from the dishonesty of clothes, standing without shame in the light of the Piazza della Signoria at the door of the Palace, he would display his manhood as he took up arms: the vital masculine spirit of the

Republic replacing the malign feminine black magic of the deathly
Judith.

There was, however, another possible voice lurking behind the
Herald's, shaping his speech. After denouncing the *Judith*, Messer
Francesco went on to criticise Donatello's *David* in the courtyard
of the Palace, another spot the government favoured for Michel-
angelo's work: 'The *David* in the courtyard is an imperfect figure,
for its back leg is cracked; for all these reasons I'd put this [i.e.
Michelangelo's] statue in one of those two places, but preferably
where the Judith is.'[23]

Donatello's bronze *David* is revered to this day as one of the
supreme masterpieces of European sculpture. It was already recog-
nised as such in Renaissance Florence – that was why it was taken
from the Medici house to the government Palace, because it was
such a public asset. But here Messer Francesco abruptly dismisses
Donatello's talent, saying his statue is 'imperfect'. This is a familar
tone of voice, one strongly reminiscent of Michelangelo's own in
Condivi's *Life* and in the artist's letters. Always ready to criticise
other artists, he rubbished Donatello to Condivi – saying that the
sculptor never polished his works properly – before correcting the
comment, taking it back, in a conversation with a friend.[24]

So the sculptural criticism offered by Messer Francesco seems
to reflect Michelangelo's opinions. As, in truth, does his invoca-
tion of supernatural terror to damn Donatello's *Judith*. For
Michelangelo believed as firmly in planetary influences and ghosts
as he did in God. Messer Francesco's mixture of arguments – art
criticism and the supernatural – makes it likely that Michelangelo
advised him on what to tell the assembled artists to convince them
of the need to place his *David* in front of the Palace.

* * *

In his biography of Leonardo da Vinci published in 1550, Vasari
uses the language of astrology to praise the genius of the great poly-
math: 'Truly celestial was Leonardo . . .' There is nothing casual

about this language. He makes his meaning clear: 'The greatest gifts are often seen to be rained by celestial infuences [*influssi celesti*] into human bodies naturally; and sometimes supernaturally one body is given beauty, grace and ability . . .'[25] There was no rational explanation for a perfection as vast as Leonardo's: he must have been shaped by supernatural means. When Condivi's *Life of Michelangelo* appeared three years later, written under the direct influence of its subject, it made it clear that he could match and outdo Leonardo's heavenly pedigree. With an accuracy worthy of the *Clock of the Planets*, Condivi related how Michelangelo was born on

the sixth day of March, four hours before daybreak, being a Monday. A great nativity certainly, and it showed the kind of child he was to be, and of what ability, because, having Mercury with Venus in the house of Jupiter with a benign aspect, it was favourable, promising he would have the noble and high genius to triumph in everything, but principally in those arts which delight the senses, like painting, sculpture, architecture.[26]

Michelangelo himself must have been the source of this personal information. His line identifying himself with his statue – 'David with his sling, I with my bow' – reveals that for its creator this was an intensely personal image. Messer Francesco's indictment of Donatello's *Judith* implies that the *David* was somehow astrologically superior. In Michelangelo's mind it certainly was, for it shared his own excellent horoscope.

Michelangelo had carved the statue in secret, in seclusion. In turning his imagination away from oblivion towards action, in turning to face the world, it was as if he was dramatising his relationship with other people through his statue. Angry, difficult, lonely, he created an image that faced down dangers, and in facing Florence it demanded, as if in a dream, to move from the secrecy of the workshops to the very centre of the city, to stand on the Piazza della Signoria.

But very few of the artists at the committee meeting could see why this should be so. Cosimo Rosselli and Botticelli wanted it to stay in the neighbourhood of the Cathedral, as a religious work, perhaps on the steps facing the Baptistery. Then Giuliano da Sangallo spoke. He recognised that the *David* was a 'public thing':

> My feeling was very much for the corner of the Cathedral, as Cosimo said, where passers-by would see it: but in the end this is a public thing, and recognising the imperfection of the marble which is tender and fragile, and if it stands in the open air, it doesn't appear to me it will last, I thought it would be better under the middle arch of the Loggia della Signoria, either under the vault so you can walk right around it, or against the back wall, in the middle, with a black niche behind it as a kind of tabernacle, for if it is put in the open air it will truly deteriorate quickly. Better cover it.[27]

This speech changed the mood of the entire meeting. Sangallo was the most experienced architect and engineer there. He was consulted all the time about practical building problems. His words had weight. Instead of the airy language of the First Herald, all that occult hyperbole, here was plain technical reasoning. Even the First Herald's nephew, the Second Herald, agreed with Sangallo that David should go under the Loggia. His comment sounds as if it was influenced by the chill of the month:

> I've listened to all, and all have spoken good sense for various reasons. And considering these places from the point of view of frost and cold, I have thought about the need for cover, and the installation should be under the Loggia della Signoria as has been said, but under the arch nearest the Palazzo della Signoria, and there it would stand under cover and be honoured by its closeness to the palace; and if you put it under the middle arch, it would break up the order of the ceremonies that the Signori and the other magistrates hold there.[28]

The Loggia was a ceremonial stage at 90 degrees to the nearby Palace where the Signori stood during public events – they had stood there to witness the execution of Savonarola. It was an honourable location especially if, as the Second Herald wished, the statue were placed under the arch nearest the Palace. When Andrea il Riccio added his voice, however, the argument shifted once more from the purely technical to something more mysterious. The *David*, he couldn't help stressing, was a daunting, even a menacing figure that seemed to look at you as if it were alive. He made it clear that he wanted it under the Loggia in the same way that it's best to keep a bear on a chain or a lion in a cage. The Loggia, he said in a way that perhaps naively revealed the other speakers' hidden agenda, would neutralise the eerie power of the *David*: 'I agree with what the Herald has said, both because it will stand well sheltered there in the Loggia, and because it will be more esteemed and looked at if it is not ruined, and it will stand better under cover, because then passers-by will go to see it, and it will not be as if it goes to meet them, and we will go to see it, and not have the figure come to see us!'[29]

Here il Riccio reveals something unstated in Sangallo's argument but obvious. Under the Loggia the statue would be less dominating. It would be muted, tamed. 'We will go and see it, and not have the figure come to see us!' – this is a sinister image. Il Riccio imagines a scenario a bit like Pushkin's poem 'The Bronze Horseman', in which an equestrian statue chases a man through the streets of St Petersburg. In other words, he sees as much uncanniness in the *David* as Messer Francesco claimed to see in the *Judith*. The *David*'s penetrating gaze is so lifelike – best keep it in the shadows under the tall Gothic Loggia instead of letting it rule the open space of the Piazza. Once again magic haunts the discussion as il Riccio invokes popular superstitions about the evil eye.[30]

The next three speakers – Lorenzo della Volpaia, Biagio d'Antonio Tucci and Bernardo di Marco della Cecca – all agreed with Sangallo. Then Leonardo da Vinci spoke.

Had Leonardo really spent the meeting up to that moment sketching the *David* in his notebook? He was certainly to add a feature to it that makes visible sense of what he said when called upon to speak about Michelangelo's statue. As with the other artists, the transcript records Leonardo's actual words about Michelangelo's youthful masterpiece. And what insidiously aggressive words they were: 'I confirm that it should stand in the Loggia, where Giuliano has said, but on the little wall, where they hang the tapestries on the side of the wall, with decent ornament and in a way that will not spoil the ceremonies of the officials.'[31]

Leonardo went out of his way to stress the need to hide the *David* away, to keep it at the edge of things. There isn't much love for Michelangelo or his work in his words. Andrea il Riccio had already let the cat out of the bag and suggested that in the shade of the Loggia the potent statue could be kept under control. Leonardo similarly betrayed his desire to hide it away, to marginalise it literally: to shift it from the heart of the Piazza as if it were an afterthought, an interloper in the public heart of Florence. But that was not his most outrageous suggestion. He added that the statue should have 'decent ornament', '*ornamento decente*'.

If we miss the meaning of these words it is only because we no longer live in a shame-filled society. Until very recently the primary meaning of 'decency' was the Christian one of modest covering and behaviour. In calling for the *David* to be given *ornamento decente*, Leonardo meant that its genitalia should be decently concealed.[32] This was a curious concern for a man who dissected human bodies and who, in that same year, in his sketches for his battle cartoon, drew a man on horseback in which he observed that the rider had an erection. But any doubt of his meaning is erased by the drawing of the *David* in his notebook. There he gives Michelangelo's statue metal underpants, drawn in ink to resemble bronze.

Magic hung in the air that day. The First Herald had opened the meeting with talk of witchcraft and star signs; il Riccio revealed that he saw the *David* as an entity with demonic aspects that might

'come to see us'. Leonardo cast a spell of his own, a spell that worked by using the right words at the right time. In Tuscan the word for 'spell' was *'incanto'*. Like a verbal incantation or a talisman placed in the foundations of a building, Leonardo's introduction of the phrase *'ornamento decente'* into the discussion sought to change reality by precise intervention. His words entered the transcript and were perhaps repeated in other discussions, maybe as he showed his drawing of what the statue would look like with a metal modesty belt. No one else had used such language. No one at the meeting took up Leonardo's idea. But it stayed there malevolently.

To veil the statue's nudity was an attack on its power. It resembled what witches did. The late fifteenth-century demonological work *Malleus maleficarum* specifies male impotence and even the destruction of men's penises as a crime of witchcraft.[33] Perhaps that was what was in Leonardo's mind. As if he were a witch, he cursed the *David*, seeking to neuter Michelangelo's statue – a statue that was a passionate expression of its maker's own being. This assault on his rival's virility was just as vicious as anything Michelangelo said outside the Palazzo Spini.

* * *

On the night of 14 May 1504 Michelangelo's statue was slowly rolled out of the Operai del Duomo, standing upright, suspended in a mobile scaffold devised by the Sangallo brothers. A team of forty men laboriously moved it forward on fourteen oiled tree trunks which had to be moved in rotation to maintain the effect of a conveyer belt. To get the 'marble giant' out of the workshops they had to smash the wall above the door. That night, the statue had to be guarded from mysterious assailants who threw stones at it.[34]

Statues in motion are curious entities. In religious festivals which still take place in some Italian cities, a sacred statue – for example, the Virgin of Trapani in Sicily – leaves its home one night a year to move through the city streets, carried by devout young men. The effect is genuinely unearthly: the statue moves, it has come

to life. The stillness of stone is suddenly animate. The crowd, at first onlookers at a spectacle, become increasingly involved and emotional. On its return the statue is applauded. It has proven that it is more than a dead thing.

Michelangelo's statue did not, does not, need to prove its vitality by actually moving. His achievement is to make David seem alive. That is magical – understand the word as you will. But as it moved through the streets, slowly, majestically, the colossus suddenly stopped being a work of art. The men who met to speak of it in January had been artists, and only Andrea il Riccio – and, coolly, Leonardo – realised that this work was somehow more potent than any other statue. More than an aesthetic curio. Its progress turned it into a popular legend. It entered the city's soul. The apothecary Luca Landucci wrote in his diary of this extraordinary event, and it is he who calls the marble man 'the giant'. Yet only at the end of his enthusiastic account does he say it was carved by one Michelangelo Buonarroti. For him it was more than art. This ordinary shopkeeper and member of the Great Council was constantly writing of sacred statues and paintings of the Virgin – for him the important images in the streets and churches of Florence were sacred idols like the Virgin of the Annunziata. He wrote of 'the giant' in the same way.

When it finally reached the Piazza della Signoria the statue had to be painfully, slowly manoeuvred out of the Sangallos' contraption onto its pedestal. In July, when all that had been done, it stood in front of the main entrance to the government Palace. The First Herald had after all been speaking for Soderini and Machiavelli. The artists' advice to the contrary had no effect. Perhaps their spite was too obvious. Donatello's *Judith* was moved, and the *David* took her place.

Only one thing said at the meeting in January, after the First Herald spoke, had any effect. Perhaps it was directly because of what Leonardo said, or perhaps he simply understood the Republic well, but before Michelangelo's *David* was installed outside the

Palace, on whose wall it cast a long shadow, it was fitted with a brass thong very like the device in Leonardo's drawing, with twenty-eight copper leaves to make it *decente.*

Even as the city assimilated its new symbol and took the *David* to its heart as a marvellous being, the small victory of emasculating it was turning to dust for Leonardo, however. He had yet to start painting his battle scene in the Great Council Hall, the vast room just through the Palace past Michelangelo's colossus. The young sculptor had conquered the public heart of Florence. He had projected his emotional life outward in a unique way. In carving the *David* he imagined acting in the world: and the statue acted in the world. When it took up its grand vigil outside the Palace it instantly reshaped the public identity of Florence – transfigured the Republic's self-esteem. Florence now had the greatest statue in the world as its symbol, a work that eclipsed even the dome of the Cathedral as a universal icon. It does, to this day.

Luca Landucci's awed account of the statue's journey through the nocturnal city[35] provides an insight into how ordinary Florentines immediately recognised this public sculpture as something intended for them. But it is more precisely significant than that. This pious shopkeeper had watched the Hall being built, had stood in it in grief-stricken silence listening to the officers read out Savonarola's confession. He represents the target audience for Soderini's plan to decorate the Hall[36] – and his diary bears witness to the fact that when it came to popular art, in Florence in 1504, it was Michelangelo who had the magic touch.

Five

THE ASCENT OF ART

On 4 May 1504, just days before the journey of Michelangelo's *David* out of its birthplace in the Cathedral workshop, Leonardo da Vinci went to the Palazzo Vecchio to see Niccolò Machiavelli. It was an uneasy meeting. Leonardo had some explaining to do. He had been commissioned to paint his battle scene in the Great Council Hall the previous October. Nearly six months on, he hadn't even finished his full-size cartoon. Machiavelli now signed, on behalf of the Republic, a new contract that tried to impose some order on the process. Negotiating the terms of your employment with the author of *The Prince* does not sound a cosy prospect, yet there's no hint of Machiavellian ruthlessness in the piece of paper they both signed. On the contrary, it was the artist who befuddled his patron. You can almost see the sweat run on Machiavelli's brow as he tries to keep up with the complex, ambiguous movements of the mind of Leonardo, the devious intricacy of the artist's explanation for not having begun his painting.

The document points out peevishly that 'several months ago Leonardo, the son of Ser Piero da Vinci, and a Florentine citizen, undertook to do a painting for the Hall of the Great Council'.[1] It notes that 'this painting [has] already been begun as a cartoon by the said Leonardo' and also that he has been paid 35 *fiorini larghi* in gold (the highest-valued denomination of Florentine currency) since accepting the job. It stresses that matters are becoming urgent: the Signori and the Gonfalonier desire 'that the work be brought as soon as possible to a satisfactory conclusion'. But the measures

the contract takes to ensure this are gentle and consensual, accepting the validity of Leonardo's slow and thoughtful way of working. It agrees to go on paying him for his work on the cartoon at Santa Maria Novella, provided he finishes that in reasonable time: '[T]he previously mentioned magificent Signori . . . have decided . . . that the said Leonardo da Vinci must have entirely finished the said cartoon and carried it to its complete perfection by the end of the next month of February . . . without excuse, or argument or delay: and that the said Leonardo will be given in payment each month 15 *fiorini larghi d'oro* in gold . . .'[2] After February, if he hasn't finished the big drawing, the contract threatens that he may have to pay back all the money and forfeit whatever portion of the cartoon has been completed by then, presumably so another artist can finish it and decorate the Great Council Hall.

The next paragraph reads as if Leonardo has already thought of a delaying tactic. Of course, if the artist should start painting in the Hall in the meantime, he can have longer to finish the cartoon. A final thought reassures him and protects his work: so long as Leonardo does keep to the contract, 'the painting of this cartoon will not be allocated to another, nor will it be taken away in any manner whatever from the said Leonardo without his explicit consent . . .'[3]

The contract shows no desire to strip Leonardo of his commission. It evinces every eagerness on the government's part to see a masterpiece by him materialise in the Great Council Hall. He is a genius, after all – the new Apelles, as Machiavelli's colleague Agostino Vespucci put it. Indeed his inability to finish his works resembles that of Apelles, commented Vespucci. The contract that Machiavelli signed with Leonardo in May 1504 seems on the whole a sympathetic document.

What happened next was, however, punitive. It was clever, too. If you had to give a name to the tactic the Florentine government now applied, you might say it was Machiavellian.

In the summer of 1504, the young Michelangelo was invited to paint his own mural in the Great Council Hall to rival Leonardo's putative picture. It seems he was to work at the other end of the very same huge wall that Leonardo was decorating. Only the Gonfalonier's Loggia would stand between them. By this intrigue the Republic was chastising Leonardo without seeking direct confrontation. Perhaps the shock would goad him to finish, and if that failed there would in any case be a work by Michelangelo.

And so a competition was born.

Vasari's account of the origin of Leonardo's commission for *The Battle of Anghiari* is faithful to the detailed evidence of letters, annotations, payment records, the contract. This is his version of what transpired next: 'It happened that, while that rarest of painters Leonardo da Vinci was painting in the Great Council Hall, as narrated in his "Life", Piero Soderini, then Gonfalonier, because of the great ability he saw in Michelangelo, got part of that Hall allocated to him; which was how it came about that he did the other façade in competition with Leonardo [*a concorrenza di Lionardo*] . . .'[4] It would be impossible for anyone to mistake Michelangelo's commission for anything except a directly competitive response to Leonardo for one simple reason. He was not simply required to paint a mural in the same room, but to depict a second Florentine battle – a pendant to Leonardo's picture, a mirror of its martial theme. He was to paint, on the same grand scale as Leonardo's *Battle of Anghiari*, a narrative of another famous Tuscan conflict.

Michelangelo's subject was to be the Battle of Cascina, a collision between Florentine and Pisan forces in 1364. There were many other tasks the Republic might have required of him if it simply had wanted to add a work by Michelangelo to the planned glories of the Great Council Hall. It could have asked him to make a sculpture for the vast room – a new work in the art of which he was so evidently a master. One speaker at the meeting to site the *David* had in fact suggested placing the mighty figure in the Hall;[5] an alternative would have been to order a new work in stone

or bronze, like the bronze *David* commissioned as a diplomatic gift. Or, if Soderini really wished Michelangelo to try and paint, there was the option of getting him to finish the altarpiece originally commissioned from Filippino Lippi, who had since died. Michelangelo's previous paintings that survive include two unfinished religious panels, *The Entombment* and the *Manchester Madonna*.

All these options would have fitted more logically into Michelangelo's career so far than getting him to paint a mural. There was, however, an urgent reason for pushing him into the new territory of painting on a wall, and the reason is made explicit by the fact that his subject was a direct reflection of Leonardo's. The doubling made it clear that this parallel commission was intended to be a competition.

From the fourteenth century onwards, the idea of competition was fundamental to the culture of creative excellence we call the Italian Renaissance. Artists in Italy began to stand out from those of other European countries in the age of Dante and Giotto. Just as Italian writers and scholars began in the 1300s to develop a new Humanist style of thought, based not on dogma but on the close reading of texts,[6] so artists began to search for a new reality, an art that mirrored nature. As soon as artists began to experiment, they began to compete. Dante writes of it in his *Divine Comedy*:

> In painting, Cimabue thought that
> he held the field, and now Giotto has the cry,
> so the fame of the other is obscured.[7]

This is in the early 1300s, when Italian artists are just beginning to raise their status from that of mere craftsmen, and the idea of a famous artist is novel. By the time Leonardo and Michelangelo trained to be artists, the lessons they imbibed in Florentine workshops reflected two centuries of rivalrous excellence. Everyone knew the shining bronze gates at the east entrance of the Florentine

Baptistery facing the Cathedral, with their sophisticated reliefs cast by Lorenzo Ghiberti, and everyone knew the story of how Ghiberti got the job. The Arte della Lana guild staged a formal competition to choose an artist (initially for the north doors); the competitors were challenged to make a single panel portraying the Sacrifice of Isaac. To this day, the rival Sacrifices cast by Ghiberti and his fellow-competitor Filippo Brunelleschi remain on display in the Bargello Museum in Florence. It says something for the tastes of the judges that even after nearly six centuries of changing artistic values we can see Ghiberti's is better.

Exactly why it is better repays a moment's thought. Ghiberti's panel is more organised and disciplined in its use of space: the relationships between the figures are more dynamic and realistic. In other words, when it comes to making a pictorial relief in metal, he was more advanced than Brunelleschi along the road of continual progress and improvement which Renaissance artists aspired to blaze. Their competitiveness was linked to this faith in progress. The most explicit statement of it is Vasari's *Lives*. Beyond all his anecdotes, over and above his responses to particular works, Vasari presents a coherent history of the ascent of art. In the fourteenth century, he argues, artists first turned from dry Byzantine dreams to look at nature; in the next century they started to invent perspective to give depth to their pictures and to depict bodies with real volume in space. The early Renaissance was still, in his eyes, a period of research, and however innovative artists such as Uccello, Masaccio, Brunelleschi and Ghiberti were, they were too obviously straining for technical mastery. Finally, by the beginning of the sixteenth century, artists attained total control, total ease. Art became beautiful and sublime in ways unimaginable before. The first artist of this 'modern' age, according to Vasari, was Leonardo, and its ultimate genius Michelangelo.

Vasari didn't create his grand theory out of thin air. It grew out of the sayings and potted histories that circulated in all the workshops in Florence. The idea that artists should aspire to originality,

even to transform art itself, was inseparable from the culture of rivalry. Artists wanted to excel, which meant, literally, outdoing others. As Leonardo said, 'Sad is the disciple who does not progress beyond his master.'[8] This acute way of putting it is far more direct, somehow, far more cutting, than Vasari's general theory. Every artist in the Renaissance had a 'master'. Artists learned their craft in apprenticeships to qualified masters in a system regulated by the painters' guild. Leonardo lived as a teenager in the house of his master Andrea Verrocchio with fellow-pupils who included the young Pietro Perugino. He never forgot the experience. He says in another note that it's good for young artists to work alongside others, precisely because this inculcates the competitive spirit: 'I say and say again that to draw in company is much better than working alone, for many reasons, the first of which is that you would be ashamed to feel inferior to the other students, and this shame will make you study well; secondly good envy [*la invidia bona*] will stimulate you to be among the number who are more praised than you, and the lauding of the others will spur you on . . .'[9] There's a harsh social vision at work here, a tough and realistic anthropology that was learned the hard way in the workshop. Leonardo postulates 'good envy' – a vice become virtuous; envy is '*bona*' if it makes you work harder, think harder, strive to catch up with the others. This useful *invidia*, the gnawing pain of competition, can stimulate the artist to excel.

It was not wealth or taste or intellect that made Florence more creative than other cities, thought its inhabitants, but its rabid individualism. Vasari tells many stories about artistic competition, but perhaps the most piquant is his tale of why Donatello chose to return to the city after he had been welcomed by the people of Padua: 'He was held to be a miracle by every intelligent person there, but he decided he wished to return to Florence, saying that if he stayed there, being so praised by all, he would forget everything he knew; and that he wished to return to his homeland, where he would be continually blamed; for that blame was a reason

to study and consquently achieve greater glory.'[10] It was the back-biting rivals denouncing his works that Donatello missed, the mean-minded critics he couldn't do without. In this view even Michelangelo's harsh words to Leonardo outside the Spini – '. . . you who tried to cast a bronze horse . . .' – come straight from the bitter creative furnace of Florence.

Machiavelli, who was so closely involved with the Great Council Hall competition, fully shared this belief that Florence benefited from its surplus of antagonisms. In his *Florentine Histories* he chastises previous annalists of the city for suppressing its many feuds and factions in their glowing accounts. This is to miss the whole point of Florence, he says. No city has seen so many civil disorders, so much hate, and yet the mayhem goads its citizens on.[11] The talents of Florence grew well on bloodied earth, insisted Machiavelli and Vasari alike.

* * *

Leonardo, meanwhile, fulfilled his own criterion for the 'happy' pupil. He outstripped his master. He did it in public and with devastating finality, and for the ages. Every visitor to the Uffizi Gallery in Florence can see the divided nature of Verrocchio's *Baptism of Christ* (1470–75), can see profound variation in the quality of different parts of it. Verrocchio's style is bony and harsh, effective at showing muscles but lacking vibrancy, lacking life – at least when you compare it, as how can you not, with the hand that painted the angel in profile at the left of the picture. Glowing with delicate warmth, the angel's face has the softness of real flesh, remote from Verrocchio's sinewy rigour. Its golden curls sign it as a Leonardo. Vasari relates that Verrocchio gave up painting, and stuck to sculpture, after this embarrassing defeat: 'Leonardo painted an angel . . . and did it in such a manner, that the angel by Leonardo was much better than the figures by Andrea [Verrocchio]. This was the reason that Andrea no longer wanted to touch colours, ashamed that a boy knew more than him.'[12]

Leonardo had been Verrocchio's apprentice as a child and teenager; in 1472, when he was twenty, he joined the Guild of St Luke and became a painter in his own right. When he worked on the *Baptism* with Verrocchio he seems to have been back in his old master's house, 'staying' with him, according to a court document.[13] So it was while living with Verrocchio that he contributed to this painting and established once and for all that he had progressed beyond his teacher's capacities.

In 1504, however, he was the mature master, and it was young Michelangelo who was going out of his way to knock him off his pedestal. Michelangelo was just a few years older than Leonardo had been when he had painted the angel in Verrocchio's *Baptism*. And Michelangelo was consciously, explicitly inviting comparison with the older man. It was no coincidence that when he insulted Leonardo in the street he drew attention to the unfinished project for a bronze horse in Milan. Yet this could never be a simple case of the pupil outstripping the master.

In the model of emulation and transformation of which Leonardo's contribution to the *Baptism* is such a famous example, the older artist has long ago mastered a style. The youth absorbs this style and then mutates it: adds new insights and unexpected, unprecedented dimensions. Change happens, art grows, competition begets creativity – and age gives way.

Leonardo da Vinci, however, was not the practitioner of a settled style. He was still experimenting, still making discoveries. He was a rootless, courageous intellectual adventurer. And he was developing a new idea of art. He was making it bigger, in effect: making it clearer in its scope, grander in its imaginative reach. The curious thing is that Michelangelo was embarked on a very similar quest. A coincidence of biography had allowed them to develop along comparable paths, quite separately. Because Leonardo left Florence and worked as a court artist in Milan from the early 1480s until 1500, his art did not impose itself on Michelangelo when the younger artist was growing up. So Michelangelo thought himself

to be unique when independently he began to enlarge his conception of art.

The grandeur of Michelangelo's art hardly needs stressing. Here was an artist who started carving marble when he was a child and who worked naturally on a colossal scale. The *David*, however, was not the first colossus of the Italian Renaissance. It was merely the first to be completed.

*　　*　　*

They sit high on their horses, the warriors and conquerors, bestriding the earth, crushing the defeated. In Rome, the statue of the emperor Marcus Aurelius, cast in the second century AD, surveys the city from the Capitoline Hill on his great bronze horse, hand outstretched graciously. In Venice, the fifteenth-century mercenary commander, or *condottiere*, Bartolommeo Colleoni, cast in bronze by Verrocchio in imitation of such ancient works, glares menacingly, eyes in shadow beneath his helmet, body massive in armour, while his horse walks proudly through the sky.

Before the coming of modern warfare, the horse served in battle as tank, armoured car and fighter jet. Cavalry were the aristocracy of war. In the ancient world, horses pulled chariots and carried soldiers on their backs. In the Middle Ages, to be a knight meant by definition to be mounted. In art, the horse from very early times has been the mobile throne of the ruler, the living engine of triumph. On a box decorated in Mesopotamia with shell, red limestone and lapis lazuli in 2600–2400 BC, known as the Royal Standard of Ur, military triumph is embodied by warriors in chariots: their horses, in an image that will be repeated again and again down the centuries, crush fallen enemies beneath their hooves. In ancient Egypt, too, pharaohs were portrayed in their chariots riding roughshod over enemies – the king towers over the defeated in a relief of Seti I at Karnak, his chariot surging forward behind mighty rearing horses.

This ancient Middle Eastern and North African tradition was

taken up in classical Greece and Rome, where the chariot is often displaced by a mounted warrior in the imagery of triumph. The figure of a cavalryman on a rearing horse with a fallen barbarian beneath his hooves appears, as an archetype of conquest and power, on military tombstones all over the Roman Empire. At its most sculpturally ambitious this becomes the life-size equestrian figure, confident and graceful, his command of his elegant and powerful horse the physical manifestation of authority. In Renaissance Italy the equestrian statue was revived by artists determined to emulate the skill of ancient Greek and Roman sculptors. It was the most complex type of bronze figure to survive from antiquity: to cast a life-size horse in bronze was a formidable technical challenge, to give it beauty and life even more difficult.

Equestrian statuary had not disappeared with the fall of Rome even though its grace had. In eighth-century Baghdad an automated statue of a warrior on horseback, armed with a long lance, stood atop the green dome of the royal palace at the very centre of the circular city. William of Normandy's knights were similarly portrayed on horseback with lances on the Bayeux Tapestry in eleventh-century Europe. Life-size stone statues of mounted warriors were carved for tombs and city squares from Magdeburg to Milan. The thirteenth-century *Magdeburg Rider* is very similar to Verona's fourteenth-century equestrian statue of Can Grande della Scala and Milan's mounted figure of Bernabò Visconti; all three stone horses stand rigid as wooden dolls, with all their legs firmly planted on the ground.

The challenge for sculptors in the early Renaissance was to transcend such gigantic, inanimate toys and to revive the lifelike bronze equestrian art of antiquity. Florence cheated when it came to raising an equestrian monument to the fourteenth-century mercenary commander John Hawkwood. This fearsome English warrior who had a contract to command the armies of Florence was promised a marble statue. Instead, when he died in 1394, the painters Agnolo Gaddi and Giuliano Pesello painted a

mounted Hawkwood in Florence Cathedral − a picture of an equestrian monument in place of the real thing. When Paolo Uccello repainted it in the fifteenth century, he created a dreamlike illusion of a real statue: employing green pigment to suggest bronze, and making brilliant use of the new art of perspective to give the round, geometrical flanks of the horse and the rectangular masses and cornices of the imaginary statue's classical base a tremendous feeling of depth, he gave the dead soldier a robustly graceful equestrian monument. The fact that it is merely the painted illusion of a statue is overcome by the sheer power and naturalness of the depiction. And there is a very important innovation: this bronze horse has one hoof off the ground, breaking with the caution of Gothic artists, reviving the sense of actual movement that ancient Greek and Roman horses have. This is not just a fantasy − it is a design for how such a bronze horse might − in Florence, where the arts of antiquity were being so brilliantly revived in Uccello's time − be cast.

Uccello's painting, done in 1436, was a challenge to Florentine sculptors. His contemporary Donatello took it up. Seven years later, in Padua in northern Italy, this Florentine artist cast a bronze statue of the Venetian mercenary commander Erasmo da Narni, nicknamed Gattamelata, or 'Honeyed Cat', on a mighty horse. This potent sculpture rivals the mounted emperors of the ancient world and in truth outdoes them in expressiveness, as Gattamelata's tough face towers above the piazza and his horse strides almost angrily forward, as if eager to charge into battle. Just like the horse Uccello had painted in Florence Cathedral, this one raises a hoof and bends its other legs in lifelike movement − but Donatello really did cast his dynamic horse in bronze, a task at the cutting edge of late-medieval technology. In about 1481 Leonardo's master Verrocchio − whose career as a sculptor survived the younger man's defeat of him as a painter − took on the commission to cast a bronze mounted monument to the *condottiere* Bartolommeo Colleoni in Venice that would rival Donatello's masterpiece. At

just the same time, his most gifted pupil wrote to the new ruler of Milan asking for work.

Ludovico Sforza, nicknamed *Il Moro* ('The Moor'), was the son of the mercenary commander Francesco Sforza, one of the most brilliant and dangerous soldiers in early fifteenth-century Italy, who achieved the dream of all mercenaries. Instead of dying an unloved stranger, reliant like John Hawkwood on a city that had never really trusted him to provide a monument to his pride and strength, Francesco Sforza became the ruler of a city state of his own – and not just any city. Milan was one of the biggest and most industrious cities in Italy, an ancient Roman town that still had Early Christian basilicas and classical gatehouses, and that rivalled Venice for dominance of the whole of northern Italy. Set on the Lombard plain in sight of the Alps, it resembled German and French cities both culturally and economically – its great arms-and-armour industry rivalled those of Northern Europe and its art was full of Gothic exuberance, expressed at its wildest in the vast Cathedral whose spires and pinnacles were being raised in Germanic style even as domes and colonnades were transforming the appearance of more southerly Italian cities.

When Francesco Sforza made himself Duke of Milan, he established despotic rule over this big, booming city. To this day the Sforza Castle from which he and his family wielded power dominates a large area at the centre of Milan, its massive round towers and long curtain walls concealing a wide outer courtyard leading to more enclosed, shaded spaces. In its vaulted inner chambers, the Sforza presided over a magnificent court. Ludovico was a usurper who seized power from his own nephew and would only, much later, become duke when the nephew conveniently died: if illegitimate, he was also a cultured ruler, determined to bring artists and intellectuals to Milan. Leonardo was to make many friends there including the architect Bramante and the mathematician Luca Pacioli. But it's impossible to walk around the menacing and formidable Sforza Castle without intuiting that Milan was a militarised

city, a place ruled by the sword. The tournaments and banquets, masques and intrigues of the court took place behind stern walls: the civilisation inside the castle was sustained by arrogant might. 'The House of Sforza has been and will be hurt more by the castle of Milan built by Francesco Sforza than by any disorder in that state,' warned Machiavelli, because stone walls were no substitute for the people's love.[14] Behind their castle walls the rulers of Milan were hated, pointed out Machiavelli – when their time came they would depart unmourned.

You still sense this today, in the way the castle seems to push the city's life away from it, to skulk behind its outer walls like a recumbent giant. Leonardo da Vinci saw this, too, and in the early 1480s he addressed Ludovico Sforza – for whom he would design his doomed bronze horse – as a man he assumed must be more interested in war than culture. In his letter asking for work, Leonardo did not offer his services primarily as an artist, but as an inventor. It was the first time he promoted himself as scientist, engineer, polymath. But it was exclusively military science over which he claimed mastery:

Having, my illustrious Lord, seen and sufficiently considered the works of all those who claim to be masters and makers of instruments of war, and that the inventions and operations of these instruments are no different from what is in common use: I will try, without denigrating anyone else, to explain myself to your Excellency, showing you my secrets *[li secreti mei]* . . .

1. I have a type of very light and strong bridges, adapted to be most easily carried, and with these you can chase and at any time flee the enemy, and others safe and indestructible by fire and battle, easy and convenient to carry and place; and ways of burning and destroying those of the enemy.
2. I know how, when a place is besieged, to drain the moat . . .
3. If because of the height or strength of a place and its position

it is impossible during a siege to use the method of
bombardment, I have ways to destroy any stronghold or other
fortress, if it were built on a rock etc.

4. I have again types of bombard that are very convenient and
easy to carry: and with these I can hurl small stones almost like
a storm; and with the smoke of these can cause great terror to
the enemy . . .[15]

He went on to list his methods of mining underneath a fortress;
his 'covered chariots' (*carri coperti*); his guns 'far from the usual type';
his catapults, mangonels and indestructible ships; his 'unusual and
marvellous machines'. Only at the end of this work-seeking letter
did he offer his talents as an artist, after adding: 'In times of peace
I believe I can give excellent satisfaction and equal any rival in
architecture and the composition of public and private buildings:
and in conducting water from one place to another.'[16]

It suddenly makes sense, reading this letter, that Leonardo was
still living with his old teacher when he was in his mid-twenties
and that he made no urgent effort to complete early works in
Florence such as *The Adoration of the Magi*. He offers Ludovico
Sforza a long list of military inventions – he must have spent time
thinking about them. In other words, he was already living in
Florence in his twenties as he later would live – surrounded by
notes, playfully conducting experiments, dreaming up inventions.

The position of court artist was perfect for Leonardo. It meant
being someone the ruler could consult on all the arts, much as he
might consult his astrologer on all matters relating to fortune and
the heavens. It was, in other words, a chance to show off Leonardo's
infinite variety. Once in Ludovico's employ, a lot of his ingenuity
was dedicated to entertaining the court, designing fanciful tour-
nament costumes, constructing elaborate stage machinery. His
scientific research was released, not held back, by frivolity.
Experiment and play are never far apart in his notebooks. Yet at
the heart of his efforts in Milan was a single great project that

welded together art and science, imagination and technology, the
palace of beauty and the workshop of war. It was to be the summit
of all his projects for nearly twenty years, to consume and justify
enormous efforts of research and experiment, to tantalise his public
and ultimately to remain a dream. Leonardo offers to work on it
in his letter to Ludovico at the start of the 1480s: 'Again work
could be taken up on the horse of bronze [*cavallo di bronzo*], which
will be to the immortal glory and eternal honour of the happy
memory of the lord your father and the illustrious house of
Sforza.'[17] There were already plans to create an equestrian monu-
ment to Francesco Sforza, to give Milan its rival to other horse
statues in northern Italy. It made sense for Ludovico to raise a
'horse of bronze' as a memorial to Francesco. As a usurper who
could not yet claim the title duke, it would stress his lineage.

Leonardo did work on the design for the metal horse, but it was
to become a utopian venture, a kind of myth. In 1489, when he
had already been in Milan for at least six years, the Florentine
ambassador there wrote to Lorenzo de' Medici to say that Ludovico
wanted to remember his father with an enormous equestrian statue.
Although Leonardo had been entrusted to create a model, says
the letter, can Lorenzo suggest a couple of artists who might be
good at such work?[18] In other words, six years or more after he
offered to take it on, Leonardo's progress on the *cavallo di bronzo*
was not such as to fill his employer with confidence. At least one
other artist was in the running to make it: the Florentine painter
and sculptor Antonio del Pollaiuolo drew a design for an eques-
trian monument with a man in armour on a mighty horse. The
rider's face is that of Francesco Sforza. This artist definitely knew
how to cast bronze: in the 1480s, when Pollaiuolo drew this design,
he was working on the formidable bronze tomb of Pope Sixtus IV,
a 15-foot-long metal box on which the pope sleeps above florid
leaves, grotesque heads, and allegorical personages. Pollaiuolo's
proposal for the Sforza monument is equally ambitious: it depicts
the mighty mercenary duke on a horse that rears up, its front legs

suspended above a fallen enemy. In a cunning technical ploy, the screaming, naked fallen man raises his arm defensively and it acts as a support for the rearing horse above him, as do cloth hangings which in reality would have functioned as metal scaffolding. In Leonardo's early drawings for the Sforza horse he imagines exactly the same rearing pose. Pollaiuolo seems to have been offering a practical design to give reality to Leonardo's vague fancies. Two drawings by Leonardo on blue paper, done sometime between the mid-1480s and 1489, also make practical attempts to give his statue strength. In one, a conveniently placed tree stump connects with one of the horse's raised hoofs. In the other, a fallen warrior's shield supports one of the legs. [19]

Leonardo proposed to outdo statues that survived from ancient Rome and to trump the modern works of Donatello and Verrocchio. Having a horse stride forward with one foot in the air was nothing: his would rear up, its two front legs soaring. Ludovico Sforza apparently doubted this was feasible, and the drawings by Leonardo himself and by Pollaiuolo try to make it more practical. To support the horse in that pose you'd have to introduce some support which, however ingenious, would ruin its spectacular liberty. Only in the seventeenth and eighteenth centuries would European sculptors develop the means to cast rearing horses on a colossal scale. When Leonardo took up his grandiose scheme again in 1490, he would still try to have two feet off the ground – but this time it would be one front leg and one back leg as the horse strode purposefully on its plinth above the amazed populace.

'On the twenty-third day of April 1490 I commenced this book and recommenced the horse,' notes Leonardo in a manuscript in Paris.[20] In the 1490s he made more dedicated efforts on his great work than ever before, building a full-scale clay model that captivated all who saw it. This model, recorded the mathematician Luca Pacioli, stood 12 *braccia*, or almost 24 feet, tall, the height of four tall men standing on each other's heads, without the plinth,

which might easily have added another 10 feet.[21] So it was to be a true colossus, a fantastically imposing creature of metal. Yet, in 1498, it still existed only as a giant clay model.

Witnesses to Leonardo's life in Milan saw the horse as the centre of his labours – he appeared to be working on it constantly for nearly two decades. A revealing note suggests that this is how he too thought of his time in that city: 'You can see in the mountains of Parma and Piacenza a multitude of perforated shells and corals still stuck to the rocks, of which, when I was making the great horse at Milan, a large sack was brought to my workshop by certain peasants who had found them in that place.'[22] In this glimpse of his life in his workshop in the Corte Vecchio, beneath the gargantuan building site of Milan's Cathedral, the model of the horse is at the centre of everything: it makes sense of who he is and what he's up to, because it is where his art and science meet. The mind that local peasants knew would find fossil shells worth collecting was engaged and intrigued by every aspect of the *cavallo*. It was a work apparently without end that justified his passion for research.

Leonardo was licensed by his great sculptural project to study horses up close, draw them and measure their proportions. He became a regular visitor to the castle stables. On a sheet with a sketch of a horse's foreleg, marked all over with measurements of the lengths and widths of its different parts, he notes, 'The Sicilian of Messer Galeazzo'. In other words, this drawing done in the 1480s is an observation of a particularly fine horse in the Sforza stables, in whose excellent physique Leonardo was seeking general rules of proportion. He believed, following Vitruvius, that beauty was a quantifiable fact, the perfect proportions of a human or a horse measurable.[23] Another drawing of a finely proportioned horse covered in scribbled dimensions is marked, 'The big jennet of Messer Galeazzo'.[24]

Leonardo's visits to the stables were not just cold academic exercises. He always kept horses himself, claims Vasari. Perhaps it was

concern for the animals' welfare that made him design, in the late 1480s when he was making his studies of perfection in horses, a hi-tech stable with hay storage above the stalls, which are served by a proper drainage system to take away waste. He didn't like to see these beautiful creatures living in filth.

The *cavallo di bronzo* was a symbol of nature, a monument no longer to Francesco Sforza, but to the power and grace of animal creation. When Leonardo went to look at an ancient equestrian statue in Pavia, what impressed him was its suggestion of movement and life: '[T]he movement more than anything is to be praised . . . the trot is almost of the nature of a free horse.'[25] What he wanted to create was an imitation of a living horse, a scientific simulacrum of organic, vital nature. This scientific ambition – to model life – is revealed by the strange slip that occurred as his design evolved.

Francesco Sforza vanished. From drawings in which a rider in armour controls his rearing horse, Leonardo progressed to designs of ethereal grandeur in which, to clarify the horse's lines and concentrate all eyes on its form, he does not encumber it with a rider or saddle. It is a 'free horse'. Since he never did cast it, perhaps this was always left ambiguous in conversations with Ludovico, but in none of the later drawings for the horse and its casting machinery is there any hint of a plan to add his father. The model was accepted and praised on these terms – as the *cavallo*, a self-contained and unique thing. It became a wonder, a marvel, a legend – the 'Horse of Bronze'.

It took all of Leonardo's science to calculate how he might cast the horse. Once his design was perfected and its staggering scale established, he started inventing machinery to make it. He studied how giant cannon were made in Milan's foundries, and developed a complex way of casting modified from the ancient lost-wax technique. From the giant clay model – the one stage he actually completed – he planned to create a hollow outer mould; this would be lined with wax, and against the wax he would build a strong

inner sculpture of fire-resistant clay. After the central wax was melted out, the molten bronze could be poured into the gap. Leonardo invented pulleys and cranes for lifting the horse and its mould, a system of underground furnaces to melt the huge amount of bronze he planned to use. He gave Renaissance Italy its most captivating display of technological ambition.

The loveliest relics of this effort are red chalk drawings in his notebook Madrid Codex II. A gigantic form for the horse's neck is held inside a latticed iron frame: its sheer size and strength become poetic in this great drawing.[26] Another red drawing in the same sequence shows the horse's abstract-seeming mould, a gigantic cylinder atop tubular legs, held within its wooden scaffolding like a rocket on a launch pad.[27] The drawings are not just aesthetically ecstatic but minutely detailed: if Leonardo had any doubts that he could make this machinery and cast this horse, his drawings conceal them. It really looks as if, in the first years of the 1490s, he was on the verge of manufacturing his marvel. Beside his drawing of the neck's vast mould in its latticed armature he wrote instructions full of technical casting terms such as 'male part' which exude the practicality of real plans for a real process:

These are the pieces of the form of the head and neck of the horse with their armatures and irons. The piece of the forehead, that is, of its *capa* which has the thickness within of wax, must be the last thing to be secured, so that the male part can completely fill this window, that goes in the head, ears, and throat, and is surrounded by the wood and iron of its armature . . . In the muzzle there will be a piece that will be fastened on both facets with 2 forming pieces of the upper cheeks. And below it will be fastened to the *forma* of the forehead and the *forma* under the throat. The neck must be held by 3 forming pieces, 2 of the parts and one in front, as is demonstrated in the drawing above.[28]

He says in one note that the notebook will record 'everything related to the bronze horse presently being executed' and dates this statement 1491.[29]

But three years later the great operation was still gathering steam. In fact, a mass of bronze had been set aside for the horse, but Ludovico Sforza was as restless in his political schemes as Leonardo in his study of the natural world. Ludovico, in a stratagem that went badly wrong, encouraged the French king to pursue an old claim to the crown of Naples. In his attempt to use the French as a weapon in his own power struggle with that city, he grossly miscalculated. When the French army came through the Alps in 1494, their train of cannon immediately threatened the security of Milan itself, just as the invasion would end Medici rule in Florence. The bronze set aside for the *cavallo* was sent to Ludovico's relative Ercole d'Este of Ferrara to cast urgently needed artillery pieces. Leonardo, meanwhile, was given a new public commission sometime between 1493 and 1495: to paint a mural of the Last Supper in the monks' refectory at Santa Maria delle Grazie in Milan. Yet he did not stop working on his design for the horse. Matteo Bandello remembers in his *Novelle* how as a young monk he would see Leonardo move meditatively between his two great monumental projects and, 'departing in the afternoon from the Corte Vecchia where he was creating his stupendous clay horse, and coming straight to the Grazie, ascend the scaffolding and give one or two little brushstrokes to one of the figures . . .'[30]

In 1499 the clay model was used for target practice by Gascon bowmen after the French, five years after their first incursion, toppled Ludovico Sforza and seized Milan. That December, Leonardo left the city. 'Of the horse I will say nothing because I know the times,' he had written to his prince after the disaster of 1494.[31] Yet the model was, in its earthen beauty, a living project right up to the moment of Sforza's fall and Leonardo's flight. In about 1500 a Milanese armourer engraved a memory of it on a

breastplate now in the Stibbert Museum, Florence. Even after the model was destroyed the horse lived on as legend.

* * *

'You explain it yourself, you who designed a horse to be cast in bronze but couldn't cast it and abandoned it in shame.'

Michelangelo's words outside the Spini Palace make him one of the first critics ever to express what has, since the sixteenth century, been seen as the paradox, even the tragedy, of Leonardo da Vinci. Here was a mind of unparalleled beauty and sublimity, cavernous in its creativity, awe-inspiring in its abundance and plenitude of promise. And yet, for all the ambition and richness of Leonardo's ideas, for all the unparalleled excellence of his abilities, how many works did he ever finish? The horse is the emblem of a life strangely lost in its own genius, a creator whose creations seem largely to have stayed in his own mind, recorded for posterity – mercifully – in the private world of his notebooks. 'Truly marvellous and celestial was Leonardo,' says Vasari in the undercutting second paragraph of his – at first sight so enthusiastic – 'Life'. 'And he was outstanding in erudition and in the principles of letters, in which he would have done very well, if he had not been so changeable and unstable. For he tried to learn many things and, having begun them, abandoned them.'[32] The bronze horse was the ultimate example of this: '[H]e proposed to the duke that he would make a marvellously big horse of bronze, in order to put the image of the duke on it as a memorial. And so grandly did he begin it and develop it that to bring it to a conclusion was not possible. And there is an opinion of Leonardo, as with other things he did, that he began it without ever intending to finish it . . .'[33]

It is precisely this strange inability to complete his works – or lack of interest in finishing them – that Sigmund Freud proposes to explain in his 1910 book *Leonardo da Vinci and a Memory of His Childhood*. Even in the artist's own lifetime, marvels Freud, this prodigy mystified people. Although he created masterpieces, his

investigative spirit was constantly preying on his time and energy and distracting him from painting. Freud argues that Leonardo's immense curiosity about everything ultimately became pathological. He was compelled to endless research on every subject because he was in reality sublimating a child's sexual curiosity: not only was he homosexual, says Freud, but he was celibate, and the erotic side of his nature was transferred to a passion for research.[34]

Long before Freud attempted to understand it, Michelangelo pointed out the strange disparity in Leonardo's nature between infinite aspiration and limited public achievement. At the Spini, while the crowd listened amazed and Leonardo stood in red-faced silence, the young sculptor accused his elder of designing the horse, finding himself incapable of casting it and giving up through 'shame', *vergogna*. The same manuscript compiled in 1540s Florence that relays this insult adds: 'And again Michelangelo wishing to bite Leonardo, said to him: "And those capons of Milanese really believed in you?"'

This is a still more pointed remark. The bronze horse, by implication, was one of Leonardo da Vinci's cons. Yet of course, it was nothing of the sort. It was not even a failure. It was the clarity of its idea that mattered. As Leonardo developed the design, he purified it. In the mind it is an image of remote tranquillity, heroic stillness: The Horse.

* * *

In the long white room, your soul is stilled by that same clear, lofty vision. The work that Leonardo did finish in Milan breathes softly, like a cool breeze in the hot Lombard afternoon. If pigment on plaster could flutter, it would be fluttering ever so gently in the motions of air that seem to emanate from its depths.

Of no other painting in the world is it so appropriate to say 'depths'. So much of the *Last Supper* is lost, peeled away, smothered by restorers, peeled again. There are beauties here that are lost to us. What survives is the painting's space, its creation of a

world that is the sublime mirror of our own. Other paintings
describe illusory worlds, but theirs are cheap tricks in comparison
with the precisely calculated perspective of this room that recedes
into the wall with such baffling conviction. Its surface is a shat-
tered skin, a mosaic of fragments. Its colours don't seem right. But
the spatial illusion of the *Last Supper* is incontrovertible. It gets
inside you. It is not a painting that stays in the mind but a real
place.

Thirteen men are seated at table. A terrible announcement has
interrupted their simple repast. Christ's declaration that one of
the disciples gathered in an upper room will betray him has them
all rise or stare or jolt back in horror, fury, fear. But the drama is
suspended. It is held in this silent moment. As Christ looks down,
the room behind the long white-clothed table rushes away towards
its vanishing point. A coffered ceiling creates a grey grid that maps
the diminishment of appearances with distance like a diagram
above the disciples. Doors and hangings, faded badly, count down
the shrinking walls towards zero. That zero is a cool, quiet northern
Italian landscape seen through an open window.

The vaulted hall that holds this fragile treasure was the refec-
tory of a monastery. The monastery still functions; in its cloisters,
the noise of modern Milan feels a long way off. Leonardo painted
a scene to divert and chasten the monks at their meals, and his
eye-fooling space is part of the serious joke. The room painted on
the upper part of a wall is as real as this one, yet it is a place
where the carnal is transfigured. The grace of Leonardo's compo-
sition makes flesh and pain equally ethereal. In that room, the
horror of life is elevated into tragedy. As the disciples raise their
hands and cry out, voiceless, pain is held and contemplated. It is
a philosophical painting: it distils the chaos and frenzy of exis-
tence into measured intervals, visual music. The figures are essences
of figures, their passions at once universal and abstract.

Call it mathematics, call it a new grasp of the principles of clas-
sical Greco-Roman art and architecture learned in his studies of

Vitruvius and his conversations with the architect Bramante, but this painting at once grasps the richness of reality and finds order in the universe. Christ's prophecy, his revelation of his own coming death and the treachery of Judas, is horrible, shocking. The company react accordingly. But they inhabit a lofty realm, a theatre of heroes. So massive are their forms, so sedate their hysteria, that suffering itself becomes a thing of perfection. The *Last Supper* offers the beholder an elevated experience. You are invited in. But it does not come out to you – does not come down to you. To experience it fully you must accept its philosophical rapture.

Leonardo worked on it like a philosopher developing an idea. Matteo Bandello watched: 'I saw and observed him many times, going in the morning at a good hour and climbing his scaffolding, for the *Last Supper* is high up; often, I say, he would not put down his brush, but would paint from dawn to dusk, forgetting even to eat or drink. Then for two, three or even four days he might not put his hand to it, but every day for one or two hours just contemplate, consider, examine and judge his figures.'[35] This is a convincing account of how Leonardo mulled over and pondered this masterpiece, for its quality of meditation is what calms you, and mystifies you, in the refectory. Art that strives to induce meditation, to liberate the mystical impulse, often favours big, empty images. The large, calm face of Christ painted by the Russian icon master Andrei Rublev is a majestic example.[36] The *Last Supper*, too, exploits scale and simplicity to free the mind. Its figures are almost like great blots of colour. You are estranged, set free by it. Leonardo is expressing his ability to stand back from the immediate. It is a monastic work, in the end.

The *Last Supper*, like the bronze horse, is monumental. It achieves a grandeur that had not been seen in art since ancient times. You would have to go to the Acropolis in Athens – which was not accessible to Renaissance travellers – to find its like. Or to Rome, to see the youthful works of Michelangelo.

There is a symbiosis between these two very different artists

despite themselves. In the 1490s both are transcending all the Renaissance has been up until that moment. They are ascending towards a higher conception of art – and a bigger one. Robust, absolute, universal figures replace what seems by comparison the illustrative, clogged classicism of fifteenth-century art. Instead of archaeologically studying the remains of the ancient world, they are creating their own autonomous classical works whose spiritual scope inspires awe and wonder. Art can say the deepest things imaginable about life and death. It can speak with sublime, pure eloquence. And it can heighten the experience of the beholder, like a bacchic ecstasy. All this art can do, in the hands of Leonardo and Michelangelo.

One thing they share is the fantasy of the colossus. Michelangelo dreamed of sculpting a statue out of a mountain – an idea even more surreal than Leonardo's horse and no more practical. Another is an effortless heroism. Robed figures and pristine bodies express the anguish of humanity with oratorical dignity. But what is crucial to understanding their competition in Florence is that both believe in a public vocation for art. And monuments and frescoes are the appropriate forms for an art that is about to ascend to its true nobility.

In the Great Council Hall, bare walls awaited a new art. It was not just a rage for rivalry that gripped the Republic. Piero Soderini was astute. He wanted to dignify Florence, to raise it up. He wanted to fill its citizens with heroic self-respect. Nothing could do this more sublimely than the heightened art these two rivals had attained with the *David* and the bronze horse, the *Pietà* and the *Last Supper*. The heroism of Leonardo and Michelangelo, however antagonistic, was truly sublime. It would surely make this the most imposing room in all the world.

Part Two

THE ART OF WAR
1504–5

Six

BLOODSTAINS

The battle is a bloody, even a faecal, pool of brown ink on a small scrap of paper that has miraculously survived the centuries and found its way into the Accademia Gallery in Venice. Using a sharp metal nib, squiggling and scratching at the paper to create tangled ambiguity and gory suggestiveness, Leonardo da Vinci has visualised a hellish mêlée, a frantic, murderous congestion of men and horses. Yet look closer and it is all quite precise – horribly precise. The ground is a dense network of lines that darken the scene, among which we glimpse a horse knotted into itself and a man twisted on the ground, desperately dragging his broken, naked body away from a rearing horse that's about to bring its hooves down and crush him. Above these tortured figures mounted warriors charge, the huge, round flanks of their horses shining out of the slaughter as if glistening with sweat, the men bent over the horses' great necks holding on for dear life as they plunge long, sharp lances at their enemies. The lances are decorated with fluttering banners; one flag streams free of the slaughter, another is tangled up with the horses as, at the heart of the struggle, a rider raises a club high above his head in a grim gesture of command.

This is the most developed of three battle sketches in the Accademia. On the same sheet, nude infantrymen swing clubs and sticks in rapid sketches of different poses they might adopt in battle. On another, still smaller scrap of paper, nude infantrymen approach another desolate knot of warriors: on closer examination this is exactly the same battle scene as on the first sheet, with the same

horses and banners and the central figure of the warrior raising his weapon – but in this drawing there are more infantrymen, one rushing between the horses and trying to spear a knight, others fleeing a horse-borne attacker. Nearby is the arch of a stone bridge, with a struggle on it enigmatically delineated by a few smoky wisps of ink – the cloud of marks becomes solid and matted, like smeared flesh in a butcher's shop, when you risk a second look.

A third sheet reveals still more bodies fallen beneath horses, with knights cruelly plunging their lances into naked men on the ground below them, as if they were hunters slaughtering a pig their dogs had run to ground. A fallen horse raises its skull-like head to the sky in a scream of pain – for all the world like a detail from the painting Picasso would create more than 400 years later to protest the bombing of Guernica during the Spanish Civil War. At the same time Leonardo's briefly sketched horse recalls horses painted on cave walls in France 30,000 years ago. His drawings are timeless in their frenzy. It's a strange word to use of a Renaissance artist, but their power is primitive. Around the horses on this final sheet, infantrymen are massacring one another so chaotically that it's impossible to tell who's fighting whom: this anarchy of slaughter is even more disturbing in a scene below in which clouds of dust are raised by the last exhausted killers on a battlefield strewn with the dead and dying.

These three small sheets cut from a notebook show Leonardo dreaming up the tremendous painting with which he planned to astonish the Great Council of the Florentine Republic. The subject he was given was a famous victory, intended to put courage in the hearts of the assembled citizens.

Nothing in the history of Florence was prouder than the tale of the Battle of Anghiari. On 29 June 1440 a Florentine army faced the forces of Milan across the valley of the River Tiber on the border between Tuscany and Umbria. The brilliant *condottiere* Niccolò Piccinino was poised to lead the Milanese into Tuscany, to menace the very liberty of Florence. That morning the

Florentines, camped in front of the hill town of Anghiari, watched a cloud of dust moving towards them from Borgo San Sepolcro on the far side of the plain: instead of charging towards Piccinino's advance, they waited, and Leonardo Bruni, who was then Chancellor of the Republic, believed the sweat and exhaustion of Piccinino's army were factors in its defeat. Still it was a close-run thing. Hundreds of mounted knights clashed across a bridge over a small tributary of the Tiber close to Anghiari; each side in turn held the bridge and was driven back, while squadrons of infantry swarmed over the stream in flanking moves. At last Piccinino's ranks broke, the survivors desperately fleeing, leaving behind arms, armour and their standards – an emotional loss in that age of chivalry. Piccinino survived, shamed by his flight. The war with Milan was not over, but Florentines remembered it as the day their liberty was saved.[1]

From tiny sketches great battles grow. Leonardo's scribbled compositions in Venice are just pocket-sized squares of paper, the figures on them no more than an inch tall at the most, the drawings essays, attempts, trials. You might almost call them doodles. But his immense mural is taking shape here, in these quick designs, and what's more its power is already formidable – even at this scale, the violence unleashed by his imagination is frightening. Leonardo is probably the greatest draughtsman in history. This is the reason he is able so magically to move from art to science, from fantasy to practical – or apparently practical – inventions. Drawing is the thread that weaves his disparate interests into one beautiful braid. Because he can create a living image in a few pen strokes and can elaborate a detailed, shaded, finished drawing without ever turning it into something dry, his mind generates a mind-boggling universe of fascinating form. These three sketches in which he works out the composition of *The Battle of Anghiari* are among his most impressive works because – in themselves, in their tiny compass – they contain enough horror, fear, tension and energy to sustain a work a thousand times bigger. In other words it is literally as if they are the seeds of the

finished painting – it will be far bigger but it will replicate their DNA. The Battle of Anghiari lives in these little fragments of paper: an epic history of killing is held within them. In a sense they are not drawings 'for' anything – not designs for another, more important work, but living and complete masterpieces in themselves. Leonardo was in love with the process of creativity, and wanted to make this process visible to others. He let people see his designs, and in those designs he touches on emotional and psychological forces that make it absurd to call them 'preparatory'.

Look into even the weakest of the Venetian drawings for *The Battle of Anghiari* – the sheet that does not have flowing banners or a man raising his sword arm high at the centre of a dense struggle, but instead tries out more diffuse compositions – and your imagination is led into a place of horror. Dead and dying bodies carpet the battlefield: pen lines that at first seem innocent start to resemble lakes of blood, or a morass of pulped organic matter. Horses' heads seem to jolt free of their vertebrae. Warriors merge into their mounts as if they were becoming centaurs – half-man, half-horse. None of these perceptions are fixed, none are unambiguous – none are final. You see something new with each glance. The drawing is a bit different every time. The only constant is its strength.

* * *

There are the battles in the history books and the battles we dream of. In this world, Leonardo's world, people saw soldiers in the sky and spectral armies in broad daylight. In 1494, on the eve of the French invasion, armoured knights massed in the clouds above the Arezzo region – where Anghiari is – to the thunderous sound of drums and trumpets. Many people saw them.[2] In July 1504 witnesses reported seeing a squadron of knights in a meadow near Bologna; one witness walked over to see what the soldiers wanted and the people watching saw him brutally cut down: then he came back, saying he'd found no one in the meadow. An army came out of a wood and fought a terrible battle: many died and carts

carried the corpses away. Again, when people approached there was no trace of an army, no sign a battle had taken place.[3]

As we have seen, the Battle of Anghiari had taken place more than sixty years before Leonardo received his commission to paint it. His imagination rose to the occasion, but what transfixed him, what makes the drawings in the Accademia so viscerally shocking, was not in the past. War was real and immediate to Leonardo da Vinci. He knew it at first hand and it troubled his dreams. He also knew a method of generating visual images which he recommended to young artists while admitting it might seem 'trivial and laughable': '[T] his is that when you look at any wall marked with various stains or with variegated stones . . . you may be able to see the likenesses of different landscapes, enriched with mountains, rivers, rocks, trees, plains, wide valleys and hills of several types, or again you may be able to see all kinds of battles . . .'[4]

In his drawings for *The Battle of Anghiari* it is tempting to think Leonardo used his surrealistic method of seeing battles and other visions in the spots on walls

* * *

When Leonardo received his great commission, Florence's war
with Pisa was nine years old, a sad affair of siege and attrition.
Sometimes nothing would happen for weeks, then a group of peas-
ants sent out to burn Pisa's crops would be caught and slaugh-
tered. Part of the delay and discontinuity arose from the seasonal
nature of war in Renaissance Italy. Armies campaigned only in
the spring and summer when the ground was best for horses. At
the end of each season hostilities broke off, until the next year.

Florence knew it was the dominant power in Tuscany when it
finally conquered Pisa after a cruel siege in 1406. Losing the city
again in 1494 was a devastating blow to patriotic pride – if we
can speak of patriotism when the state in question is not a nation
but a city, its countryside and subject towns. An Italian word for
this intense local feeling is *campanilismo*, loyalty to your own cath-
edral bell tower. Florentine pride expressed itself in devotion to
its famous dome – a character in Machiavelli's play *Mandragola* is
loath to let the dome out of his sight.[5] This is a joke on
parochialism, but there could be no bigger joke, it might seem to
us, than a republic that fought year after year, wasting blood and
money, causing misery and suffering, just to conquer a neigh-
bouring city thirty or so miles away. This is of course to misun-
derstand all wars, all polities. The war that Florence was still
fighting, as Leonardo returned to the city in 1503, to reconquer
Pisa was a microcosm of the ambitions of larger states. Anyway
who is to call Florence small? It was the most cultured and sophis-
ticated city in the Europe of its day, and its intellectuals, steeped
in the ancient works of Thucydides and Livy, could write the
history of their micro-empire as grandly as the story of Rome
itself. The great Florentine Humanist Leonardo Bruni, who was
Chancellor of the Republic at the time of the Battle of Anghiari,
wrote a history of Florence in three volumes in Latin modelled
on the classical historians. He wrote of skirmishes between a few

mercenaries outside Italian villages as seriously and poetically as if he were narrating the campaigns of Alexander.[6]

If you want grandeur, consider Dante, who – after he was exiled from Florence in the feuds of Guelfs and Ghibellines – dedicated his remaining years to writing the greatest literary work of medieval Christendom. The *Divine Comedy* is a journey through the entire cosmos, from the pit of Hell (*Inferno*) up Mount Purgatory (*Purgatorio*) to the ethereal space of Heaven itself (*Paradiso*). Yet at the same time it is a passionate imaginary journey through Tuscany, a series of encounters with the shades of Florentines and their neighbours. The universe is infinite yet local. The most appalling story in the *Inferno* ends with an invective against Pisa. As they walk on the frozen lake of Cocytus, the pilgrim Dante and his guide, Virgil, see a damned soul chewing at another sinner's head. He explains that in life he was Count Ugolino, and the flesh he mauls for all eternity is that of Archbishop Roger, who had him and his sons sealed in a dungeon with no food at the bottom of a tower in Pisa. Seeing the pain on his face, his children begged him to eat them; as they starved to death, he went blind with hunger until in the end he was fumbling among their corpses, calling out to them desperately. Finally 'Hunger overpowered grief'.[7]

The story of Ugolino, depicted in art by Carpeaux, Blake and Rodin, has proven to be a timeless and universal image of suffering – and of the passion for vengeance. Far from ending in a plea for universal mercy and tolerance, Dante, a medieval Florentine to his bones, calls for the extermination of a city that can permit such crimes:

> Ah! Pisa, shame of the peoples
> of the beautiful land where *sì* sounds out,
> because your neighbours are slow to punish you
> let Capraia and Gorgona move!
> Let them block the Arno and let it flood
> and let every person in you drown.[8]

The hatreds of Tuscans were big enough to fill a region a hundred times larger. Capraia and Gorgona are islands off the shore of Tuscany; so deep was his loathing for Pisa that one of Europe's supreme poets lavished his imagination on a local apocalypse just for the Pisans.

If only something as fast and final could have ended the current war. Contemplate the wretched events of one summer. In May 1503 Gianpaglo Baglioni, the mercenary captain hired by Florence, paraded with forty mounted knights in the Piazza della Signoria before riding to Pisa. Foot soldiers were mustered and the poor were hired as despoilers, to go into the Pisan country-side and destroy crops. Later in the month, sixty of these agri-cultural vandals were crushed in an accident – or perhaps it was a Pisan trap. With their crops ruined and French troops arriving to help Florence, it looked bad for Pisa. In June Florentine soldiers seized the fortress of La Verrucola near the Arno, considered strategically valuable. A Pisan counterattack was repulsed – but then Florence had to take troops from its western front to hold down Arezzo, where it was rumoured the feared warrior-prince Cesare Borgia might shortly turn up. And that was pretty much it for the campaigning season that year. Perhaps 1504 would prove more conclusive.[9]

Small armies, punitive raids, attacks on crops – it was a war fought half-heartedly, its cruelties chaotic. During that summer of 1503, before the end of the campaigning season, and just a few months prior to getting his commission to paint in the Great Council Hall, Leonardo was advising on a ruthless stratagem that just might bring the Pisan conflict to a conclusion.

* * *

Leonardo was at Cascina, a little town beside the Arno. Its bed was broad and dry, pockmarked with stones around which olive-green water eddied in the summer heat. Pisa was just a few hours' ride downstream. He looked across the river at the lovely

mountains hanging in the blue sky, and drew the vista in a few spontaneous strokes of chalk.[10] He had grown up in these hills and he loved them. On one of the topographical sketches he made in Madrid Codex II, the notebook he carried with him on that horseback journey, he was even able to mark his birthplace, Vinci.[11]

The British landscape painter John Constable said his art had been formed by the scenes of his boyhood. Leonardo's boyhood scenes had helped to make him a poet of landscape. His very earliest dated drawing, today in the Uffizi Gallery in Florence, is also the earliest dated study of a landscape in Western art: done on 5 August 1473, it depicts a view from the hills around Vinci, looking down on the Arno plain towards Pisa and the empty brightness of the Mediterranean. At least that view is Leonardo's starting point – what he actually creates in this ink drawing is a fantasia of rocks and rounded slopes, vast craggy overhangs, sheer precipices and organic nodules of earth, an idyll in which you can feel the warmth of the summer air. Exactly thirty years later – one of the maps in his notebook is dated 22 July 1503, three months before he received his commission to paint the great battle scene[12] – he found himself back in the countryside where he'd grown up, once more sketching that summer landscape with its river heading for the sea beneath hills crested with towers and towns. But this was no innocent nostalgic holiday.

He was riding along the river sketching views of its environs, marking the positions of towns, not as preparation for a painting – although you can't help wondering if the journey through the Arno Valley fed into the watery, rocky vista behind the *Mona Lisa* – but as a mapmaker and engineer. The roughly sketched map dated 22 July 1503 shows the course of the river from Pisa eastward, including Cascina and the fortress La Verrucola. More maps in the same notebook, polished and coloured, show the river, its tributaries and canal routes in refined detail. He is making a careful study of this river, of what might be done with it. On the 22 July map he has written, 'Levelling of the Arno'.[13]

Not even Leonardo da Vinci claimed to have the technology to shift Capraia and Gorgona and block the river to drown all Pisans. Dante's murderous vision was, however, made almost plausible by the real menace of the Arno. A fast river rising from mountain torrents, it regularly burst its banks. Even in modern times, flooding has devastated Florence – works of art damaged in the floods of 1966 were still being restored in the twenty-first century.[14] If the river could do such harm without warning, on its own, what if it were harnessed? Might not some revised version of Dante's scenario help win the Pisan war?

A plan was concocted in 1503 to divert the Arno *away* from Pisa, depriving it of its life-giving connection with the sea. Piero Soderini and Niccolò Machiavelli were its most enthusiastic proponents;[15] Machiavelli thought it a creative stratagem that might break the wretched deadlock. In 1502, he and Leonardo were both at the court of the notorious Cesare Borgia. Chances are it was here that these two provocative thinkers met; if so, it may have been his acquaintance with the Second Chancellor that led to Leonardo's involvement in the plan.

The Pisan war demanded some kind of bold action. Machiavelli, a specialist in boldness, advocated changing the course of the river. Did he get the idea from conversations with Leonardo? It's a seductive possibility, yet Leonardo doesn't ever seem to have been the chief engineer on the project, which surely he might have been if the idea was his. Machiavelli had good cause to know he was a skilled engineer as well as an artist – for Borgia employed him as such, and Machiavelli revered Borgia. It is known that they were both with Borgia at Imola in central Italy in 1502, although no correspondence or notebook entry proves they even spoke to one another there. Why, if they were friends (as many would love to believe), would Machiavelli not have given Leonardo responsibility for the project? On such awkward questions any simplistic belief that Leonardo and Machiavelli collaborated to divert the river founders.[16] The relationship between Leonardo and reality is never

as straightforward as that. But his notes make it hard to resist the conclusion that he played an important part in devising the scheme. Madrid Codex II explicitly mentions 'levelling' the Arno, as we have seen.[17] The notebook reveals him considering options, moving meditatively through the landscape, studying the river, proposing the best places to dig a diversion.

Leonardo's drawings of riverbeds done in 1503 and 1504 are never only technical solutions to an immediate problem. Practice may be the soldiery, but theory is the captain. In a series of sketches in the Codex Arundel he appears to be trying to work out how to change the course of a river using rocks: 'It is possible to change the flow of a small river with a big stone.'[18] His drawings of boulders piled onto a riverbed and changing the flow of water might look like studies for the Arno diversion. Yet they are scientific experiments. In a proposed book on water he planned to have a section about 'obstacles'. It's the simplest experiment you can do in a shallow river – place rocks in it and see what the little dam does to its flow. A game a child might play – that Leonardo himself might have played when he was growing up near the Arno. The bed of the river in summer is broad and there are rocky shoals. Clambering on these, picking up rocks and testing how obstructions made waves and ripples and weirs around themselves, was Leonardo's idea of science. It was a beautiful idea.

He made a rough map showing the river's approach to Pisa, marking Cascina and other towns and forts, at the front of Madrid Codex II. As he travelled along the Arno he drew views and made quick maps of the towns and the river's course. And he drew two hypothetical diversions. He had a grand idea for a shipping canal that would divert the river from just west of Florence in a great geometric curve through northern Tuscany, giving the Republic a navigable route to the sea. On one of the maps in Madrid Codex II and a sheet in the Royal Collection he carefully charts this canal.[19] By contrast, his ideas for the Pisa diversion are marked much more abruptly on these two maps in rapid, rough strokes

showing how channels could be dug from the river between Cascina and Pisa towards the Stagno, a large pool to the south. This is in fact broadly the plan that would be finally attempted by hydraulic engineers working for the Florentine Republic in the autumn of 1504.

Which suggests that Leonardo's mapping of the Arno in July 1503 did indeed play a significant part in planning the madcap scheme to win a war with water. His theory would be put into practice by others the following year. But there is more. In that summer of 1503 he made another map in Madrid Codex II that concentrates exclusively on the Arno and its canals in the vicinity of Pisa.[20] This map is concerned with what interested the Florentine army – the waterways around the enemy city. It is finished and coloured, and Leonardo has written placenames in conventional left-to-right script, rather than using his secretive mirror script. It is intended to be shown to others; it is part of a discussion. On it he has sketched a new canal that could be dug from just west of Cascina to connect the Arno with the Stagno. What could the purpose of such a canal be, if not to divert the river?

This map shows how badly Pisa's life could be disrupted by a diversion, describing the network of canals and pools around the city, all of which would be damaged if the Arno changed its course. On his rough sketch map on folio 1 verso of the Madrid notebook, the one that's dated 22 July 1503, he also focuses on the Pisa region – this is where he is 'levelling' the Arno. The placenames that keep reappearing in the topographical sketches in Madrid Codex II are of fortresses and towns close to Pisa where he was looking in detail at the lie of the land and the flow of the river: Caprona, Veruccola, Dolorosa, Cascina. In other drawings, the river looks like a bloody cluster of arteries, its bed mapped in soft red chalk. A map in the Royal Library, Windsor, is a great shadowy organic veil, the river like a serpent sloughing its skin.

These drawings are at once real and dreamlike – if Florence truly did rely on them as advice, it was allowing itself to be lured

into a borderland between the possible and the impossible, history and utopia. The plan to divert the Arno was a Faustian fantasy of limitless power over nature – no true marriage of science and politics, instead a dangerous liaison.

The rich and evocative portrait Madrid Codex II paints of a summer mapping the Arno lends enormous weight to the idea that Leonardo did indeed give Florence crucial advice about diverting the river. It fleshes out the record in the Archivio di Stato that in July 1503 the Florentine Republic paid him 'to level the Arno near Pisa',[21] and even contains clues to conversations between him and Machiavelli. His topographic drawings in this notebook are at once practical mapmaking research and beautiful landscapes. He stood at Cascina, drawing what his note calls the '*veduta*', the view. Cascina is a low-lying town, and his drawing looks up from this spot towards nearby hills. In the dedication of *The Prince*, as if remembering Leonardo that summer, Machiavelli reaches for an artistic image: it may seem presumptuous for a lowly man like him to offer a ruler advice, but 'it is as if one who wants to draw countrysides puts himself down on the plain to consider the nature of mountains and high places and, to consider the low places, will put himself on the mountains . . .'[22] There were not many artists in early sixteenth-century Italy who went drawing in the countryside – Leonardo was ahead of his time in his enjoyment of landscape for its own sake.

On 24 July 1503 one Francisco Ghuiducci wrote a report from the Florentine military camp near Pisa – '*Ex castris*' – informing the Palazzo della Signoria about a visit by Leonardo da Vinci and other wise heads. They looked at drawings and plans and, 'with many discussions and doubts', approved the work 'whether the Arno was turned here, or remained in a canal . . .'[23] Ghuiducci signs his letter 'from the field against Pisa' – it is a dispatch from the front line. That is where Leonardo was, close to the walls of the enemy city behind which children were going hungry and old people and paupers dying off, in the misery of siege.

* * *

There are more ways than one to fight a war. Leonardo was clearly involved in planning the Arno stratagem in the summer of 1503. The Florentine Republic did not, however, put the venture in his charge when it was finally attempted more than a year later. Instead it commissioned him in October 1503, within months of his Arno journey, to decorate the Great Council Hall. His patriotic battle scene would inspire the assembled citizens to vote taxes to pay for the Arno diversion and any other measures that Soderini and his military expert Machiavelli judged necessary. What is crucial to understand is that when Leonardo started to design his battle picture that autumn, war was not an abstraction for him. It was urgent and immediate. He had been in the countryside where Florence was fighting Pisa, had mapped the river close to where peasants were ruining crops and being ambushed. He knew the reality of warfare – a reality that even before this he had described with dreamlike precision in a note on how to paint a battle: 'Make first the smoke of the artillery, mixed in the air with dust thrown up by the movements of horses and combatants . . . And if you make anyone who has fallen, mark the place where he has slipped and been dragged through the dust and bloody mud, and in the half-liquefied earth show the impression of the footprints of men and horses who have passed, make also a horse trailing his dead master, and show the mark of the dragged body in the dust and mud . . .'[24] Leonardo's scientific attempt to analyse smoke and describe the effects of gunfire from the point of view of a painter gives way to a sickening scene. He dwells on the morass of battle, the mashing of everything into a landscape of pulped flesh. It's the same nightmare battle we see in the three compositional drawings for *The Battle of Anghiari* in Venice: the world become a bloodstain.

THE GENIUS IN HIS STUDY

Michelangelo's earliest surviving lines of verse can be found on drawings connected with the Great Council Hall competition. One is especially enigmatic: '*dolce stanza nell' inferno*' – 'a sweet room in hell'. It is sharply inscribed in ink on a small square sheet of paper, above a sketch of a bloody battle scene.[1] In the battle, mounted knights charge one another with lances, men on the ground fall or struggle against the horses, and at the heart of the chaos a horseman raises his sword or club above his head preparing to bring it down mercilessly on one of the riders' arms as he struggles with a lance.

The scene is strangely familiar, if you have been looking at Leonardo da Vinci's designs for *The Battle of Anghiari*.

* * *

Michelangelo's commission for the Great Council Hall directly confronted the never-ending war with Pisa. In 1364 the Florentine Republic had also been at war with the nearby rival city. In his *History of Florence* – the book that was Michelangelo's source – Leonardo Bruni tells how, late in that summer campaigning season, a Florentine army was camped at Cascina:

> The summer heat was immense, and many of the soldiers were weaponless or lying in their tents or bathing in the nearby river. At this time there was no care or anxiety about the enemy. Then unexpectedly the enemy rushed the fortifications, hoping with its

first impetus to overcome the camp and subdue unarmed men caught at leisure . . . When the Florentines had thronged together from everywhere . . . they were not content to merely defend the fortifications, but bursting forth fell upon the enemy, compelling him to take flight.[2]

Michelangelo's early designs for *The Battle of Cascina* are visibly influenced by Leonardo da Vinci's battle drawings

The enemy that day was led by Sir John Hawkwood, the English mercenary who later worked for Florence and got his equestrian portrait posthumously painted in the Cathedral. He was not a foe to be taken lightly. Yet the Florentines recovered the advantage and won the day.

This is one version of the story. The chronicler Villani tells it differently: according to him, the army were not surprised by Hawkwood, but tested by one of their own captains who gave a false alarm to save them from their torpor.

Michelangelo's first designs for his battle scene do not rise to the possibilities of this story. They are derivative. He had evidently

seen Leonardo's explosive sketches – and they had impressed him, almost too much.

Michelangelo had never been near a battlefield. His drawings of rampaging horsemen and frenetic close combat seem – brilliantly – cerebral; studies of weight, movement, but with very little heart. It's not him, this theme. He won't win the competition by aping Leonardo. It seems fitting that a poem – his first – on the reverse of his little square battle scene expresses anxiety about the fragility of reputation:

> After living happily for many years, in one
> oh-so-brief hour you lament and suffer;
> or someone who fame or ancient lineage
> illuminates, is darkened in a moment.
> There is no moving thing under the sun
> death does not conquer or fortune change.[3]

One question this and related drawings – including a still more manifestly Leonardesque battle in the Ashmolean Museum, Oxford[4] – invite is how he knew his rival's work so closely. Either he or a spy must have visited the amazing workshop Leonardo da Vinci created for himself in a Florentine monastery.

* * *

On 24 October 1503 Leonardo picked up the keys to the Sala del Papa and other rooms off the Great Cloister of the Dominican monastery and church of Santa Maria Novella.[5] This was where he was to live at the expense of the state while he worked on his cartoon for the Hall in the Palace. It was here that, a year later, he would store the clothes listed in his inventory as being 'in a chest at the monastery'. And it was from here that he had to walk every time he needed to visit the Palazzo della Signoria, to collect his monthly pay, ask for funds for paper or wood and carpenters to build the machinery he said he needed, or explain why the

entire project was proceeding more slowly than his employers would have liked. The marble façade of Santa Maria Novella overlooked a broad piazza in the north-western part of the city close to the gardens and palace of the wealthy Ruccellai family. The Ruccellai in the fifteenth century had favoured the gifted architect and polymath Leon Battista Alberti, a true Renaissance man who had anticipated Leonardo in his intellectual appetite – writing books on painting, politics and family life as well as designing imaginative reinterpretations of ancient Roman buildings. In the 1450s Giovanni Ruccellai, who was at that time with Cosimo de' Medici one of the two richest men in Europe, commissioned Alberti to design his house: its use of flat pilasters evenly spaced reproduces a particularly graceful antique effect yet makes it slightly surreal. At nearby Santa Maria Novella, the same architect created – with Ruccellai's money – a great vertical plinth of green and white marble with scrolls on its curved upper storey like engravings lifted out of the frontispiece of a book. This façade is the most classical of any church in Florence; walking towards it you feel you're about to enter a Roman temple or perhaps a library.

It's a deception. Alberti's modern façade was added on to a medieval church with a tall, simple Gothic nave, a great barn of a place that originated in the struggles between orthodoxy and heresy that had gripped thirteenth-century Europe. It was built by the preaching order founded by St Dominic to combat the Cathars and other religious subversives. Dominic, martyred in a revenge attack by heretics, was a hero of Catholic orthodoxy and Santa Maria Novella the outpost of the papal curia – the pope's court – in medieval Florence. When the pope visited the city in days gone by, he had stayed here. On the west side of the church stood a complex of monastic cells, big meeting and dining halls, and comfortable guest chambers built around two square cloistered courtyards. The Sala del Papa and its connecting rooms where Leonardo was now to be based were – as the name implies – built for the pope's use, but by 1503 there were far more salubrious

residences where Florence could put up important guests. The Sala del Papa had been allowed to decay. The first thing Leonardo did when he saw it was to ask for carpenters to mend the leaky roof. The repairs started before Christmas 1503 and were still going on in January, so the rooms allotted to Leonardo must have been in a shoddy state.[6]

At least it was peaceful. The monastic atmosphere of the cloisters with their square gardens and shady walks provided space in which to think. Leonardo loved places like this; it was reminiscent of Santa Maria delle Grazie, where he'd spent so much time slowly painting the *Last Supper*. His workplace was situated off the Great Cloister. The nearby Green Cloister was decorated with green-tinted paintings by Paolo Uccello, including his powerful *Deluge*, with doomed sinners still fighting one another viciously as they cling to bits of flotsam beneath the floating fortress of Noah's Ark. As for the church itself, it was a veritable museum of Florentine painting, with chapels and side altars decorated by painters including Masaccio, Ghirlandaio and Filippino Lippi (who had only recently, in 1502, completed his paintings in its magnificent Strozzi Chapel).

What would Leonardo's new studio have looked like? It's a fair guess it would have held a lot of books and papers. As workmen repaired the roof of the Gothic Sala del Papa, it wasn't just painting materials that Leonardo was preparing to install there.

* * *

The massive leather volume lies on a table in the Royal Library, Windsor. Its huge folio cover is worn and reddened. When you open it up there is nothing – this is an empty book, an eviscerated tome. The drawings and written notes it once held have in modern times been carefully removed and each precisely catalogued sheet sealed in plastic to preserve the fragile blue and pink papers.

When we speak of 'Leonardo da Vinci's notebooks', we are

referring to actual, physical objects of fragile antiquity. This particular great album was assembled in Milan in the sixteenth century, found its way to Spain and ended up by the close of the seventeenth century (by a mysterious route) in the British Royal Collection. It contained a raw collection of Leonardo's notes assembled after his death from papers he left to his pupil and friend the Milanese nobleman Francesco Melzi; another vast collection assembled in the same way is the Codex Atlanticus in the Ambrosiana Library in Milan. Often 'Leonardo's notebooks' means these vast collections of diverse sheets and fragments. But sometimes a 'notebook' means a notebook that Leonardo used as such and that survives as it looked when he owned it – from the novel-sized Manuscript B in the Institut de France, Paris, to the pocket-sized Codex Forster II in London's Victoria and Albert Museum.

Leonardo da Vinci's notebooks contain everything from lists of books and clothes, instructions to young painters, drafts of letters and household accounts to drawings of grotesque faces, maps of Italy and science fiction stories. They are the direct, unedited transcription of one person's thoughts: the mind of Leonardo moves in his notebooks from one interest to another, one level of reality to another – the most refined philosophical questions appear side by side with the most prosaic matters. Many of his sheets contain a diversity of themes and speculations, and when a written note appears beside a drawing it does not necessarily mean the two are connected. A diatribe against cannibals might be next to a drawing of the human heart.[7] Leonardo's words and images together – the words in a reversed script to be read with the aid of a mirror – constitute a unique form of art, as well as an intellectual marvel. When Vasari wrote his *Lives* he reported on the astonishing notes he had seen in the house of Leonardo's heir Melzi: '[A]nd he cherishes them and looks after them like relics, along with the portrait of the happily remembered Leonardo, and to those who read these writings, it appears impossible that that divine spirit

reasoned so well of art, and of the muscles, and the nerves, and the veins; and with such diligence of all things'.[8]

The wonder that Leonardo's notes inspire has not diminished in 500 years. From being pure enigma, however, they have been gradually transcribed, translated and published. The first attempt to put them in order was by Melzi himself, who collated the master's writings about art into a manuscript 'Treatise on Painting', printed in French in 1651 and in English in the Napoleonic age.[9] The trouble with such attempts to edit Leonardo's notes into a coherent 'book', however, is that even though he did *plan* to write books, he never did in fact, and to remove the mess and chaos of his notebook pages is also to remove the dizzying energy and mystery of his mind's convolutions. In 1883 Jean-Paul Richter transcribed and edited the first modern edition of Leonardo's writings, *The Literary Works of Leonardo da Vinci*, which gets far closer to the sprawling complexity of Leonardo's thought.[10] Since then, his notebooks have been quarried not so much for artistic advice as for marvellous inventions and science. Here too there's a danger of rationalising away their magic, for Leonardo got no closer to complete scientific theories than he did to finished works of art. It is the process, the journey, that mattered to him as both artist and scientist, and the pleasure of following his mind is that of exploring a meandering river's unexpected course.

* * *

He was a self-taught intellectual who took a big book collection with him wherever he went. The same notebook that contains the inventory of the clothing he put into storage when he left Florence in the autumn of 1504 also lists the books he left behind. They ranged from a volume about palmistry to a treatise on architecture by Alberti; works of natural science including the ancient Greek geographer Ptolemy's *Cosmography*, a work by the Arab astronomer Albumasar and Pliny's *Natural History*; and mathematical works including basic arithmetic primers as well as Euclid. As

with maths, so with literature; Leonardo's curiosity was never held
back by snobbery or pretension. Just as he collected school-level
maths books to help him with his calculations, he owned basic
grammars and comic verse, including Sebastian Brant's *Ship of
Fools* (1494), yet he also possessed three volumes of Livy's *History
of Rome*.[11]

Many of these books had been in Leonardo's collection for years
and are recorded in an earlier inventory; others were new. Who
knows, perhaps he found some of the saints' lives that are fairly
numerous in the 1504 inventory lying around the monastery and
quietly added them to his hoard.[12] All his books were for use rather
than ostentation. His own copy of one of the items listed in this
inventory survives: the manuscript of his friend the Sienese archi-
tect Francesco di Giorgio's treatise on architecture in the Laurentian
Library, Florence, still has the annotations that Leonardo made in
it.[13] They show how, when he read, he made notes, singled out
useful ideas and images. In fact he often transcribed what he read
into his own manuscripts. The 1504 inventory shows he still had
his copy of Valturio's compendium of miltary inventions *De re mili-
tari* with him in Florence; in his notebooks from his time in Milan
in the 1480s he'd copied out many of this book's descriptions of
ancient war machines and drawn his own improved versions of
them.[14] Reading was not a leisure activity for Leonardo – it was
part of the process of creative thought.

That shows in the compendiousness of his reading materials.
Fifteenth-century Florence had seen an intellectual revolution.
Humanism (as later historians named it) was a movement to revive
and properly translate the works of ancient Greek and Roman
authors. Yet Humanism was by definition led by an elite that wrote
in Latin. Leonardo da Vinci did not belong to that elite. He did
not have a university education. As an adult he taught himself
some Latin – his primers are there in the inventory – but most of
his reading was in Italian. And he did not in any way regulate it
according to the hierarchies a Humanist might follow; classic

literature had to share shelf space with trash. There are some key Florentine Humanist works in his 1504 list:[15] Ficino's interpretation of Plato and the Hermetic tradition, *On the Immortality of the Soul*; Matteo Palmieri's *On the Civil Life*; and Alberti's writings. There are translations of the classics, too – including Ovid's *Metamorphoses*, the great source of ancient mythology in which Renaissance artists found stories like the fall of Icarus, the loves of Jupiter, and the battle of the Lapiths and Centaurs.

But the classics rub up against a wild mixture of themes and authors. Leonardo is as happy with a book on palmistry – *De Chiromantia* – as with the medieval *Philosophy* of Albertus Magnus, as fascinated by Aesop's *Fables* – of which he stored three editions, one in prose, one in verse and one in French – as he is keen to study medical works such as *Guidone on Surgery* and *Montagnana on Urine*. He reads to learn about the world and that means books about herbs and hydraulics, the works of Aristotle and a peculiar attack on women called *The Mangle*. Books by his friends Francesco di Giorgio and Luca Pacioli bear witness to the fact that, far from brooding in solitude, he was a social person whose ideas were freely shared with others – as were his books. He lists a couple in his inventory that were on loan to acquaintances; notes scattered through his papers reveal him constantly borrowing and lending books. He always seemed to be looking for books by Archimedes, yet this reverence for an antique author does not make him a classically fixated Humanist. On the contrary, in one of his notes on Archimedes' war machines he plucks this scientist from ancient Greece and dumps him in medieval Spain: 'I have found in the Histories of the Spaniards that in their wars with the English was Archimedes of Syracuse who at that time resided in the company of Ecliderides, king of the Cirodastri . . .'[16] This sounds like something Leonardo might have read in a chivalric romance. In the same notebook that contains his book inventory, on a map of the Pisa region he mentions (in the summer of 1503) the 'castles of Cascina' in an apparent reference to a popular romance called *Amadis of Gaul*.[17] In some

ways Leonardo's reading of poetry and history was not that different from the popular literacy of Don Quixote.

Books were raw material for the notebooks he kept filling in such profusion. In the chest in 1504 he stored some of his own codices: a book of war machines with a skull on its cover and one of designs for the armature of the bronze horse.[18] Other notebooks would have gone with him on his travels – including, obviously, Madrid Codex II. In these years he also was adding to Codex Arundel and producing notes that ended up in Codex Atlanticus in Milan and in the Royal Library, Windsor. In other words, when he lived at the monastery in Florence he was producing notes and drawings with giddy creativity. His varied collection of books helped stimulate a heightened fluency of thinking that might take him in one of a multitude of directions at any moment.

If you look at his notes from around 1504 you get some inkling of the vast range of his interests at the time he took on the commission for the Great Council Hall. He was thinking about canals, water music, waves, mythology, artillery, fortifications, the wind and, above all, pure mathematics. Any one of these topics might engross him for hours, for a day, in the rooms off the Great Cloister at Santa Maria Novella. To call these topics 'distractions' is inaccurate because the life his notebooks reveal is one long distraction.

Even setting up his workshop provided days of fun. In February 1504 a labourer was paid for making a doorway to give Leonardo direct access to the Sala del Papa, where he was drawing his cartoon, from his *camera*, his living chamber.[19] Surely this *camera* was also a study. Renaissance artists were drawn to the image of the intellectual at work in a well-appointed study. Their paintings breathe a romance of books and paper. Fathers of the Church are portrayed at work in monastic spaces – that is, in settings that are idealised versions of the Florentine cloister where Leonardo based himself from October 1503 onwards. In Antonello da Messina's painting *Saint Jerome in His Study*, the scholar works in a fabulously well-designed wooden cubicle inside a monastery. He has every-

thing he needs: a lectern for reading, a comfortable circular chair, convenient shelves on which his books are propped open to the right page so he can consult them with minimum fuss, even a couple of potted plants. The Gothic cloister is airy around and above his open study so he gets both privacy and space.

In reality, Leonardo's rooms at Santa Maria Novella centred on a semi-derelict old hall whose roof urgently needed to be mended – but he would certainly have striven to make his cloistered environment as comfortable as St Jerome's. In his writings on the painter's beautiful life – he pictures himself working in fine clothes, gently touching a picture with the lightest of brushes, while musicians play for him or poetry is read out to him – Leonardo devises a living-machine as fine-tuned as Jerome's: '. . . a chest, where it is possible to raise and lower the work, so the work moves up and down and not the master; and every evening you can let down the work and shut it up on top, so that in the evening it may function as a chest which when closed makes a bench'.[20] This is his personal device for making work easier, an artist's version of the ergonomic furnishings that appear in Renaissance images of studies. One type of Florentine chair was even named after the prophet Savonarola, who was said to have invented it for use in his study at the convent of San Marco: woodcuts in the prophet's books portray him working with a lectern as cleverly designed as the one painted by Antonello. Leonardo, of course, was not a conventional scholar: he was an artist who worked with ideas, and what he needed was to be able to draw efficiently. His chest on which the work could be lowered up and down was adapted to his lifestyle.

Leonardo lived up to the image of the Renaissance man, the universal mind, portrayed in paintings like Antonello's. One of the greatest of these images is Botticelli's *Saint Augustine in His Study*, done on a wall in the church of Ognissanti in Florence in about 1480. It dates from the moment when Leonardo was starting to reveal himself as a thinker as well as an artist. Botticelli was his contemporary and rival, and in his vision of St Augustine's study

he portrays a life of the mind as free-ranging as the one Leonardo was embarking upon as he designed his *Adoration of the Magi*. In Botticelli's painting, the Father of the Church is no narrow theologian. Behind his workstation with its intricate lectern that doubles as a chest of drawers (a nearly identical one appears in a woodcut of Savonarola's study),[21] Augustine has an astronomical globe and a clock, books in fine bindings – and, intriguingly, an opened codex covered with handwriting and geometrical drawings.

It looks teasingly similar to some of Leonardo's notebooks. At the very least this shows the idea of intellectual life to which Leonardo aspired: a world of mathematical speculation and mysterious 'secrets' in great handwritten volumes. At a pinch, who knows – it could even be an allusion to his own first attempts at making notes (though no notebooks survive from his early years in Florence). Not only did he know Botticelli, but this painting was commissioned by the Vespucci family for their local church, and Leonardo was friends with the Vespucci, including of course Agostino, who in the 1500s worked in the government Palace. 'Il Vespuccio wishes to give me a book on geometry,' Leonardo reminded himself in a note.[22]

Leonardo may have had books like St Augustine's, but he was no saint. He did not live a life of asceticism. The rooms at Santa Maria Novella would have been filled with all sorts of stuff – including his luxurious velvet and satin garments. He was constantly collecting and then giving away or selling odd things, to use in experiments or for art or just for pleasure. Stray notes give glimpses of a chaotic material life:

tapestry
compasses
Tommaso's book
Giovanni Benci's book
box in the Dogana
to cut the cloth

the sword-belt
to resole the little boots
a light hat
the canes from the ruined houses
the debt for the tablecloth
swimming bag
book of white paper for drawing
charcoals.[23]

Notes by other hands – probably his assistant Salaì's – among his sheets from about 1504 include shopping lists for meat, bread, wine – to feed not just Leonardo (who may already have been a vegetarian at this point, as he certainly was later) but his team. He had assistants and students with him at Santa Maria Novella. Salaì was the leader, always around except when he was off getting expensive clothes made. Leonardo also had a servant, Tommaso. In August 1504 'Jacopo the German' joined them, and in April 1505 a seventeen-year-old called Lorenzo. In between his ingenious thoughts Leonardo had to take care of his working family: 'The morning of St Peter's Day on the 29th day of June 1504 I took out 10 ducats, of which I gave one to my household servant Tommaso to spend.' 'On Monday morning one to Salaì . . .'[24] And Salaì writes:[25]

The morning of Santo Zenobio on the 29th day of May 1504, I had from Leonardo Vinci 15 gold ducats, and commenced to spend them.

to Mona Margarita	S 62 d 4
to repair the ring	S 19 d 8
clothes	S 13
good beef	S 4
eggs	S 6
owed at the bank	S 7
velvet	S 12
wine	S 6 d 4

meat	S 4
mulberries	S 2 d 4
mushrooms	S 3 d 4
salad	S 1
fruit	S 1 d 4
candles	S 3

The food wouldn't only have been for Leonardo and his associates. The gregarious artist would surely have had other people over to eat with him. The still life he painted of a meal laid out on metal plates on a neat blue-trimmed white cloth in the *Last Supper* suggests the kind of simple but good fare you'd have enjoyed at Leonardo's table.

* * *

Leonardo's life was not the background to his work, nor was science a diversion from art. His notebooks reveal no such distinctions. There was no hierarchy in his mind between designs for commissioned paintings and free-ranging speculations on whatever happened to interest him. This is at the heart of the story of the Great Council Hall competition. The simple fact is that Leonardo had many other things on his mind as well as the battle painting for the Republic. As far as the government of Florence was concerned, his job in 1504 was to make a painting for the People. In his own mind the painting was only one of several areas of activity, one winding road among infinite regions of thought.

I think he liked Santa Maria Novella. He liked it so much that he arranged to work there instead of in the Great Council Hall. For he chose to work in Florence in a way that differed from and yet also tried to recreate his previous experience of this kind of painting, when he created the *Last Supper*.

He had worked slowly and subtly while painting his Milanese mural, rejecting the traditional, tried and tested technique for painting on plaster, *buon fresco* – which means painting onto wet

plaster so the colours harden into the very surface and can endure
as long as it does – because fresco has to be painted in rapid bursts
before sections of plaster dry. Each section is called a 'day': the
technique defines the pace.[26] Leonardo instead painted on the dry
wall, slowly, delicately. The disastrous fate of the *Last Supper* is
owing to the meditative way in which he lingered over this
thoughtful work in its monastic setting.

The point is, the quiet of a monastic setting gave Leonardo
time and space to think. The Great Council Hall, on the other
hand, was a busy, secular, sometimes very crowded room at the
political heart of Florence. It was not possible to work in privacy
or calm there. In our attempts to understand the story of the
competition between Leonardo and Michelangelo, this simple fact
is easy to lose sight of. For an artist who insisted on a contempla-
tive style of life and thought, working in the Great Council Hall
was an unpleasant prospect. He was better off prolonging his time
at Santa Maria Novella. There, he could work peacefully.

There was a way to legitimise the decision. Leonardo transferred
the slow and meditative process that had created the *Last Supper* to
the drawing of a cartoon. He had already impressed Florence with
the one he had exhibited at the Annunziata. Now, he set to work
drawing a full-scale cartoon for *The Battle of Anghiari*. The contract
of May 1504 reveals that he was still working on this preliminary
design and planned to complete it before he even started to transfer
or copy it onto the wall.[27] His drawings had aroused wonder in
Florence at the start of the sixteenth century. Now he was forging
ahead with a truly gargantuan one, and before he even started work
in the Palace, his battle picture could be admired in the monastery.

Yet even the execution of the cartoon was not straightforward.
Before beginning it, he needed to do some research.

When Leonardo carefully stashed his books at the monastery, he
put with them a series of drawings he had done in 1503–4 from his
base at Santa Maria Novella. His inventory lists 'A book of horses,
sketched for the cartoon' ('*un libro di cavalli, schizati pel cartone*')[28] – an

entire notebook full of studies of horses that he considered essential
to designing his painting of a battle. After all the years in Milan
observing horses in the duke's stables and mapping their proportions
in order to design his bronze colossus, he still felt the need to make
fresh studies before he could draw the full-scale cartoon for his mural.

Leonardo obviously cared for horses and loved to look at them,
even to look after them – the 1504 inventory includes a book of
horse medicine[29] – but he also found in the horse a majestic natural
metaphor. All the forces of nature could be encapsulated in its elegant
yet potent form. A horse can look gentle and dangerous, expressive
and remote, tame and wild. In all his scientific work Leonardo
remained loyal to the medieval idea of microcosm and macrocosm.
In this traditional view of the cosmos, everything is a token of every-
thing else: the same elements that compose a human being compose
a tree, and unexpected analogies can be discerned by the knowl-
edgeable mind in things apparently quite different from one another.
In his most spectacular exposition of this belief, Leonardo reveals (in
a drawing done in the early 1490s) how the layers of fatty tissue and
bone in a bisected human head exactly match the layers of an onion.
The drawing depicts a halved onion next to a diagram of a head in
profile, and his note explains that just as you can see the inner rinds
of an onion laid bare when you halve it, so the bisection of a human
head reveals the outer hair and muscles, then the pericranium, the
cranium, the pia and dura mater, the rete mirabile and the bone.[30]

Brilliant as this anatomical observation is, it is also a statement
of a pre-modern, and by later scientific standards mystical, concep-
tion of nature. Leonardo expressed his belief in microcosm and
macrocosm theoretically: 'Man has been called by the ancients a
little world, and certainly the name is well given, for if a man is
made of earth, water, air and fire, so is this body of the earth; if
man has in him bones that hold up his flesh, so the rocks hold up
the earth; if man has in him a lake of blood, where the lungs
increase and decrease in breathing, the body of the earth has its
ocean which similarly rises and falls . . .'[31]

When he compared a bisected head with an onion, Leonardo was becoming increasingly acute in his studies of the human microcosm. His account of the layers of flesh and bone beneath the scalp follows on from a series of drawings of the human skull that he made in 1489: these are his first great anatomical studies, the beginning of what would become his most outstanding contribution to science. Drawn with a fantastic, steady strength and so sensitive to anatomical realities that they include details not observed by medically trained anatomists until centuries afterwards, these drawings are contemporary with the time when Leonardo was renewing his concentration on the bronze horse. It is not a coincidence. As he clarified his sense of human anatomy he waxed in confidence in his vision of the horse; instead of a rearing steed bearing a warrior, he advanced his idea, and built his model, for a majestic animal standing riderless, like a scientific model.

If humanity was a 'little world', the horse was something more: both a microcosm and, in its strength and power, an image of the macrocosm. The horse was big enough to bridge the gap between flesh and the abstract elements: it was the living personification of air, fire, earth and water. When the Florentine Republic commissioned Leonardo to paint a battle scene in the Great Council Hall, it unwittingly offered him an opportunity to return to a favourite theme. War was fought by men on horses,[32] and no battle scene could be contemplated without the spectacle of rearing, galloping, charging and falling steeds. They teem on the battle scenes carved on Roman military sarcophagi preserved in Pisa's Campo Santo cemetery, whose ancient remains many Florentine artists studied. One visitor, the sculptor Bertoldo di Giovanni, in about 1473 distilled the essence of these ancient battles in a bronze archetype of conflict: his battle relief, a free artistic exercise, includes waves of horses ploughing down barbarians. Leonardo now had a licence to make a brand-new scientific study of a creature that embodied his fascination with the natural world.

He embarked on a study of horses from life, scrutinising them

now not for their proportion and grace when they stood still, but for their display of energy and movement. His sketches for the cartoon went far beyond essential preparatory work. They constituted an entirely new project, an analysis of motion in horses that anticipated, by several centuries, the photographic motion studies of Eadweard Muybridge or the Impressionist racing pictures of Degas. The 'book of horses sketched for the cartoon' has long since been dismembered. Pages survive in the Royal Library, Windsor, however, that were undoubtedly made in preparation for *The Battle of Anghiari* and almost certainly come from the very notebook mentioned in the inventory. They are among the greatest evocations of movement in the entire history of art. They don't merely anticipate Muybridge and Impressionism, but Futurism into the bargain. Movement, something that had obsessed Leonardo ever since he had tried to draw the blur of a cat's squirming limbs, is here expounded as a theme with blood-red intensity.

Drawn in red chalk, very fast, from life, a horse is going wild, shaking its body with frenzied abandon as Leonardo dares himself to capture its changing form. Its rear legs, firmly planted on the earth, and its muscular rump possess a densely shaded solidity: this very solid, sculptural sense of mass gives the animal, which after all is just a flat chalk sketch a couple of inches tall, compelling reality. It is not simply that Leonardo finished this part of the drawing and then was forced to sketch the rest more quickly when the horse started to rear and rave. Rather, centuries in advance of the disjunctive multiple glances of Cubism, he drew the horse from two viewpoints, as if it were two creatures in one: while its rear half is impressively fixed and detailed, its front legs, head and neck – everything forward of its ribcage – shakes and shudders. It has three front legs clawing at the air, as Leonardo uses a deliberately grotesque device to record motion. Its twisting neck starts as a detailed study and becomes a tangle of tough lines and curves tracing its panicky movements. Its head, with a dark, round eye, is a whirl of curves and glimpsed nostrils, as fluid as a cloud of

electrons. In this drawing Leonardo goes beyond the fictions most art settles for: he recognises the mobility of nature, the fluency of life, and – this is what makes the drawing so profound – the limits of eye and brain in assimilating the true complexity of reality. It is almost as if the horse were a composite monster, a half-human centaur: in that doubleness, Leonardo reveals two ways of seeing anything, as matter and as energy. All this in a sketch of a horse.

Leonardo challenged himself to see and record things that are impossible for the naked eye to see and record – or are they? His drawings from the book of horses convey the power of speed not just suggestively but through his sincere attempt to record it: he was, manifestly, looking at actual horses and trying to put on paper their fleeting passage. In one small sketch in Windsor, on a torn sheet that surely must have come from the book of drawings left at the monastery, he is visibly trying to delineate a horse and rider as they whiz past him: and he does it magically, by abandoning detail and drawing a quick caricature of the animal's long head thrust forward like a torpedo, perfectly horizontal and streamlined, its mane seeming to pull back in a great arch of effort, the rider just a ghost on its back, its two front legs off the ground. Doubtless in embarking on his intense study of the horse in motion in 1503– 4 Leonardo was going beyond what any other artist might consider necessary preparation for a painting. Once again, as Freud might say, the 'investigator' in him was pre-empting the painter. But no one who looks at these sketches can believe he was wasting his time.

Michelangelo was daunted by all this. He not only imitated the frenzy of Leonardo's battle composition, but even tried to draw horses in the stable; an ink study of one in the Ashmolean Museum reveals him for once in his life flailing. It looks flat, un-anatomical and rigid, even without Leonardo's stupendous horses for comparison. But Michelangelo was learning fast. Soon he would liberate himself from the weight of emulation, discover what a battle might mean to him in his heart – and fight passion with passion.

Eight

NAKED TRUTH

The young men hang around talking, some of them sitting on the stone wall, others leaning against it nonchalantly. One of them playfully pulls away his companion's colourful robe so he will be as naked as everyone else. Tousle-haired and louchely muscular, the youths have nothing on at all apart from the decorative draperies slung over their arms like towels. That hint of bathers by the pool is not an anachronism. In about 1506 Michelangelo included this gang of five nude men disporting themselves in the background to his heroic circular picture *The Holy Family*. While a powerfully masculine Mary raises Christ aloft towards the bright, wise dome of his father Joseph's head and an infant John the Baptist in wild-animal fur looks up from behind a grey parapet, these relaxed nudes have no obvious reason to be chatting in the middle distance. They almost function as a signature of the artist, who was at that moment the revolutionary prophet of the nude. But naturally, interpreters interpret. Perhaps the nudes represent the pagan era that Christ's coming brought to an end.

Perhaps. But sometimes, even in a painting by Michelangelo, quotidian experience intrudes. These nudes look as if they are at the baths. The communal bathhouse was an important part of Renaissance life and had an obvious connection with the art of the nude. That connection was certainly not lost on Leonardo da Vinci. 'Go every Saturday to the baths where you will see naked men [*nudi*],'[1] he reminds himself. He doesn't specify that his reasons are artistic. A woodcut by Albrecht Dürer portrays a public bath

in a German city in the late 1490s: six undressed men stand and sit under a wooden canopy in the open air. Two lean against a stone wall reminiscent of the architecture in Michelangelo's painting, and indeed the entire scene is like a down-to-earth pendant to his group of nudes in his painting of the Holy Family often called, after the collector who commissioned it, the *Doni Tondo*. Dürer jokes on the relationship between this very real bathing scene and the ideal art of antiquity: a fat bather drinks from a huge German beer stein but also resembles Silenus, the foolish companion of Bacchus in classical myth, while two men play musical instruments like shepherds in Arcadia. Their fulsomely incised bodies exist between the real and the ideal, the naked and the nude. Dürer puts them in tiny thongs that unconvincingly hide their shame, but one of them just happens to stand behind a suggestive water tap.

Going to the baths was an important social ritual, a chance to speak with the powerful on terms of intimacy. Bertoldo di Giovanni, who supervised the artists at Lorenzo de' Medici's sculpture garden, got a chance both to see nudes and talk to his employer when he accompanied *Il Magnifico* to the baths.[2] Bathing establishments could be as elaborate in Renaissance Italy as in ancient Rome or the spas of the eighteenth century: in the Studiolo of Francesco de' Medici in Florence is Girolamo Machietti's painting of the baths at Pozzuoli, where numerous ailing men enjoy the naturally heated water of the volcanic Phlegrean Fields near Naples. Uniformed servants bring towels, the spa has a grand colonnaded loggia. In Machiavelli's play *Mandragola* the hero plots to meet the woman he's in love with at a spa, where anything might happen.[3]

Only the super-rich, on the other hand, could afford a private bathroom. Raphael designed a luxurious one for Cardinal Bibbiena in Rome, and one for his own house. These were rare sybarites. For most people going to the baths meant stripping naked in front of other men or women. In Florence you didn't even need to visit

the bathhouse to see men undress. In the panoramic fifteenth-century view of the city called the 'Chain Map', youths are fishing in the Arno in their trunks.

Naked bodies are naked bodies, then and now. The word *nude* has taken on pretensions over the centuries. Eighteenth-century connoisseurs sought to distinguish the nude in art from pornography, to stress its lofty intent.[4] But in early sixteenth-century Italy *nudo* simply meant 'naked'. When Michelangelo depicted a gathering of undressed youths apparently at the baths, he was daring people to point out this banal similarity. The fact that apparently no one did is proof of the extraordinary triumph of his vision in Florence in 1504: the triumph of the nude.

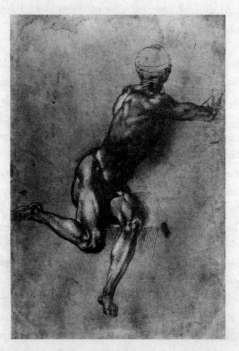

As Michelangelo planned his painting of *The Battle of Cascina* he decided to concentrate on his favourite subject – the male nude

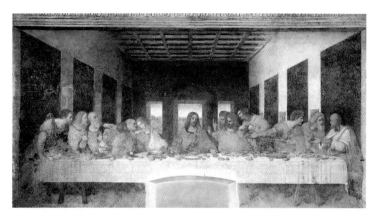

Leonardo da Vinci's wall painting *The Last Supper* started to decay the moment it was finished but the fame of this masterpiece in Milan helped goad Florence to commission its own mural, *The Battle of Anghiari*

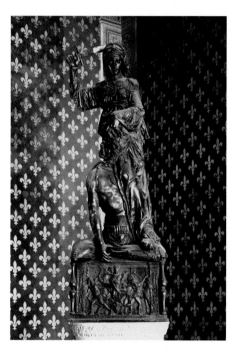

At the start of 1504 Donatello's *Judith* with its eerie image of 'the woman killing the man', as the First Herald of the Republic described it, stood guard outside the government Palace

Bacchus, the ancient pagan god of wine, is lost in ecstasy in Michelangelo's earliest surviving nude statue

This fragile little drawing in the Uffizi is Michelangelo's sketch for *The Battle of Cascina*. It gets us closer than any other relic to what contemporaries found so entrancing in Michelangelo's lost work

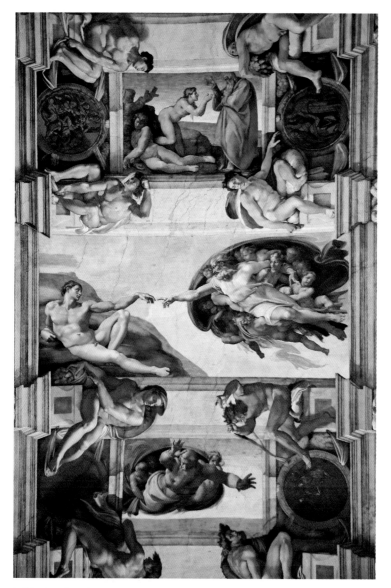

Michelangelo's victory in his competition with Leonardo paved the way for his greatest triumph, painting the Sistine ceiling

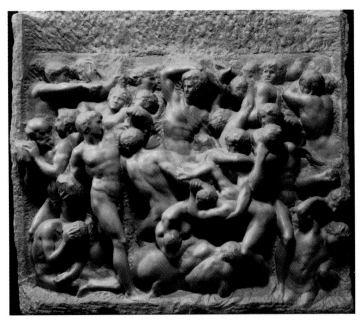

The themes of Michelangelo's *Battle of Cascina* are all there in his adolescent work *The Battle of the Centaurs*

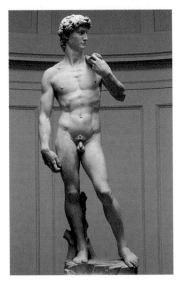

When he carved his *David* out of a damaged block of marble in the workshop of Florence's cathedral Michelangelo revealed what art can be

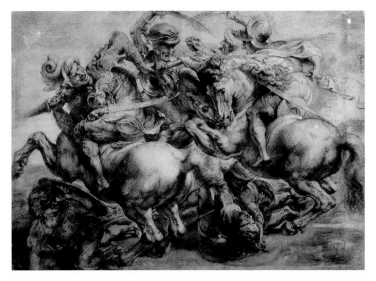

Leonardo's *Battle of Anghiari* is sympathetically reconstructed in this great drawing by Pieter Paul Rubens, who reworked an older copy

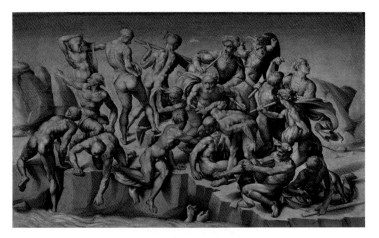

This painting by Battista da Sangallo is the most complete surviving copy of Michelangelo's *Battle of Cascina*

Leonardo's surviving sketches of *The Battle of Anghiari* already contain, in their tiny blot-like intensity, all the horror and violence eyewitnesses discerned in the full-scale picture

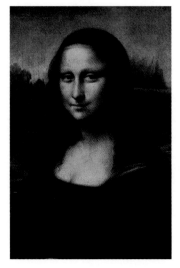

In Florence in 1503 Leonardo da Vinci started to paint the *Mona Lisa*. The instant fame of this portrait led to his commission to decorate the Great Council Hall

Leonardo da Vinci's design for a mortar attack on a besieged enemy probably depicts Pisa or one of its fortresses and is a contribution to the Florentine war to re-conquer this neighbouring city

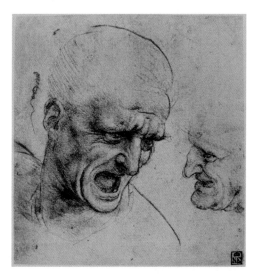

The deathly face of Niccolò Piccinino screaming with rage is Leonardo da Vinci's sinister pendant to his smiling *Mona Lisa*

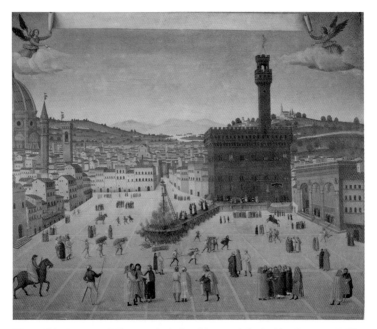

The political centre of Florence is depicted here as it looked in about 1500. The gothic fortified government palace – today's Palazzo Vecchio – dominates the pink Piazza della Signoria with the tall Loggia of the Signoria on the south side of the square. Donatello's *Judith* stands outside the Palace where Michelangelo's *David* was to replace her in 1504

A centaur depicted with uncanny naturalism is controlled by Minerva, goddess of wisdom, in one of Botticelli's crystalline visualisations of myth and magic

* * *

'. . . *chon ornamento decente*'. Leonardo's suggestion that before going on public exhibition Michelangelo's statue of David should be made modest was like pointing out that the emperor had no clothes. Michelangelo's statue stands alert and energetic, a work of tremendous and manifest importance: it communicates its seriousness so absolutely that to see its nudity as in any way carnal seems blasphemous. Leonardo's words are not prudish – they are lewd. For in pointing out the need for *ornamento decente* he was reducing the *David* to the one thing Michelangelo's art never seems to be: mere fleshy depiction. He was caricaturing the statue in words just as he caricatured it in his notebook drawing, where the statue becomes meaty and earthly: its heroic transcendence of the ordinary is refused. To display such a thing without covering its *membrum virile* was surely scandalous.

Michelangelo was getting away with something: breaking the rules of his society and being celebrated for his transgression. His outrage was a mirror of Leonardo's own, for which the older man had been persecuted.

The question of male nudity gets us to the most intimate layer of their relationship: close to the heart of the onion. Leonardo and Michelangelo had something intimate in common. Both had a strong sexual preference for men. In modern language they were gay – but of course there was no such terminology in their world. Without modern terms for homosexuality, is it an anachronism even to speak of such an experience? The history of private life is a history of images and words. Emotions, the most fleeting of human realities, can only be known through their cultural forms. This makes the sexualities of Leonardo and Michelangelo rather more interesting than if we simply said they were homosexual. It's much more singular than that. They themselves spoke openly about, and visually explored, desire, and the very different ways in which they did so reveal self-definition at the heart of their hatred.[5]

* * *

Michelangelo wanted to defeat Leonardo. At Santa Maria Novella the older man was painstakingly making an immense drawing. Michelangelo too prepared to make a cartoon. In October and through to Christmas, records of payments show that workmen were helping to paste together a gigantic sheet of paper for the young artist to draw on.

Taking on Leonardo in drawing was the most foolhardy thing Michelangelo had ever done. Drawing was the essence of Leonardo in the same way that sculpture was the essence of Michelangelo. If Michelangelo found himself when he picked up a chisel in Lorenzo de' Medici's garden, it was in his very first drawings – a landscape of the Arno, a head of a warrior, a child with a cat – that Leonardo revealed his uniqueness. No other fifteenth-century artist drew with his abandon and diversity, no one else so consummately put drawing at the very heart of his enterprise. Unifying all his interests, infinitely adaptable – a drawing can be anything from a tiny sketch to a vast finished cartoon, can be done in the workshop or in the street – it was Leonardo's true medium. And he revolutionised its techniques, pioneering a kind of free-form scribble to generate ideas and (beginning in the 1490s) to use exquisite red chalk to create supple, living shades, adding a new weapon to his graphic repertoire.

Michelangelo's early drawings are crisp, bold, cross-hatched designs, but nothing to compare with the incredible graphic output Leonardo preserved in his notebooks. It was by looking at the older artist's red chalk horses and rivers that the younger man, in 1504, suddenly discovered this sensual, evocative medium.[6] He still made ink and silverpoint drawings, whose power increased enormously as he quickly absorbed Leonardo's revolutionary lessons that drawing is an art in itself, and that the experience of making one can be as intense as the carving of stone. But he also made big, expansive sketches in chalk, in which he worked with tremendous freedom

and strength, all of a sudden a great, a stupendous draughtsman. Whatever he learned from Leonardo's technique – and he learned a lot, very quickly, from his rival in 1504 – it was not mere method that took Michelangelo in a few months to the same heights in drawing he'd already reached as a sculptor. It was the accuracy with which he recognised himself: the courage with which he decided to concentrate on the most personal subject matter at his command. It was the season of the nude. His giant *David* stood now at the heart of Florence, and if you ignored the ridiculous metal underpants, it was a defiant statement of the beauty and perfection of the human form – which for Michelangelo meant the body of a man. In preparing to draw his cartoon for the Great Council Hall he relentlessly took this as his theme: he threw himself passionately into drawing the male nude. Even the dignity of the *David* was to be outdone by the mountainous backs and twisting muscles he put on paper.

In sculpture, the nude male form was traditional. Even though it had been eclipsed in the Middle Ages, its revival was inevitable as soon as artists set out to rival the marble statues of antiquity. Michelangelo's *Bacchus* acknowledges the weirdness of this revival, the eeriness of digging up dead naked gods. In painting and engraving too, fifteenth-century artists emulated the nudes of ancient Greek and Roman sculpture. A youth with a physique like a statue's is tortured with crossbows in the Pollaiuolo brothers' painting of St Sebastian; in Botticelli's *Venus and Mars* the sleeping war god exhibits a classical nude form. But there is always in these works the excuse of revival, the mask of classicism: the nude is less a thing felt than a thing learned. A great exception is Donatello's bronze *David*, so dangerously erotic in its invitation to look. Michelangelo had already, by 1504, brought the Renaissance rediscovery of the classical nude to unprecedented heights of authenticity. His art is his alone and so are his nudes: quotations of classical statuary are beside the point. Every body sculpted by him becomes part of his meditation on the agony of the soul's

strange physical imprisonment. Every pose in his art is reimag-
ined. To say his encounter with nakedness was personal is a drab
understatement.

To draw the nude passionately is, however, something else again.
A drawing is an intimate study and an emotional experiment – at
least that is what Michelangelo learned it could be, from Leonardo.
His drawings for *The Battle of Cascina* depart from technical design
or studies of classical statuary. He is looking at young men naked,
drawing their bodies in the poses he asks them to assume. Anyone
who hadn't registered before that young Michelangelo was utterly
besotted with the bodies of men was certainly going to notice now.

The bathhouse is never far away from these drawings. One
youth drawn in brown ink and black chalk raises his right arm
and reaches with the left towards that underarm as if drying
himself; he is nude, facing the artist with casual elegance as he
turns as if to speak to a fellow-bather. He is not at the baths; there
is no cloth or brush in his hand; it is a pose Michelangelo has
required of him.[7] But there is an unnervingly private sense that it
is a pose he's seen, and wants the model to recreate – a pose he
finds desirable.

Another model is sitting down, twisting around to look behind
him. Again it seems this could be a pose Michelangelo has seen in
an instant at the baths and got this nude to hold, so he could draw
it in colossal detail: here ink is used sublimely, each dimple and
bulge of the superb flesh seen with an eye like steel. The youth is
proud and beautiful, and he looks away from Michelangelo: the
way the drawing is heightened with lead white makes his skin almost
shine in its perfection.[8] In the *Bacchus* the young Michelangelo imag-
ines ecstasy, in the *Pietà* death, with the *David* he faces the world:
in his drawings of nude bathers in 1504 he confesses desire.

* * *

Some people gamble, others set sail for new continents. The
compulsion to take risks is a mysterious part of what makes us

human. Michelangelo, as he approached the age of thirty, was in thrall to risk. It made him feel alive. It makes us feel alive, when we look at his art. We may not see his sculptures or his paintings or his drawings as in any way dangerous, only as marvellous, but the reason they feel so vital and real to the beholder has everything to do with daring: they are not anchored by any certainties at all, Michelangelo's works; they break free from the moorings of convention, artistic, spiritual, moral, and risk everything – risk death, of one kind or another – in their pursuit of new experience. He lives in his art because he lived through his art. Its unendingness is that of the way we experience the world.

In 1504 he was risking a new explicitness about the sexuality of his art even though there was no need to do so. In addition to the established model of the antique nude, there were other models, too. It was in Christian images that nudity first returned to medieval art. In the Baptistery of Pisa, in the thirteenth century, Nicola Pisano sculpted Daniel as a nude. Michelangelo's sense of the body is Christian as well as classical.[9] In 1504, as he was experimenting with the red chalk he'd seen Leonardo use, he went back to one of his oldest Florentine haunts, the Brancacci Chapel. Here, in the early fifteenth century, the austerely gifted young Masaccio had painted a cycle of religious histories that both Michelangelo and Leonardo revered. As a teenager Michelangelo had spent so much time drawing here that he was seen as acting as if he owned the place. A rival sculptor, Pietro Torrigiani, got so fed up with Michelangelo's brooding presence that he punched him in the face, smashing his nose. Torrigiani was exiled for disfiguring *Il Magnifico*'s darling. In 1504, Michelangelo went back to the chapel in the Santo Spirito quarter and made a red chalk drawing of Masaccio's great, bleak depiction of Adam and Eve. As Adam walks cast out from Paradise, his face in his hands, his genitalia, not yet covered with shame, are robustly and somehow tragically portrayed.[10] Michelangelo had precedent on his side, had the reverence for antiquity on his side, even had God on his side. But in 1504 he

deliberately risked all that. He unmasked the longing in his passion for the male nude.

* * *

Leonardo had his own enigmatic relationship with male beauty. In the Sala del Papa, he was surrounded by sensuality. His clothes, all those pinks and purples, satins and velvets. His hair, and Salaì's. His accounts list many expenditures on Salaì, including a haircut: according to Vasari, Leonardo especially adored his assistant's hair. But the clothes too kept coming as he bought Salaì shirts and shoes, jerkins, caps and hose, constantly replenishing the youth's wardrobe, constantly trying to keep track of the money he gave him. In one list of what Salaì spent appear these two items:[11]

to Paolo for a . . .	20 *soldi*
to a fortune-teller	11 *soldi*

Salaì was then in his twenties, only a few years younger than Michelangelo. Leonardo was fifty-two. The friendship of a younger and older man was a traditional template of same-sex relationships going back to classical Athens, although Salaì had joined Leonardo's household when he was just ten. In an enigmatic note, Leonardo remarks that when he made a Christ Child he was imprisoned. 'Now, if I do him as an adult you will do worse to me.'[12]

When he was in his twenties, in Florence in the 1470s, Leonardo had felt the chill of communal disdain. In April 1476 the twenty-four-year-old was one of several men accused of committing sodomy with a teenaged apprentice goldsmith named Jacopo Saltarelli.[13] That June the charge was brought again. Possibly the reason it went no further was that his co-accused included young men of wealthy and influential families. Sex between men was not considered a rarity in Renaissance Florence – it was seen as wide-

spread. The Office of the Night was set up specifically to combat behaviour contemporaries believed to be especially prevalent in the city. In Germany a nickname for a homosexual was *florenzer*. A higher proportion of men in Florence than elsewhere never married.[14]

So Leonardo was not necessarily that unusual – but perhaps he was unguarded, or unlucky, because it seems he was injured by these accusations and other reports. He was, as it were, expelled from the Garden. Long before Michelangelo studied in Lorenzo the Magificent's garden, it was thrown open to the young Leonardo, claims the early sixteenth-century manuscript biography of him by the Anonimo. He worked there with Lorenzo's encouragement, much as Michelangelo was to do. But any Medici nurturing of Leonardo faded away and he decided to leave Florence – under a cloud? In 1479, *Il Magnifico* was sent a man who had fled Florence after accusations of sodomy. He got as far as Bologna, whose rulers sent him back after imprisoning him for six months, to answer to Lorenzo for his lifestyle. His name was Paulo de Leonardo – he was apparently an assistant of the young painter.[15]

Leonardo, it seems, was already surrounded by an alternative household as a young artist in Florence: he may have been influenced in this by his own teacher Verrocchio. Later it seems to have simply been accepted that this was how he lived. He was put up in monasteries, visited courts like that of Isabella d'Este in Mantua, and everywhere he was accompanied by the beautiful youths led by Salaì. This was his family.

In his art, nothing is that down to earth. He is capable of obscene and overt sexual jokes. In a late drawing closely related to his sensual painting of John the Baptist in the Louvre, he portrays a long-haired youth pointing up to heaven while sporting an enormous erection. So much for *ornamento decente* – Leonardo's comment at the 1504 meeting was a political, not a heartfelt, remark. It may also be worth mentioning that he made a detailed anatomical study of the anal sphincter. Yet Leonardo shows no preference for

portraying men in his art. He responds as intensely to beauty in women as in men — more subversively, he merges the two. He delights in angels, beings of indeterminate gender, like the gorgeous one in the second *Virgin of the Rocks*. He positively wants his figures to be clothed because clothing creates ambiguity. It is a paradox: Leonardo veils his sexuality, indeed veils the body, in his art while he seems not to have disguised the way he lived. Michelangelo thrusts forward his love of the male body while denying to his last breath the intimate meaning of it.

In his biography of Michelangelo, Condivi, relaying the artist's own views, says:

> He has . . . loved the beauty of the body, as one who knows it well, and with the kind of love that, among certain carnal men who do not know how to understand the love of beauty unless it is lascivious and ignoble, it has been taken as a reason to think and speak ill of him: as if Alcibiades, a most attractive young man, had not been loved by Socrates most chastely, from whose side, when he rested with him, it was said that he got up just as if he had lain beside his father.[16]

This is how Michelangelo defended himself against gossip. He invoked Plato's *Symposium*, a dialogue about love in which the philosopher Socrates and his pupil, the charismatic politician Alcibiades, speak. And this is not an isolated quotation. His love poetry, especially from the 1530s on, is shaped by the Neoplatonic ideal of chaste love that had been popularised by Marsilio Ficino in fifteenth-century Florence. Michelangelo wrote a series of tremulous poems to Tommaso Cavalieri, to whom he also sent powerful drawings including one of the homoerotic myth of the Rape of Ganymede. In verse he simultaneously insists on the physical beauty of his love object and transfigures that beauty into a spiritual, not a fleshly, phenomenon:

Well, alas! How will it be heard,
the chaste desire [*la casta voglia*] that burns the interior of my heart
by those who in others always see themselves?[17]

Michelangelo's poetry is not alone in the sixteenth century in
exploiting the language of Neoplatonic love to paradoxically limn
desire as something utterly ethereal even as it is utterly bound to
the human face and body. It is, to be frank, a cliché of the age –
but his version of it has intensity and conviction. His poems have
a massive, even clumsy, rock-like force that transcends the brittle-
ness of convention (just as his *Bacchus* transcends classical quota-
tion.) Through this language of love he finds a way to experience
love – for he sincerely pursued Cavalieri and later formed an
equally chaste relationship with a woman poet, Vittoria Colonna.
Neither relationship was unreal – or real.

His poems to Cavalieri are risky, provocative. He starts sending
and giving them to the young nobleman when there is at first
uncertainty, even refusal, on Cavalieri's part. This is not a courtly
game: the sense of an old man perhaps making a fool of himself
is very real. Michelangelo was in his fifties when he met the twenty-
three-year-old Cavalieri in 1532. The poems gradually persuade
Cavalieri to accept the artist's admiration and build a monumental,
passionate myth that connects the two men, but it is only a myth:
there is no evidence to question Michelangelo's claim that he was
celibate, that his love was chaste. And yet, it is love. It does focus
relentlessly on physical desire, even as it insists that this desire is
angelic. It's as if the poetry as such is the consummation that turns
body to spirit. One of Michelangelo's favourite poetic images is
the fire that consumes him – an image of heat that dissolves, of
the physical becoming pure energy. Desire becomes art and its
very intensity turns base matter to pure form.

* * *

In 1504, when he was still a young man, Michelangelo was not

yet the powerful writer he would become. But his drawings of the nude as he planned *The Battle of Cascina* are his first great transfiguration of the erotic into a loving art. Their sexuality is touchingly, blatantly real. When he draws a man's back and runs his eye down every muscular furrow, caressing the bones under the skin with black chalk, it is unequivocally desire that binds him to this object. But the very keenness of the regard somehow transfigures this blatant eroticism. There is extreme emotion in these drawings: to put it in terms both more universal and more accurate to Michelangelo's art than the rhetoric of Neoplatonism, they are drawings in which desire turns to love. He starts out desiring the men he observes, but as each great density of shade carves each back into a mountain landscape, the feeling changes: it matures. It is love these drawings speak of. They are moving homages to the beautiful young nudes he sees. Their faces are invisible, and yet you find yourself seeing them as individuals and wondering what their fate will be. Time is included in Michelangelo's vision of them: death is included. There is a tragic power to these drawings. He portrays young men in their full strength and beauty and yet shades them with intimations of ruin. Lust becomes love becomes compassion: *Pietà*.

Leonardo, seeing the *David*, saw through it. This nude was obscene, it needed decent ornament. But he was struck, he was startled. On a creamy-white sheet of paper next to a monumental drawing of a rearing horse that he'd sketched for his battle cartoon, he scribbled two very fast, frenetic chalk blurs of physicality then used a pen to reveal definite compositions within these 'stains': he even drew in rectangular frames in brown ink, to show what this would look like as a painting. They are ideas for a nude, but Leonardo's nude is anti-Michelangelesque by definition: she is a woman.[18] While Michelangelo disgorged his passion for male beauty, Leonardo experimented with ideas for a nude painting of Leda. In ancient mythology the god Jupiter transformed himself into a swan to make love to this beautiful nymph: their offspring,

two sets of human twins, hatched out of swans' eggs. In Leonardo's drawings he lavishes the imagination Michelangelo was bringing to his bathers on a woman who kneels on her right knee, her thigh an ample curve of flesh shaded warmly within the inked lines, and reaches around to her left towards a vaguely defined child: but under these forms in the two drawings, one smaller and one larger, you can see alternate poses, phantom curves and twists as Leonardo intensely improvises. The nude, in these drawings, has become a daring game of the artist's imagination: what poses can a body assume? What contortions can be incorporated into the ideal of beauty? Human beauty becomes a plaything.

There is a direct parallel with Michelangelo's drawings of naked men twisting, stretching, arcing. Both artists are competing to invent the most spectacular physical performances. This competition had its roots in the works that confirmed Leonardo's fame in Florence at the start of the sixteenth century.

Michelangelo was doing something unprecedented in his personal odyssey of nude convolutions – wasn't he?

In reality, he was desperately competing with Leonardo. When the older artist returned from his long self-imposed exile, he amazed the Florentines with drawings that spectacularly arranged the human figure in strange yet beautiful compositions. Citizens flocked to see his cartoon of the Virgin and St Anne at the Annunziata as if it were a festival: in the version that survives, there is a majestic, complex game being played with human bodies, a dream of some infinitely ingenious classical sculpture. As Mary sits on the lap of her mother, resting on Anne's broad right thigh while Anne's left knee is raised, she is brought so close to the other woman that they almost resemble a mythic two-headed being, their shoulders sloping at the same angle to form a smooth semicircular curve, the face of Anne turned nocturnally towards Mary's bright orb, as if they were the moon and the sun. Their bodies are clothed, their knees pressing against the draperies, but there is nudity here, too: Christ in Mary's arms is lovingly admired by the young St

John, whose face is a fleshy sphere under his soft curls and who is naked except for a loincloth.

You can imagine, looking at this finished drawing the size of a painting, how Leonardo must have discovered its unique constellation of bodies in some exercise of improvised doodling like the one for his Leda – in fact his initial small sketches survive.[19] You can see how Leonardo spewed out a great whirl of chalk, released this eccentric form, and then drew in the lines of the limbs and heads in ink over the almost random chalk blot. Out of weirdness he discovers harmony: that's the game, to reveal pattern in chaos.

Leonardo's new kind of composition – phantasmic, wilful, at once impossible and natural, grotesque and beautiful – took classical models apart and put them together again with a new power. It may be that his *Virgin and Child with Saint Anne and John the Baptist* was influenced by seeing ancient robed and seated statues at the emperor Hadrian's Villa near Rome, yet it more closely resembles the robed goddesses on the Parthenon, not to be widely known until the nineteenth century. In reality, Leonardo did not rely on any one classical model, but created his own new and heightened idea of sculptural majesty. The group obsessed every young artist who saw it – including Michelangelo. Versions and interpretations of it – maybe he had more than one cartoon on show at Santa Maria Novella – are a major genre of early sixteenth-century Florentine art. In a round marble relief known as the *Taddei Tondo*, Michelangelo takes the theme of Mary with the infant Christ and St John from Leonardo's group and invents a composition that is the antithesis of Leonardo, while paying – accidental? – homage to his rival by giving much of the unfinished work a Leonardesque softness, an equivalent in stone of the older master's painterly haze.

Out of this haze comes a harshness. Leonardo portrayed an intimate friendship between Christ and St John. In Michelangelo's tondo, Christ is virtually leaping out of his mother's arms to fly away from John: in place of closeness there is revulsion. This infant Christ is the most finished part of the work, his little body precisely

hewn, right down to the small baby's penis. Michelangelo insists on Christ's full humanity as he tries to escape his mortal destiny.[20] At the same time he offers a dynamic, explosive contrast to Leonardo's massive, organic whole – and displays an ingenious physical possibility all his own, of a Christ who does not stay in Mary's arms, but who becomes a kind of flying putto, soaring out of the pictorial group into three-dimensional reality. Sculpture, claims this work, trumps painting.

In the painted tondo he created for Agnolo Doni, designing a richly carved wooden frame for it, Michelangelo defies Leonardo's cartoon of the Virgin and St Anne even more unequivocally. Leonardo had created a doubly maternal group – Christ's mother and grandmother, intertwined – but in this circular painting Michelangelo does the opposite. His Holy Family is dominated by Joseph, a choice radically at odds not just with Leonardo, but with the Florentine culture to which the Annunziata cartoon strongly appealed. For Leonardo knew what he was doing, exhibiting his image of Mary and her mother at the Annunziata, which was famous all over Italy for its precious relic, the miraculous painting of the Annunciation kept there in a tabernacle designed by Michelozzo. Like other Italian medieval cities, Florence adored the Virgin – the city was full of icons of her and she was prayed to almost as a mother goddess. Leonardo jokes about this in his *Prophecies*:

Of Christians.
Many who hold the faith of the son only raise temples in the name of the mother.[21]

Michelangelo is driven in his tondo to attack Florentine popular culture in order to attack Leonardo. It's reminiscent, oddly, of the First Herald Francesco's criticisms of Donatello's *Judith* – it is not good for the woman to kill the man, and it is not good, implies the *Doni Tondo*, to depict a Holy Family dominated by women. In

Michelangelo's painting Joseph gets his due: a good old man, strong and sensitive, he towers over his young wife (clearly modelled on a boy) who is doing the correct thing and presenting Christ to him. And the arrangement of human forms is spectacular: Mary kneels, twisting around to raise up Christ, her arms arcing in space. It is a blatantly competitive pose. Not only does Michelangelo strive to create a more exciting physical complication than the one Leonardo imagined in his St Anne studies. In the kneeling Mary, he sets out to improve on the kneeling Leda whose form Leonardo had invented as his riposte to Michelangelo's nudes.

Yet there is more to these reconfigurations of Leonardo than a cool comparison of styles. Michelangelo finds fault not only with his rival's art, but with his life. There is something very personal in his vision of the Holy Family. Michelangelo loved his father. Ludovico was a good Christian man, old-fashioned in his ways, his son told Condivi, and in Michelangelo's letters his efforts to be loyal and solicitous to a man who actually seems to have been tetchy and dependent are moving.[22] Not only did Michelangelo respect and help his father, but he did his best for his brothers, especially his beloved Buonarroto, whose death caused him great grief. The family home in Florence was in the Santa Croce quarter, east of the Piazza della Signoria, a working-class district where Michelangelo was later to increase their property: today the Casa Buonarroti museum is there. Michelangelo worked on his cartoon for the Great Council Hall in a room at the Hospital of the Dyers in this quarter, near the family home. At this time of his life there is no record of him indulging in flights of Platonic love or expressing his admiration for male beauty in any other realm but his art: it may well be significant that his pursuit of Tommaso Cavalieri and other men become an overt part of his life only after his father died. In 1504 he was a good son and brother[23] who chose to work on his cartoon in his own family's quarter. On the other side of Florence there was Leonardo with his strange *famiglia* centred on a relationship with a handsome young criminal type,

Salaì, who, in between visits to the barber and the fortune-teller, functioned as something between Leonardo's adopted son and his lover.

With his coiffed hair and his pink tights and his extravagant wardrobe, his equally finely got-up servants and followers, Leonardo simply repelled Michelangelo. There is real rage towards the older man's blurring of male and female beauty, his strange sensuality and 'family', in the younger artist's responses to the Annunziata cartoon. His *Doni Tondo* rejects the alternative Holy Family depicted in Leonardo's vision. Not only does a firmly masculine family replace a feminised one: the infant Baptist is portrayed by Michelangelo at a respectful distance from the Family, separated from them by a grey stone wall. This is a pointed contrast with the intimate, indeed sensual, way the young Baptist approaches Christ in Leonardo's cartoon in London. Michelangelo makes the same point even more insistently in his marble tondo: Christ flees the young John as if disgusted by him.

In 1504, as they plot their rival cartoons for the Great Council Hall, these two titanic minds are systematically competing in every aspect of their designs. Consider Michelangelo's drawing of a seated nude turning away from the beholder, twisting his entire body and neck while maintaining elegance. This might seem remote from Leonardo. But one of the works to be seen in his rooms at Santa Maria Novella was his portrait of Lisa del Gioncondo – a seated figure who turns around in her chair, twisting her body with such apparently effortless grace that the convolution of the pose goes unnoticed. Not by Michelangelo. The *Mona Lisa* is a hidden enemy with which his gyrating nudes compete. Her circular motion even as she sits still becomes, in his drawings of mighty male figures turning their heads, twisting their backs, a vortex of power. And this, in turn, provokes Leonardo's final devastating riposte to the strident energy of all those nudes.

Daunted as he was by the *David*, in the end Leonardo didn't find his rival's obsession with the male body that enviable. In his

notes on painting he denounces an art that appears to be Michelangelo's: 'O anatomical painter, in your desire for your nudes to display all their emotions, guard against your extreme awareness of the bones, chords and muscles making you a wooden painter . . .'[24] This is a direct criticism of the kinds of nudes Michelangelo was drawing. In fact it is an insightul analysis of their meaning: Michelangelo set out to 'display all their emotions' not in their faces but on their bodies. In a great drawing of a man's back he reveals pathos and passion inscribed in the very flesh in exactly the way Leonardo suggests. But this muscular emotion is 'wooden', says Leonardo, and in the *Mona Lisa* he offers his considered reply to the anatomical grandeurs of Michelangelo's nudes.

When Michelangelo insulted him in the street, Leonardo couldn't think of an answer; when it came to art, he was more eloquent. The earliest imitation of the *Mona Lisa*, painted by Raphael in about 1506, transposing her features onto those of Maddalena Strozzi Doni, notably lacks the most famous thing of all about her. Maddalena does not smile. This doesn't prove that Leonardo had yet to make his painting smile – but a scientific investigation of the picture by the Louvre revealed an unsmiling image below the one we see. It's conspicuous that Raphael should have left out the feature that most struck later observers and was assiduously copied or inventively reimagined by so many later artists. The *Mona Lisa*'s smile in fact seems connected with the anatomical drawings Leonardo did after 1506, in which among other things he dissects 'the muscles called lips'. If so, her face is his true answer, in the aftermath of his competition with Michelangelo, to the young man's 'wooden' anatomical nudes. All those surging backs and stretching limbs, those contorted poses, that strident heroic display of feeling in the human body – and really, the only muscles you need to display emotion are your lips. Without stirring from her chair, Lisa del Giocondo banishes Michelangelo's men with a mocking smile.

Nine

MASTER OF WAR

L eonardo explored the fortress by the sea, observing weaknesses, devising solutions. It was November 1504 and work on *The Battle of Anghiari* had been interrupted – but this time it wasn't his fault. The government of Florence sent him on a mission connected with the war on Pisa. The small city of Piombino on the Tuscan coast commanded the coastal route south and was considered strategically essential. Earlier that year its lord, Jacopo d'Appiano, had nearly switched sides in Tuscany's war and gone over to the Pisans. As he was such a valuable ally cutting off the rebel city's link with Naples, the Signoria sent the excellent Niccolò Machiavelli to visit Piombino and mollify its ruler. Machiavelli smoothed things over and Leonardo was sent, in effect, as a goodwill gift. To confirm the renewal of Florence's alliance with this tinpot local despot, the great genius was despatched to mend his castle. It was at this point that he packed his books and clothes away at Santa Maria Novella, to ride out into the rocky, riverine Tuscan landscape towards the glittering Mediterranean.

The coming of the artillery age had reduced the picturesque walls of medieval chateaux, their lofty turrets and quaint portcullises, to decorative playthings, good only for romance literature. We have already seen how the French invasion in 1494 had turned the politics of the peninsula upside down. It led to the fall of the Medici and Ludovico Sforza, and caused the war with Pisa that Florence was still fighting. This single catastrophe dominated Italy for decades. In his political writings Machiavelli returns to it

obsessively, sees it as a dividing line between the golden age of fifteenth-century Italy and his own tumultuous times. But the most disturbing new reality that struck Italians in 1494 was the fury of artillery. This war marks a fault line in European history. It was the first time cannon truly determined a conflict's outcome. After a century of experiment with bombards and siege guns, this was the moment when an army deployed mobile cannon to maximum effect and proved that the age of gunpowder had truly come. War would never be the same again. The year 1494 is a critical date in the birth of the modern world.[1]

Contemporary Italians understood this with stunned clarity. In his *History of Italy*, composed in the 1530s at the end of the cycle of conflicts the invasion inaugurated, the Florentine politician Francesco Guicciardini describes the fatal impact of the new technology. Siege guns had gradually been improving in impact and mobility for decades, but there was a sudden transformation in 1494 when the French brought

> . . . many pieces which were even more mobile because they were solely of bronze, that were called cannons, and used balls of iron, where before stone ones had been used that were heavier and grosser beyond comparison, and they were pulled on carriages, drawn not by oxen, as was customary in Italy, but by horses, with such agility of men and instruments chosen for this task that they almost always progressed alongside the armies, and were conducted to the walls and positioned with incredible speed . . .[2]

The impact on castles and walled towns was devastating. A style of defensive architecture that had evolved organically over long centuries and that still, to this day, comes to mind when we picture the medieval world was blown to pieces. A drawing by Leonardo illustrates this catastrophic dawn. A tower explodes in fragments, literally disintegrating in a cloud of smoke and dust.[3] This was the kind of scene people had to get used to. Walk around the old walls

of Florence, or examine any medieval castle, and the problem is obvious.[4] Tall, narrow barriers of stone were no use against a cannonball. Italy had an especially deep emotional investment in those old walls. Italian images of cities show houses jammed into a circle of walls – in San Domenico in Bologna stands St Petronius, carved by Michelangelo, holding a model of towered Bologna safe within its mural enclosure. City walls were symbols of liberty and communal solidarity. The idea of a city safe behind its defences was too potent to be abandoned. Thus was born one of the most surprising inventions of the Italian Renaissance: the bastion.

This was a great age of architecture – and of radical architectural thinking. The rediscovery of classical Greco-Roman architecture was at the very heart of the Italian Renaissance. In studying the buildings of Rome and reading the writings of Vitruvius, architects such as Alberti didn't only start to rethink houses and temples but defences, too. Even before 1494, engineers, architects and military men set about inventing new kinds of fortification for the artillery age. After 1494 the search intensified. Antonio and Giuliano da Sangallo, Francesco di Giorgio Martini and Leonardo himself realised there were ways to outwit the besieging gunners. The new ideas had first been advanced by Alberti, and it is significant that Leonardo had Alberti's architectural writings in his book collection.[5]

Renaissance architects were in love with geometry. It was the rejection of arbitrary Gothic fantasy, the ordering of space on principles of proportion and symmetry. That was what fifteenth- and sixteenth-century Italians so revered in the temples that survived in Rome. Brunelleschi launched the Renaissance when he surmounted Florence Cathedral not with a crazy spire, but with a regular, harmonious dome. The same curiosity that made architects want to build domes made them see that mathematics could save cities. Instead of tall walls which presented easy targets, you could fortify a site with massive embankments, sloping and zigzagged and filled with rubble, and with circular or triangular gun towers with a formidable visual command of their surroundings. Low and

sinister, more like pyramids than walls, the new fortifications could turn the tables and make artillery attack impossible while maximising the defenders' firepower.[6]

Leonardo da Vinci is not usually thought of as an architect. A would-be aviator, an inventor of diving suits – everyone knows he was these things, but an architect? And yet architecture is the hidden channel that links the entrancing world of his notebooks with physical, built, Italian – and French – reality. Always, when you read his notes, contemplate his inventions, you wonder what was ever made. There are no records of his tank ever scattering the enemy as it trundled across a battlefield, or of his diving suit being used to sink enemy ships or fish for pearls. There are no buildings by him either, but his architectural ideas had a real, observable influence on his contemporaries. A spiralling well at Orvieto, a chateau staircase in the Loire Valley – there are buildings in the world that are visibly indebted to Leonardo's drawings. His designs contributed to the ingenious development of Italian architecture.[7]

His most scintillating architectural drawings are in the notebook Manuscript B that he compiled in Milan in the 1480s. They explore one of the most cherished forms that architects were starting to dream of: a totally centralised 'temple' that rejected the asymmetrical aisles and cross-shaped plans of traditional churches. It was the logical culmination of the quest for architectural harmony. In Leonardo's drawings a tall central dome is surrounded by eight smaller domes which form a circle; the squared outer walls have niches with statues set into them. The drawings have a compact, compressed power; the temple with its domes is forever perfect in the memory of anyone who has seen them.

There could not be a more committed expression of the Renaissance classical ideal. Leonardo's domes are mathematical dreams. He applied the same geometrical mind to the new science of military architecture.

* * *

At Piombino in 1504 Leonardo rapidly devised an impromptu masterpiece of geometrical defence. What the seaside castle needed to make it modern and impregnable was, he reasoned, a massive circular mound with a squat gun tower sunk into it, linked to the main fortress by a covered passage, with a deep trench and massive banks adding to the defences. His designs analyse the long, low, sloping banks from the point of view of artillery sight lines, and show how jagged, angular trenches provide a more difficult target for gunners. At the same time he thinks of his mound as a 'pyramid', which starts him thinking about the pure mathematics of pyramids – but that too has practical value. It was by thinking geometrically that Renaissance architects invented the science fiction bunker-like forms of the new fortresses, so devoid of picturesque detail.

Leonardo understood ballistics and the sight lines necessary to maximise defensive firepower while making attack difficult. He had often considered it from the other point of view. In this very year of 1504 he made an eerily beautiful drawing of a row of mortars planted by a besieging army into the ground outside a fortification. The mortars fire upward, and their diffusions of shot arc over and fall into the courtyard on the other side of the walls. He draws the lines of the mortars' trajectories as spectacular red fountains, spilling over behind the enemy walls: it is like a fireworks display. That is what it is, a murderous fireworks display. The point of the plan is to cover the area behind the walls in an even shower of devastating grapeshot. A hard rain is falling on Pisa – for surely the fortifications are meant to be Pisa's. This is a design for a massive artillery attack on the city Florence was besieging. There is also a sketch for it on the reverse of one of Leonardo's horses drawn for the cartoon of *The Battle of Anghiari*.[8]

In Piombino, on All Saints' Day 1504, Leonardo demonstrated to Jacopo d'Appiano how the landscape itself could be reshaped as a defensive measure. If the little hills beyond the trench were flattened into a geometrical plane, this would give a perfect, lethal

sight line to the gunners in the squat tower. Exactly this type of mathematical analysis was soon to become the universal principle of fortification. Leonardo made explicit the rationale of his gun tower: it provided a secure vantage point 'where men are stood to batter all the countryside with artillery'.[9] In one of his designs for the tower, its body rises from a torqued star of triangular buttresses, their acute angles designed to deny enemy gunners a target.[10] Even in designing the layout of trenches in front of the walls he uses geometry, explaining how mathematical accuracy is the secret of survival in this new age of ballistics. He draws a triangle and then cuts through its interior with zigzag lines representing the trenches: the apex of the triangle is marked with the letter 'p', representing the enemy; Leonardo calculates the best angles of these trenches to minimise their exposure to this enemy.[11]

In Leonardo's notes on his work at Piombino in Madrid Codex II, we see him not as an isolated visionary, but as a participant in avant-garde military science. The design of bastions was a very real and significant evolution in European warfare.[12] It seems from this rare glimpse of him actually at work – as opposed to theorising – that Leonardo truly was a master of war. His friend Francesco di Giorgio, whose writings on military architecture he transcribed and whose manuscript architectural treatise he annotated that same winter,[13] was another. But Leonardo's proposals to the lord of Piombino were superbly original applications of the new technique of fortress-building – and they were practical. He planned to make earthworks central to the scheme, and his notebook contains detailed calculations of the labour necessary to do the digging and move the rubble. He costs every part of the scheme based on his calculations of the volume of earth to be moved and the pay of workers per man-hour.

Leonardo was not trying to create something aesthetic here, but something that worked. He pragmatically opted for earthworks, simple banks and ditches, as a means of creating strong bastions quickly. In a note dating from the early 1500s he points out that

'for a bastion to be elastic, it should have a layer of fresh willow branches placed in the soil at intervals of half a braccio'.[14] That is, by weaving willow into your earthen bastion you can make it absorb cannon fire more effectively, like a springy cushion. This is a quite different Leonardo from the visionary scientist who was an enigma to his contemporaries. The Leonardo the Florentine Republic sent to Piombino is a useful engineer.

He also knows enough about war to know that science is not its lifeblood. What if the enemy do get inside his defences, he wonders? It will be a close-quarters fight. The enemy will be trapped in a narrow defile created by his earthworks, and then the defenders will strike back: '[T]hrowing smoke and flames and other fetid things, they will clear out the enemy with fury.'[15] In war, however much you calculate, in the end it is down to the visceral force of irrational violence, the release in otherwise perfectly normal human beings of murderous fury. This image of *furia* connects his work at Piombino with the cartoon of the Battle of Anghiari that still had to be finished in Florence. In Leonardo's battle picture, wrote Vasari in 1550, 'rage, bitterness and revenge are perceived as much in the men as in the horses'.[16] It was a painting of anger, of hate – of the fury of battle. This is what generation after generation has seen in Leonardo's battle picture. In the seventeenth century Pieter Paul Rubens drew a version in which the frenzy of the horses is like that of monstrous dragons. In the nineteenth century the critic Walter Pater shuddered that 'we may discern some lust of terrible things in it'.[17]

One of the drawings Leonardo made for his battle cartoon reveals him researching fury by studying facial expressions in a maddened horse. In this fierce little masterpiece horses rear and rage, and Leonardo moves closer to study bulging eyes, chomping teeth, lips bared. The horse's flesh is pressed down on its skull, revealing the contours of the bone; its teeth are primitive, grinding instruments, its eye a circle of irrationality. Next to it he draws a roaring lion and a screaming man, to stress and

analyse the idea of *furia*.[18] As he plans his battle painting he is thinking about the psychology of war. This drawing matches his observation in his notebook at Piombino that if the enemy get into the defile they can be driven out with 'fury'. The new artillery changed war, but the face of battle was an eternal scream of hate.

* * *

There seems to be an obvious contrast between Leonardo's work on *The Battle of Anghiari* and his visit to Piombino. He broke off from designing an imaginary battle to offer his services in a real war. But this is a modern perspective. Art in sixteenth-century Florence was not a 'soft' activity compared with the real world where 'hard' reality prevailed. Images were effective. Paintings and statues in churches could have miraculous virtues or manifest protective saints. In public art, too, mysterious forces were at work, as became so apparent at the meeting to decide the *David*'s location. The Republic knew of Leonardo's talents as an architect and engineer. It consulted him – perhaps was strongly influenced by him – in planning to divert the Arno and sent him to advise on fortifying Piombino. His painting in the Great Council Hall was also intended to advance the war against Pisa. We're familiar with propaganda. Leonardo's painting was intended to celebrate a patriotic victory and inspire the city in its current war. And yet, its purpose may have been more precise than anything we expect of political imagery. Art – as we saw in our discussion of Botticelli's paintings – could be a charm, a rite.

Machiavelli had radical ideas about images and their effects. He idolised antiquity, and his political writings – in 1504–6, when he was trying to win the Pisan war, as much as later on, when he wrote his infamous books – are saturated in classical learning. But he did not see the Greek and Roman world through rosy spectacles. He worshipped its power and energy, and attributed these qualities to forces that were dangerous and unstable. He defended

the riots and tumults of ancient Rome for, he argues in his *Discourses*, these disorders bred liberty and drove the Roman Republic to conquest and war. Machiavelli's ancient Rome is in some ways a primitive place. He disparages Christianity for its softness and pity, for muting the old warlike ways of pagan Italy. In his most provocative onslaught on the religion of his own day, Machiavelli claims the reason ancient cities fought so much harder for freedom than modern ones can be found in

> . . . the contrast between our education and that of the ancients, founded on the contrast between our religion and theirs. For having shown the truth and the right way, our religion makes us think less of worldly honour: while the pagans, thinking a lot of it and seeing it as the supreme good, acted more ferociously. This can be understood from many of their constitutions, starting with the magnificence of their sacrifices compared with the humility of ours, which have a pomp more delicate than magnificent, but no ferocious or energetic action. Theirs did not lack pomp or magnificence of ceremony, but to this was joined the action of the sacrifice packed with blood and ferocity, with the killing of a multitude of animals; and this spectacle, being terrible, made men similar to itself.[19]

This idea of sacrifice as a bloody visual spectacle that rouses violent passions in the spectator is powerfully suggestive about the purpose of showing the citizens of Florence, assembled in their Great Council Hall, a painting of a battle. Today, in sixteenth-century Italy, says Machiavelli, the pieties of the Church honour weakness and celebrate 'humility'. Christianity's tranquillising effect pacifies citizens and makes them easy to tyrannise. Ancient religion was the opposite: paganism valued this world and its glories, and, most of all, its rites were bloody and cruel. The scene of sacrifice was violent and ferocious: 'being terrible', it 'made men similar to itself'.

Machiavelli here advocates a use of visual horror to make

citizens cruel and violent, to prepare them for war. He was ulti-
mately concerned as a political thinker with changing the subjec-
tive feelings and dispositions, awakening the energy, of his
fellow-citizens. Republics in his eyes were made free by passion:
people were more alive, and that meant more aggressive, in free
cities: 'But in republics,' he sardonically warns would-be tyrants
in *The Prince*, 'there is greater vitality, greater hatred, more desire
for revenge.'[20] His praise of ancient blood sacrifice is on these
grounds: by watching blood flow on their altars, the old pagans
absorbed pitiless, but strong and warlike, ways.

Leonardo da Vinci was designing a monument to fury, a painting
that visually manifested the warlike passions. Armies marched to
the beat of drums. What if we pictured his painting as the visual
equivalent of a stirring drumbeat, drumming war into Florentine
hearts as they met in their Hall to vote taxes to pay for the defeat
of Pisa? A Machiavellian understanding might see *The Battle of
Anghiari* as the equivalent of a pagan sacrifice, a rite of violence
to harden hearts.

If so it would be a true Machiavellian attack on piety. The Great
Council Hall was a room drenched in religion. Built by Savonarola,
it had an altar for which Filippino Lippi and then Fra Bartolommeo
were contracted to paint the Virgin and saints of Florence, a
wooden loggia on top of which a nude Christ was planned. But
in place of humility and sanctity, Leonardo's wall painting would
bring a vision of rage, anger, revenge – of the Machiavellian
virtues. The callous qualities Vasari would see in it – '[R]age,
bitterness and revenge are perceived as much in the men as in the
horses' – are, according to Machiavelli, the strengths a Republic
needs if it is to survive.

* * *

Fury and fire burst off the pages of Leonardo da Vinci's notebooks
in designs for cannons, mortars, bombs, missiles, fire ships and
armoured cars. In a drawing in Manuscript B that he works up in

more detail on a sheet in the British Museum, he gives form to his idea for a 'covered chariot'. Leonardo's predecessor of the modern tank is a round-roofed wagon, moved by gears, armed with cannon which blast away as it rolls across the battlefield. A note by the side of the drawing suggests some uses: 'These replace the elephants. You can joust with them. You can hold bellows in them to spread terror among the horses of the enemy, and put gunmen in them to break up any battle formation.'[21] That is, they could be as terrifying and unexpected as the elephants the ancient Carthaginian general Hannibal used in battle – a prophetic image of the kind of shock tanks would cause in the twentieth century. But Leonardo also suggests the wagons might be used for jousting, conjuring up a science fiction picture of young knights driving their wooden tanks at one another while ladies of the court look on.

Leonardo's notes on fortifying Piombino in November and December 1504 are so realistic, so practical, that they raise a startling question about his work as a military engineer. In his letter to Ludovico Sforza in about 1481 he claimed to have many 'secrets' of war. In his notes from Manuscript B made in the 1480s, with its original inventions mingled with interpretations of ancient war machines, to a plan for a submarine attack he wrote while in Venice in 1500, there are many military inventions and stratagems.[22] Yet it can seem that these are in the end pure theory – that his plans were never really put into practice. This assumption has the convenient effect of absolving the modern world's favourite Renaissance genius from any involvement in actually killing people. But the rare day-to-day record of him at work in Piombino does not reveal a hapless fantasist, let alone someone whose military designs were satires or intellectual games.[23] It is very real, prosaic stuff, calculating costs and man-hours, digging ditches, shifting earth. The conclusion seems unavoidable that he had done this kind of thing before, that he was an accomplished engineer who could get results. His capacity for fiendish inventions was combined with a total lack of snobbery, a readiness to think in terms of

ditches and dirt, that made him a good pair of hands to have
around on the battlefield.

Leonardo had worked as chief engineer for Cesare Borgia in
1502. There was nothing whimsical about Borgia's attitude to
war. He was not staging jousts; he didn't need a court artist. If
he employed Leonardo it was because he found him genuinely
useful. If the inventor hadn't been able to offer anything substan-
tial and real to back up his talk of 'my secrets' in Borgia's
company, he could even have ended up dead. And as we have
seen, soon after returning to Florence in 1503 Leonardo was
being consulted by the Republic about its plans to use the River
Arno against Pisa – which suggests his work for Borgia was known
and respected.

What does this tell us about his drawings of crossbow bolts with
heads packed with incendiary materials to turn them into explo-
sive missiles, of spheres to be fired from mortars that spray out
smaller projectiles from holes in their bodies, of multi-barrelled
guns and fire ships? All these martial inventions can be found in
his notebooks, often drawn in great detail. They are not recon-
structed on television programmes as often as his flying machines
are. But they do resemble real weapons that were manufactured
in sixteenth-century Italy, and beyond. Henry VIII of England,
who was keen to keep up with the latest military know-how, bought
ingenious artillery pieces from Italy including a multi-barrelled gun
and a set of handguns fitted with shields to protect the user. Both
these devices (examples survive in the Royal Armouries and were
found on Henry's warship the *Mary Rose*) resemble inventions in
Leonardo's notebooks.

It would be exciting to find some shred of evidence that directly
connected his ingenuities with sixteenth-century warfare. And I
have found one. In London in 1588 – the year the English used
fire ships against the Spanish Armada – a translation was published
of the Italian pioneer of ballistics Nicholas Tartaglia's book on
the 'Art of Shooting'. Translated by Cyprian Lucar, gent., it has

an appendix by Lucar compiling various innovations and insights from Italian works of military science. Among these is a mention of a name it's surprising to find Elizabethans bandying about: 'Frauncesse George of Sena was the first inventor of Mynes [i.e. tunnels] for the subversion of Fortes, Castles, and walles of Cities . . .'[24] The English in 1588, very serious about war, looked back to Leonardo's friend Francesco di Giorgio as an important inventor. Leonardo had met this Sienese architect, engineer and artist – a polymath like himself, without the drawing ability – when he had been at the court of Milan. They both competed unsuccessfully – as did Donato Bramante, another architect friend of Leonardo's – to become the designer of the climactic central section of Milan's Gothic Cathedral. In 1490, Leonardo went with Francesco di Giorgio on a work trip to Pavia. But before this, Leonardo himself had boasted of his ideas for mining fortresses. In the letter he sent to Milan's ruler offering his talents as a master of war at the start of the 1480s, he says, 'If through the height of the banks, or the strength and site of the place, it is impossible, when besieging somewhere, to carry out a bombardment, I have means of ruining every stronghold or other fortress . . .' Later in the letter he is explicit: 'I have means by secret and tortuous caves and ways to come silently to a chosen place . . .'[25]

Nor was this an idle boast. Leonardo gives serious thought to how to tunnel underneath a fortress in Manuscript B.[26] Evidently he already had ideas about undermining fortresses before he met Francesco di Giorgio; the primacy the English book awards his friend in this art actually belonged to him. Elizabethan soldiers eager for every scrap of knowledge that would help defeat the Spanish were consciously indebted to Francesco di Giorgio, and behind the name of Leonardo's collaborator stood the inventiveness of Leonardo himself.

The inventions listed in the English book were almost all derived from Italian military science. The sources it cites include Vannuccio Biringuccio, Girolamo Ruscelli, Girolamo Cataneo,

Francesco Ferretti and Cosimo Bartoli. To take one example of these Renaissance authors, Girolamo Ruscelli's *Precetti della militia moderna* (1572) – *Precepts of Modern Warfare* – describes a wide variety of 'fireworks' including a fused bomb, a spherical shell that bursts into a shower of lethal fragments, and a 'dart of fire' that can be shot from a crossbow and contains burning matter inside a rocket-shaped wire frame.[27] All these weapons have infinitely better-drawn counterparts in Leonardo's notebooks. This doesn't mean they originated with him. He too adapted ideas from Valturio's *De re militari*, a compendium of unusual weapons ancient and modern.[28] On the other hand, as well as improving Valturio's designs, his notebooks are full of his own notions like weapons with built-in shields.

When it comes to the arts of war, it doesn't make sense to see Leonardo in dreamy isolation. His inventions are closely related to real – and ghastly – weapons that were made and used in sixteenth-century Europe. You can see, in armouries, Renaissance devices that exhibit exactly the same mentality as his inventions. He was working in an age when everything was changing on the battlefield, when war was highly experimental, and even his wildest ideas should not be seen as daydreams or jokes. Leonardo was a working military engineer whose means of offence were as real as the means of defence he demonstrated so gracefully at Piombino.

Does this make him a sinister, amoral military magus, the Dr Strangelove of Renaissance Italy? Not necessarily. War was a field of research for many early scientists. The new age of artillery offered a unique opportunity to study ballistics, and Leonardo drew and calculated the trajectories of mortars and crossbows in ways that look forward to the Scientific Revolution. In his designs for the bombardment of Pisa he finds incongruous beauty in the trajectories of destruction. In the later sixteenth century the great Pisan scientist Galileo Galilei would also write on ballistics and fortifications, and in the seventeenth century Isaac Newton would reach

some of his most important conclusions by considering the fiery arcs of the artillery.[29]

* * *

In Codex Madrid II you can see exactly why the practical engineering problems of war interested Leonardo: they were mathematical problems. His notes on fortifying Piombino enigmatically melt into speculations in pure geometry, and back again. Only gradually do you understand how pertinent his apparently gratuitous calculations on the nature of the pyramid are to his designs for mounds, banks and trenches.

In October 1504, the month before Leonardo was sent to Piombino, the most spectacular attempt to apply science to the defeat of Pisa went risibly wrong. We know that back in the summer of 1503 he had been consulted about the Florentine Republic's apocalyptic scenario of changing the course of the Arno to deprive Pisa of the river that was its lifeblood. In a roiling drawing done in about 1504 and giving his composition for the Great Council Hall a marine twist, Leonardo portrays Neptune, god of the sea, dark-eyed and downward-glaring, raising his trident in his right arm, ready to plunge it down in fury, unleashing some terrible storm that will sink ships and drown sailors. His sea horses, personifications of the waves, manifestly originate in the great drawings of horses Leonardo was making for his battle cartoon. They shake and judder their forelegs in the air in a cinematic blur of hooves, like something you might see in a zoetrope. Their magnificent faces are raised and their muscular necks twisted in passion; only Neptune himself can control these horses of the sea, whose bodies taper into dolphin-like tails, twisting like whirlpools. The drawing is a translation into marks on paper of the whirlpools and waves and sheer might of water.[30]

Neptune did not smile on the military stratagem to divert the Arno. His waters would not be ruled by Florence. In October 1504, a hydraulic engineer, or 'master of water', hired for the job

named Colombino attempted to dig a channel to divert the river with a force of 2,000 men. Determined to try anything, wrote Francesco Guicciardini in the late 1530s, the Florentines 'dreamed up an ingenious new way to injure the Pisans by trying to make the River Arno which runs by Pisa . . . flow into the Stagno'.[31] Not only would this cut the supply line to Pisa from the nearby sea; it would also prevent rain flowing to the sea and so isolate Pisa in a muddy swamp. The city would not drown quite as totally as Dante had once imagined, but it would rot in a quagmire. Nor would the Pisans be able to attack traffic from Livorno to Florence because it would be guarded by the new course of the Arno. But, continued Guicciardini, '. . . this work commenced with the greatest hope and followed through at still greater expense turned out to be in vain: because, as happens many times with these kinds of things, although the demonstration with its measures may be almost palpable, one will discover by experience they are fallacious (a clear example of how great the distance is between putting things to design and putting them into action) . . .'[32]

The failure, says Guicciardini, contradicted the optimism of the 'many engineers, and experts on water' who were consulted. Leonardo was one of those experts, as we've seen. Guicciardini – a friend of Machiavelli – seems in truth to be alluding to the marvellous drawings of the polymath. It is so suggestive, the way he writes of the 'almost palpable' plans with their authoritative measurements. The conviction in the design – *disegno* – that led Florence astray sounds exactly like the effect of Leonardo's drawings on the beholder.

The failure of this strategy depressed the Florentine leaders and made them angry at the engineers responsible. Cardinal Francesco Soderini, the Gonfalonier's brother, wrote to Machiavelli lamenting the catastrophe and blaming the supposed experts.[33] The Second Chancellor turned against the whole idea of technocracy. Wars are not won by science, Machiavelli insists in his later military writings. Fortresses are phoney consolations, artillery can be defied by

the brave, and the tactics of the ancient Roman legions are still applicable. These ideas were born in the wake of the error of the waters. As the Arno settled back in its usual course, Machiavelli sat down and wrote a poem called the '*Decennale*', in which he calls for a new approach to making war. The true curse of Italy's city states, the fatal flaw in their fight to preserve their independence, was and always had been their use of mercenaries. In proclaiming this, Machiavelli was returning to older republican ideas. The use of mercenary troops by Italian cities had long nagged at virtuous minds. How could you claim to be the new Rome if your troops were foreign hirelings?[34]

Italy had become a boom market for professional soldiers in the fourteenth century, when the Hundred Years' War created roaming bands of rootless knights who wandered over the Alps during breaks in the fighting between Britain and France. Because there were so many independent towns in Italy and the hierarchies of feudalism were eroded by centuries of urban self-confidence, there could be no feudal standing army like that of France. Jousting was popular, but in reality Italy north of Rome was a mercantile economy, and young men had better things to do than become knights. Hired soldiers were the answer. But such hired soldiers cannot by definition be morally worthy, says Machiavelli in *The Art of War*, 'because no one will be judged good, who if he wishes to always get something out of his job, must be rapacious, fraudulent, violent and have many qualities which of necessity do not make him a good man'.[35]

His answer was a citizen militia. It is an idea at the very core of his political thinking and it proves he was no fan of tyrants. In fact Machiavelli was an idealistic believer in republican government, and his 'big idea' was an attempt to reform corrupt republics from within. By forming a militia of its own people, training them and calling them up at times of crisis, the Florentine Republic could free itself from the corruption and dishonesty of mercenaries. But this was not the only benefit. Citizen-soldiers were better

citizens: their training made them braver and bigger-hearted. Like the youth of ancient Athens, Rome and Sparta, they would not ask what their city could do for them, but what they might do for their city. Citizenship in a true republic was active, it was 'virtuous', and the militia would inculcate an understanding of this. It would also bond and unite the community, as citizens became comrades.

Machiavelli would push this idea for the rest of his life. He had advocated it as early as 1503 in a speech he wrote to raise funds for the army,[36] but after the failure of the Arno diversion it became the new panacea for the endless war with Pisa. His increasing boldness in promoting it had immediate relevance to the competition in the Great Council Hall, for as he told everyone about his idea for a citizen army, Michelangelo was mustering an army of nudes.

Ten

THE RAID

Michelangelo was lucky with his subject, for not many battles include pastoral moments of naked bathing. Whether he himself found the most suitable battle in Bruni's *History of Florence* or it was selected by someone in the Palace, the choice must surely have been deliberate, for it offered a rare opportunity to portray an army with its clothes off. Michelangelo's cartoon for *The Battle of Cascina* was to be so unlike a conventional battle scene that some prefer to call it *The Bathers* instead.

All his life studies drawn in the autumn of 1504, all those men who look like they're at the baths, are designs for figures in his agitated army. These painted heroes would tower in the Great Council Hall just as the *David* towered outside the Palace. On the piazza, the gigantic statue stood stone in hand, eyes on the prize, ready to act. In the Great Council Hall a few steps away, the Florentine army would leap out of the river, rushing to put on armour, stretching and twisting and running to see the enemy. The *David* and the *Bathers* have something else in common. The Florentine army in *The Battle of Cascina* aches and strains to see the enemy. But that enemy is invisible to us, just as there is no monstrously vast Goliath for David to look at. There is a particular unease to the way these heroes face a danger urgent yet invisible: surely what it does is to transfigure Michelangelo's heroes from the real world to a larger cosmos of the imagination. Yet what it also achieves is to destroy complacency: to prevent any resolution of the moment the work – portrays? No, *portrays* is not

the word: *enacts*. The *David* and the bathers of Cascina enact alert-
ness. They are awake. And because the goad to their wakefulness
is unseen, it is also unfixed – it might be tyranny, it might be death.
What matters is the wakefulness, the fully conscious state, that
Michelangelo's unclosed heroic drama creates.

So he was not only competing with Leonardo but also setting
out to complete his conquest of Florentine public space. The citizen
approaching the Piazza della Signoria would first see the *David*
framed against the Palazzo Vecchio, its white form casting a long
shadow: then would go through the Palace to the Great Council
Hall, where the colossal *Bathers* rushed to fight the invisible enemy.
The entire sequence would be a monumental theatre, in which
the citizen was the true actor, for all these nudes urged a state of
mind identical to theirs. They were not so much depictions of
primed energy as trumpet blasts to awaken it.

* * *

The Battle of Cascina portrays a real moment in history, is scrupu-
lously close to a written source – and yet it comes from deep within
Michelangelo's artistic personality. At the very beginning of his
life as a sculptor he created a work that already contains it: the
giant nudes he drew that winter, as 1504 became 1505, on his vast
sheet of paper in the Hospital of the Dyers, echoed a work he
had sculpted when he was a teenager. If you look at the stains on
a wall, said Leonardo da Vinci, you may see various forms
including battles. When he was about seventeen, Michelangelo cut
into a slab of marble and found a writhing mass of human bodies.
It is as if they have welled up in the shallow pool he carved out
of the rectangular vertical block, as if they are swarming from the
stone and taking shape before our eyes. Base matter becomes form,
yet in the very moment of assuming recognisable shape, these crea-
tures strangle, stone, club and crush one another.

The poet Angelo Poliziano started it. When Michelangelo was
living in the Medici Palace, this erudite author suggested to his

young friend that the Battle of the Centaurs might make a good subject for him.[1] He told Michelangelo the story, related in Ovid's *Metamorphoses*, of how the centaurs, those half-human, half-horse monsters, were invited to a wedding by their human neighbours the Lapiths; how it all went fine until the centaurs got drunk and tried to carry off the Lapith women; how a frenzied, savage battle broke out.[2] It was a myth richly suited to art, full of visual challenges: the impossible centaurs to portray realistically, as well as the vast variety of poses that battle unleashes, which had been studied so powerfully by another artist in the Medici orbit, Antonio del Pollaiuolo, in his print *Battle of the Nudes*.

In Pollaiuolo's engraving a group of nudes have met in a forest clearing to fight one another: it is a dream of struggle, almost an image out of a folk tale or an uncanny mass vision like the army seen in the sky over Arezzo in 1494. The men fight with swords, bows and arrows, axes and daggers: like gladiators, they slaughter one another for our delectation. The battle displays the authority and excitement of the nude: the men are seen from different angles, in poses that mirror and complement one another, revealing the artist's ingenuity in manipulating the human figure. Yet it is disturbing: the full beauty of the nude seems only to be revealed in violence; the strength and agility of these men's bodies is at its most heightened in the moment they kill one another. This print is one of the few works that can meaningfully be said to have 'influenced' Michelangelo. Engraved in about 1470, it would certainly have been available to consult in the Medici Palace, where he could also see more monumental works by Pollaiuolo – his three large-scale paintings of the Labours of Hercules, done in about 1460, lost now but recalled in two small painted panels by Pollaiuolo in the Uffizi Gallery. In one of these, Hercules lifts the giant Antaeus, whose strength derived from the Earth, right off the ground: this wrestling scene is even more Michelangelo-like than *Battle of the Nudes*. The tremendous crushing of Hercules' powerful back as the body of Antaeus presses down on him from

above must surely have been studied fervently by the young sculptor in Lorenzo's house – it is exactly the kind of sensual suffering he discovers in the marble as he chisels out his *Battle of the Centaurs*.

The close-quarters fighting in *Battle of the Nudes* and, even more, the grappling, lifting and squashing together of bodies in Pollaiuolo's *Hercules and Antaeus* gave the young Michelangelo something he needed. Pollaiuolo saw that nudity in art did not have to mean beauty. It could also mean terror, cruelty, pain and death. Michelangelo, when he was seventeen and for the rest of his life, could relate to that. His *Battle of the Centaurs* takes up the compression and claustrophobia of Pollaiuolo's cruel nudes. Just as the older artist's naked men battle in a clearing that is cut off by tall vegetation behind them – a natural arena – Michelangelo's struggling bodies are trapped in a shallow basin with no room for manoeuvre. They can only throttle and pull hair – and hug. For there is an ambiguity here that has nothing to do with Pollaiuolo: where his wrestling men only wrestle, some of the grapplings in Michelangelo's relief are more double-edged. Embraces become strangulations, assaults marriages. The intertwined struggles are somehow larger, more universal than Pollaiuolo's. Where his predecessor had studied the nude in a new and harsh way, Michelangelo transfigures it into an allegory of life. The *Battle of the Centaurs* is manifestly an image of life as mortal combat; the world as a battle in a locked room, humans as helpless lovers and enemies condemned to grapple one another in this world's stony prison. At the heart of the battle of life is a man with his back to us. His spine is a deeply cut line rising diagonally as he stretches towards the left. The same back will appear in the same pose, reversed in direction, in the cartoon for *The Battle of Cascina*.

* * *

Michelangelo's most moving preparatory work for his cartoon is an almost invisible sketch in misty black chalk that survives in the Uffizi Gallery,[3] its figures as if fading before your eyes into the

heat haze of that day beside the Arno. Some of them reach forward, away from us, in a sloping pyramid of foreshortening whose dynamic sense of the body moving in three-dimensional space potently transliterates Michelangelo's sculptural genius into pictorial art: the spectacular dispositions of the Sistine ceiling are already here in a nutshell. The bathers in this little drawing are, unequivocally, bathers: the men climbing out of the Arno onto the shore show their buttocks directly to us, and one man bends over just like Diana or Susanna in later bathing scenes by Titian or Tintoretto. In other words, it is both sexually charged and feminising: and emotional. Michelangelo portrays in this little drawing a community of nudes who help one another, rely on one another and are collectively imperilled. Their alarm is like that of a herd of gentle animals – they seem more boyish than heroic, they seem vulnerable.

* * *

The visitor was handsome and courtly, with fine, long hair and the manners to match. He had come there to learn from the best, to watch Michelangelo and Leonardo at work and assimilate their styles into his own. That very desire shows how different a person Raphael was from either of his elders. He was an orphan, brought up in the painting workshops of his native Umbria. His father, a painter and poet at the court of Urbino, had died when he was eleven, and Raphael's lifelong quest for grace and harmony, in art and life, might be seen as a search for reassurance, for a structure to his existence. He was calm and frank in his internalisation of other artists' styles: first his father's, then that of Perugino, the most famous artist in Umbria at the turn of the sixteenth century. Raphael could afford to relax about his own individuality. He was a prodigy, like Mozart. The perfection of his touch is there from the very start, and by the time he was twenty-one he could create a work as sublime as *The Marriage of the Virgin*, his heavenly vision of a piazza in the open countryside that recedes

towards a many-sided domed temple, with an airy loggia all round it and a view through its interior of the clear, bright sky beyond.[4] It is a place you want to visit, but it is more perfect than any real building – although Raphael's friend Bramante did try to create perfections like this.

Raphael was hypnotically drawn to the competition between Leonardo and Michelangelo. He visited the workshop at Santa Maria Novella and drew works in progress by Leonardo – including *Leda*, in the alternate version of this long-nursed composition that shows her standing upright, embracing her swan.[5] He looked long and hard at the *Mona Lisa*, the *Virgin and Child with Saint Anne* and the unfinished cartoon for *The Battle of Anghiari*. He also followed Michelangelo around, presumably at a safe distance from the volatile man who was eight years his senior, and drew the *David* from behind. He sketched other sculptures and paintings Michelangelo was at work on, the constellation of designs that were born, or not, at the same time as the cartoon of the *Bathers*.

For the Cathedral Michelangelo had accepted a contract in April 1503 to sculpt twelve gigantic Apostles as his follow-up to the *David*. He only ever made much headway on one, St Matthew. For a family of Flemish cloth merchants he was carving a statue of the Madonna that is another masculine riposte to Leonardo's melting Madonnas – the mother of Christ sits coldly upright, her son is a nude boy who also stands, leaning on her lap, already conscious of who and what he is. Leonardo's childish intimacies of John and Christ and his enfolding maternal couples are replaced by a vertical shaft of strength.

Raphael saw the serious game the two artists were playing, the feints and insults as they rivalled and rejected one another's poses, tones, mentalities, and he replays it in his own art. In paintings that he made as he internalised this spectacle, he perfectly juxtaposes, and unifies, the contemporaneous works of the two masters. In his *Madonna of the Goldfinch*, a Christ visibly adapted from the infant hero in Michelangelo's *Bruges Madonna* rests against Mary's

lap and looks, in a Leonardesque way, into the eyes of his friend John the Baptist as they play together with a pet bird; Mary puts her arm on John's back and looks tenderly downward, smiling gently, just like the Madonna in Leonardo's St Anne cartoon. Raphael's *Madonna of the Meadow* contrives a very similar synthesis, and in his *Bridgewater Madonna*, the flying, fleeing Christ Child of Michelangelo's *Taddei Tondo* is placed in the arms of a mother of Leonardo-like tenderness.[6]

What does Raphael identify as the contrasting traits of the two artists? He was an eyewitness to their struggle for supremacy, after all, and we are not – and besides, he looks at them with the eyes of genius. In these paintings by Raphael it is not simply different poses that are borrowed from Michelangelo and Leonardo. He identifies them with two different principles. Michelangelo is energy. The sideways, soaring movement of the child in Mary's arms in the *Bridgewater Madonna*, the determination of Christ to stand upright – the strident, passionate fluency of Michelangelo's art – are unmistakable in Raphael's quotations. But this is balanced by the courtly Raphael with the softness of Leonardo, the yielding, enveloping quality of his compositions and his painterly delicacy of tone. It is no mere simile to compare Raphael with a courtier, intelligently recognising the best qualities in both older painters and weaving their antitheses into a civilised synthesis. He was famous for his social graces, for being a model courtier as well as a great artist. One of his closest friends was the diplomat Baldassare Castiglione, whose *Book of the Courtier*, published in 1528 and widely translated in the following decades, became the guide to civilised behaviour for every socially ambitious sixteenth-century European. In it Castiglione – quoted here in the Tudor translation that introduced Leonardo and Michelangelo into the English language – encourages the courtier to take a tolerant and pluralistic attitude to artistic style: 'Behold in painting Leonardo Vinci, Mantegna, Raphael, Michelangelo, George [Giorgione] of Castelfranco: they are all most excellent doers, yet are they in working unlike . . .

everie one is knowne to bee of most perfection after his manner.'[7] In Florence in the early years of the sixteenth century Raphael is already reaching the gracious view later to be expressed by his friend Castiglione that each great artist excels equally 'after his manner'. Neither Michelangelo nor Leonardo is the 'best': in talents of this order you can only compare their differences, and recognise their aesthetic personalities. Raphael does that in his paintings.

This is a powerful insight into what it was, this competition between Leonardo da Vinci and Michelangelo. It was a recognition that such a thing exists as a personal artistic style. There had been artistic competitions before. But what sense of the two artists' personalities do you get from Brunelleschi and Ghiberti's rival reliefs of the Sacrifice of Isaac in the Bargello? None at all. They are simply competing craftsmen: the better work is the more technically proficient. You can't for one minute conclude that Ghiberti was more emotionally involved in the scene, that he identified more deeply with the boy waiting to die or the father ordered by God to carry out this terrible deed – there is absolutely no sense that either artist personally engaged with the story in that way.

A century later, the competition between Leonardo and Michelangelo was fundamentally different. Personality was at stake. The two artists were being compared and contrasted in their dramatically dissimilar styles rather than being given points for technical merit.

This was really something new. It was unimaginable before, among painters and sculptors. Artistic personality was coming to the fore for the first time in history. Leonardo da Vinci and Michelangelo Buonarroti did have something in common: their works' wilful singularity. Leonardo and Michelangelo were 'themselves', and themselves alone, as artists, in a way no one had ever been before. The confrontation that came about in Florence in 1504 was the consequence and acknowledgement of this.

Leonardo's notebooks, his misty painting style, his very evasiveness and complexity in his working habits, set him apart – and Michelangelo's gravitas, strength and self-consciousness set him apart, in parallel with his rival. Their competition arose because Florentines could see this and were enthralled.

It was the recognition of Leonardo's inner mind, his imagination on view, in Florence at the start of the sixteenth century that had begun this new way of looking at art. In flocking to see a mere drawing for an unfinished work at the Annunziata, people were admiring the personal nuances of Leonardo's style, the 'genius' of the artist, rather than welcoming one more addition to the city's collection of beautiful images. He took the same approach to his commission in the Great Council Hall, setting out to design a vast cartoon at Santa Maria Novella. People could witness his mind, his fantasy, the process of his art, even before he began to paint. And when Michelangelo entered the fray with him in the autumn of 1504, that was the challenge he took up: he threw himself into drawing, and composed a cartoon at the Hospital of the Dyers so people could see that he was just as personal, just as manifestly himself. It was a competition in idiosyncracy.

If this was the history of a battle, we might say that Leonardo was the first onto the field, had his choice of territory and time to prepare his positions, but that he diffused his forces over the landscape and failed to prepare any defences. Michelangelo, coming late in the day but with his army of nudes superbly trained and resolute, thrust straight into the middle of Leonardo's scattered ranks with a crushing, devastating attack. While Leonardo was away from Florence in November, Michelangelo was massing his men. By the time Leonardo returned in time for Christmas 1504, the daring raid on his camp was well under way.

Michelangelo, to look at it another way, had more to prove. The *David* was a sensation, but its maker was still regarded as essentially a brilliant sculptor. Leonardo was seen as a great artist in a much larger way. 'And those capons of Milanese really believed

in you?' – Michelangelo's bitter question was also a reluctant recognition that an aura of enigmatic genius hung around Leonardo. The real challenge Michelangelo took on in 1504 was to show that he too was a thinker, a visionary, to make the personal nature of his art impossible to ignore. You can see a change in his entire conception of himself as an artist during his competition with Leonardo. In these years he was working on a spectacular range of sculpture commissions: as well as the Apostles in Florence there was a series of statues for Siena Cathedral. But these projects fell by the wayside. Only one Apostle was even begun. For Siena he turned out hack work. He didn't care. Why? Because these were old routines. It might seem as if he rejected everything about Leonardo. In reality he was learning from Leonardo, and what he saw was a bigger, bolder way to be an artist.

To Michelangelo, the notebooks with which Leonardo's workshop and *camera* at San Lorenzo was stuffed must have looked like what their editor J-P. Richter called them in the nineteenth century: 'The Literary Works of Leonardo da Vinci'. It cannot be coincidence that it was during their competition that Michelangelo started to produce his own 'literary works'. His first fragments of poetry are on sheets that also carry drawings for *The Battle of Cascina*.[8] Not only that, but on some sheets of paper he seems to be deliberately mimicking the heterogeneous richness of Leonardo's notebooks. Verses are juxtaposed with drawings of rich architectural decoration and, on the sheet's other side, a statue design with a battle sketch and stray, mysterious lines of poetry. The fact that he's imagining architectural details is itself significant: Michelangelo was not yet an architect, but here, as he confronts the polymath genius of Leonardo da Vinci, he is imagining forms that in fact do resemble the masks and grotesques that decorate his later interiors. He's thinking big, expanding his idea of the artist's role. Why not do everything?

And why does art have to be finished? The greatest lesson Leonardo had to teach Michelangelo was the most dangerous. The

supposed flaw in the older artist's character that made him delay and evade and fail to finish his works was a succinct way of differentiating genius from mere craft. The products of genius are worth studying even if they are only notions, rough drafts, sketches: that was what Leonardo proved when he won acclaim for 'mere' cartoon drawings. It was also the lesson of the Horse of Bronze, and for all his coarseness about it, Michelangelo understood this. During his stand-off with Leonardo he became less the efficient artisan and more prepared to leave works unfinished. He had failed to finish things before, it's true, but for practical reasons. However, his statue of St Matthew, begun for Florence Cathedral during the years of the competition, is a masterpiece whose very poetry lies in its being unfinished. It is the first of his sculptures in which, as Matthew's form emerges in fragments and feints from the mottled block, wild stone becomes part of the work's meaning. It is the sculptural equivalent of Leonardo's tantalising drawings: a stone *schizzo*, a sublime sketch.

Michelangelo's supreme sketch was the gigantic cartoon he was drawing at the Hosptial of the Dyers. There is no explanation for the way it turned out except sheer competitiveness. In his great drawing he took Leonardo on intimately, on his own ground – as a draughtsman, and as an eccentric. If Leonardo was putting his own preoccupations into his design at Santa Maria Novella, well, Michelangelo would push the personal preoccupations of his own work to the edge of complete self-indulgence. His cartoon trumpets individual passion and disdains explanations.

At Santa Maria Novella the personal nature of Leonardo's battle cartoon had been clear from the start. His sketchbook of horses records his continuing quest to understand nature – and that completely individual quest continued into the cartoon itself. As he drew it, two massive horses' rumps took shape on the great sheet of paper, parallel to one another, like two planets. The horses were rearing up – like the first design he'd submitted, long ago, for the Sforza monument, and like the rearing, thrashing horse he

drew from life in his sketchbook. The horses in his cartoon were the wild children of his spectral bronze steed: they were fearsome beasts, ogres of the equine. Not the grace but the power of the horse. It was not an aspect of his cartoon dictated by history, or by the Florentine Republic, this monumental revelation of frenzied horses. It was part of his artistic biography and a reassertion of his reasons for making art.

But if Leonardo could draw these horses like great signatures at the heart of his battle picture, Michelangelo would go further. He would relentlessly concentrate on his own personal subject, the male nude. He would draw vast nudes, a whole crowd of them – and nothing else. No battle. No fighting. Just men getting out of the water, naked, and struggling to put on armour, racing to see the enemy. The oddity of it was the entire point. *The Battle of Cascina* was an essay in individuality: a declaration of artistic independence. No, it was more pointed than that. It was a deliberately grotesque exercise. Not grotesque because it was ugly, but in its fanciful freedom. It was a kind of joke. It was hyperbolic. It set out to leave no confusion. In all his works Michelangelo was drawn to the nude. Here, he flaunted it as an obsession – drew attention to his habit, dramatised his penchant.

To this day, *The Battle of Cascina* is a confusing title, hence its alternative moniker of *The Bathers*. The drawings of men fighting that he made early in his thinking are, I believe, essentially responses to Leonardo – as soon as he found his own idea he stopped drawing fighters and concentrated entirely on nudes. *The Battle of Cascina* was to be portrayed entirely through this vast scene of naked men. Michelangelo sought to outdo his rival in sheer abstract wilfulness.

* * *

In the Strozzi Chapel at Santa Maria Novella, in 1502, Filippino Lippi had finished a work of surpassing strangeness. Lippi's fresco *Saint Philip Exorcising the Demon in the Temple of Mars* portrays a dragon

being driven by an early Christian out of a hole in the steps of a classical temple. This temple is an architectural phantasmagoria: trophies of armour, jagged, violent statues, offerings and living sculptures decorate its weird semicircular niche inside while the god Mars – not a statue, but the god himself – stands on a plinth, raising a broken lance above his head, a wolf at his side. Around the surreal temple, colossal painted pilasters are covered with intertwining abstract creatures, garlands and foliage in white relief on a dark background. Even the people in the crowd watching the exorcism are out of the ordinary, with exotic faces and headgear.

Lippi, like Michelangelo, had been in Rome, where in the last years of the fifteenth century the buried corridors of the Golden House of Nero were rediscovered beneath the Esquiline Hill. This vast villa connected by a subterranean passage to the Palatine palaces was Nero's indulgent whim, a pleasure house that so shocked the Romans they consigned it to a *damnatio memoriae* and built over it. When a way into its underground passages near the Colosseum was found, artists lowered themselves on ropes to study by torchlight its curious paintings. These were the first ancient Roman paintings to be seen by Renaissance artists: up to then any knowledge of Roman painting, as opposed to sculpture, had come from descriptions by authors like Cicero and Pliny. Now, ancient frescoes could be compared with modern ones, and the artists were confounded by how unlike they were. The murals in the Golden House were free-flowing fantasies of colour and design: monstrous creatures, ornate tendrils, masks and foliage were strung together in random shapes juxtaposed with planes of pure colour. These monstrous fantasies were found in a cave, a *grotto*, so they were named *grotteschi*. Lippi's painting is one of the first to import the grotesque to Florence.

It is especially striking because the grotesque is not confined in it to the playful decorations on the painted pilasters. The entire painting is grotesque: a spirit of disordered fantasy has entered every aspect. The repulsive Temple of Mars, the living statues, the

piles of armour and clutter of offering vessels – it is all pleasantly deranged. Lippi's painting reveals how thoroughly the idea of the grotesque could be applied by a Renaissance artist – it wasn't just masks in the border. It was a release of disorder into the very core of a work of art.

Michelangelo had an appetite for the grotesque. Drawings of ornate capitals for columns that he did in 1503/4 have empty-eyed masks and interlocking gryphons in a free architectural play absolutely indebted to the Golden House and taking it, as Lippi does, as a licence to imagine monstrosities within a classical idiom: this would one day result in the extravagant freedom of his architectural master-piece, the Laurentian Library. This new understanding of art also destabilised his cartoon. Its bathers weren't ugly. But their arbitrary and self-pleasing display showed grotesque freedom.

The men in the cartoon were arranged in a complicated serpen-tine group whose convolutions created a tremendous sense of energy and panic. They were rushing and reaching in all direc-tions. Some had staffs. Some put on armour. An old man sat on the rocks pulling on his clothes, a garland in his hair. Two hands rose tragically from the river, as if someone had panicked and was drowning in the rush to reach the shore. The drawing of a nude sitting on the rocks, twisting round to face into the group, grew into a huge chalk figure in the cartoon. So did the man with his back arched, a deep black spine engraved into his jagged form. There was a dramatic creation of three-dimensional space, not in the landscape (which was just perfunctory rocks) but in the revolving figures: they seemed incredibly solid as they veered towards or away from the beholder. There was no consistent direction to their energy: they cut across one another, contradicted one another.

Michelangelo made his point. *The Battle of Cascina* was so personal it was befuddling. The subtleties of Leonardo's drawings were shoved aside by a bravura display of one man's manner.

* * *

Raphael's civilised idea that the differences between Leonardo and his competitor could be gracefully elided, that each man was perfect in his own style and these styles might be blended in an ideal harmony, was utopian. What he failed to see was that Leonardo and Michelangelo's opposition went deeper than style. It was as if they had been born for this moment, so absolutely did they negate each others' personalities. They saw the world and humanity in radically different ways.

As Leonardo came back to Florence from Piombino in mid-December 1504, his rival was speeding ahead. By the following February, when Michelangelo received a payment from the Signoria for his work on *The Battle of Cascina*, it seems the young contender had drawn much of his nude composition. And yet, the records contain a surprise. Leonardo, too, was satisfied he'd done enough on his own cartoon to start painting in the Great Council Hall. In February 1505 work began to erect scaffolding there. It would take until June for him actually to set his brush to the wall – and as well as building a scaffolding as complex as the one he'd created at the monastery, he was still buying more cartoon paper.[9] But now history, in the person of Pope Julius II, intervened to make Leonardo's life a bit easier.

Il Papa sits melancholically on a throne decorated with the massive gold acorns that symbolise his family, the della Rovere, in his portrait by Raphael. Huge emeralds and rubies decorate his fingers, a long white gown falls like a waterfall over his knees. His new-grown white beard bristles beneath a face of compassionate authority. Raphael's reverence for order finds its perfect expression in this painting of the father of the Church that was to provide a template for later portraits of seated popes by Titian, Velázquez and Francis Bacon – but few written accounts of Julius II make him seem so gentle. When Giuliano della Rovere, Cardinal of St Peter in Chains, was elected pope in his sixtieth year in October 1503, he set out to restore the might and prestige of the Church – a work he interpreted as secular and indeed military. In Italy's

age of war, he was the Warrior Pope. Where the Borgia pope had placed his son at the head of the papal armies, the new pope would lead his own campaigns. Julius set out to reconquer Italian cities, including Bologna. From this springboard he attempted to forge a grand alliance to drive the French out of Italy, to expel these 'barbarians' and restore Italian liberty under the leadership of Rome. This imperial pope, who took the name Julius to identify himself with the greatest Roman soldier of them all, also took mighty steps to renew Rome itself, to restore the city to a glory that matched and even outdid the Caesars: the seat of the popes would become truly imperial and impressive, a city to overwhelm pilgrims and amaze ambassadors, not just with ancient ruins but with brand-new structures that revived the antique.

The process of rebuilding had begun under Sixtus IV (1471–84), who created a gracious new bridge over the Tiber with advice from Alberti. It continued under Alexander VI, who transformed Hadrian's mausoleum by the river into a richly appointed papal fortress. With Julius, however, a truly ostentatious new Rome began to rise. The architect to whom he entrusted his stupendous ambition was Bramante, who had been one of Leonardo's friends at the Milanese court; they shared ideas just as Leonardo did with Francesco di Giorgio. When their employer Ludovico Sforza was driven out of Milan and both men had to flee, Leonardo listed Bramante's architecture among the things he mourned and lamented:

The small hall above for the apostles [i.e. the *Last Supper*].
Buildings by Bramante.
The castellan made prisoner.
Visconti dragged away and then his little son killed.
Gian della Rosa robbed of his money.
Borgonzo began and . . . his fortunes fled.
The duke lost his state, his things and his liberty, and none of his works were finished by him.[10]

While Leonardo painted the *Last Supper* in the refectory of Santa Maria delle Grazie, his friend Bramante was rebuilding the choir of the monastery's church, right next door to the long Gothic hall where Leonardo was working. Indeed, their conversations on architecture, perspective and illusion are nakedly recorded in their works that survive in Milan. Bramante's choir resembles some of Leonardo's architectural drawings, while the *Last Supper*'s eye-fooling perspective is intimately related to Bramante's architecture. In the church of Santa Maria presso Santo Spirito in Milan, in the late 1470s, Bramante had created an exactly parallel effect, a barrel-arched chancel that delights you when you realise it is an illusion, a shallow stone theatrical device that creates the fiction of a far larger space. Leonardo and Bramante were both, in Milan, experimenting with architectural fictions and dreaming of temples.

In 1502, the Spanish monarchy commissioned Bramante to build a small chapel to St Peter where he was said to have been crucified, on the Janiculum Hill in Rome. The architect created a circular temple with a dome, an upper storey of recessed niches, a balustraded parapet and a lower storey of smooth colonnades surrounding a circular room with four doors. It is not so much a building as a vision of what buildings might be like, a manifesto for classical harmony and perfection that mirrors Bramante's young friend Raphael's vision of the ultimate temple in his painting *The Marriage of the Virgin*. Bramante's Tempietto has a lot in common with Leonardo's drawings of centrally planned churches. It was the first fully fledged Renaissance 'temple' to have been built in Rome, and right at the start of a new age of building it introduced a form this city would take on to bigger things – a form Bramante, like Leonardo, loved: the dome. Bramante's Tempietto impressed the new pope. In 1505 Julius gave him a magnificent task – to build a new palace, the Belvedere, that would take up a vast area of the Vatican with three gargantuan courts, so large that a niche in one of them can hold a colossal pine cone found on an ancient Roman chariot course and make it seem

entirely appropriate and in scale. The Belvedere would transform
the Vatican into a secret city of power and mystery. Its scale and
audacity revealed a direct attempt to rival the vast palaces of the
Roman emperors on the Palatine Hill.

Raphael's portrait of Julius contains a truth. Julius was sensi-
tive – at least when it came to art. It went with his rage, was the
obverse of his mercurial temperament. Machiavelli characterised
the pope whose election he witnessed as a man of unstable,
emotional character who was lucky enough to rule at a moment
when spontaneity was the right stuff: 'Pope Julius II proceeded
impetuously in all his actions, and found times and matters so
suited to his way of proceeding that things always turned out well
for him.'[11] This 'impetuousity' led him to start wars overnight, but
it also made him a generous and enthusiastic patron with an eye
for the very best. Before he became pope he had employed Giuliano
and Antonio da Sangallo as his architects, and in 1505 Giuliano
moved from Florence to Rome, expecting the relationship to
continue: but Julius saw that Bramante was better. He made an
instinctive decision to give Bramante one of the biggest architec-
tural jobs in history and he was right. The secret of Raphael's
portrait is that Julius really did have an inner life: there is no other
way to explain his patronage. In February 1505, it was
Michelangelo who got the call.

It was said that Sangallo had praised the young sculptor to the
pope and urged him to hire his fellow Florentine citizen. Doubtless
he did, but there was also of course physical evidence in Rome
to persuade Julius that it was worth hiring this artist he had not
yet met. Just as Bramante's Tempietto was a sublime calling card,
so were the sculptures Michelangelo had carved in Rome in the
1490s – his *Bacchus* and *Pietà*. In fact, Pope Julius was the uncle
of the cardinal who first brought Michelangelo to Rome and
commissioned the *Bacchus*. Maybe word spread through the della
Rovere family. However it happened, by the end of March 1505
Michelangelo was in Rome squaring up to a project as stupen-

dous as anything Julius had yet imagined. Julius wanted the young artist to build his tomb. Giuliano della Rovere rose to the Holy See at sixty; he knew time was short. As Machiavelli saw it, this was part of his success, for 'the shortness of his pontificate did not permit him to taste failure'. As he paced up and down inside the awe-inspiring stone drum of the emperor Hadrian's tomb which was now a papal fortress, the Warrior Pope craved a mausoleum of his own. Michelangelo in the city below was eyeing the Tiber, thinking how he might bring great blocks of marble down the river for this gargantuan work.

THE GREAT SWAN

Leonardo da Vinci thrilled with excitement at the great work he was about to accomplish. His cartoon for *The Battle of Anghiari* was ready to transfer to the wall in the Great Council Hall, a team of workers was assembling his scaffolding, and Michelangelo was in Rome, apparently out of the fight. Leonardo was making plans, precise last-minute designs, and getting everything ready. It wasn't the battle painting that so enthused him, however.

Walking and riding out into the Florentine countryside that spring, he watched birds of prey hovering in the air. It entranced him how a kite could hold its position in the sky, rigid in empty space, preparing to dive in an instant when it spotted something far below. He marvelled at how birds would mysteriously glide upward, exploiting updraughts to rise without even flapping their wings. All the secrets of bird flight astonished and delighted Leonardo, but his interest was not only in observation. Heading north out of the city, you approached the big sloping back of Monte Cecere, 'Swan Mountain', in whose flank nuzzled the ancient town of Fiesole. From that high hill the view of Florence was glorious, the city spread around its russet dome on the yellow plain. The very name of the mountain associated it with a picture Leonardo was working on, his nude painting of Leda, the ancient nymph seduced by Jupiter in the shape of a swan. In a copy probably done by one of his assistants on *The Battle of Anghiari* in around 1506, Leda stands above her newborn children in a rich Tuscan

landscape, in a secluded spot by a pond protected by a mossy over-
hang. She embraces the coiling neck of her swan lover while her
babies hatch from their eggs. A distinctively shaped mountain in
the distance could almost be Monte Cecere itself.

'The great bird will take its first flight from the back of the
great swan, filling the universe with amazement and filling all writ-
ings with its fame and bringing eternal glory to the nest where it
was born.'[1] Leonardo's prophecy appears on the cover of a note-
book he filled with studies of birds and flight in the spring of 1505.
Another equally allegorical promise is on a sheet in the same book
that helpfully bears the date 14 April 1505: 'From the mountain
that takes its name from the great bird the famous bird will take
the flight that will fill the world with its great fame.'[2] In the midst
of his labours for the Florentine Republic, he was planning the
first human flight. His apparently arcane statements become
completely clear from the other notes in his codex *On the Flight of
Birds*. Leonardo was about to test a flying machine from Monte
Cecere just outside Florence. It was going to bring infinite renown
to him and his Florentine 'nest'.

It seems the most remote distraction imaginable from the Great
Council Hall. Yet it was not quite that simple. Leonardo's mind
saw connections others failed to make. For one thing, the flight
experiment was an attempt to awe and amaze Florence, to reassert
his fame independently of the competition with Michelangelo.
Whatever people thought of his slowness in the Great Council
Hall, they would be impressed when they saw his flying machine
in the sky. At a more intellectual level, his flight attempt in 1505
grew directly out of his researches for *The Battle of Anghiari*. All
the drawings he made in 1503–4 of horses rearing and galloping,
his studies of equine speed, led him into a study of bird flight.
Behind both lay a desire to cross between the human and animal
worlds.

Leonardo grew up with an empathy for the animal kingdom.
One way he expressed it was through vegetarianism. 'Man and

the animals are properly the transit and the conduit of food, the sepulchre of animals and hotel of the dead,' he exclaimed in a passage that suggests his disgust with meat-eating.[3] He himself did not eat meat, reveals a letter in 1515 in which Andrea Corsali tells Leonardo's patron Giuliano de' Medici about a group of people who are vegetarians – like Leonardo da Vinci, he comments.[4] Lists of food and recipes in the notebooks refer to '[b]eans, white maize, red maize . . . kidney beans, broad beans, peas' and to a sauce or paste made with parsley, mint, wild thyme, burned bread, vinegar, pepper and salt.[5]

Just outside the Tuscan hill town of Vinci you can visit the simple stone dwelling in one of whose bare, tall rooms the artist is traditionally said to have been born. The setting of this rustic house, surrounded by olive groves and yellow grass, probably wasn't the actual location, yet it movingly conveys the world in which the future vegetarian first set eyes on blue skies and gliding birds. Even today, Vinci is set amid an unspoiled and abundant landscape. Vines and cypresses fill the valleys below. You can ramble from its sloping streets into meadows and woods. Until he was about twelve years old Leonardo lived in Vinci, in his grandfather's house, and his lifelong feeling for and knowledge of nature took shape in this town and its countryside. In his notebooks are exquisite drawings of flowers and plants he'd have found in the first landscape he knew: blackberries, oak leaves, flowering anemones, rushes, reeds, Job's Tears and Star of Bethlehem. He draws these plants with acuity, tenderness and precision. In his writings, as he gives advice on how to paint landscapes, he imparts sharp memories of rural vistas: 'The dark colours of the shadows of mountains at long distance take on a very beautiful blue, simpler than the parts that are illuminated, and from this it is born that when the rock of a mountain is reddish the illuminated parts are of violet, and that the more they are illuminated the more they reveal their proper colour.'[6] In a passage like this you can see Leonardo standing in a valley in the afternoon, contemplating the distant hills – his

observations of nature so manifestly come of a lifetime's exploring the Italian countryside.

Leonardo records, in the Codex Atlanticus, a childhood memory in which the natural world is not simply something to be contemplated and admired but an enveloping power, a surrounding and overwhelming presence that becomes, in the strangest way, part of him – literally enters him. In a note on the flying techniques used by birds of prey, he observes: 'This writing clearly about the kite appears to be my destiny, because in the first memories of my infancy it seemed to me that, when I was in the cradle, a kite came to me and opened my mouth with its tail, and many times struck me inside my lips with its tail.'[7] This is an extraordinary recollection, and Sigmund Freud made it the central piece of evidence in his book *Leonardo da Vinci and a Memory of His Childhood*. For Freud, it is unlikely to be a literal memory and rather resembles a fantasy formed in adulthood and imagined to have taken place in infancy.[8] His interpretation of it is erotic and also has to do with mothers, for he relied on an inaccurate translation that turned 'kite' into 'vulture' and so encouraged his speculations on the vulture-headed Egyptian mother-goddess Mut.

Leonardo did not believe this memory was a 'phantasy'. He tells it not as a fable or dream, but as an exact recollection of something that happened to him in the simple stone house in Vinci, 'in the cradle'. Growing up so close to nature, he remembered that he was actually penetrated by nature – it got inside him. For Freud the penetration was sexual: he explicitly interprets the tail in the mouth as a fantasy of fellatio.[9]

This is one way of looking at it. Another would take Leonardo's experience more literally. It is not, after all, a bony mammal tail but the feathery tail of a bird that he believes struck him on the lips repeatedly: it was, whatever else it was, an intimate, life-changing encounter. Leonardo believes he was altered by the experience – he gained special knowledge. He can 'write clearly of the kite' because of the close oral encounter he had with one as a

baby. Far from being a metaphor for hidden sexual content, this makes complete sense within the mental universe revealed by Leonardo's notebooks – a mental universe in which humans and animals are constantly meeting, merging and melting into one another.

If Leonardo's earliest memory involves an unusual encounter with the animal kingdom, so do his recorded dreams. In his notebooks he writes enigmatically of dreams, and in the examples he gives, conversations with animals play a prominent role. It's surely his own dream life he reveals when he says that people 'will hear animals of every species speaking in human language', and again that when you dream, 'you will speak with animals of every kind, and they with you in human language'.[10] In his mind, it appears, Leonardo inhabited a realm in which birds might visit him in his cradle and horses, dogs or cats speak with him. It sounds like the experience of a shaman.

Science, for Leonardo, is the study of the natural world. In this he looks back to ancient writers such as Pliny the Elder, and forward to Charles Darwin. He insists that natural processes have their own laws and logic and can be understood through experiment. He excludes 'spirits' and magic from the powers he believes shape the physical world. He also debunks the theological belief in humanity's uniqueness. In Leonardo's notebooks, human beings are animals, and our bodies work in ways essentially similar to those of other creatures. In Renaissance philosophy, as in the traditional teaching of the Church, man is a spiritual being: God, said the fifteenth-century intellectual Pico della Mirandola, set humanity between the beasts and the angels and told man: 'I created thou a being neither heavenly nor earthly, neither mortal nor immortal only, that thou mightest be free to shape and to overcome thyself. Thou mayst sink into a beast, and be born anew to the divine likeness . . .'[11] Such metaphysical visions of humanity do not interest Leonardo at all. He sees human beings as organisms among other organisms, and his notebooks pursue not the

hidden but the visible truths of nature. To see what is inside, he dissects. To discover the seat of the soul, he makes a cast of a brain's interior.

Leonardo's vegetarianism is a clue to his distance from traditional theological conceptions of the hierarchy of being. In the Book of Genesis, God specifically tells Noah and his sons after the Flood that animals are food for them: 'The fear of you and the dread of you shall be on every beast of the earth . . . Every moving thing that liveth shall be meat for you.'[12] In the notebooks of Leonardo da Vinci we encounter the opposite of this confident affirmation of man's superiority to the creatures and his unique place in God's creation. The human species is just another variety of animal: this understanding is central to Leonardo's most accomplished campaign of sustained scientific research, his dissections of human and animal bodies, which he recorded in unrivalled drawings now in the Royal Library, Windsor. In planning a book of anatomy, Leonardo makes an observation almost in passing that anticipates Darwin: '*Man*. The description of man, which in it contains that of those animals almost of like species, such as the baboon, the monkey and suchlike, which are many.'[13] And he stresses the close relationship between humans and other primates on another sheet: 'Write the variety of the intestines of the human species [*delle spetie umana*], monkeys and the like.'[14]

Even his casual reference to the 'human species' betrays an attitude very remote from that of the Bible or of Pico della Mirandola's oration 'On the Dignity of Man'. Humans are closely related to apes and monkeys – that is clear to Leonardo, the dissector of nature. Not only are we not fundamentally distinct from other species, we are not even uniquely effective or competent. He is fond of pointing out ways in which humans are weaker than other creatures – our eyesight, he stresses, is not very good compared with that of cats. Nor can we fly like birds.

Leonardo dissected more than ten human bodies in the course of his research, but he also dissected animals, and he assumed the

knowledge he got from studying pigs or cows could be applied to human beings – and this is where his thought becomes not so much an ancestor of Darwin as something altogether less recognisable. Leonardo blurs the anatomy of humans and other species in ways that cannot be rationalised as precocious evolutionism. In his most famous anatomical drawing of all, for example, he places a human foetus inside a womb that is partly human and partly that of a cow.

The baby curls up, a ball of shiny, warm flesh, with perfectly formed toes and a great dome of a skull, its umbilical cord coiling around a foot, inside a fatty chamber that has been opened as if it were the outer shell of a horse-chestnut. The exposed layers of the uterus wall are connected by interlocking protrusions like the teeth of gears: other drawings on the sheet analyse how these 'gears' interlock, designing, in effect, a science fiction version of the human uterus, just as if it were one of Leonardo's inventions for flying machines. For the nodes that, he imagines, must be part of the human womb's workings – called cotyledons – are actually not part of human anatomy at all. He had observed them in a dissection of a cow's uterus. So deep is his assumption that knowledge of other species can be applied to the 'king of the beasts' that he fuses human and cow.[15]

Leonardo dreamed of speaking with animals. He remembered a kite putting its tail in his mouth when he was a baby. In the light of these fantastical encounters, it is too rationalist to see his incorporation of cow anatomy into human biology as simply a mistake. It reflects a sense of concordance between humanity and the rest of nature, a mysterious integration of his own life into that of the world around him. This misting of distinctions defines his art. In one of his earliest paintings, the *Annunciation*, he depicts the angel's wings as real bird wings, with a loving and precise observation of how feathers fold together and a scientific curiosity about how wings might take root in a humanoid body: like his invention of the human-cow uterus, this is science fiction, a detailed fantasy

that imagines an angel as a real physical being with wings that appear to grow out of its shoulders in a very tangible, fleshy way.

Even before this, Leonardo might have been the creator of a little grey dog who walks along loyally in a painting of Tobias and the Angel from the workshop of his teacher Verrocchio. This dog is a sensitive creature, a lovable pet. Drawings done by Leonardo in the 1470s or early 1480s show, in a mesmerising attempt to capture movement itself in a flurry of poses, a toddler playing with a pet cat. Pets, in other words, are part of Leonardo's artistic imagination from his very early career in Florence. He tenderly depicts the way the child hugs and strokes the cat, and the cat in a blur of limbs struggles to escape.[16]

The fact that Leonardo shows the cat trying to wriggle free does not undermine the drawing's charm. It makes it real. The child's love of the cat is slightly clumsy. The same lifelike tension is stressed in drawings for a planned early painting of the Madonna and Child in which the young Christ was to play with a cat. Long afterwards, in *The Virgin and Child with Saint Anne*, one of his last paintings, Leonardo has Christ play with a lamb that again tries to get away – in both designs there's a lovely, acute realism in observing children with their pets. This surely goes back to Vinci and the young Leonardo playing with animals himself. But adults, too, have pets in his paintings: in his portrait of Cecilia Gallerini, poet and mistress of Ludovico Sforza of Milan, she shows off a pet ermine, holding her long fingers against its white furry body in a gesture at once gentle and firm. Where the children in Leonardo's pictures cuddle cats and lambs clumsily, Cecilia knows how to control a creature without hurting it. Again this is an exquisite observation of real animals, as creatures with wills of their own. His most ecstatically alive animals of all, however, are the frenetic, fast horses he drew in preparation for painting *The Battle of Anghiari*.

* * *

The cave is a glistening cathedral of crystalline spires, a place
made magical by electric light which suddenly becomes deathly
and isolating when you peer into the shadows. It is one of the
places humanity first became aware of its own mental equipment;
and you can still sense the danger of that discovery here, after
hiking into the village through a silent landscape pockmarked with
cavernous holes, climbing the mountain path and descending to
the painted grottoes of Pech Merle. Nature is so awe-inspiring in
this cave in the Cahors region of south-western France, geology
so imposing, that it is almost a disappointment to see the paint-
ings, drawings and engravings human beings made here long
before the invention of writing, or cities, or history. It takes a
moment, standing before a black charcoal image of a mammoth
in a dark gulf within the chaos of rocks, to realise the utter extra-
ordinariness of what you are seeing – a portrait by a Stone Age
hunter of an animal that has long been extinct.

Primal power and visceral energy course through Leonardo's intoxicated
horse studies for *The Battle of Anghiari*

Deeper in the dark, footprints survive in a muddy pool, left by the explorers of this place tens of thousands of years ago. An outline of a hand floats on a rocky overhang among a field of soft red spots: the hazy effect was achieved by putting pigment in the mouth and spitting it. The process may well have been toxic. All these painted images are surrounded by sparkling, orotund cascades and pillars of calcite-bright stone: and then you see the horses.

They materialise like spirits on a section of rock that stands alone, a vertical wall whose expansive flatness provided the artists with a natural painting surface. The black images they created by spitting charcoal pigment at the wall are at once horses and fields of dots. Two animals stand back to back, their hindquarters over-lapping: black circles fill their forms and spill out beneath them, making it hard to tell if the painters intended the misty discs as decorations for the horses or not. Each horse has a stylised thin black face on a triangular black neck, and they have slender legs that almost look moulded out of clay. One of the animals has a second, more realistic head around its heraldic black one, formed by chance, by the natural shape of the rock wall – did this shape suggest the horses? Did they literally grow out of the stone?

Across the millennia there's an undeniable affinity between the earliest paintings of horses and the drawings that Leonardo made when he was preparing to paint *The Battle of Anghiari* on a wall. His drawings of horses from 1503–4 have a raw and savage power as well as infinite subtlety. Sometimes the very species seems to regress as if, concentrating on their speed and fury, he was able to imagine the wild horses of prehistoric Europe. Big teeth, sucker-like lips, heads reduced to crude triangles – his sketches capture the horse in a primitive state. Yet there's something else, too. Cave-art researchers see evidence in the art and its dreamlike locations beneath the earth of shaman-like rituals. In cultures around the world, shamans induce trance-like states in which they seem to travel to other realms, to animal worlds. The paintings in caves

might be a record of visions, of animal other-worlds, a dream of communication with nature.

Leonardo's method of finding ideas by staring at a wall sounds like a shaman's way of inducing a trance or reverie. Gazing into the marks and stains and cracks, he says, you may see battles, faces, landscapes. How long do you have to look? He presents this as a practical method for the young artist, but it is far more than that. It involves relinquishing control, drifting into a daydream. As if to stress its peculiarity, Vasari ascribes this method not to Leonardo but to the eccentric painter Piero di Cosimo: 'He would stop some-times to contemplate a wall where for a long time sick people had been spitting, and from this would appear to him battles of horsemen [*battaglie de' cavalli*], and the most fantastic cities and vastest landscapes ever seen; and he did the same with the birds of the air.'[17] Piero may well have learned the method from Leonardo, who records in his notebooks that he also discussed it with Botticelli. But in making Piero the originator, Vasari associ-ates this strange procedure with that artist's anti-social, quirky personality and taste for the grotesque and fantastic. Piero di Cosimo painted scenes of the primitive world and wild moments from myth. If you look at his compositions, some look like ink blots, as if he were following Leonardo's method of accepting the images that take shape to an unfocused mind. Some of Leonardo's own drawings also undoubtedly look as if he is letting his mind ramble, his hand move rapidly and almost unconsciously, to produce an unruly image. For Vasari this is all very odd and irra-tional, and he can't bring himself to associate it with the divine Leonardo.

Dream images seem to well up in Leonardo's sketches for his battle painting. In his drawings of horses rearing, galloping, raging, there's something else – a visionary journey into the world of animals, perhaps. Anyway a rapturous quality as the riders in bloody red chalk are dwarfed by the might and power of their mounts. They blend with the horses as if sharing the same thought.

They are faceless, passive, sucked along in the horses' momentum, even appearing sexually aroused by the ecstatic speed.

On the same sheet as his early sketches for *Leda* – and on the reverse of a drawing of mortars pouring fire into Pisa – a grey horse rears up massively. It takes a while to notice its rider, palely, spectrally sketched over the animal's much more solid form: he leans over so that his head is in front of the horse's mighty neck, and this creates a prodigious effect. The man's face seems to merge with the horse's neck muscles: a hybridisation is occurring. A centaur is being born.[18] Half-man, half-horse, this phantom is the essence of Leonardo's drawings as he planned *The Battle of Anghiari*. He is not only observing horses. He is letting himself be dragged by them wherever it is they're galloping. Why does he draw all these horses, anyway? It is not just to find out what a horse looks like. It's a way of imbibing the horse, drinking in its life: as if he is absorbing all the speed, energy, fury onto a sheet of paper. Soaking up the horse's wildness. His drawings are his trance.

* * *

Leonardo discovered in these drawings an unrivalled ability to analyse motion with the naked eye. From horses, so fast they nearly fly, he looked up into the sky (as Vasari says Piero did) at the birds. His notebook known as *On the Flight of Birds* contains the most sustained scientific observation of the natural world by him that survives. He made it when he was in the middle of creating *The Battle of Anghiari*, in the spring of 1505. Here the acute observation of speed and energy in his horse drawings of 1503–4 becomes a much more explicit scientific enquiry. How do birds fly? How do they use those little feathery wings to move so easily in the sky? This is the mystery he tries to decipher simply by standing in the countryside between Florence and Fiesole, looking up. One page has beautiful, simple drawings of birds that might be swallows whirling, gliding, ascending. Beside the drawings Leonardo writes, 'Of the 4 reflex and falling motions of birds under different wind

conditions always the oblique descent of birds against the wind will be made beneath the wind. Their reflex movement will be made above the wind . . .'[19]

You can hear the wind in these words, see it in the taut drawings. The notes seem to feel their way through the sky, to register in words each twist a bird makes: it is a determined act of looking. Leonardo stands and stares long enough to become aware of when a bird is descending 'upon the wind', when it is 'beneath the wind'. A rich awareness of the air itself is essential to what he's doing; to describe birds he also has to describe the atmosphere they inhabit.

Turn the page, and the reverse of the same sheet – in the same ink, evidently written at the same time, in the same train of thought – is a surprise. A drawing shows a bird horizontal, and looking oddly stiff. Another diagram displays the inside of what appears to be a synthetic imitation of a bird's wing, with 'bones' worked by pulleys. Leonardo's note is at first confusing:

> Always the movement of the bird must be above the clouds so that the wing does not get wet and to survey more countryside and to flee the danger of the revolutions of the winds among the mountain gullies which are always full of winds going backwards and forwards. And beyond this if the bird turns itself upside down you will have lots of time to turn it over again with the orders I have given before it reaches the ground.[20]

What kind of bird is this? It is not a bird at all – not a real bird. Leonardo gives the name *uccello* to his flying machine, and talks about it as if it were the same as the birds whose mastery of the sky he observes so acutely. Even in the drawings on this page, the ambiguity persists: in fact it seems quite clear from these and other sketches in the notebook that in 1505 Leonardo is planning to launch a machine that imitates a bird in flight. His boast on the cover of the notebook is not just a metaphor. Throughout *On*

the Flight of Birds you are never sure when a note on living birds will mutate into a conclusion about the flying machine.

Leonardo's observation of birds soaring above him is not disinterested naturalism. He needs to understand how birds do it so he can overcome the apparently insuperable obstacles to human flight. By the time he made these notes in 1505, he had been designing flying machines for at least twenty years. In Milan he came up with a whole series of ideas for a vehicle to be powered by human energy that could lift its pilot into the air. In his various drawings an aviator lies flat beneath a heavy system of pulleys and pedals madly to operate the wings above, or sits in a bucket almost like a flying saucer pumping the wings up and down via an equally complex and heavy set of gears. These early designs do not look too promising, but he developed sophisticated details such as bat-like wings with a leather skin and vents to let through air on their upward sweep – he reiterates the need to imitate the membranous wings of the bat in his 1505 notebook.[21] He also devised a machine for testing the lift of his wing designs. A drawing in the 1505 codex still shows the flyer standing vertically as he tries to balance the bird. A note elaborates: 'The man in the flying machine has to stand free from his belt upward so he will be able to balance himself as in a boat in order that his centre of gravity and that of his instrument may constantly change balance where necessary because of a change in the centre of its resistance.'[22]

What is new in this attempt to fly in April 1505 is a focus on the sky itself, the way birds use the air. The way to fly, Leonardo reasons, is to become like the birds, because birds know how to save their energy. Leonardo seems to blame the previous failures – he apparently attempted at least one flight in Milan – on the impossibility of a human body producing enough power to raise its own weight (and that of a wooden machine). As he writes,

Maybe you will say that the nerves and muscles of a bird are known to be without comparison more powerful than those of man because all the fleshiness of so many muscles and of the flesh of the breast

goes to help and enhance the movement of the wings while the
breast bone is of one piece and so gives the bird the greatest power
. . . To which the reply is that such force gives it a power beyond
what it ordinarily uses to sustain itself . . .[23]

Here Leonardo's determination to fly melts again into his love for
the natural world. The technique of successful human flight has to
emulate the way birds conserve energy: they do this, he explains,
by gliding and riding the air. The human flier too must know how
to exploit updraughts and follow the winds. It's a skill. The machine
he plans in his 1505 notebook will have wings like a bat's, with a
leather membrane, and be constructed as lightly as possible, held
together with cords, avoiding the use of metal. But its success will
depend on flying it like a bird, steering its articulated wings with
pulleys to exploit and survive the currents of the air.[24]

A bird, Leonardo agrees, is stronger than a human being. It's
a confession of the less than perfect nature of the human form.
On the Campanile beside Florence Cathedral a cycle of four-
teenth-century reliefs carved by Andrea Pisano, perhaps from
designs by Giotto, includes an image of the Greek scientist
Daedalus, who escaped from Crete by making himself wings of
wax. Daedalus in this image is a bird-man: his entire body is
covered in feathers. In 1505 Leonardo was on the verge of
becoming a bird-man himself. His notes on bird flight are moving
in their sensitivity and captivating in their dream of flying – not
as humans eventually did learn to fly in powerful machines, but
in a light contraption of wood, silk and leather, navigating with
the freedom and grace of a bird.

There is no record of what came next, only those notes
announcing that Leonardo planned to launch his bird from the
mountain north of Florence. It would be wonderful to know if he
made the attempt, who was in the machine – and what happened.
Part of you, after reading *On the Flight of Birds*, half believes he
soared, for a perfect moment, in the blue.

Twelve

HELL'S MOUTH

Thunderclouds hung above the Piazza della Signoria, black and blue phantoms low over the pink tiles. The very statues shivered. The long finger of the Palace tower pointed high into the thickening air, daring lightning to strike. Through the courtyard, through the apartments, was the door into the gloomy Great Council Hall. Its low ceiling and inadequate window lighting made the darkness gather, the day's ill omens congeal, around Leonardo as he climbed the ladder to begin his painting on Friday, 6 June 1505. The cartoon had been brought into the Hall, carefully transported across Florence from the monastery so he could use it as the template for his wall painting. He had assistants with him to help with the work, but it was Leonardo who stood up there on the scaffolding, brush in hand, when suddenly the great bell of the Palace shook his bones with its sonorous clang.[1]

On the vast drawing suspended in the sepulchral Hall, hell had already broken loose. A horse's wild eyes stared out as it sank its teeth into its enemy's forequarters, its lips sucking on the smooth equine flesh like some monstrous lamprey's mouth. These beautiful beasts, these *cavalli*, were behaving like blind creatures in the depths of the sea, like heartless, brainless hunters. They had gone mad in the heat of battle. Beneath their wild forms men fought desperately on the ground, in the blood and mud, about to be trampled together into the same mire beneath the mighty hooves. One man screamed desperately as he lay pinioned by his enemy, who, even as a vast war horse reared murderously right above

them, stared into his enemy's eye and prepared to plunge a dagger into his throat. Another fallen man held up his shield against the lashing hooves, sheltering terrified in its shadow, as high above the riders yelled and cursed in their fanatical struggle for possession of a shaft of wood hung with a fluttering cloth. One man twisted around with a mighty grimace, in his fantastical armour decorated with a ram's skull on the breastplate, a spiralling, spiky seashell on his raised shoulder, reaching around so that he could grasp with both hands the lance-like pole behind his head, as his enemies riding in from the right, one of them in a helmet whose raised visor was a grotesque mask, tried to take this standard away from him. At the heart of the struggle, his face a contorted scream of fury, an old warrior gripped the pole and raised his sword high over his head, ready to scythe his enemies' grasping arms. From his black wide-open mouth a silent scream of hate filled the Hall.

It was the distilled essence of battle, this infernal mêlée. No other horses, infantry, cannon smoke, not even a landscape appeared in the cartoon that Leonardo had finally decided he was ready to transfer to the wall. They were not necessary. Looking at it, you felt you were at the deadly centre of some immense whirling struggle. While knights and horses and foot soldiers howled all about, invisible, these riders fixed every fibre of their being on their fight for possession of the symbol of victory or defeat, the old warrior's proud standard. They saw nothing but each other. They knew nothing but loathing and fury.

* * *

The painting Leonardo finally began in the Great Council Hall that brooding June day was a horrific revelation of the nature of war. In spite of all the diversions, all the delays, this was perhaps his greatest masterpiece. It was, no question, the work of his that would cry out most keenly down the ages to artists who felt the need to witness the pathology of war in their own times. In it Leonardo distilled what battle is, for all time. *The Battle of Anghiari*

reached back to the imperial art of antiquity and the chivalric art of the Middle Ages, but what makes it different from its models and precedents is its truthfulness. This is what it is really like, Leonardo says. This is the face of battle. It is a face frozen in a hopeless howl.

The greatest of all Leonardo da Vinci's surviving designs for his painting of the Battle of Anghiari is a study of the head of the old warrior he visualised at the bloody heart of the struggle. In the frenzied composition he started to paint in the Hall in 1505 this man raised his sword over his head in his right hand while he screamed hate and defiance at his enemies. While he was planning the picture, Leonardo made an emotionally devastating drawing of the man's head, with an old man, perhaps a soldier, as his model, that is one of his supreme drawings.[2] The man glares downward from eyes with sharp black pupils beneath a mountainous, rumpled brow. His nose is wrinkled in rage. The muscles around his mouth are distorted and strained in great crevices as he opens it wide, a dark hole fringed with stubs of teeth. Old creatures, as Lorenzo de' Medici had long ago observed, always have some of their teeth missing, and in Leonardo's desperate portrait this man has just a few square molars in his cavernous mouth. A very large-scale copy in Oxford that may exactly reproduce the scale of the wall painting – it has even, implausibly, been identified as a scrap of the lost cartoon – makes the fewness of the teeth even more prominent.[3]

It is a face of acute concentration as well as rage – a face fixed on battle. In this, it is a direct reply to the gigantic face that went on view outside the Palazzo Vecchio in 1504. This is Leonardo's answering glare to the noble gaze of Michelangelo's *David*. In David's eyes there is keen attention, readiness, an anger that is life-giving: the eyes of Leonardo's warrior are just as aware as he, like David, attains almost supernatural consciousness in the excitement of battle. Look at the drawing of the warrior and his brow is a massive, furrowed fact: with its two lines deeply sculpted by passion

above the nose, and its flaring eyebrows, it is a quotation of the brow of Michelangelo's *David*.

Michelangelo, the artist still in his twenties who had never seen a real battle, portrays heroism in his statue of David as the elevation of human consciousness. His statue was installed outside the government Palace because it was the perfect symbol for the Republic – an image of courage and defiance. David is getting ready to kill a tyrant. He poses calmly, stares intently. Has a soldier ever looked like this in battle? That is the question asked so acutely by Leonardo, the man in his early fifties who had seen wars and known warriors. A lifetime's experience of military matters lies behind his riposte. If David is a hero, Leonardo's furious warrior is an anti-hero. And if David tells the old lie that it is sweet and decorous to die for your *patria*, the warrior Leonardo was about to paint in the Great Council Hall had in his eyes the desolate truth that is left when we are done with lies.

Leonardo's face of a warrior is a systematic response to the *David*. There is a force, a sharply etched strength, to the warrior's head that resembles the Giant on the Piazza. Even his long, flared nose is like the *David*'s. But the antitheses are extreme. Where David is young, this soldier is old. Where David is beginning, he is ending. And where Michelangelo's statue has a face of caricatural simplicity, characterful and yet not in the slightest real – no actual face looks like this – in his drawing Leonardo gives equally battle-roused features a tender, subtle realism. What makes this face so great are the nuances in Leonardo's use of chalk: the leathery texture of skin on the delicately vibrating right cheek, the muzzy grey muffle of the tongue inside that awful mouth, the supple delineation of creases in the distorted flesh and masses of wrinkled folds under the eyes, the white bloodless lips and stiffened tendon in the neck. Michelangelo gives beauty itself a grotesque boldness in the face of his *David*. In this drawing Leonardo gives a grotesque expression the same microscopic accuracy and delicacy he put into the face of the *Mona Lisa*.

It is once again a pointed contrast: the face of the *David* is not real. This face is real. This is the real 'fury', *furia*, that Leonardo knew from experience was the face of battle. All the science and technology in the world didn't change that face – in the end the decisive moments in war were fought at close quarters by soldiers worked up into a heat of hate.

There is an overwhelming truth to Leonardo's drawing. Its disillusion is so absolute that it attains the grandeur of tragedy. The nineteenth century historian Jacob Burckhardt observed that Renaissance Italy did not give birth to great tragedy.[4] He reckoned without Leonardo da Vinci.

* * *

The Battle of Anghiari in 1440 was a victory for Florence. It was also a defeat, the great defeat, for a soldier who had risen to fame on Italy's battlefields and hoped to end as prince of some petty state. The contracted commander, the *condottiere*, a freelance expert in war, became a powerful type in Italy in the fifteenth century, when states relied almost exclusively on mercenaries to fight their wars. In the wake of fearsome individual soldiers like the Englishman John Hawkwood, the *condottiere* became admired as a muscular hero whose prowess in arms and strategy made him the modern equivalent of the great Roman soldiers of old. Some *condottieri* ruled their own small cities like Federico da Montefeltro, Duke of Urbino; others aspired to do so. In Italy's chaotic political map these mercenary leaders who ranged the landscape had a lot to play for.

Francesco Sforza, whose equestrian monument in Milan occupied Leonardo for nearly twenty years, was a spectacular instance of the hired warrior who became ruler of a state. His rival in the early fifteenth century was Niccolò Piccinino, who came from Perugia and started his career as lieutenant of a powerful warrior named Braccio di Montone. On the reverse of a medal of himself, Piccinino has as his emblem the griffin, heraldic beast of Perugia,

suckling two children – him and Braccio – just as the she-wolf suckled ancient Rome's founders, Romulus and Remus. Braccio was killed in battle by Sforza, leaving Piccinino as the toughest soldier in central Italy, under contract to the Florentine Republic before he abandoned it to enter the employ of Milan. As Machiavelli writes in his *Florentine Histories*, 'There were at that time two sects of arms in Italy, the Bracesca and Sforzesca: the head of this last was Count Francesco Sforza; of the other the prince was Niccolò Piccinino. . . to these sects nearly all the other armed men in Italy were drawn.'[5]

Francesco Sforza had the upper hand, not least because he was promised to marry the daughter of the Duke of Milan. But Niccolò was a powerful warrior, and in 1440, at the head of the armies of Milan, he stood poised to enter Tuscany and threaten the very survival of the Florentine Republic. At Anghiari he met his nemesis. The Florentines took his standards and he ran for his life; afterwards the Duke of Milan kept employing him, but Sforza's rise continued at his expense. As Machiavelli tells it, the Duke of Milan recalled Niccolò on a pretext so that Sforza could isolate and defeat Piccinino's son near the fortified town of Monte Loro: 'Niccolò arrived in Milan; and seeing he had been tricked by Filippo; and learned of the rout, and the taking of his son, he died of grief in 1445 at the age of sixty-four years, having been a captain more talented than lucky.'[6]

Leonardo's picture of the Battle of Anghiari concentrated on the despairing figure of Piccinino. The scene he prepared to paint in the Hall on 6 June 1505 shows a frantic last-ditch struggle for Piccinino's standard; at the heart of this fight the old warrior himself prepares to inflict a last cruel wound, to take revenge. But how did Leonardo find such depth of emotion and truth in the face of Piccinino?

He looked hard at the sources, for a start. The passion for histor- ical research that he showed in his preparations to paint *The Battle of Anghiari* matched his more famous love of scientific research.

History was the favourite literary genre of the Humanists. It was what Florentine intellectuals such as Leonardo Bruni, Poggio Bracciolini, and (in the early sixteenth century) Machiavelli and Guicciardini specialised in. Depicting a historical event was a great chance for Leonardo to demonstrate to such people the intellectual seriousness of painting. In his writings he argues, with literary Humanists in his sights, that painting can narrate a complex event like a battle more immediately than any written description: '[B] ut I ask no more than that a good painter should depict the fury of a battle and that a poet should write about it, and that they might be put in public where many people could see them and then we would see where the witnesses would look more, where they would give the most praise and which would satisfy them more; certainly the painting would please more, being more useful and beautiful.'[7]

Here the painter and engineer challenges Humanists who value the literary arts over the scientific, word over image. The commission to paint a historical battle in the public heart of Florence, in the Palace, where classically trained political characters like Machiavelli and Agostino Vespucci were steeped in the ancient histories of Livy, Tacitus and Xenophon, was a chance to prove that painting was serious by these literate intellectuals' own criteria. Leonardo read the histories of Bruni and Bracciolini to learn about the Battle of Anghiari, but he went further. He searched for visual evidence of what the battle had really looked like.

The Battle of Anghiari was a richly visualised event. A few years before it took place, Paolo Uccello painted three big panels illustrating another recent fight, between Florentine and Sienese mercenaries, really just a skirmish that his paintings elevate into the noble pageant that is *The Battle of San Romano*. Clad from head to foot in heavy plate armour with florid plumed helmets, waving long banners that flutter in the breeze, charging one another with coloured lances, the knights in Uccello's lovely paintings seem to be participating in a tournament rather than fighting to the death.

Huge rearing horses, crossbowmen in particoloured costumes hunting hares, oranges in the trees and the sweet face of a pageboy add to the vibrant life and joy of these paintings of battle as a gaudy rite of spring. Uccello's happy paintings lend credence to Machiavelli's claim that mercenary cynicism and the theatre of chivalry combined to make war in fifteenth-century Italy, fought (as Machiavelli sneered) only in the spring and summer as if it were a sport, harmless because the *condottieri* treated it as a craft instead of a matter of life and death.[8]

When Florence made its stand before Anghiari in 1440, however, something real was at stake, and the seriousness of the struggle was remembered in images. A memorial survives, worn by time, on the battlefield itself. The earliest wall painting of the struggle may also be in the immediate area, in the church of San Francesco in Arezzo. In the 1450s or thereabouts – his work is notoriously hard to date – the local master Piero della Francesca painted his calm and monumental fresco cycle *The Legend of the True Cross* in this church. It includes two battle scenes which have a gravity quite unlike Uccello's tournament. In one battle, the Christian emperor Constantine defeats his enemy Maxentius. In the other, *The Battle of Heraclius and Chosroes*, warriors fight desperately and murderously at close quarters.

Piero came from the town of Borgo San Sepolcro, which faces Anghiari across the plain of the Tiber. It was from this town that Niccolò Piccinino charged across the broad valley in 1440. It is very possible that Piero, who seems to have been in Borgo San Sepolcro at the time and who indeed spent most of his life there, witnessed the fight.[9] If so, his paintings of battle may incorporate his memories of that day. The Battle of Constantine was fought across the Tiber at the Milvian Bridge outside Rome; Piero's painting moves the scene to his own landscape of the upper Tiber Valley. The army of Constantine, stately and confident with its lances aloft and banner high, slowly chases the fleeing imperial pretender, the pagan Maxentius, across a narrow, glassy river that

looks exactly like the tributary of the Tiber over which the Battle
of Anghiari was fought. Maxentius' dragon banner looks remark-
ably like the griffin banner of Niccolò Piccinino. The pale, rocky
landscape with patches of scrub and the reflective river are those
of Piero's own immediate locality, also portrayed in his *Baptism of
Christ.* Here, the location is unambiguous. As Christ stands in the
river's shallow mirror, the walls of Borgo San Sepolcro can be
seen in the distance on the far side of the valley. It seems Christ
is being baptised on the very site of the battle. In these paintings
the Battle of Anghiari is remembered with the compassionate still-
ness that makes Piero such a great artist.

So there is every reason to think that Piero's paintings record
the most dramatic event that happened in his landscape in his life-
time – but no reason to think Leonardo would have understood
this. He certainly knew about this Umbrian painter because Piero
was a mathematician as well as an artist, who wrote manuscripts
on geometry.[10] Leonardo's friend the mathematician Luca Pacioli
knew Piero's mathematical works well and was even accused of
plagiarising them.[11] In 1502, when Leonardo was with Cesare
Borgia and Borgia's captain Vitellozzo Vitelli was fomenting rebel-
lion in Arezzo, this Vitelli promised to get the artist and engineer
a copy of a work by Archimedes that was in Borgo San Sepolcro.[12]
It could easily have been a book that had belonged to Piero. And
if Leonardo visited Arezzo at that time he could have seen *The
Legend of the True Cross.*

Piero's landscape, that dry, scrubby plain of the upper Tiber
Valley between the walled towns of Borgo San Sepolcro and
Anghiari, is recognisable in a painting Leonardo definitely does
seem to have looked at: a long wooden panel that survives in the
National Gallery of Ireland, Dublin, made for a piece of furniture
in Florence in the 1460s and decorated with an epic painting of
the Battle of Anghiari.[13] This brightly detailed history has colour
and pageantry and a vivid sense of place. In the distance, the walled
cities of Tuscany – the entire region was Piccinino's potential prize

that day – stand on their hilltops. In the foreground, the walls of
Borgo San Sepolcro – white as in Piero's *Baptism* – face fortified
Anghiari on its hilltop, the houses inside its grey walls honeyed in
hue just as they are today. The painting shows different moments
in the battle simultaneously: the Florentines march up the hill to
Anghiari and simultaneously stand massed for battle below it, while
Piccinino musters his men outside Borgo San Sepolcro.

There are rich details. Women wait beneath the walls of
Anghiari with big earthenware jars full of water – the Florentine
forces were fresher and less physically stressed as they fought on
their own ground, said Bruni, who was Chancellor of the
Florentine Republic in 1440, and here we see that illustrated.[14]
The scene of the water carriers is a very immediate detail that fits
well with Bruni's contemporary written account: it is so homely
that it raises the possibility that, like Piero della Francesca, this
unknown artist was an eyewitness of the battle. Who but an eyewit-
ness or a painter with access to very immediate details would
include those women or depict the local landscape just as it is in
Piero's paintings?

Leonardo reached the same conclusion. He appears to me to
have treated this painting – or a lost one very like it – as a histor-
ical source. Here was a picture that, as far as he knew – and he
may have been right – portrayed the battle from direct observa-
tion, and so he looked at it very carefully.

At the heart of the dusty landscape, between two branches of
the Tiber, the battle is fought in a passionate clash of men, horses
and arms. As in Uccello's and Piero's battle paintings, knights go
to war in full plate armour with elaborate helms, wooden lances
and swirling banners. Their war horses are mighty beasts bred to
carry all the steel plate their riders wear. It is a spectacular clash
– and at the heart of the tangled fray, a man who must be Niccolò
Piccinino, his head uncovered and bandaged, looks downward in
grim, grey-faced determination as he raises his baton or club high
over his head in a steel-gauntleted hand, just as he will in

Leonardo's painting. Around him, the banners of his army are falling. The loss of Piccinino's standards was still remembered in Florence in the 1500s and the tattered banners were kept in the Gonfalonier's chambers in the Palace. The griffin standard of Perugia and the serpentine banner of Milan topple in the Dublin painting: in the struggle, hands grasp the poles of banners as they fall; men are tangled up in the cloth; in front of Piccinino, two horses charge into the fray, their massive hindquarters parallel.

The figure of Piccinino in Leonardo's painting was adapted from this scene – the similarities are too close for coincidence, and not just in the way the desperate old soldier raises his right arm above the fray. The two horses, the tumble and tangle of banners – the elements of Leonardo's painting are all here in a primitive form. There is a close relationship between this and his gory compositional drawings that survive in Venice: the way banners swirl as an old warrior raises his arm is very similar. But in the final version he composed as a cartoon at Santa Maria Novella and at last began to paint in June 1505, he isolated just four riders, concentrating on Piccinino's struggle for the banner with leaders of the Florentine army.

Was this scene meant to be part of a larger composition? Leonardo had already shown with the *Last Supper* how ruthlessly he was prepared to isolate a single dramatic moment and tell a story entirely in one scene, compressing past and future into a pregnant present, and so giving art a new eloquence. The *Last Supper* strives for truth and so did *The Battle of Anghiari*. Leonardo found an eyewitness record of the battle and sought to preserve that truth even as he heightened the power and poetry of it through radical simplification. He aspired to paint a Florentine history as authoritative as the Humanist literary works of Bruni and Bracciolini. His martial spectacle would not be fiction but harsh reality. He even sought out the bronze medal of Piccinino cast by Pisanello in the *condottiere*'s lifetime. Portraying the proud warrior in profile as if he were a Roman emperor, this contemporary image

shows Piccinino as a tough-faced man in a tall, soft hat.[15] In his painting, Leonardo gave him the same headgear.[16] All these exact visual details add to the sense that he is seeking the truth of this battle.

But Leonardo had more than one way to discover the truth. He looked at old pictures of the battle, read the chronicles and compared these documents with his own experience of war. All that makes it seem a very sombre exercise. It was nothing of the sort. When he tried to build a mechanical 'bird' shortly before starting to paint in the Great Council Hall, science slipped into a realm of dream. We have noticed how he seems in his observations of bird flight to imagine himself becoming a bird and how, in a similar way, his drawings of galloping and rearing horses done in preparation for *The Battle of Anghiari* identify with the energy of the excited animals. The riders he started to paint now in the Hall were not rationally controlled emblems of war but something more demonic and potent. They were the other side of Leonardo's fantasy of becoming a bird. Human beings become beasts in *The Battle of Anghiari* – not symbolically but actually. The men merge with their horses. Their armour sprouts organic forms, their faces are bestial masks. They are centaurs. They are the monsters lurking in the stain on the wall. In visionary experience the traveller through fantastic realms risks meeting evil as well as benign beings.[17]

*　　*　　*

If it is Piccinino's story it is also Leonardo's own. The artist had good reason to identify with the mercenary's acrid disillusion. He too was a kind of mercenary. Like Piccinino he had served a ruler of Milan. He was a veritable *condottiere* of science, a military engineer for hire who just in the last few years had tried to sell a stratagem to Venice before entering the employ of the notorious Cesare Borgia. Just before or just after returning to Florence in 1503 he wrote a letter offering his services to Sultan Beyazit in

Istanbul: emissaries from the Ottoman ruler, whose father had conquered the ancient capital Constantinople in 1453, visited Borgia, and Leonardo must have spoken with them. In his letter he recommends himself as an engineer to build a bridge from Pera to Constantinople. He invokes Allah enthusiastically. In the culture of the time there could hardly have been a more blatantly treacherous gesture than to sell his Christian birthright.

In 1504, as Leonardo worked on *The Battle of Anghiari*, his pupil Salaì wore a cloak that had belonged to Borgia. In the summer of 1503 the pope and his son suddenly fell ill in Rome. It was rumoured that they accidentally swallowed poison they meant for others. Alexander died. Cesare survived, but the pope's death fatally weakened him. The election of Julius II, an old enemy of the Borgias, as pope that autumn sealed Cesare's fate. As Leonardo worked on *The Battle of Anghiari* the soldier who had so recently seemed destined to conquer Italy and drive out the French, the sinister man of arms whom Leonardo had personally known and worked for, was ruined. By August 1504 Cesare was in prison in Spain; he would escape in 1506, but die the following year without ever getting back to Italy. The haunting portrait of Niccolò Piccinino is a study in defeat, the tragedy of a bloody man. It surely also suggests Borgia, the malevolent warlord whose fall was so swift in the end. Borgia's sudden destruction happened just as Leonardo took on the commission for the Great Council Hall. Other fates, too, haunt his portrait of Piccinino. He had known soldiers who were modern versions of the fifteenth-century mercenary. There was Borgia's captain and Leonardo's friend Vitelli, killed when Cesare took revenge on disloyal followers. Machiavelli's account of this murderous night in the small city of Senigallia reads like a Jacobean tragedy – especially in the Jacobean prose of a translation published in 1640. After being trapped, Vitelli and other traitors were held in a palace Borgia had taken over: 'But the Dukes souldiers not satisfy'd with the pillage of *Oliverotto*'s Souldiers, began to sacke *Senigallia*. And had not the Duke by the

death of many, stopd their insolence, they would utterly have sackt it. But night being come, & all stirres quiet, the Duke thought fit to put *Vitellozzo* and *Oliverotto* to death, and having brought them together, causd them to be strangled.'[18]

This was the kind of scene that happened not in the pages of history but in Leonardo's own lifetime, to people he knew. It was fresh in his mind when he was working on his painting of desperate violence. So was the fall of his patron in Milan, the soldier and schemer Ludovico Sforza, whose plot against Naples encouraged the French invasion in 1494 and led by the end of the fifteenth century to his own destruction: 'The duke lost his state, his personal possessions and his liberty,' commented Leonardo.

The Battle of Anghiari does not suggest he found soldiers attractive close up. The warriors whirling in dead space are the visual equivalent of the bleak vision of humanity he put into words in one of his 'Prophecies':

Of the cruelty of man
 Animals will be seen on the earth, who will always be fighting
 among themselves, with the greatest harm and many deaths on
 either side; these will have no limits to their malignity . . . o world,
 why do you not open and precipitate them into the deep fissures
 of your chasms and caves, and no more exhibit to heaven so cruel
 and ruthless a monster![19]

To call it the 'tragedy' of Niccolo Piccinino is not to imply that Leonardo's battle painting was sentimental. Rather it glimpsed the last shreds of self-knowledge in warriors whose mask-like grimaces and extreme actions take them to the very limit of sympathy and fellow humanity. This is what makes Leonardo's drawing of the face of Piccinino so subtle. It manages to be at the same time utterly monstrous and hauntingly human. In his desperation the warrior opens his mouth in a scream of hate and rage, and Leonardo's drawing portrays his contorted visage. And yet, in his

eyes there is a dim spark of memory and life: inside his leathery hide there is still a human being, and you see the humanity in those eyes, callous and despairing as they are. The tragedy in this scene is that of the damned souls we encounter in Dante's *Inferno* and Shakespeare's *Macbeth*. The desolation and hopelessness of Piccinino's eyes as he prepares to bring down his sword in a futile blow could almost be a premonition of the final self-knowing moments of Macbeth: Tomorrow, and tomorrow, and tomorrow.

The portrait drawing reveals a last pulse of humanity in the hardened carapace of the warrior, yet at the same time Leonardo's design openly questioned the full humanity of the men on their mighty horses. He became absorbed in the details of their elaborate armour, but this was not fancy for its own sake. In portraying it he let grotesque imagination run riot. This had as clear a function in the drama as the noble robes worn by the disciples in the *Last Supper*. The robes stress dignity and grandeur of spirit. The armour of the warriors in *The Battle of Anghiari* made them into misbegotten beings, 'so cruel and horrible', part-man, part-beast, part-metal.

Leonardo, the connoisseur of clothes, had seen his share of real armour, had even designed it. The armour he gave the warriors of Anghiari was not that much odder than actual armour you would see in tournaments, where knights wore extravagant costumes and fantastic masks. Leonardo had designed costumes of savage 'wild men' for a tournament in Milan.[20] Masked, ornate armour was not purely decorative. When Roman cavalrymen wore bronze masks – uncanny metal replicas of faces – for training games, the alienating device must have made it easier to forget they were fighting comrades. The same estrangement is fundamental to the masked helmets of samurai warriors, bristling warrior faces that transfigured their wearers into personifications of war. In Renaissance Italy, as the history of earlier civilisations was studied and revived, armour became a self-conscious dramatisation of the martial persona.[21] Drawings done in Florence in the

1470s show crests of dragons and monsters sprouting from helmets; a very early surviving example of a fantastic helmet, made towards 1480, enclosed a metal sallet – a protector for the upper head – inside the golden head of a lion.[22] It transformed the wearer into a brave beast.

Verrocchio's workshop, where Leonardo was trained, specialised in fantastical images of armour. Marble reliefs of ancient heroes in profile made by Verrocchio and his assistants – one was reputedly sent by Lorenzo de' Medici to King Matthias Corvinus of Hungary – portray them in an imaginary version of ancient armour with Medusa breast ornaments and dragon helmets. Leonardo's early drawing of an old warrior, today in the British Museum, is closely related to these reliefs but has far more power: his soldier's leathery face is an ancestor of Niccolò Piccinino's.[23] The man's armour threatens to mutate him into a dragon as bat wings sprout from his helmet, crocodilian scales cover his shoulder (ancient Roman armour did, in fact, include suits of crocodile hide) and a lion – not, as Leonardo draws it, a sculpted beast, but the actual head of a living lion – roars on his chest. This drawing is oddly reminiscent of the story Vasari tells of how Leonardo made a composite monster from dead animals and painted its image on a shield. Another early drawing by him is of a helmet with a visor that is a mask of a human face. He was not merely observing the rise of new fashions in armour: he helped create them. *The Battle of Anghiari* in turn would license the ornate grotesques and satyr-like visors invented by sixteenth-century armourers such as the Negroli family.[24]

The armour of the warriors in Leonardo's battle painting was so laden with bizarreries that it twisted their very identities. One man wore gigantic coiling sea shells on his shoulders and a huge ram's skull on his chest. Both were skeletal remains of exhausted nature. Leonardo studied fossilised sea shells and wrote of the skeleton of an immense animal he identified as a whale, discovered in a cave. He wondered at the aeons of time the fossil had

witnessed and observed that its bare bones now seemed to support the mountain above, as if its ribs were pit props. Death leaves a skeleton or shell that becomes a fossil; in such passages it is clear how much fossilisation intrigued Leonardo.[25] The rider at the left of his battle scene, his flesh invisible within a skin of chain mail encrusted in bony growths, with the horns of a ram's skull suggesting at once potency and death, masculinity and desiccation, was turning into a fossil even as he twisted around and grimaced at his enemies, grabbing onto the shaft behind his head as his body transformed into a freakish spectacle of dead forms, fit for a cabinet of curiosities. Beside him Niccolò Piccinino raised a sword arm encased in plate armour, while two Florentine captains confronted them, both wearing splendid helmets. One helmet was crested with a writhing serpentine dragon. The other had a visor in the shape of a bearded satyr mask, a second face, half-human and half-goat, to be lowered over the real flesh as the rational, normal personality disintegrated in battle's fury. This mask was the emblem of war's alterations, its transfiguration of men into monsters.

As they screamed and grabbed at the wooden shaft of Piccinino's standard, the warriors' very horses cannibalised each other. A horse sunk its teeth into another's neck, locking its mouth in place. The men and their horses formed centaur-like allegories of war's nature. The men with their arms and armour embodied technological warfare, the horses the savagery beneath – the unconscious of war. Where the men at the top of the painting – literally higher up, mounted on the backs of the horses – clothed their violent instincts in chivalry, dressed as knights, with heraldic crests and finely wrought weapons, their horses manifested their lower, base selves, their driving instincts. Below the lie of civilised warfare, the reality of primitive cannibalism.

The idea of an original, primitive 'state of warre', as Thomas Hobbes was later to call it, held Florence spellbound at the start of the sixteenth century, for news had reached the city from a Stone Age society, and it was unnerving.

* * *

The little wooden ships with their high rear castles bobbed on the undulating ocean. The men on board, who had sailed so far, as far surely as any human beings in history and certainly as riskily, waited uncertainly while their captain looked with interest at the strange people on the land mass ahead: a crowd of men and women as naked as newborn babies, parading long-haired beneath the palms.

Later he would sit in his house in Portugal, dazed by what he'd seen, wondrous and awful things: the waste of the mid-Atlantic that made him feel like Ulysses on his last hellish voyage, as he knew it from reading Dante, then the mighty forests of the western shores, but most of all the people, at first sight so innocent, in reality so bestial – cannibals, as he discovered. He couldn't get the horrible images out of his head: feasts at which everyone gorged on a mother and her children, battles fought with stone-headed weapons after which the enemy dead became food. The horror; the horror. And yet that land was so rich, so promising – and it seemed to go on so far south it could not after all be just an outpost of the Indies. It was a continent apart, a *Mundus Novus*.

Troubled as his mind was by nightmare scenes of New World savagery, as he took up his pen at his desk in Lisbon, he was cheered by thoughts of the lovely far-off republic of which he still considered himself a citizen. His exhaustion and the salt in his skin, the beauty and terror of all that he'd seen, did not stop him from wanting to express his sincere admiration for the Magnificent Gonfalonier and that Sublime Republic with whose affairs Piero Soderini was perpetually busy.

* * *

Such is the burden of the *Letter to Soderini*, sent to Florence by the Atlantic navigator Amerigo Vespucci from his base in Lisbon in 1504, and rapidly issued to the city's printing presses.

It is a book built on water. Even its frontispiece is misleading. It starts with an engraving of Amerigo and his men in their three ships observing the naked people of what this explorer's previous report, published in Florence in 1503, had already named (in Latin) the New World. But this is a recycled engraving originally produced to illustrate Christopher Columbus's account of *his* discoveries. The theft of the image is of a piece with what follows. Vespucci claims that he sailed to the mainland of the new continent in 1497, a year before Columbus reached *Tierra fierma* in 1498. This is probably a lie. But was it Vespucci's lie? Or did editors in Florence concoct the *Letter to Soderini* without his knowledge?[26]

Vespucci was a Florentine citizen – the cousin of Agostino who worked with Machiavelli – who went to Spain as a business agent of the Medici, was excited by the voyages of Columbus and, in 1499 (assuming the 1497 voyage to be fiction, as most historians of exploration insist it was), sailed westward himself. Whatever the real origin of his letter, its appearance in Florence in 1504 undoubtedly influenced *The Battle of Anghiari*, for it portrays the New World as a place of perpetual war between cannibal tribes. These people go to war, it seems to Vespucci, essentially to catch prisoners to eat: 'They eat little flesh, other than human flesh, for Your Magnificence should know that in this they are so inhuman that they outdo every custom of the beasts, because they eat all the enemies they slaughter and capture, women and men, with such savagery that to tell it seems a brutal thing; how much worse to see it, as I was fated to see it many times and in many places.'[27]

The raw, primitive warfare of Vespucci's New World was instantly reflected in Florentine art. Piero di Cosimo's paintings in these early years of the sixteenth century imagine a world of un-sophisticated humans and half-human hybrids, a wild Stone Age whose frenetic violence is surely marked by Vespucci's report. In his *Battle between the Lapiths and Centaurs*, humans and monsters do battle with improvised weapons as a wedding degenerates into savagery. The knot of crazed fighting at the centre of the

panoramic scene suggests the intense grouping of Leonardo's horse-borne furies. Piero, as it happens, painted some of his primitive histories to decorate one of the houses of the Vespucci family.

Piero di Cosimo may have been inspired by news from the Americas, but he got his knowledge of the Stone Age from a Latin poem. When Poggio Bracciolini discovered a manuscript of the Roman poet Lucretius' philosophical epic *De rerum natura* – *On the Nature of Things* – in 1417, he brought to Florence not just a text whose details of classical myth enriched those known from Ovid's *Metamorphoses* but an ambitious vision of human development. Lucretius is positively Darwinian in his materialist explanations of how humans advanced from savagery to civilisation. The first people lived like wild beasts. They had no agriculture, laws or fire. Their lives were tough, says Lucretius, but they did not know the 'civilised' cruelties of war. Slowly, people learned to use fire and live in simple communities, and language evolved. One day lightning caused a forest fire and in the hot earth humans saw molten metals: the arts of metalworking were born and with metal came weapons. Piero di Cosimo's painting *The Forest Fire*, done in Florence around 1505, depicts this epochal fire.

Leonardo too was reading Lucretius. In a suggestive note he quotes the Roman author's claim that 'the first weapons were hands, nails and teeth'. In Leonardo's note the original is slightly embellished: 'Lucretius in the third of The Things of Nature: hands, nails and teeth were the weapons of the ancients. Also they used as a standard a bunch of grass tied to a pole.'[28] He works in a satirical image of his own, introducing the notion that primitive humanity went to war behind a bunch of grass fluttering from a pole; it adds another dimension to the fight for possession of a standard in *The Battle of Anghiari*. The desperate struggle in the painting is for something as worthless as any savage totem – the standard that Piccinino fought so vehemently to save was no more intrinsically valuable than the primitives' bunch of grass on a pole. The armoured warriors were technologically advanced, clothed in

metal and armed with sharp blades, but Leonardo revealed how close their fury made them to the cannibal rage of their horses. War was just armed barbarity. The wretched images of the New World spread by Amerigo Vespucci informed Leonardo's vision of war as a grotesque ornamentation of primitive instincts, but it only confirmed the evidence of his own eyes. What he saw of battles and tournaments had convinced him that deep down, whatever technology it uses – a tank, or just the dagger a man on the ground thrust at an enemy's throat in *The Battle of Anghiari* – war is no more elevated than mauling someone with your teeth.

This image of fighting with your teeth, of using the most basic of weapons, is one that Leonardo kept returning to. It was at the very centre of *The Battle of Anghiari* in the disturbing spectacle of a horse biting into another horse's throat, its eyes maddened. It struck him to find this image in Lucretius – that the first weapons were nails and teeth. And in his passionate essay 'How to Paint a Battle' he dwells on it again: '[M]ake dead men, some partly covered with dust, others completely . . . others as they die grinding their teeth, rolling their eyes, tightening their fists against their bodies, their legs distorted; some might be shown, disarmed and beaten down by their foes, who turn on the enemy to take a cruel and bitter revenge with teeth and nails.'[29] Unarmed and defeated, the men take a cannibal revenge. This image of disarmed soldiers biting and scratching their enemies was probably composed late in Leonardo's life. It surely draws on his battle picture for the Great Council Hall and the experiences and ideas that forged it.

Leonardo's cartoon, which he now began to transfer to the wall, drew on anthropology as well as history, incorporating the latest reports – however inaccurate – of life in the Americas. We are all at heart animals with animal instincts, and when we are cornered we fight like maddened beasts, says Leonardo in his disturbing masterpiece.

If his image of cannibalism reached across the Atlantic to the new world being discovered in his day, it also struck close to home.

For all true Florentines knew the most compelling horror story in the *Divine Comedy* of their city's great poet Dante. Deep in the pit of Hell, on frozen Lake Cocytus, Dante and his guide Virgil see Count Ugolino – whose story will end with Dante's call for the destruction of Pisa. A spectacle of cannibalism holds their gaze:

> . . . I saw two frozen in one hole,
> so that one head was a cap to the one below;
> and as the starving gorge on bread,
> just so the one on top put his teeth to a human meal,
> right there – where the brain is joined to the neck.[30]

The vengeful biting horse of *The Battle of Anghiari* called forth Dante's infernal feast. You didn't need to cross the world to find the heart of darkness.

* * *

It is always with us, it is history's curse. For everything that is built, every beauty that is nurtured, there is a destructive warrior waiting in the wings. In the empty spaces of pitiless time, horsemen fight forever on a dusty plain. So Leonardo da Vinci suggests in his early unfinished marvel of a painting, *The Adoration of the Magi*. Of all his surviving works this is the most intellectually ambitious. He began it in 1481 for the convent of San Donato a Scopeto outside the walls of Florence, but left it incomplete when he moved to Milan. Even so, this painting, or honeyed drawing, leads us deep into his imagination. As the dark-eyed Magi proffer gifts to the Christ Child and sensitive horses look melancholically at us, a vision of history unfolds in the painting's distance. A fabulous classical architecture rises into the sky, ruinous and unfinished at the same time: trees grow on broken walls, staircases ascend to nowhere. Amid the ruins of human ambition, spectral armies fight. And far away, in an empty, sterile no-man's-land, two horsemen

are locked in mortal combat, their horses rearing, their faces masks of fury.

The image that Leonardo began to paint in the Great Council Hall in June 1505 had lain in his mind for a long time. It went back, at least, to *The Adoration of the Magi*. And yet to compare the two works is to compare a dream and a nightmare. The battle in the *Adoration* is just one aspect of life's wonder and mystery; the one he started to paint in the Great Council Hall blotted out every good thing. Claustrophobic despair greys the eyes of the warrior

Part Three

THE LOST BATTLES
1506–Present

Thirteen

THE GOOD CITIZEN

The fury of Pope Julius II was terrible to contemplate. Raging, yelling and served by men who were always ready with fists and cudgels, the Warrior Pope was casual about issuing death threats. The poet Ariosto, on a diplomatic mission to Rome from the court of Ferrara, had to endure being menaced with a dunk in the Tiber. When Michelangelo was nearing the end of his labours high amid the vaulting of the Sistine Chapel, the impatient Julius asked when he would finally finish.

'When I can,' said the artist whose neck was sore from bending backward as he stood on the wooden platform under the vault.

Julius flew into a rage: 'You want me to have you thrown from that scaffolding!'

It was not wise to get on the wrong side of Julius.[1]

As Michelangelo told the story to Condivi, he decided discretion was the better part of valour when Julius harried him in the Sistina, and brought his work to an end, leaving a few gold trimmings undone. That was after years of experience had told him when to fight Julius and when to let it go. In May 1506, however, he decided it was time to fight – and the pope had well and truly met his match.

Michelangelo had been working for more than a year making preparations for the tomb that Julius had commissioned from him. He had personally led the quarrymen in Carrara in cutting the right stone for the many sculptures that were to grace a free-standing mausoleum inside the old church of St Peter's. Its tall,

rectangular form, like a vast sarcophagus with a statue of the pope enthroned on top, was to be decorated, if that was the right word for the contorted figures Michalengelo had in mind, with prisoners of war seething or submitting in their chains, with biblical prophets including Moses, plus plenty of putti and angels. It was a stupendous scheme that would unavoidably eat up years of time and sacks of gold, and result in a monument of sublime arrogance and ostentatious intellect.

Yet even as his marble awaited the first blows of the chisel, Michelangelo could feel that something was wrong. Intrigues were in the air. He no longer had the ear of the pope – he couldn't even get an audience. Flunkeys turned him away at the door, when there was so much that needed discussing, and paying for.

Finally he snapped. One morning he went to see the pope again and was told he couldn't enter. This time, it was clear the refusal came directly from Julius himself. No one gave Michelangelo the cold shoulder like this. You didn't freeze him out: he froze you out. He went back home and ordered his servants to pack. That very night he set out on horseback, and he didn't stop riding until he reached Florentine territory. In a letter he sent to Giuliano Sangallo from Florence on 2 May 1506 he explains:

Of my departure, it is true that I heard the pope say on Holy Saturday, speaking at table with a jeweller and with the master of ceremonies, that he did not want to spend a penny more on stones small or large: by which I was quite amazed; yet, before I went, I asked him for part of the funds to get on with the work. His Holiness answered me that I should come back on Monday; and I did come back on Monday and Tuesday and Wednesday and Thursday, as he himself saw. In the end, on Friday morning I was sent out, or rather chased away; and he who sent me away said that he knew me, but he had his orders. When I heard this speech that Saturday . . . I became very desperate. But this was not the

only reason for my departure. There was another thing, which I
don't want to write about; enough that it made me think that, if
I stayed in Rome, my own tomb might be made before the pope's.
And that was the reason for my immediate departure.[2]

You sense the terrible pride of Michelangelo in that acid obser-
vation that he was reduced to eavesdropping on a conversation
between Julius and a jeweller – as if trinkets had the same value
as great art. You believe he was indeed capable of becoming
desperate in such a crisis. But he claims there was more to it:
what is the thing he doesn't want to write of?

Michelangelo believed that the architect Bramante was
constantly plotting against him, slandering him to the pope, and
in this letter his paranoia about rivals at the papal court reaches
the point of fearing for his life. It is a stark revelation of how real
and fundamental competition was, in this age of growing artistic
ambition, that Michelangelo seriously thought it might lead to
violence. However exaggerated his suspicions might be, they
reflected a Rome where artists saw themselves as fighting for work
of cosmic scope. With such extraordinary commissions in the
offing, it seemed realistic to suspect a rival of planning to injure
you. Nor were Michelangelo's terrors totally unrelated to reality.
A little later in the sixteenth century Benvenuto Cellini did actu-
ally murder a rival in the contest for papal patronage.[3] In 1506,
noticing Bramante had the ear of *Il Papa*, Michelangelo decided
he'd be better off on home ground.

The truth was that Julius II was in talks with Bramante, and
was losing interest in the project for a colossal tomb, because he
had an even bigger dream. He wanted to build a new St Peter's.
This made Michelangelo's carving him a monument in the old
St Peter's irrelevant. Julius commanded Bramante to build the
new basilica on a scale to outdo the ancient Romans whose ruins
loomed so large in the papal city, and in a classical style to assert
the rebirth of beauty at the heart of Christendom. It was one of

the most important cultural decisions in European history. The building of a new St Peter's would become a collective task for which Bramante only had time to lay the groundwork before it was continued by Raphael, Sangallo and ultimately Michelangelo himself. The incredible expense would necessitate exceptional fundraising measures including a special sale of indulgences, the pope's personal guarantee of a reduced number of years in Purgatory, to gullible Northern Europeans. Unfortunately they were not as gullible as was hoped. The indulgence sale provoked a German theologian named Martin Luther to publish the protest that started the Reformation. The greatest building in Christendom paradoxically helped to divide and fragment European Christianity.[4]

In 1506 all this was in the future. Michelangelo had just done something unprecedented in the annals of artists' relations with their employers. It was a heroic, and dangerous, assertion that artists are worthy of respect. As Condivi tells it, 'Michelangelo, who had never found an entrance denied him before, got angry when he saw how he was being pushed about, and replied, "And you can tell the pope that if he wants me from now on, he can seek me elsewhere."'[5] All Michelangelo's passion and invective that so hurt Leonardo on the streets of Florence was now aimed at the most powerful human being in Italy. As messengers from the pope urged him to return – to be forgiven, or beaten, or worse? – he turned for support to his friends in the government of the Florentine Republic.

Piero Soderini was a friend, he knew. But if he was to guarantee the Gonfalonier's solidarity, there was one thing he'd better do. Soon after his arrival back in Florence, Michelangelo did what was necessary and took up work again on his cartoon for a history painting in the Great Council Hall.

* * *

Despite his absence for more than a year, and his failure so far to move beyond drawing his historic *Bathers*, Michelangelo had an advantage in the competition. Leonardo had made a disastrous and demoralising start on his painting in the Hall. As Leonardo himself tells it in Madrid Codex II: '6th June, 1505, a Friday, on the stroke of the thirteenth hour, I started to paint in the Palace. At the very moment I applied the brush, the weather deteriorated and the bell resounded, calling the men to their deliberations. The cartoon tore, the jar of water being carried broke and water spilled. And suddenly, the weather broke and it rained vast quantities of water until evening. And the atmosphere was like night.'[6] Leonardo da Vinci, this diary-like personal note reveals, believed like all his contemporaries in the significance of omens and prodigies. Nature was a book full of cryptic meanings. He records the grim weather on the day he started to paint in the Hall in an apocalyptic tone of dread. He reads some sinister meaning into this coincidence of meteorological misfortune and a spillage of water. The implication appears to be that he will never get anywhere on his wall painting: it is cursed. It confirms that he found the Great Council Hall an awkward working environment. The Hall was open for business as usual. As he worked and the great bell of the Palace rang to call a meeting, you sense his frustration – how was he going to concentrate in such a setting?

Another problem was becoming apparent. Leonardo still did not believe in the tried and trusted fresco method. *The Battle of Anghiari* was being painted onto the dry wall. He tried to create a binding agent, apparently using flour, that did not stick properly. Even as he and his team coloured the colossal horses and their monstrous riders, paint was flaking off.[7]

Yet there were other reasons, beyond the slowness of his work, for the Florentine government to fall out of love with Leonardo. The very fact that Michelangelo had been brought in to compete with him already implied less than a ringing endorsement. From the start the Republic seemed to be rooting for the younger man

– as if to punish its former star. Despatching Leonardo to Piombino that November gave Michelangelo an advantage, and by the time Leonardo returned to Florence his up-and-coming rival had already done a huge amount of work on his cartoon of an army of nudes.

Michelangelo's composition was not only a crowd of nudes. It was also a picture of a river. Among the muscular troops is an old man with vine leaves in his hair trying to dress. He represents the commander that day who, according to Villani's chronicle,[8] was old and ill and all too ready to let his men have a dip in the Arno while he rested. Michelangelo stresses his decadence, even his corruption, by giving him the look of a sensualist votary of Bacchus.

The Battle of Cascina anticipates, in an elusive and unresolved way, the scenes of bacchanalian revelry that would become one of the great courtly themes of sixteenth-century art. A painting like Titian's *Bacchanal of the Andrians*, painted in the 1520s for the Camerino – the Cabinet – of the Duke of Ferrara and today in the Prado in Madrid, with its tipping, swaying, bending nudes, is indebted to Michelangelo's *Bathers*. His pastoral army gave a new grandeur to the nude that was to influence not battles but erotic scenes of massed naked feminine flesh, from Titian's *Diana and Actaeon* to Peter Lely's *Nymphs by a Fountain*.[9] In collaboration with his early rival Giorgione, the young Titian painted nudes in the German merchants' building the Fondaco dei Tedesci in Venice in 1508–9 that directly emulate *The Battle of Cascina* by putting naked skin into a city's public space. Look again at the *Bacchanal of the Andrians* and you see how closely some of his nudes resemble Michelangelo's *Bathers*.

You also see in Titian's pastoral scene, lying dead drunk on a hilltop, the bearded figure of Silenus, the teacher of Bacchus and, in Greek myth and Renaissance art, a ridiculous old sot, an emblem of indulgence. Michelangelo's depiction of an elderly commander bears a resemblance to such Sileni. He has a beard,

a garland – you could mistake him for the mythological drunkard. This detail is singled out in a copy from Michelangelo's design painted on a maiolica plate in about 1539–47, which by setting the scene in woodland outside a town removes it from any association of battle and makes it purely bucolic.[10] But why does Michelangelo stress such a decadent character, if not to satirise folly? Could he be making a cruel allusion to Leonardo and the Arno diversion? Cascina, as we have seen, is close both to Pisa and to the point where Florentine engineers tried to divert the river towards Livorno in October 1504. Michelangelo might just have been exposing Leonardo as the bacchic voluptuary who led Florence into dangerous waters. Now, the Republic had bravely to extricate itself from the folly of the river and renew its strength against the Pisan enemy. And this is where the urgent political resonances of Michelangelo's battle picture become hard to ignore. As he was planning his design in the autumn of 1504, Machiavelli was moving on from the disaster of the waters to push the idea of a citizens' militia. It was the trained and disciplined bodies of young men that would win the Pisan war, not the delusion of technocratic schemes. Michelangelo's army of awakened heroes looked very like a recruiting poster for Machiavelli's militia.

* * *

When Michelangelo returned to Florence in the spring of 1506, Machiavelli was at the height of his campaign to give Florence a truly republican army. Typically of him, the idealism was accompanied by a gratuitous toughness: he pushed to get Don Michelotto, a notorious former henchman of his idol Cesare Borgia who had helped massacre the disloyal captains at Senigallia, as its commander. Nor did he recruit the cream of Florentine patrician youth. Instead, the Ten of War authorised Machiavelli in January 1506 to go into the countryside of the Mugello and Casentino and recruit young countrymen between the ages of fourteen and

forty. It was a draft rather than a volunteer battalion. But when Machiavelli's new soldiers were paraded in Florence at Carnival time, they were presented as the core of what would become a citizen army of thousands. The 400 conscripts were drilled on the Piazza della Signoria, uniformed in white jerkins, red-and-white stockings, white caps, white shoes, and iron breastplates and lances. Their red-and-white colours matched the cross design of the Florentine Republic's flag; they'd have looked like red-and-white versions of the Vatican's Swiss Guards.

Machiavelli's toy soldiers impressed the populace and promised a new dawn in the Republic's ability to make war on Pisa and any other enemy. 'This was thought the finest thing that had ever been arranged for Florence,' reported Luca Landucci.[11]

As we've seen, that same spring Michelangelo fled Pope Julius II and sought the protection of the Republic. Condivi says the very reason Soderini protected the artist from the pope was because Soderini hoped he would 'paint the Great Council Hall'.[12] So while Machiavelli was drumming up patriotic enthusiasm for a standing army, Michelangelo 'finished that marvellous cartoon begun for the Council Hall, in which he represented the war between Florence and Pisa and the many and varied accidents that occurred in it'.[13]

In Michelangelo's memory as he communicated it to Condivi years later, the earlier war with Pisa had become the war Florence was fighting in 1506. This is a revealing slip. Michelangelo's *Battle of Cascina* was a much more direct comment on the current war with Pisa than Leonardo's – while Anghiari was on the other side of Tuscany, everyone knew Cascina was close to Pisa. It was a place that featured regularly in news of the war. And Michelangelo's image of alert, courageous, active soldiers rushing to seek the enemy, turning crisis into triumph, fitted perfectly with the rhetoric coming out of the Palace in 1506.

Early that year Machiavelli published his poem 'Decennale' to promote his military ideas. His plan was enthusing citizens high

and low. In Michelangelo he found a mirror of his zeal. A painting done in Florence in about 1510[14] makes the connection between Machiavelli's ideas and Michelangelo's art explicit. In this portrait a young Florentine citizen stands poised to defend his Republic. He is clad in armour, hand on his sword, in front of the Piazza della Signoria. A flash of white in the distance catches your eye – it is Michelangelo's *David*, posed in front of the Palace. The painting associates this man's readiness to use his sword with David's preparedness to fight Goliath: it makes a direct connection between Michelangelo's art and the ideal of a citizen-soldier. In a speech he wrote calling for funds for the war, to be delivered in the Great Council Hall, Machiavelli uses a suggestive image, saying it is better to have your own sword than to rely on someone else's to defend you; and better to put it on before the enemy arrives.[15] This is just what the young man in the painting has done. Looked at in this light, the painting is surely an explicit allusion to Machiavelli's idea that citizens must fight for their own liberty. It draws an overt analogy between the Republican militia and Michelangelo's *David*. It consciously interprets the *David* as a work of Machiavellian political art.

When Machiavelli said it is better to have your own sword than to rely on the sword of another, he meant that a city with its own standing army is stronger than one that relies on mercenaries or on powerful allies. The young man in this painting grasps his sword: he is not reliant on mercenary hirelings to defend him and his city. The young soldier's body is clad in armour, but behind him you can see the glittering white nudity of the *David*. To be a citizen-soldier is to emulate the virtues of a Michelangelo nude – readiness, alertness, selfless energy.

Machiavelli argues in his book *The Art of War* that one of the advantages of a citizen militia is that it gives young men something to do. On festival days you see youths idling about. Instead they could be parading proudly in armed and uniformed companies.[16] This idea of soldiering as both the natural expression,

and a perfect way of managing, the aggression of young men illuminates Michelangelo's portrayal of an army of youths leaping out of the water in rapid, well-trained collective action. His nudes didn't get their muscular bodies by lazing around: they are exercised to a peak of fitness. Machiavelli's ideal of a citizen-soldier was, precisely, of young men so trained and honed that weapons and armour were almost besides the point. The militia he was campaigning for in 1506 as Michelangelo was finishing his cartoon looms behind the muscular shadows of *The Battle of Cascina*. Now the seal was set on a special bond between Michelangelo and the republican rulers of Florence. The idealistic young man shared the political beliefs of Soderini and Machiavelli. Far more than Leonardo, he was a proud citizen of Florence – a patriot. His family claimed a long (if partly fictitious) and honourable role in the history of the city. When, later in his life, an emissary sent to collect a painting from him said something sarcastic to the effect that Florence was just a city of merchants, Michelangelo refused to hand over the picture.[17]

*　　*　　*

Shortly after Michelangelo had returned from Rome, Leonardo had begun trying to get permission from the Florentine government to leave his painting aside and visit Milan. So as Michelangelo worked on his image that heroically mirrored Machiavelli's militia, Leonardo was doing his best to get away from Florence. Milan was now under French rule, and the French were deeply impressed by his works there; it was said the king lamented that it was not possible to remove the *Last Supper* from its wall and take it to France.[18] That spring Leonardo and his collaborators on his altarpiece depicting the Virgin of the Rocks in a Milanese church started suing for unpaid fees;[19] this marked the start of a new relationship with the city where he had worked so long and apparently happily.

Within weeks of his rival's return to Florence, Leonardo wanted

to go elsewhere. It is surely not a coincidence. Here is the personal tension between Leonardo and Michelangelo set in the cold ink of a legal contract. The Signoria made the older artist sign a document promising to return to Florence within three months to continue *The Battle of Anghiari*. The French were determined to get him to the northern city, and negotiated with Florence to save him from a threatened financial penalty. In this record of the very different relationships that emerge in 1506 between Leonardo and the Republic on the one hand, and Michelangelo and the Republic on the other, we can discern a defeat, and a victory.

* * *

There never was a formal prize; it was nastier than that. A prize ends it. The loser can shrug. This competition was a battle for hearts and minds – a struggle for prestige – whose consequences were limitless and uncontrollable. Michelangelo was proving, in the eyes of all who were there to see the spectacle, that he, not Leonardo, embodied the future of art. But what won over the Florentine Republic, what endeared him to Soderini, was politics. He was a good citizen. His cartoon showed the heroism it takes to win a war. *The Battle of Cascina* was a grave work, full of compassion for its soldiers, who go naked into the fray. Michelangelo didn't have to pretend to be a passionate republican. He believed in his city and he believed in liberty.

What did Leonardo believe in?

This was the disturbing question that Leonardo's painting in the Great Council Hall raised. It was not a patriotic citizen's work of art at all. It was not a rousing image of military courage. It was horrifying, and frightening. The Republic had asked him to glorify a famous historic victory. What he was slowly committing to the wall was a shocking image of battle's madness. It looked suspiciously like a denunciation of war.

* * *

The French historian Lucien Febvre once asked if it was possible
to be an atheist in the sixteenth century.[20] It was not, he proceeded
to demonstrate, claiming that even to conceive of the non-
existence of God was impossible then. If we ask the same ques-
tion of pacifism, the answer is very different. It was entirely
possible to be a pacifist in the sixteenth century. The condemna-
tion of war has deep origins in European culture. Christianity in
the early Middle Ages criticised war: the chivalric code and the
Crusades can be seen as negotiations between this early anti-war
bias and the military orders that dominated medieval society.[21]
By the 1500s the pope himself was making war, but the idea that
war is evil could be eloquently expressed in the Renaissance. In
1515 the great Dutch Humanist Erasmus published an essay on
the Latin adage '*Dulce bellum inexpertis*', 'War is sweet to those who
have no experience of it'. In it he expresses disgust that war has
become a respectable pursuit. There is nothing more wicked and
un-Christian than war, he insists.[22] Yet people enthusiastically
embrace it. Even priests and bishops go to war without a second
thought. So universal is the enthusiasm for war that '[i]t is consid-
ered impious, I almost said heretical, to disapprove of the one
thing in the world that is the most wicked and wretched'.[23]

Erasmus goes on to denounce war in images that recall
Leonardo's *Battle of Anghiari*. As it happens, Erasmus went to Italy
in 1506 as the Great Council Hall competition was reaching its
climax and stayed on for two years, visiting Turin, Bologna, Venice
and Rome. Is it conceivable that he heard descriptions or saw
copies of Leonardo's battle painting? In his anti-war essay he
describes the wonder and beauty of humanity, God's finest
creation. He continues:

> Now on the other hand we will compose, if you would like to see
> it, the picture of war. Suppose now, therefore, that you see the
> barbaric cohorts, inspiring horror with their very faces and the
> sound of their voices, the iron-clad men drawn up for battle, the

formidable noise and glare of weapons, the odious roar and onrush
of vast multitudes; threatening eyes, raucous horns and startling
trumpets, the thunder of the artillery, no less terrifying than
thunder itself but truly more noxious. Insane clamour, furious
assault, savage mangling, the cruel fates of the fallen and killed,
heaps of bodies, fields streaming with gore, rivers stained with
human blood.[24]

This epic and brilliant onslaught on the horrors of war can be
traced as an influence on Northern European artists. Erasmus's
word-picture of war's horrors haunts Pieter Brueghel's and
Albrecht Altdorfer's paintings of massed armies. It also bears a
striking resemblance to Leonardo's word-picture of war in his text
'How to Paint a Battle': '[Y]ou might see someone who has been
maimed, fallen to the ground, covering himself with his shield,
and an enemy bent low over him trying to finish him off . . . And
do not show any part of the field that feet have not trampled with
blood.'[25] That's Leonardo in about 1510. Nor do we need to turn
to Erasmus to find an explicit statement that war is a scourge and
a crime, for it is there in Leonardo's notebooks. He explicitly
called war a 'most bestial madness', and in his prophecy 'Of the
Cruelty of Man' it is one of the reasons this 'inhuman monster'
deserves to be destroyed. But perhaps his most moving repudia-
tion of violence is a paean to humanity. If his studies of nature
move you, says Leonardo, remember that humanity is even more
marvellous. If after reading him you believe it is wrong to destroy
nature, 'think what a nefarious thing it is to take away the life of
a man . . .'[26]

War is the destruction of the most wondrous thing in the world,
ourselves. Leonardo, like Erasmus, contrasts the inhumanity of
war with the miracle of humanity.

Leonardo was painting a negation of the patriotism the
Republic sought to instil with its parade of new soldiers in their
red-and-white costumes on the Piazza della Signoria. *The Battle*

of Anghiari was more liable to scare the assembled citizens of the Great Council into peace than fire them to war. The heroism of Michelangelo was more in tune with the effort to defeat Pisa – that noble struggle.

There is, to be sure, another way of seeing *The Battle of Anghiari*. The rage and violence of it have not struck all observers as denunciatory. All images are ambiguous in nature; one way to understand this painting is simply as a manifestation of what war is, a personification of its passions. The luridly ornate decorations of real garnitures of armour in sixteenth-century Europe, we have seen, resemble the grotesque metallic shells of Leonardo's warriors. Armourers competed to create the most bizarre metallic disguises for aristocratic warriors to wear. Clearly this was not a pacificist statement. To acknowledge war's violence was not, in other words, necessarily to condemn it. It is possible that portraying war's fury might have been intended to release a primal savagery in the Great Council. But if so, this was poor politics. A vision of war that sees it as unleashed barbarism might well be defended by an unusually honest and radical military thinker – in short by Machiavelli – but in reality, in inculcating patriotic feeling, it was counterproductive: a thought best kept to yourself. A heresy.

* * *

When Erasmus denounces priests and bishops for making war, he is undoubtedly thinking of Julius II, the Warrior Pope, who in 1506 personally led his armies on his campaign to reconquer the traditional Papal States, long since become autonomous cities, for the Church. Julius stormed towards the Apennines. Michelangelo's worst nightmare was coming true: the furious pope was headed his way. Condivi says that while Soderini did his best for Michelangelo, after Julius had written three times demanding to see his artist there could be no more refusing.[27]

In September 1506 the young sculptor – he was still just thirty-one – set out on horseback from Florence, headed for a terrifying

meeting with an employer he had audaciously insulted. Julius had conquered Bologna and was holding court there. For Michelangelo it was a moment of truth. Out of fear or pride, he turned back before he reached the city. The trip is not mentioned by Condivi and is not usually mentioned by Michelangelo's biographers. But it was recorded, because Machiavelli was already in Bologna, at the height of his prestige, serving as Florentine ambassador to the pope. Michelangelo was asked by the Florentine Chancellery to take Machiavelli some money to cover the politician's expenses. After the artist turned back to Florence, his servant returned this money to the Palazzo della Signoria with apologies. Machiavelli's colleague Biaggio Buonaccorsi wondered what to do next because, he wrote to Machiavelli, he didn't know whom else to trust. This reveals how involved Michelangelo now was in the affairs of the Palace, how much faith was placed in him, and hints at a friendly relationship with Machiavelli.[28]

Florence and Rome negotiated over a guarantee of Michelangelo's safety until in late November 1506 he finally felt sufficiently confident to make the journey to Papa Giulio in Bologna. When he got to the conquered city he went to San Petronio to hear Mass, and while he was there some of the pope's grooms recognised him. He was taken to the Palace of the Sixteen, where the pope was at table. Julius II glared at Michelangelo.

'You were to have come to find us, yet it appears as if we have come to find you.'

The artist knelt before the pope and asked pardon, saying he had not been able to endure being chased away by servants. The pope sat there in silence, his head bowed.

At this point, a priest representing Florence's Cardinal Soderini, the Gonfalonier's brother, spoke up in Michelangelo's defence: 'Your Holiness, pay no attention to his error, because he has erred through ignorance. Painters, outside their art, are all like this.'

This clumsy intervention – making explicit a disdain for artists – turned out to be a lightning rod for the pope's wrath.

'It is you who speak rudely to him and not us,' the pope yelled at the Florentine churchman. 'The ignorant one is you and you're the scoundrel, not him. Leave me immediately and go to your ruin.'[29]

When this poor man was slow to react, Julius had his servants beat him out of the room. Meanwhile Michelangelo stayed, unharmed and unabused, once more the pope's artist.

Julius pardoned Michelangelo and ordered him to stay in Bologna awaiting a new task. Soon the order came: he must cast a colossal bronze statue of the pope to show Bologna who ruled it. It was a martial image, a statue of a conqueror. Michelangelo was told to portray the heir of St Peter with a sword in his hand.

In another victory over Leonardo da Vinci, who as he pointed out had failed to cast the bronze horse in Milan, the supremely skilled Michelangelo succeeded in the technical challenge of casting a colossus. It took him just over a year to create this awe-inspiring imperial work. Later, records Condivi, when Julius' rule was overturned, this statue 'was hurled to the ground and melted down by the fury of the people. Its size was three times larger than life.'[30]

* * *

When Michelangelo was preparing to go to Bologna, he sought as much reassurance and protection as possible from Piero Soderini and the Florentine Republic. Communications between Soderini and the pope's aide Francesco Alidosi smoothed his path, and Soderini wrote a touchingly affectionate, almost paternal letter for Michelangelo to present to the pope, praising 'the bearer . . . the sculptor Michelangelo' as a fine young man, unequalled as an artist in Italy if not the entire world. If treated well, praised and cherished, said Soderini, he would do great works. With love and favour his creations would astonish everyone. Here in Florence, he added, Michelangelo had started a marvellous history painting for the people.[31]

Soderini stresses Michelangelo's youth in the letter; implicitly it is the passion of youth that excuses his impulsive behaviour. He also makes a clear judgement of Michelangelo's art, leaving no doubt who had triumphed, to Soderini's mind, in the Great Council Hall.

It is sadly instructive to contrast this letter with another that Soderini wrote that same autumn. Leonardo's French friends were trying to buy him more time in Milan. Charles d'Amboise wrote to the Florentine government asking leave for Leonardo to stay there a bit longer. Soderini sent this caustic reply on 9 October 1506: 'Excuse the Signoria for not agreeing a day with Leonardo da Vinci who has not carried himself as he should towards this Republic: because he has taken a good sum of money and made little beginning on a great work which he must do, and out of love for your Excellency has already delayed it: we don't want any more requests, because the work is to satisfy the people.'[32]

Michelangelo is a marvellous young man, but Leonardo has let down the Republic. A judgement has been made and it is not only artistic. Soderini is furious that Leonardo would rather serve the French nobility in Milan than create a work to satisfy the popular public of his own city. Leonardo has shown Soderini his true colours. The Gonfalonier is contemptuous of someone who would rather be a courtier than a citizen.

* * *

We tend to picture Leonardo as a benign and inspiring philosopher, bearded and otherwordly. Michelangelo meanwhile is often imagined as a bad-tempered, daunting character. It is Leonardo who charms the modern world. Yet to Soderini, who knew them both, their personalities looked remote from their later images. Leonardo was a lazy and dilatory rogue, Michelangelo a sincere and virtuous young man. In short, Soderini liked – even loved – Michelangelo but came to seriously dislike Leonardo. Clearly this reflected his disappointment in the older man and his hopes for

the younger. But it also implies something more elusive in Michelangelo's victory over Leonardo. It was that Michelangelo communicated more naturally and openly with his fellow citizens of Florence. They could relate to him. At one level this was a popularity contest, and he won it.

Fourteen

SCHOOL OF THE WORLD

The very stones would cry out against it if they could, said Michelangelo. He was far away in Rome when it happened, and he was lucky.[1] It was far safer to be braving the wrath of Julius II than negotiating the terrible last days of the Florentine Republic. It was 29 August 1512, and citizens of Florence could see the smoke rise from their close neighbour Prato and hear disturbing details from refugees streaming into the gates.

Some of Machiavelli's militia were defending Prato, positioned to hold back the attackers who were streaming through a hole made in the walls by artillery, but when they saw the enemy pouring out of a hell of smoke and rubble they simply fled. The conquerors were full of fury and expended their rage, their hot blood, on the town. It was a sack, a sustained and ritualised outburst of violence. Guicciardini, from his vantage point in the 1530s, writes that 2,000 soldiers were killed in cold blood after they surrendered. Another contemporary put deaths of soldiers and civilians at 4,500. At the very least, hundreds died[2] in a consciously brutal spectacle designed to scare Florence into surrender. The attackers were Spanish troops, and their purpose was to return the Medici family to power. It worked. Everyone knew the Republic had been sold down the river by a deal done with Julius II and other great powers. Soderini was visited in the Palace by a group of pro-Medici patricians who threatened him with physical violence unless he resigned at once. With help from Machiavelli, the Gonfalonier fled. Giuliano de' Medici soon

entered the city. The family with a habit of authority was back in charge.

Symbols matter in politics. The most imposing symbol of the Florentine Republic was not a person – there is no famous portrait of Piero Soderini to reproduce in this book, which must say something about his character as well as the Medici's determination to have him forgotten – but a room. The Great Council Hall was seen by ordinary citizens as the soul of the Republic, the physical expression of popular power. Built for Savonarola, it was literally sacred, a consecrated structure dignified by fine wooden furnishings and great works of art. The Medici family now set out to desecrate it and destroy its special aura. A deliberate and systematic act of vandalism took place, to express contempt for what the Hall stood for. It was a ritual intended to purge the city of republican pride.

That December the laying waste of the Great Council Hall began.[3] All the finely carved wooden seating was torn out, all the hangings and fittings. Partitions were constructed to turn it into a guardroom. It was a deliberate offence to anyone who still wept for Savonarola. What became of Leonardo's unfinished *Battle of Anghiari* while all this systematic vandalism was going on? Were things thrown at his painted horses by the soldiers who drank and gambled there, just as it was said arrows had been fired into his clay horse in Milan?

Only in the spring of 1513 was a wooden cage set up around Leonardo's painting to hide it from boozing soldiers. The relevant document in the Archivio di Stato[4] records that a carpenter had been paid for making a box to protect *The Battle of Anghiari* from being 'laid waste' (*'per difendere che le non sieno guaste'*). It is dated 30 April 1513, nearly five months after the attack on the Hall began. What happened to Leonardo's painting in the intervening time?

* * *

The competition had been, remembered Benvenuto Cellini, 'the school of the world'. As a child, this son of a musician, who would grow up to become a goldsmith, sculptor, soldier, murderer and auto-biographer, was captivated by the rival battle pictures of Leonardo and Michelangelo. As he tells it in his manuscript 'Life of Benvenuto Son of Giovanni Cellini, Written by Himself in Florence', (c. 1558–62), he himself drew a copy from *The Battle of Cascina*:

> This cartoon was the first beautiful work in which Michelangelo showed his marvellous talent, and he made it in competition with another who was at work there: with Leonardo da Vinci; the works were intended to serve for the Council Hall of the Palazzo della Signoria. They represented when Pisa was taken by the Florentines; and the admirable Leonardo da Vinci chose to show a battle of horsemen with the seizure of certain standards, as divinely made as it is possible to imagine. Michelangelo Buonarroti showed numerous infantrymen who because it was summer were bathing in the Arno, and in the same instant that the alarm was given he showed these nude footsoldiers rushing to arms, and with so many beautiful gestures that no work by the ancients or moderns was ever seen to reach such a high mark, and as I have said, that of Leonardo was most beautiful and admirable.[5]

Cellini claims that although Leonardo's painting was excellent, it was outdone by *The Battle of Cascina*, for Michelangelo's cartoon was simply the greatest work of art in the history of the world. He adds that although Michelangelo went on to paint the Sistine Chapel, he never again reached the heights of his battle cartoon.

Perhaps what is most extraordinary in this memory is that Cellini is speaking with such reverence not of paintings, but of very large drawings.

When Leonardo da Vinci returned to Florence in 1500 he had amazed the city with a cartoon, a full-scale preparatory drawing, for a composition of the Virgin and St Anne. Today, in the National

Gallery in London, his only extant cartoon – also representing the Virgin and St Anne – hangs near his oil painting *The Virgin of the Rocks*, much of which was painted by assistants. The oil painting always commands a bigger crowd than the cartoon nearby. Eyes are drawn to the colours and brightness of oil paint, while a cartoon, just chalk on paper, requires much greater adjustment and imagination on the beholder's part.

In Florence in the early sixteenth century this imagination was not lacking. People were more than ready to contemplate drawings and compare Michelangelo and Leonardo on this basis. Leonardo's earlier triumph with his Annunziata cartoon revealed the sensitivity and radicalism of Florentine eyes. A city that had already seen two centuries of artistic experiment since the days of Giotto was ready to take the final leap and value artists not for their finished works, but for their ideas. It might seem as if the Great Council Hall competition was a dismal failure, and an embarrassment, for the Florentine Republic. Only one of the artists even began to paint in the Hall, and Leonardo did not finish what he started. But it did not matter. For young artists like Cellini, whose very vocations were shaped by it, the competition was about genius; it was about looking into the minds of great creative spirits.

In 1514 Albrecht Dürer, who was very familiar with the reputations of both Leonardo and Michelangelo, engraved *Melencolia I*, a winged woman who sits brooding among the tools of sculpture, architecture and knowledge. She holds a pair of dividers limply in one hand, while the other supports her shadowed face. Nails and a saw, a plane, a hammer and stone models of the type of geometrical solids Leonardo loved to analyse are scattered about. She seems to have lost faith in her work and sits there, blackly pondering. This image of melancholic paralysis is a portrait of the 'saturnine' character the Renaissance ascribed to creative geniuses. The idea was disseminated by Marsilio Ficino, the Florentine Neoplatonist philosopher, whose works Dürer knew.[6]

Dürer's icon of Melancholy explicitly associates majesty of

invention with loss of direction and lassitude. It implies that all truly great artists and thinkers have difficulty finishing their works. It could almost be an epitaph for the career of Leonardo da Vinci, and it is also an insight into why no one thought the Great Council Hall contest a washout. To leave works unfinished is what real geniuses do. Lesser souls can learn simply by contemplating and copying these essays and fragments. This is the kind of idea we tend to believe has only existed since the age of Cézanne. In reality it flourished in the sixteenth century.

This was why, to the great acclaim of young artists, the cartoons of Leonardo and Michelangelo were displayed in competition in Florence from 1506 to the last days of the Republic six years later. Cellini recalls going from one cartoon to another to drink from the fountain of these supreme works: 'These cartoons were kept one in the Medici Palace and the other in the Sala del Papa. While they remained there, they served as the school of the world.'[7]

Although Leonardo made use of a cartoon to paint in the Palace, this seems to have been a subsidiary working copy, while his original, which he took so long to draw, remained on display in his working space at Santa Maria Novella. Monies paid for cartoon paper just before he started painting in 1505 presumably record the creation of the copy to pounce through and tear up in the process of painting while his original graphic masterpiece was preserved in the Sala del Papa.

Meanwhile Michelangelo's cartoon seems to have moved around in the course of its display. The room where he had drawn it was less central than the Sala del Papa, so *The Battle of Cascina* was taken elsewhere. Vasari says the cartoon was 'carried to the Sala del Papa with huge praise from artists and the greatest glory for Michelangelo'.[8] Condivi confirms that the immense drawing was 'left by Michelangelo in the Sala del Papa, as it was called, in Florence at Santa Maria Novella'.[9]

This was, at last, a direct, head-to-head comparison of the two battles. *The Battle of Cascina* could be seen in the same hall as *The*

Battle of Anghiari – except that it was the Hall of the Pope instead of the Great Council Hall. Later, Michelangelo's drawing seems to have moved again. At some point it was apparently taken to the prestigious setting of the Great Upper Hall of the Medici house on Via Larga – presumably towards 1512, when the Medici were rebuilding their base in the city.

A guide to Florence published in 1510, on the other hand, tells a different story. Franceso Albertini's *Memorial of Statues and Works of Art in Florence* is an artistic guide to the city that appeared in the last days of the Republic and offers an eyewitness account of the public art sponsored by Soderini. It's a fascinating hand-list compiled by a priest of where famous works of art were at that moment, in 1510. And it contains a surprise: '*Nella sala grande nova del consiglio maiore, lunga brac. 104. larga 40. e una tavola di fra Philippo, li cavalli di Leonard. Vinci et le disegni di Michelangelo.*'[10]

Like some modern guides, Albertini can't resist giving the exact dimensions – 104 *braccia* long by 40 *braccia* wide! (*braccia* being arms' lengths) – of the Great Council Hall. The works of art he mentions there include an altarpiece by Fra Bartolommeo, itself an unfinished work. This was the commission that had originally gone to Filippino Lippi; after he died Soderini gave the job to Fra Bartolommeo, a Dominican friar and follower of Savonarola – it was a blatantly political choice. In having a Savonarolan paint the Hall's altarpiece, the Republic was paying lip service to pious citizens. Although unfinished, the painting went on view anyway; you can see it today in the Museum of San Marco in Florence, a classical, dignified composition of the Virgin and patron saints by a painter who had much in common with Raphael as a master of order and harmony.

With the display of this unfinished work you get the impression that in 1510 the Florentine Republic was doing its utmost to make the best of things in the Great Council Hall. In addition to Fra Bartolommeo's incomplete painting it staged an exhibition of the rival works by the greatest Florentine artists of all. As well as '*li*

cavalli di Leonard. Vinci' – the painted horses of *The Battle of Anghiari* – you could see '*le disegni di Michelangelo*'.

'The drawings of Michelangelo'. In 1510, according to Albertini, Michelangelo's cartoon could be seen in the Great Council Hall along with Leonardo's painting. Meanwhile at Santa Maria Novella you could still see Leonardo's cartoon – '*disegni di Leonardo da Vinci*'.

There is of course an ambiguity here – the author says '*disegni*', drawings. Could it have been preparatory drawings by Michelangelo that were on view in the Hall? This would still further deepen the sense of an exhibition that celebrated the creative process itself.

In 1508 Michelangelo wrote a letter of recommendation for a young Spanish artist who wanted to see his cartoon. He wrote from Rome to his brother Buonarroto in Florence: 'Buonarroto, the bearer of this will be a young Spaniard, who is coming there to learn to paint, and has asked me to make it possible for him to see the cartoon I began at the Sala; anyway try to make it that he can have the keys, and if you can help him in any way, do it for love of me, because he is a nice lad . . .'[11] It didn't go well for this young artistic pilgrim who apparently wanted to visit the Sala del Papa – or could the ambiguously named Sala have been the Great Council Hall itself? On 29 July Michelangelo wrote sarcastically to Buonarroto of his gratitude to the cartoon's custodians at the Palace: 'I learned that the Spaniard has not been given grace to go to the Sala. I was indeed gratified; but solicit them on my part, when you see them, to do the same for others, and recommend me to them.'[12]

Did Michelangelo's intervention make the Florentine government rethink the way it was displaying his cartoon? His letter suggests it was not that easy to view – you had to have permission and a loan of the keys to enter the Hall of the Pope. Yet the Spanish artist's visit was confirmation of the growing fame of the Great Council Hall designs. Perhaps it helped encourage the

Republic to display Michelangelo's *Bathers* in the Great Council Hall, where Albertini locates them. But the word *Sala* does leave open the possibility that an exhibition of the two rival battles already took place there by 1508. Any such triumph for the Republic disappeared from the city's histories. It was a memory laid waste by the Medici.

* * *

Artists flocked to study the gigantic rival cartoons, and to admire Leonardo's unfinished painting. The competition shaped a generation. Among the very first to learn from them was Raphael. We've already encountered some of his interpretations of works by Leonardo and Michelangelo. At the heart of his study of the two titans loomed their battle cartoons. A copy by him survives in the Ashmolean Museum, Oxford, of *The Battle of Anghiari*; the small, quick, extremely precise drawing looks as if it was sketched on the spot while he was admiring Leonardo's work.[13] Yet when he started making great history paintings of his own it was Michelangelo's *Battle of Cascina* that most gripped him. You can see its influence very clearly in his *Entombment*, painted in 1507. This majestic, emotive vision of the burial of Christ was commissioned in memory of a youth killed in the faction fighting that bedevilled the city of Perugia. Raphael's large group of figures is organised at sloping, drastic angles in contradiction to one another: this way of suggesting agitation owes a lot to the tormented arrangement of Michelangelo's nude soldiers.

The Battle of Cascina peoples the frescoes Raphael went on to paint in Rome in the Vatican apartments of Julius II. In his *School of Athens* (1509–10), a semi-nude figure running in from the far left is visibly adapted from one of the soldiers in Michelangelo's cartoon. Once you spot this, further echoes abound. Even the way in which the huge group of philosophers in this painting is organised – above, on and below a flight of steps – suggests Cascina with the rocks become stairs. The difference is that Raphael wants

to communicate harmony instead of panic, but the idea that so
many bodies can be made to function together in a noble crowd
scene is beholden to Michelangelo's Florentine history. Raphael's
dramatic fresco *The Fire in the Borgo* (c. 1516–17) returns again to
Michelangelo to capture the essence of panic and terror, as people
try to escape a burning city; nudes, contortions, all the muscular
drama of *The Battle of Cascina* is here.

Raphael's *Triumph of Galatea* (1511–12) in the Villa Farnesina,
Rome, features trumpeting tritons who echo a musician in
Michelangelo's design. Twisting watery nudes pay homage again
to the Florentine soldiers jumping out of the Arno. But the influ-
ence of *The Battle of Anghiari* is unmistakable, too. Sea horses and
rearing dolphins and a swirling composition around a dominant
central figure hark back to the energy and cyclic ferment of
Leonardo's history painting and the closely related drawing he
made of Neptune ruling the waves.

Raphael's ultimate tribute to the Great Council Hall cartoons
was to emulate their cult status and influence. In 1515–16 he
designed tapestries for the Sistine Chapel, but he made sure his
cartoons for them were so finished, including being coloured in
gouache, that these works on paper were considered worth
preserving in their own right. In later centuries they were revered
and widely emulated, ending up in the British Royal Collection
and now the Victoria and Albert Museum, London.

What this all amounts to is that Raphael's entire concept of
narrative painting, which was to be admired and imitated for
centuries in the loftiest frescoes and public art, begins in his
witnessing the Great Council Hall competition. He can't let go of
his memory of it. In fact, even after he'd seen Michelangelo's
Sistine ceiling, it was still the *Battles* that he kept acknowledging,
reassessing, reimagining. Raphael did – notoriously – sneak into
the Sistine Chapel and imitate Michelangelo's latest forms. But it
is the battle pictures that seem more crucial to his conception of
public painting. It provides surprising evidence in support of what

might at first seem Cellini's bombastical, hyperbolic claim that Michelangelo's *Battle of Cascina* was better than his later works in the Sistine Chapel.

* * *

Maybe not better, but there was an obvious reason why the *Battles* might strike artists as more useful, more reusable, than the ceiling that Julius II commissioned Michelangelo to paint in 1508. What he did in the Vatican would leave comparisons behind. The Sistine ceiling is less a painting than an event: the images up there cannot be fully experienced in isolation from their setting or from the heroic solitary labour that produced them. This is the purest expression of Michelangelo's effacement of boundaries between himself and his work, the sense that a moment of creation goes on forever in them and when you lean back to see the ceiling you are really getting a glimpse of the artist's physical ordeal in painting it.

The ceiling is unique. It cannot be imitated. One panel in it also provides evidence that Cellini's claim for *The Battle of Cascina* really was over the top. Michelangelo started painting the vault of the Sistine Chapel from the back of the room, furthest from the altar: you can see his painting become freer and bolder as he moves towards the last scenes to be painted – the images of Creation, including God making the sun and earth and giving life to Adam. One of the earliest panels to be painted is therefore one of the last in the story he tells – his picture of the Flood; this must surely look to any spectator like a far more static and crowded composition than the exhilaratingly open images he went on to paint further along the ceiling. It is also impossible to miss the fact that it is derived from his cartoon for *The Battle of Cascina*. He reuses his own work as he paints people heaving themselves out of the floodwaters onto rocks. This gives us the chance to compare *The Battle of Cascina* with the overall wonder of the Sistine ceiling and see that it was, however ingenious, a less exceptional work.

That was precisely why it so influenced other artists. In the Sistine Chapel Michelangelo achieves something no one could ever hope to rival. It is him, it is part of his life. By contrast *The Battle of Cascina* was a − wildly original, perverse and mannered − contribution to a genre, the narrative wall painting, that had existed before and would continue to exist. It could be absorbed into the tradition in a way the Sistine ceiling could not.

* * *

If it fitted in a tradition, it did something singular to that tradition. Both Leonardo's and Michelangelo's designs were full of eccentric details. Frenzied faces, monstrous armour, twisting bodies, convoluted poses, masks and mad horses − between them the two Great Council Hall images provided sixteenth-century artists with a banquet of oddities. This was because Leonardo and Michelangelo competed to assert their personalities; their individual imaginations. That was why people valued the cartoons, too − because it was the minds of the artists that fascinated them. In these works, two geniuses tried to outdo one another in sheer quiddity. Their battle pictures were singular to the point of being mannered.

This made the battle cartoons founding works of a kind of art that boasted of its *Maniera*, 'manner' or 'style' − hence its modern name, Mannerism. Even as the Renaissance reached its summit of classical authority it broke up into playful eccentricity, and if the Great Council Hall competition led to the Sistine ceiling it also led to the sometimes superb, sometimes slight, always wilful originalities of artists such as Cellini and his contemporary Bronzino. An outrageous example of how Mannerist artists quoted the Great Council Hall designs is in Bronzino's erotic *Allegory with Venus and Cupid*, painted in Florence in the 1540s. Behind the glowing white nude bodies of Venus and her son is a dark, downcast, screaming face: it probably represents Envy or perhaps Syphilis. It is a reversed copy of the face of Niccolò Piccinino in

The Battle of Anghiari – the same mouth, the same rage, everything. Bronzino's intensely precious, ornamental and stylised allegory contains a homage to the grotesque imagination of Leonardo.

Bronzino was the pupil and close friend of one of the founders of Mannerist art, Jacopo Pontormo, whom Vasari lists among those who looked long and hard at Michelangelo's cartoon: 'Aristotile da San Gallo, who was Michelangelo's friend, Ridolfo Ghirlandaio, Raphael, Francesco Granacci, Baccio Bandinelli and the Spanish artist Alonzo Berughetta [perhaps the bearer of Michelangelo's letter of recommendation], and next Andrea del Sarto, Franciabigio, Jacopo Sansovino, Rosso Fiorentino, Maturino, Lorenzetto, Tribolo as a boy, Jacopo da Pontormo and Perino del Vaga; and they all became outstanding Florentine masters'.[14] The names are a roll call of the makers of Mannerism, of this openly perverse style that deliberately twisted and polished things to stress above all else the ingenuity of the artist. Condivi calls the cartoon for *The Battle of Cascina* '*arteficiosissimo*', a Mannerist term of praise if ever there was one.[15] In stressing the 'most highly wrought' character of his cartoon to Condivi, surely Michelangelo is confessing to something about it – the way he deliberately courted quirkiness and preciousness to outdo Leonardo as an original. He is also seeing it retrospectively as a Mannerist work, similar to some of his later wilful creations such as the New Sacristy in San Lorenzo, Florence. At the core of Mannerism was the belief that what matters is artistic originality, to the point of eccentricity – and this idea can be traced directly to the Great Council Hall competition.

Vasari says these artists studied Michelangelo's cartoon, but their own works reveal that they looked hard at Leonardo's *Battle of Anghiari* as well. Pontormo drew in the 1520s a cartoon for a painting of the Massacre of the Ten Thousand, a grisly scene of mass martyrdom, in competition with Perino del Vaga. The very fact that they produced competitive drawings for paintings is a – mannered – homage to the Great Council Hall competition. In Pontormo's highly strung version, there are unmissable echoes of

The Battle of Anghiari – wild riders, men fighting with daggers on the ground – and quotations too of figures in *The Battle of Cascina*. Pontormo passed on his enthusiasm for these battles to Bronzino.

Among works by other Mannerists who studied the cartoon, the massive, straining nudes of *The Battle of Cascina* return in Rosso Fiorentino's *Moses and the Daughters of Jephron* (1523–4) in the Uffizi, while *The Battle of Anghiari* is emulated in Giuglio Romano's *Battle of Constantine* in the Vatican (1521). Romano responds more creatively to the power and energy of the Great Council Hall works in his cascading, all-embracing tumult of massive bodies, the Sala dei Giganti in Mantua (1532–4). In Francesco I's Studiolo in the Palazzo Vecchio in Florence you spot the bodies of Michelangelo's bathers among the pearl fishers and wool workers.

At the end of the sixteenth century the virtuoso painter Caravaggio made a painting to give to the Medici family as a present. His *Medusa*, in its elaborate rivalry with Leonardo da Vinci, is one of the last Mannerist paintings.

Simply looking at the snake-haired Medusa in Greek myth could turn you to stone. In art this monster became associated with the imaginative power of Leonardo, who was said to have painted a *Medusa* that in the sixteenth century was in the proud possession of the Medici family.[16] Perhaps Leonardo painted a *Medusa* that was lost, perhaps he never painted one at all. Either way, the image of this monster became snakily entangled with the memory of the old warrior's howling visage in *The Battle of Anghiari*. Early copies of Leonardo's *Medusa* actually give it the face of Niccolò Piccinino.[17] So does the head that stares out of Caravaggio's painted shield.

Caravaggio painted his Medusa gift for the Medici with a visceral energy that vies not just with Leonardo's painting but also with the hideous monster that Vasari says the young genius made from dead animals then painted on a shield. Caravaggio, too, painted his monster on a round shield – the painting was hung by the Medici in their armoury. And you believe that, like Leonardo, he

had filled his workshop with dead snakes because the serpents of Medusa's hair look so writhingly real. Caravaggio's decapitated gorgon gazes in frozen horror and terror at its own mirrored image, its mouth open in a scream that is the prolongation of the silent cry echoing from the Great Council Hall.

* * *

The cartoons that were shown side by side in Florence from about 1506 to 1512 were revered, studied, ransacked. The Great Council Hall competition cast a long, complex shadow in Italian sixteenth-century art, inspiring a new cult of artistic originality. But if the huge drawings were so treasured, what became of them? For they have vanished off the face of the earth.

Vasari tells two stories about how Michelangelo's cartoon for *The Battle of Cascina* got destroyed. In his 'Life' of Michelangelo, he says it was killed by love. In his 'Life' of Baccio Bandinelli, which didn't appear until the second edition of the *Lives* in 1568, he says it was killed by hate.

When the cartoon was placed in the Medici Palace, he says in Michelangelo's 'Life', this great work on paper was not looked after carefully enough. As one artist after another came to study it without adequate supervision, they succumbed, one after another, to a terrible temptation. They tore off bits of the cartoon. It disappeared piece by piece until nothing was left. The very adoration it received obliterated it.[18] In his 'Life' of a personal enemy, Baccio Bandinelli, Vasari claims that when the city was in turmoil at the fall of Soderini, this Baccio got the keys to the Medici house. Taking out a knife, he slashed Michelangelo's cartoon and tore it to bits until there was not a single viable scrap left. He might have done it for many reasons, says Vasari. Some said 'that he was moved to do this by his affection for Leonardo da Vinci, from whom the cartoon of Buonarroto had taken away much reputation . . .'[19] Baccio was pursuing a vendetta on Leonardo's behalf.

The image in Vasari's 'Life' of Michelangelo of artists carrying

away souvenirs raises the weird possibility that all the quotations of *The Battle of Cascina* in sixteenth-century art are not just memories. Some of the artists may have had scraps of the cartoon in their possession to work from. Some pieces were said to survive in the 1550s, 'looked after with the greatest diligence as if they were sacred things', says Condivi, and Vasari speaks of some fragments in a house in Mantua. But none are known to exist today. The destruction of the cartoon for *The Battle of Anghiari* was just as complete. A fragment in Oxford may conceivably be part of the secondary cartoon that Leonardo's men worked from in the Great Council Hall.

Perhaps the reason Florentine officials were reluctant to hand over the keys to the Sala del Papa in 1508 was because the cartoons were already badly damaged; there is also the ambiguous word Albertini uses in his *Memoriale*, *disegni*, 'drawings'. He says you can see drawings, plural, by Michelangelo in the Great Council Hall and by Leonardo at Santa Maria Novella. Could this refer to surviving fragments of cartoons already partially torn up by 1510?

This does seem a very plausible interpretation. It appears unlikely that Michelangelo's small preparatory drawings would have been shown in the Great Council Hall – the space was too vast for them to make an impact. And while it might be possible for a beholder to refer to the multiple figures of Michelangelo's *Bathers* in the plural as 'drawings', this would not make sense as a description of Leonardo's intensely centred composition. It might make sense, however, if the cartoons were already in pieces, already on their way to vanishing, by 1510. It was oddly appropriate. The competition became a display of creative originality and its very relics were absorbed into the creative process, vanishing into the life of art. All the precise quotations of the lost battles in Renaissance painting – such as the head of Piccinino in Bronzino's *Allegory* – may not simply be accurate copies. Some may have actually been made using fragments of the cartoons as templates.

* * *

The fact is that neither of the cartoons seems to have survived the return of the Medici to Florence in 1512. After the Sack of Prato came the ravaging of the Great Council Hall. The bigger picture is suggestive and disturbing. The competition in the Hall was initiated by the Florentine Republic, to dignify a space sanctified to Savonarola and the revolution that threw the Medici out. When the politically adept family came back in 1512, they vented their wrath on the Hall itself, deliberately desecrating it, using it as a barracks. Is it a coincidence that neither of the cartoons survived this crisis? It seems at least worth considering the possibility that what finally erased these masterpieces of drawing and invention from the world was neither the love of artists nor the hate of a Leonardo disciple carrying out a vendetta on Michelangelo, but politics. If so it would match the eventual fate of the last surviving relic of the competition.

Fifteen

PRISONERS

The young people worked all night to sweep and scrub and wash their beloved Great Council Hall, to purge it of Medici filth. It was May 1527, and once again revolution had swept aside the ruling family of Florence. The city cast off its Medici overlords, declared a return to republican liberty and reinstated the Great Council. The age limit was set younger than before, at just twenty-four, and this fitted the intense and exalted mood of the time. For millenarian politics were sweeping Europe. The Reformation had brought subversive hopes and possibilities in Northern Europe, and recently German peasants had taken its overturning of the traditional order at face value by rising against their overlords. In Florence, the faith of Savonarola was once again firing the young. The new Republic proclaimed Christ its only king.

It was a long time since Michelangelo had been the young idealist who had carved the *David*. In riots that preceded the expulsion of the Medici in 1527, the arm of his statue was broken by a stone hurled from the roof of the Palazzo della Signoria. He himself was in Florence, working on the tombs of the Medici family in the New Sacristy of their parish church, San Lorenzo. He was fifty-two. The most famous and lionised artist in Italy, he was enjoying a second career as an architect. His poetry was increasingly read and admired. He was fêted by young artists who vied for his approval. His chief patron was Pope Clement VII, born Giulio de' Medici, head of the Medici family. It was Clement who employed him to create the Medici tombs and whom he

needed for any future work in Rome. For artists it was wise to side with the powerful, especially as no one believed this Republic would last.

The fall of the Medici in 1527 came about because Clement was humiliated by a Habsburg army that attacked Rome, sacked the Eternal City and besieged him in Castel Sant' Angelo. This seemed the nadir of the Papacy and of the Medici family, which had dominated the holy office since the death of Julius II (before Clement, the family produced Pope Leo X). It was the Papacy that ensured Medici rule over Florence as the autonomy of city states declined. In a world of lofty power-brokers, with Italy the plaything of Spain, France and the Church, the disaster of the Sack of Rome was soon rectified. Charles V, a Catholic ruler embarrassed by his army's transgressions in Rome, found himself trying to please and compensate Clement VII, and what the pope wanted was a Habsburg imperial army sent to crush the upstart Republic of Florence.

Benvenuto Cellini, the boy who saw the Great Council Hall competition and had now grown up to be a leading goldsmith, received a personal message from Clement advising him to leave Florence and show which side he was on – and he complied.[1] What choice was there for a craftsman dependent on patronage in Rome? But Michelangelo made a different choice. In 1506 he had defied a pope on an issue of pride. Now he stood up to a pope again, in defence of his city.

He stayed in Florence and applied himself to the art of war. In his youthful *Battle of Cascina* and *David* he had created heroic images of the ideal citizen-soldier. The nude army he drew in his cartoon for the Great Council Hall embodied citizens ready to fight for liberty. This idealism had helped him win his competition with Leonardo; but it was no calculated move. It was sincere – and now he proved it. In 1528 he set out to solve a problem at the heart of republican political theory. Machiavelli, in arguing that citizens should fight for their own cities, revived an ancient

belief that was contradicted by the realities of the artillery age. In truth, how could the bravery of citizens stand up to cannon? How could a city republic be maintained by its people when city walls were no use any more?

Michelangelo now himself volunteered as a citizen-soldier, but his weapons were not a sword and pike. He would use his architectural knowledge to reinvent the science of fortification and give the young men he watched training on the piazzas something more than daring to save their lives when they faced the tyrant's guns. In 1528 he drew designs for an ambitious remodelling of the city's fortifications and was appointed to the Ten of War. In 1529, as Commander of Fortifications, he created brilliant last-minute defences for the city as the imperial army approached. Now the famous artist in his fifties stood shoulder to shoulder with young Florentines ready to die for their city's freedom.

This was the last stand of an ancient ideology. Renaissance republicanism evolved out of medieval communal values and classical theory. It was already virtually extinct when Machiavelli and Soderini tried to defend it in the early 1500s. Now it was truly a threatened species, and the great powers were prepared to crush Florence with devastating force to kill it off. In Florence, as Savonarola's prophecies were avidly reinterpreted, young men volunteered for militia companies – not rural conscripts this time but real citizen-soldiers who drilled proudly on the piazzas as war approached. Jacopo Pontormo portrayed two of them standing to attention, gazing out of the canvas, defying tyrants and fortune alike. Pontormo's two great republican portraits of Carlo Neroni and Francesco Guardi done in 1529–30 are conspicuously similar to the portrait of a young soldier in front of the *David*, attributed to Granacci, that dates from 1510. Like the earlier work they stress the youth and readiness of their subjects: Guardi, in a sensual masterpiece now in the J. Paul Getty Museum, Los Angeles, looks out of the picture especially boldly. He is dressed in red pants with a codpiece, a creamy silk tunic, a red cap. He clutches his phallic

pikestaff bravely even though he's visibly just a teenager. Emulating the *David* in a similar way to the older picture by Granacci, the young citizen-soldier stands vigilant, ready. Even though he is dressed, his delicate clothes offer little protection. It is a study of foolhardy young courage. Pontormo's portrait of Carlo Neroni is even more explicitly a homage to Michelangelo as its subject looks fiercely to the left, actively imitating the glare of David.

Michelangelo was reliving his own youth and making a bond with a new generation. At this time he drew his own sensitive portrait of a young Florentine, Andrea Quaratesi.[2] It shares the idealistic candour of Pontormo's two paintings. It's worth pointing out that immediately after this experience of war he began for the first time to openly conduct love affairs with young men.

* * *

Machiavelli would have been ecstatic to see the Republic prepare for war. His ideas were in the air. His book *The Art of War* was reprinted and intently studied. One of the speakers in this dialogue on military matters, Battista della Palla, was highly active in republican Florence in 1529 – and a good friend of Michelangelo. But Machiavelli had died in 1527, after more than twenty years of exclusion from office. One of his last essays was a radical suggestion about the need to defend Florence from the hill that overlooked its southern suburbs, Monte San Miniato, where cannon might be placed by an enemy to reduce the Santo Spirito quarter to rubble.[3]

But it was Michelangelo, not Machiavelli, who lived to do battle for the last Republic.

War had never attracted Michelangelo as a scientific testing ground, as it did Leonardo. But in the 1520s his genius as an architect emerged when he began the New Sacristy and the Laurentian Library. These deliberately gloomy, disorientating interiors, with false doors and sealed windows and columns that float disturbingly

in mid-air, not supporting anything, all done in chilled white marble and morbid grey *pietra serena*, are Mannerist masterpieces. No room on earth declares quite so powerfully as the Vestibule of the Laurentian Library does that it is poetry, that its expressive meaning overrides practical function. In these disturbing spaces, Michelangelo constantly invokes ideas of exclusion, claustrophobia and power: doors that cannot be opened and windows that admit no light, a staircase that seems a barrier to entry – his architecture is a shadowed, tragic, courtly theatre, a setting for *Hamlet*. It made poetic sense for him to move in 1527 from building tombs and a library to designing gatehouses. His drawings for new ones in the walls of Florence are both aesthetic marvels and practical designs. Seen in plan, his bastions look like satyric masks, with sinister passages in which suspect visitors can be trapped, and gunfire radiating like sharp bristles from pores in the bulbous structure.[4] But they do the job a bastion needed to do: they refuse to give the enemy any straight angle to fire at, while maximising the defenders' artillery coverage of the city's surroundings.

Ingenious and macabre as they are, these designs could not possibly be realised in time to protect the city against an attack that seemed imminent. So Michelangelo was sent to study the fortifications of Ferrara, famous for its defensive measures. What he created as the situation grew desperate in the summer of 1529 was, however, very unlike the conventional defences of such cities. He worked by torchlight with an army of volunteers and drafted workers, shifting huge quantities of earth, strengthened with branches, to build banks and mounds at key points south of the city where the walls were weakest.[5] His most unexpected coup was to turn the city's greatest defensive weakness into an asset.

As Machiavelli had observed, Florence was vulnerable to the hill of San Miniato, where artillery could be placed to bombard it from above. Machiavelli argued that an entire section of the city below the hill should be demolished because it was such a weak point. Michelangelo, however, turned this argument on its head.

He fortified San Miniato with elaborate earthworks on which artillery was placed, including a long gun – a *falcone* – actually in the top of the bell tower of the ancient church on the hilltop. If Monte San Miniato overlooked Florence, it also overlooked the landscape where the imperial army was likely to attack. Michelangelo's raised gun fort commanded this entire southern terrain.

In October 1529 an army of the Habsburg Empire arrived at the southern gates of Florence, its task to reinstate the Medici. It did not anticipate anything like the resistance it encountered. Above all it did not expect to be fired on from above. The volunteer soldiers in their red codpieces chanting Savonarolan hymns were brave. But it was Michelangelo's fortifications, especially his artillery fortress on Monte San Miniato, that changed the course of the war. The guns there pinned down attackers with devastating fire, and after their own guns failed to knock out the Republican artillery, the attackers had to face the inevitability of a long siege.

Michelangelo had a moment's panic as the enemy approached. After finishing his defences, he secretly left for Venice. His friend Battista della Palla persuaded him to come back, and after a few weeks he did, to spend the rest of the war maintaining his defences on San Miniato. It was a courageous decision. Even though the fortifications held the enemy at the gate, there was never much ambiguity about the final outcome.

* * *

The brilliance of Michelangelo as a military engineer was a new twist in his multi-faceted career and, it might seem at first sight, his ultimate triumph over Leonardo. For all his designs for military inventions and his dalliance with warfare, there is no record that an intervention by Leonardo actually contributed to an important battle. But without the fortifications Michelangelo created, it's unlikely Florence could have put up the long fight it did. A painting

in the Palazzo della Signoria shows the huge imperial army encamped outside the city. In this topographic picture you can clearly see how the artillery fort of San Miniato dominated the landscape and empowered Florence.

Leonardo, meanwhile, had died in France in 1519. If he did not, as story has it, die in the arms of François I, he did end his days in the bosom of the French monarchy, which provided him with a fine house in the Loire Valley. He was too ill to paint in his last couple of years – he probably had a stroke – but François valued him as a 'philosopher', it was said. He designed spectacular court entertainments – work he delighted in. With him he had the *Mona Lisa* and his notebooks – the painting he left to Salaì, the notebooks to his companion and favourite pupil the Milanese nobleman Francesco Melzi.

The Great Council Hall competition had been a turning point in Leonardo's life. It marked the moment at which he effectively stepped aside from the ambition and rivalry of Italian art in its supreme age. As Freud observed, at a time when individualist aggression was the norm, Leonardo stood apart in his peaceful and evasive personality.[6] The defining moment of the Great Council Hall competition, from his point of view, might have been his planned attempt to launch a flying machine in April 1505. It was a step away from the heat of the contest – very literally an escape, into the countryside and, he hoped, into the very sky. He wanted out. Michelangelo – young, ambitious, in a hurry – could have the fluttering standard, the bit of grass tied to a pole.

After the competition, this was no longer Leonardo's choice to make. He was no longer trusted with big commissions. Only in Milan did the French ask him to create a monument to their captain Trivulzio, a job for which he showed little passion. But his talent was not gone, or his private ambition lost. In Florence in 1508 he started a series of dissections that produced incredible anatomical drawings and notes. In the years that followed, he drew his mesmerising apocalyptic sequence of *Deluges*, completed the

Mona Lisa, *Leda*, his nude *Mona Vanna*, *Saint John* and *The Virgin and Saint Anne*, and wrote something close to a conventional book, his *Treatise on Painting*. But a stay in Rome, in Bramante's Belvedere Palace at the heart of the Vatican, from 1513 to 1516 demonstrated sadly how far he was now from competing with a Michelangelo or a Raphael.

Leonardo had a fine studio in the Belvedere, courtesy of Giuliano de' Medici. But he was left there to get on with his mysterious researches without any sniff of a significant commission. He had become, you can't help feeling, a curiosity, a human marvel to take out and contemplate occasionally like a rare shell. The pope had him draw a map of the Pontine Marshes. For Giuliano he worked on an idea for a giant mirror, perhaps a weapon. In a letter to this patron he reveals the kind of paranoia that seems to have been endemic in Rome, where someone was always scheming.[7]

I have suggested that *The Battle of Anghiari* was a heretical image. By this I meant it had no respect for the conventions of its time, no belief in the patriotic and civic values a painting in the Hall of the Palace of the Signoria might be expected to endorse. In Rome, there is an intimation that Leonardo was seen in powerful circles as close to heresy in a more literal sense. His science threatened religious orthodoxy. In his drafts of a letter complaining about a German assistant he not only says the man keeps going off shooting among the ruins of the Roman Forum, but that he 'blocked my anatomy by blaming it to the pope'.[8] This was a serious anxiety. In the course of the sixteenth century, as the Reformation hardened religious ideas, the Vatican would become deeply suspicious of science, burning Giordano Bruno, putting Galileo on trial. Here is an explicit worry being expressed by Leonardo that as he works on his most important scientific research, his anatomical dissections and drawings, he is risking condemnation and persecution by, or at the least icy disdain of, the Church.

A painting in the church of Santa Maria sopra Minerva in Rome casts an uneasy light on Leonardo's notebooks. It is yet another Renaissance image of the book, painted by Filippino Lippi. But the tomes and albums and notebooks in this picture, which make you think of Leonardo's codices, are not in the study of a father of the Church – they are the outcast books of religious dissidents, in a fresco that celebrates the triumph of St Thomas over the heretics. You seem to see Leonardo's notes among the books refuted by the orthodoxy of St Thomas Aquinas. Even at the height of the Renaissance, the book might be feared, especially if it was written in secretive mirror script by a man who spent his nights dissecting corpses.

Leonardo's curiosity about nature certainly struck some as subversive of the Church. In the first edition of his *Lives* in 1550 Vasari says outright that Leonardo 'harboured such heretical [*sì eretico*] thoughts that he adhered to no religion of any kind, perhaps thinking it better to be a philosopher than a Christian'.[9] In his second edition of 1568, Vasari cut out this provocative claim. But in the Rome of Pope Leo X, it seems Leonardo felt under scrutiny. He believed his dissections were being criticised to the pope. It is a potentially explosive anxiety in its implications for his thought and its relationship to Christianity. Was he aware that such notes as his observations on the closeness of human and ape anatomy, or his insistence that a 'spirit' cannot act in the physical world, might not stand up to pious scrutiny?[10]

Whether or not Pope Leo did listen to calumniators of Leonardo's science, he certainly wasn't trusting Leonardo with anything important. 'Alas this one will never do anything, for he starts thinking of the end of a work, before he has begun it,' Vasari quotes Leo as saying of him.[11] Michelangelo had recently finished the Sistine ceiling, Raphael was working on frescoes in the Vatican and in villas, palaces and churches. There were a lot of walls being painted in Rome. Even corridors were considered fresco-worthy, and Raphael decorated the bathroom of Cardinal Bibbiena in

1516, the year Leonardo decided to emigrate. But Leonardo himself was treated as *hors de combat*, with nothing to contribute to the grandeur of the new Rome. The most visible relics of him here are his unfinished painting *St Jerome* in the Vatican Picture Gallery, and the name of an airport.

Vasari claims that Leonardo left Italy to escape the '*sdegno grandissimo*', the 'very great disdain', between him and Michelangelo. Perhaps their opposition should finally be seen in intellectual terms. Leonardo's anxiety that his anatomy was being maligned in the Vatican goes to the heart of his differences with Michelangelo. The art that triumphed in Rome in the sixteenth century was a religious art. Michelangelo was profoundly Christian just as he was sincerely Republican. Leonardo was a political heretic and perhaps a religious one, too.

Michelangelo's faith is inescapable. In his poetry, he turns again and again to Christ. His most confident declaration of faith is also his bravest assertion of individuality: the ceiling of the Sistine Chapel. I have drawn analogies between the interfolding, book-like narratives and visual footnotes of the Sistina and the notebooks of Leonardo. But if the Sistine ceiling is an answer to Leonardo's notebooks, it is an antithetical answer. Michelangelo presents up in these incandescent heights a history of the cosmos and of the earth that is unshakably Christian. Compare his image of Adam receiving life from God's outstretched arm with Leonardo's scientific depiction of the foetus in the womb. For Michelangelo, life is spirit. For Leonardo, it is biology.

No wonder Leonardo felt uneasy in Rome, beneath the Sistine ceiling. If it is true that in some sense Michelangelo drove him out of Italy, it was not only because the younger man won their competition. It was because when Michelangelo went on from his triumph in Florence to paint the Sistine Chapel he gave Rome a sacred art equal to the works of ancient paganism. The same honest desire to support the Church is in the works of Raphael. In the High Renaissance are the roots of the Counter-Reformation and

Rome's recovery of nerve, the roots even of modern Catholicism.

Leonardo, by contrast, was a heretic.

The Battle of Anghiari proved that. What God would make these desolate men? What faith survives in the eyes of Niccolò Piccinino? *The Battle of Anghiari* was the obverse of the glory of the High Renaissance, the scathing, sceptical negative to the energy of the Sistine ceiling and the grace of the *Stanze* of Raphael.

Michelangelo was the prophet of an art that could renew Catholic Italy. Leonardo heard his message, and emigrated. Soon after his Roman patron Giuliano de' Medici died, he accepted an invitation to cross the Alps and become the king's painter in France. Nursed by royal generosity, free from pressure to be anything but a resident genius and courtly philosopher, accompanied by Salaì and Melzi, the exile spent his last years among fairy-tale chateaux.

* * *

Michelangelo's fortification of Florence in 1529 was a more dramatic engineering feat than Leonardo ever pulled off. It demanded just as much scientific ability as any of Leonardo's schemes. Trajectories and sight lines had to be calculated, optimum gradients worked out when creating an artillery fortress. Michelangelo's was not just an inert bunker but a strategic coup – his aggression paid off. He fought to win.

Only, this was not the straightforward triumph over Leonardo that it might seem. It was something more subtle – and something with more self-recognition. Michelangelo was in his dead rival's debt. There was more at stake here, after all, than ego. He was trying to save his beloved city – which was also Leonardo's city. And he seems to have cast his mind back to the days of their competition. In 1504 Leonardo had been sent to Piombino to advise on its defences. There, he came up with a series of earthworks – heaped mounds, deep ditches, smoothed banks. Sticks were used to strengthen the earthworks. It was an elastic, versatile method. And this was the method Michelangelo used in 1529.[12]

Michelangelo's designs for gatehouses have more in common with Leonardo's designs for fortresses and towers than with the work of any other military architect of the age. Both of them experimented with rounded, twisted forms – and neither of them stuck to the simple formulae invented by architects like Sangallo.[13] There's an intellectual freedom to Leonardo's and Michelangelo's martial architecture that is more than coincidental. It is the key to a current of intimacy beneath their antagonism. For all their rivalry they were both ready to learn from one another.

In his designs for the Trivulzio Monument, Leonardo drew bound prisoners which quote Michelangelo's *Slaves* on the tomb of Julius II.[14] He was only repaying a compliment. During their competition Michelangelo started to write poetry, aspiring to become an intellectual like Leonardo, and discovered the poetic potential of unfinished works. His later art is an unfinished symphony. His *Slaves* in Florence were left in such a tumultous state of semi-formation that Medici dukes incorporated them as curios into the Great Grotto in the Boboli Gardens. Only in the twentieth century were they moved to the Accademia to form a sublime counterpart to the *David*. Only after Cézanne could people fully see these works.

Leonardo offered an example of the truly free creative mind. In turn, Michelangelo challenged Leonardo with the nude. The anatomical dissections Leonardo started after their competition can be seen as an attempt to outdo Michelangelo's nudes – to go beneath the skin.

* * *

Architecture is their most tantalising meeting ground. Architecture is also the art in which Michelangelo is most Leonardesque, because it takes him away from the human body into the human mind. His Vestibule of the Laurentian Library with its surreally warped scrolls and staircase spreading out like blood from a chest wound is the architectural equivalent of Dürer's *Melencolia I*. This

room is a portrait in sombre *pietra serena* set against skeletal white
of a mind at once omniscient and despairing, infinite and enig-
matic. It could almost be the mind of Leonardo da Vinci. In
Leonardo's architectural drawings, domes, columns and cavernous
interior spaces are used poetically, in a softly musical way. The
classical orders and geometries are enthusiastically deployed, yet
an intense graphic energy transfigures them into something more
personal than the work of, say, Brunelleschi or Bramante. The true
ancestor of Leonardo as an architect is Alberti, the designer of
Santa Maria Novella's façade, whose treatise on building he owned.
Alberti is also the ancestor of Michelangelo's designs. What all
three have in common is a supremely individual assimilation of
classical style. In their architecture the classical grammar becomes
a language of the unconscious.

On the battlements of San Miniato it was as if Michelangelo
was haunted by memories of Leonardo. During the siege he
painted a work far from his usual subject matter – *Leda and the
Swan*. In Michelangelo's version, Leda disturbingly allows the swan
to slide between her legs and extend its long neck along her body.
This image is extremely disconcerting – and evocative of Leonardo.
Not only does it compete with the older – and now a decade dead
– man's lost *Leda*, begun during their Florentine rivalry. It also
mysteriously insinuates Leonardo's fascination with flight and the
life of birds. In Michelangelo's painting – known only from a copy,
the original having vanished like Leonardo's, as if this subject were
too odd to survive – the swan touches Leda's lips with its beak.
What a singular echo this is of Leonardo's famous childhood
memory that a kite came down and touched his lips with its tail
feathers.

In this moment of war and terror, Michelangelo found himself
thinking about Leonardo da Vinci, in a curiously personal way,
remembering the would-be aviator. He was not the only Florentine
thinking about Leonardo at this time.

Jacopo Pontormo, who portrayed the young militiamen posed

bravely to defend Florence, soon found himself seeing the war through bleaker eyes. As the siege held his city in an iron claw he dug out his old cartoon for *The Martyrdom of the Ten Thousand* in which he quoted both Leonardo's *Battle of Anghiari* and Michelangelo's *Battle of Cascina*. When it was conceived, this design was an erudite and precious Mannerist plaything. Now he painted it, on a small scale and with lurid additions, to create a disturbing image of mass murder at the hands of a merciless tyrant. A Roman emperor sits enthroned, presiding over the slaughter of thousands of innocents. He is copied from the figure of Giuliano de' Medici that Michelangelo had begun to carve on the Medici tombs in Florence.

Michelangelo's Giuliano is a classical warrior and at the same time a nightmare being. He sits in armour *all'antica*, staring harshly, and his neck, when you see it from the side, is as peculiarly elongated as that of some demon in Dante. On his figure and that of Lorenzo de' Medici (a later Lorenzo, not *Il Magnifico*) facing it in the enclosed theatre of the New Sacristy of San Lorenzo, details of dark-eyed masks, animal skulls and metal armour rendered in stone accumulate in deathly magnificence – to describe this sculpture is to recognise that here Michelangelo is recreating Leonardo's Anghiari warriors.

Pontormo pointedly includes Giuliano in his painting to make it clear that it is an allegory of the Siege of Florence. Thousands are dying at the hands of a Medici tyrant. The way Pontormo describes the horrors of war is by adducing the horrors of art: his painting quotes two figures fighting on the ground directly from *The Battle of Anghiari*, the upper one holding down his victim as he raises a dagger to deal the death blow just like the men beneath the wheeling horses in Leonardo's picture. Naked horsemen, nude versions of Leonardo's armoured warriors, ride wildly and fight for a banner: you can almost hear the screams and drums of the savage horde.

Leonardo's battle painting survived, unfinished but potent, on

the wall of the Great Council Hall in 1529. But it was coming to life on the streets, as well, just as Pontormo's picture implies. The inferno of war was consuming Florence, as if *The Battle of Anghiari* were the one true prophecy ever to have been delivered in Savonarola's Hall.

* * *

As 1529 became 1530, a city was dying.

The Republic held out for nine months. Hunger and disease set in. The modernised fortifications never gave way. Instead food supplies were cut off and civilians paid the price for the courage of Republican volunteers. The success of Michelangelo's defences produced a situation that was to become the pattern of war in sixteenth- and seventeenth-century Europe, as artillery fortresses brought battles to a deadlock and siege became a routine military strategy.[15] As ever, Florence was in the vanguard. And it paid a shocking price.

About 30,000 civilians died during the siege. One victim whose name is at least remembered was the painter Andrea del Sarto, who succumbed to plague as the gates were finally opened and the restorers of Medici rule strode in.[16] The poor, it was observed by Francesco Guicciardini, who entered Florence with the invading forces, had died en masse: this had become a city without a prole-tariat. It was the worst catastrophe to hit Florence since the Black Death.[17]

Michelangelo was on a list of Republicans to be put to the sword in those first chaotic days of the Medici restoration. He hid in cellars and crypts. Luckily no assassin located him and soon word came from Pope Clement VII for the famous artist to be spared. Close friends were not so lucky: Battista della Palla, who had persuaded him to stand by the Republic, died in prison. Clement ordered Michelangelo to take up work again on the Medici tombs, to earn his salvation. Michelangelo took up the chisels 'more from fear than love'.[18] He composed a poem

explaining the figure of Night on the tomb of Giuliano de' Medici, reclining in her mighty slumber in the same pose as his *Leda*:

> Dear to me is sleep, and even more to be made of stone,
> while damage and shame persist;
> not to see, not to feel is to me a great stroke of luck;
> therefore don't disturb me, please, speak low.[19]

The new Duke of Florence was Alessandro de' Medici, who asked Michelangelo to advise him on his construction of a massive new fortress to rule the city. Michelangelo refused to give any such advice. After Clement VII died, he knew he had no protector in Florence. In 1534 he left for Rome and self-imposed exile. He lived another thirty years, but never returned to Florence. When Alessandro de' Medici was assassinated, he carved a bust of Julius Caesar's killer Brutus to celebrate the tyrannicide.

* * *

The final fate of Leonardo's *Battle of Anghiari* is inseparable from the fate of the Florentine Republic. The Medici now consolidated their power and eventually the Great Council Hall would have to be dealt with once and for all.

Vasari now enters the story not as the author of the lives of Leonardo, Michelangelo and so many other artists, but as a painter and architect in his own right. Vasari, born in Arezzo in 1511, had been supported in his early career by Medici patronage. He was always loyal to the powerful family. After the siege, he was patronised by Alessandro de' Medici, but his finest hour came with the reign of Cosimo I, first Grand Duke of Tuscany. This most efficient and ruthless of the later Medici routed the very last Republican rebels and set out to put the stamp of his dynasty more firmly on Florence than ever before. Vasari was his court artist and architect; Vasari's *Lives* are dedicated to Cosimo.

Although Vasari's paintings are somewhat synthetic and repetitive

Mannerist concoctions, as an architect he was very creative. He built the Vasari Corridor across the top of the Ponte Vecchio to link umbilically the Pitti Palace and the government Palace, which now became known apolitically as the Palazzo Vecchio, and created a U-shaped grey-and-white building by the river for the bureaucracy of ducal Tuscany, called simply the Offices – the Uffizi. Most ambitiously of all, Cosimo commissioned him to transform the austere fortress of the republican seat of government into a palace fit for a Medici duke. Vasari added rich chambers and grand staircases, working with a team of painters to fill the palace with allegorical and historical frescoes. His masterstroke was the transfiguration of the Great Council Hall.

It was a symbolic space that needed to be stripped of the least shred of subversive meaning. Cosimo I and his architect realised that desecrating a symbol only strengthens it – in 1527 the very misuse of the Hall since 1512 gave it intensified significance, as citizens ritually cleansed it of Medici ordure. What was done in the mid-sixteenth century by Vasari was a far more intelligent and final way to efface the history of this room than simply laying it waste. He understood about the magic of place; when he built the Uffizi he buried a talisman in its foundations. What he did to the Great Council Hall was not to disenchant but re-enchant it – to turn it into a rich theatre of Medici rule. He raised the height of the hall, added new windows and a gallery at the southern end. He created a ceremonial stage for ducal appearances, the Udienza, with sculpture by his rival Baccio Bandinelli. Statues were placed in the hall, including works by Giambologna and Michelangelo's *Victory*, all chosen as images of conquest and rule. The huge frescoes and ceiling paintings repeated the message of Medici glory ad nauseam. No monarch in the Europe of the day could boast of such a hall. Memories of the Republic simply vanished into a larger room and, by implication, a bigger history, that of the Medici, first family of Florence.

Leonardo da Vinci's wall painting vanished, too. Its condition

by then cannot have been good. Later witnesses describe the 'horses' of Leonardo – were their great, round rumps all that survived? Or was the picture comparatively well-preserved? Still more ambiguous is what Vasari did to its remains. He was, after all, Leonardo's ecstatic biographer. His writings are full of passion for works of art and grief for those destroyed in wars and disasters. At Santa Maria Novella, a painting by him was discovered in modern times to conceal – and preserve – a great work by Masaccio. Perhaps Vasari hid Leonardo's martial masterpiece instead of destroying it. In recent years efforts to rediscover the lost work have become ever more intense. This is no surprise because ever since it was begun, Leonardo's battle has troubled the Western imagination.

* * *

Jacopo Pontormo was not the first artist, in the reference he made to it during the Siege of Florence, to set aside the Mannerist cult of grotesquery for its own sake and respond to *The Battle of Anghiari* in a direct, human way as a terrifying picture of war. Even during the competition itself in the early years of the sixteenth century, Ridolfo Ghirlandaio painted a *Christ on the Road to Calvary* in which a Roman soldier tormenting Christ has the cruel face of Niccolò Piccinino. This is a moral instead of an aesthetic interpretation of Leonardo's masterpiece – in Ghirlandaio's eyes the Anghiari warriors were evil men. But the artist who saw more clearly than any other the protest at war's fury in Leonardo's painting was Peter Paul Rubens.

The painting was already lost when Rubens travelled to Italy to learn from its masters at the end of the sixteenth century. He came into possession of an excellent copy, however, and adapted it into his own unrivalled reconstruction of *The Battle of Anghiari*. Rubens responds instinctively to the roaring, swirling energy of Leonardo's battle picture, but not in a cold Mannerist way. On the contrary, he sees in it the mirror of his own loathing for war.

In his childhood his home city, Antwerp, was put to the sack. Rubens grew up with a traumatic knowledge of the reality of war. When he became a famous artist and his manners and bearing won him a reputation as a courtier and diplomat, he actively tried to promote peace among the monarchs of Europe whose ear he had. He even made a painting to show Charles I of England the benefits of peace and the destructiveness of war. Children and cornucopian plenty embody peace, while war, eyeing them balefully, is held back by Minerva, goddess of wisdom.

Rubens failed to bring peace to Europe. In his painting *The Horrors of War*, he shows what happens when Mars is unleashed. A woman hopelessly tries to protect her child as a village burns in the distance. That detail of a hamlet in flames is an image that Erasmus describes in his essay on war, for the northern artist Rubens drew on Erasmus as well as Leonardo to forge his pacifist art. We've noticed a similarity between Erasmus and Leonardo as prophets of war: Rubens saw this, too.

The Horrors of War hangs in Florence, in the Pitti Palace. Through this and other paintings influenced by it, Leonardo da Vinci's *Battle of Anghiari* survives. It has never been lost. Picasso's *Guernica* with its horse screaming against the bombs has an echo of it. While Picasso was responding to the Spanish Civil War with his great history painting, Salvador Dalí actually copied figures from Leonardo's *Battle of Anghiari* designs in the Accademia Gallery, Venice, into a dusty vision of a Spanish plain. In Dalí's painting *Spain* the warriors of Anghiari return to fight their endless battle. In a landscape modelled on his own Catalan region, in a flat expanse of nothingness, Leonardo's battle becomes an image of futile hatreds. A vendetta in the brain.

* * *

The search for Leonardo's lost work on the walls of the Hall in Florence will go on, and quite possibly succeed. It is pointless to protest that what is finally uncovered will probably be even more

fragile and fragmentary than the *Last Supper* and that hysterical publicity will probably make seeing it as unsatisfactory as visiting the *Mona Lisa*. The marvel of Leonardo will never fade, and, after all, our obsession with him is entirely justified.

I hope I have shown that a recovery of the painting is almost beside the point. The lost *Battles* of Leonardo and Michelangelo are as available to us, as real, as any work of art, for all art requires imagination and thought to truly enjoy it. Almost because the originals are not visible, the process of reconstructing these great works in our minds can give us a stronger feeling for them than we might have for many a well-preserved painting. Their first audience responded to the concepts and images that were in them, not to details of execution. So can we. There are enough preparatory drawings, copies, written descriptions and allusions in later works to make these vanished pictures astonishingly real. In the end this is simply the immediacy of the greatest art.

You don't need to chip away Vasari's frescoes to see *The Battle of Anghiari*. Its shadows are eternal, its truth as old and as new as human folly. Switch off the latest barbarisms on the television news, close your eyes, and it will come to you.

* * *

The steps lead up, up above the church and the city, circling a vast emptiness. At last you emerge, onto a fenced gallery, to look down into the golden space where specks of dust float in shafts of sunlight. Far below on a marble floor people mill among colossal grey pilasters. A bronze-black canopy that towers over them seems tiny from up here. Yet the dome flies higher still, above the drum on which you're standing, which is the last work Michelangelo saw completed.

He was a very old man when he took on the challenge of St Peter's. The new basilica begun by Bramante was nowhere near completion. Michelangelo in his final years knew he would not see it finished either, but he alone possessed the clarity of mind and

the practical authority to redeem a corrupted enterprise. He imposed a vision on St Peter's so firm and magnificent that he ensured its glorious completion. It would, he insisted, be a domed temple, the supreme monument of the classical passions of the Renaissance. He himself built the stupendous stone drum on top of which the dome would rise. He built it so grandly that finishing the dome would only be a matter of time.

He was old and, for once, he was forgiving.[20] Michelangelo had once loathed Bramante, but in his designs for St Peter's he openly returned to his long-dead rival's original plans for a domed geometric monument. Michelangelo's vision built on Bramante's architecture and, in so doing, silently, perhaps unconsciously, commemorated another old rival. For Bramante's ideas for domed churches were developed in the fifteenth century in conversation with his friend Leonardo da Vinci. There are no more eloquent testimonies to the power of the dome in the Renaissance mind than Leonardo's breathtaking designs for them. There is a close relationship between these paper temples and the perfect architecture that Bramante achieved with his Tempietto in Rome. This same relationship exists between Leonardo's drawings and Michelangelo's impossible, yet real, dome of St Peter's. No one is an island. Michelangelo knew as he raised the stone drum of St Peter's that he would not see his dome finished. But he also knew it was not just his dome. It belonged also to Sangallo, to Raphael, to Bramante. And here above Rome, he repaid the greatest debt of all. Enmity does not endure. Beauty does. From the heights of St Peter's, the imaginations of Leonardo da Vinci and Michelangelo soar together – into the blue.

NOTES

All quotations in the text are translated by the author, unless otherwise stated in the notes.

ABBREVIATIONS

Richter 1 and 2: Jean-Paul Richter, ed., *The Notebooks of Leonardo da Vinci*, vols I and II, London 1883. This remains a superb anthology of the Italian texts with literal translations, but for dating and modern references to the manuscripts see the version with a commentary by Carlo Pedretti, Oxford 1977

Rime: Michelangelo, *Rime*, intro. Giovanni Testori, chronology etc. by Ettore Barelli, sixth edn, Milan 1998

Madrid I and II: Leonardo da Vinci, *De Codices Madrid*, facsimile edn of codices Madrid I and II, Antwerp 1974

Vasari: Giorgio Vasari, *Le Vite de' più eccellenti architetti, pittori, et scultori italiani, de Cimabue insino a' tempi nostri*, ed. Luciano Bellosi and Aldo Rossi from the first edn of 1550, Turin 1986

Condivi: Ascanio Condivi, *Vita di Michelangelo Buonarroti* (1553), ed. Giovanni Nencioni with M. Hirst and C. Elam, Florence 1998

Uccelli: Leonardo da Vinci, *Codex On the Flight of Birds* (*Sul Volo degli uccelli*), Biblioteca Reale, Turin, facsimile edn, Munich 2000

INTRODUCTION

1. Richter 2, n. 796, pp. 107–8.
2. *Rime*, 5, pp. 45–6.
3. Heinrich Wölfflin, *Classic Art* (originally published 1899 as *Die klassische Kunst*), trans. Peter and Linda Murray, fifth edn, London 1994, p. 57.

4. Jacob Burckhardt, *The Civilisation of the Renaissance in Italy* (originally published 1860 as *Kultur der Renaissance in Italien*), trans. S. G. C. Middlemore, new introduction by Peter Burke, notes by Peter Murray, Harmondsworth 1990. See esp. pt II, 'The Development of the Individual', pp. 98–119. For an influential modern rethink of "'individualism'," see Stephen Greenblatt, *Renaissance Self-Fashioning*, Chicago 1980, and for exemplary studies of selves being fashioned in the Renaissance world, see Natalie Zemon Davis, *The Return of Martine Guerre*, Cambridge, MA, 1983, and *Trickster Travels: The Search for Leo Africanus*, New York 2006.

ONE: THE INSULT

1. Madrid II, 4 verso.
2. Vasari, p. 551.
3. Richter 2, n. 1458, p. 438.
4. Lorenzo Lotto, *Young Man before a White Curtain*, c. 1506–8, oil on canvas, Kunsthistorisches Museum, Vienna.
5. Leonardo da Vinci, *Treatise on Painting*, trans. and annotated A. P. McMahon, Princeton 1956, vol. 2: Facsimile, n. 51, p. 20 recto and verso.
6. For a full account and detailed illustrations of the restoration, see Pinin Brambilla Barcilon and Pietro C. Marani, *Leonardo: The Last Supper*, trans. Harlow Tighe, Chicago and London 2001.
7. Richter 1, n. 664, p. 345.
8. Luca Landucci, *A Florentine Diary*, trans. Alice de Rosen Jervis, London and New York 1927, p. 181.
9. William Shakespeare, *The Complete Works*, ed. Jonathan Bate and Eric Rasmussen, Basingstoke 2007, pp. 1678, 2085.
10. Vasari, p. 545.
11. *Ibid.*, p. 548.
12. *Ibid.*, p. 555.
13. *Ibid.*, p. 554.
14. Pliny the Elder, *Natural History: A Selection*, ed. John F. Healy, rev. edn, London 2004, Book XXXV, 'Painting, Sculpture and Architecture', esp. pp. 329–336.

15. Boccaccio, *Decameron* (Florence 1554), ed. Vittore Branca, Milan 1985, *Giornata* VI, *Novella* 5, pp. 524–6.

16. Matteo Bandello, *Tutte le opera*, edited by Francesco Flora, vol. 1, Milan 1935, pp. 646–50.

17. Benvenuto Cellini, *Autobiography*, trans. George Bull, rev. edn, Harmondsworth 1998.

18. On honour see Roger Chartier, ed., *A History of Private Life III: Passions of the Renaissance*, trans. Arthur Goldhammer, Cambridge, MA, and London 1989, esp. pp. 21–67, 571–611.

19. The murder story appears in his 'Life of Andrea dal Castagno', Vasari, pp. 393–4.

20. *Il Codice Magliabechiano cl. XVII contenente notizie sopra l'arte degli antichi e quella de' fiorentini da Cimabue a Michelangelo Buonarroti, scritta da anonimo fiorentino*, ed. Carl Frey, Berlin 1892, p. 115.

21. *Ibid.*

22. Madrid II, 4 verso.

23. John Gage, ed. and trans., *Goethe on Art*, London 1980, pp. 171–2.

24. *Mandragola*, act 4, scene 2; Niccolò Machiavelli, *Teatro*, ed. Guido Davico Bonino, new edn, Turin 2001, p. 113.

25. Luca Landucci, *Diario Fiorentino dal 1450 al 1516 . . .*, ed. Iodoco del Badia, Florence 1883, p. 210, entry for 26 February 1501: '*Andorano in sul carro, attanagliatti per tutta la terra molto crudelmente; e qui a' Tornaquinci si spezzò`el caldano dove affocava le tanaglie. E non v'essendo molto fuoco, che non infallivava, el cavaliere, minacciando il manigoldo, fece fermare el carro, e'l manigoldo scese del carro e andò pe' carboni al calderaio, e per fuoco al Malcinto fornaio, e tolse un paiuolo per caldano, onde fece grande fuoco. El cavaliere gridava sempre: falle roventi; e così tutto'l popolo disiderava fare loro grande male sanza compassione. E fanciugli volevano assassinare el manigoldo se non gli toccava bene, onde gli fece molto gridare terribilissamente. E tutto questo vidi qui a' Tornaquinci.*'

26. On violence in Florentine politics, Lauro Martines, *April Blood*, London 2003, narrates the Pazzi plot to murder Lorenzo and Giuliano de' Medici; Lorenzino de' Medici, *Apology for a Murder*, trans. Andrew Brown, London 2004, is a self-justifying account by the assassin of Alessandro de' Medici; and Benedetto Varchi, 'Della istoria fiorentina', in *Thesaurus antiquitatum et historiarum Italiae*, Leiden 1723, pp. 301–2, tells how gangs of adolescents were licensed to destroy villas outside the city on the eve of the Siege of Florence in 1529. There are vivid

examples of violence in everyday Florentine life in Cellini (note 17), pp. 17–18, 23–7.

27. Boccaccio (note 15), p. 507.

28. Madrid II, 65 recto.

29. Leonardo da Vinci (note 5), n. 51, fol. 20.

30. Frey, ed., *Il Codice Magliabechiano* . . . (note 20), p. 115.

31. *Ibid.*

32. Lord Frederic Leighton, *Cimabue's Celebrated Madonna Is Carried in Procession through the Streets of Florence*, 1853–5, National Gallery, London.

33. Vasari, pp. 880–81.

34. Condivi, p. 63.

35. Letter from Michelangelo's friend Sebastiano del Piombo recounting a conversation with the pope, in P. Barocchi and R. Ristori, eds, *Il Carteggio di Michelangelo*, vol. II, Florence 1967, no. cdlxxvii, pp. 252–3.

TWO: THE FAME MACHINE

1. Raymond de Roover, *The Rise and Decline of the Medici Bank, 1397–1494*, Cambridge, MA, 1963; George Holmes, 'How the Medici Became the Pope's Bankers', in Nicolai Rubinstein, ed., *Florentine Studies*, London 1968.

2. Nicolai Rubinstein, *The Government of Florence under the Medici*, Oxford 1966; John M. Najemy, *A History of Florence 1200–1575*, Malden, Oxford and Victoria 2006, pp. 278–306.

3. Lauro Martines, *Power and Imagination: City States in Renaissance Italy*, new edn, London 2002; Leonardo Bruni, *History of the Florentine People, Vol. 1*, trans. James Hankins, Cambridge, MA, 2001; Najemy (note 2), pp. 11–27.

4. On Mediterranean urbanism, see Marc van de Mieroop, *A History of the Near East ca. 3000–323 B.C.*, Malden, Oxford and Victoria 2004, pp. 17–37; M. I. Finley, *The Ancient Economy*, second edn, Harmondsworth 1992, pp. 123–49; Jacques Le Goff, *The Birth of Europe 400–1500*, Malden, Oxford and Victoria 2007, pp. 99–121, 180–81; Fernand Braudel, *The Structures of Everyday Life: Civilisation and Capitalism 15th–18th Century, Volume I*, London 1981, pp. 479–525; Daniel Whaley,

The Italian City-Republics, third edn, Harlow 1988; Gene A. Brucker, *Renaissance Florence*, suppl. edn, Berkeley, Los Angeles and London 1983.

5.　Felix Gilbert, *Machiavelli and Guicciardini: Politics and History in Sixteenth Century Florence*, New York and London 1984, pp. 17–20.

6.　Hans Baron, *The Crisis of the Early Italian Renaissance*, Princeton 1966, and Quentin Skinner, *The Foundations of Modern Political Thought, Volume One: The Renaissance*, Cambridge 1978, offer classic – and opposed – interpretations of how republican thought evolved in medieval Italy.

7.　See Dale Kent, *Cosimo de' Medici and the Florentine Renaissance: The Patron's Oeuvre*, New Haven and London 2000.

8.　Alison Brown, 'Rethinking the Renaissance in the Aftermath of Italy's Crisis', in John M. Najemy, ed., *Italy in the Age of the Renaissance 1300–1550*, Oxford 2004, pp. 246–65, and J. G. A. Pocock, *The Machiavellian Moment: Florentine Political Thought and the Atlantic Republican Tradition*, second edn, Princeton and Woodstock 2003, are modern analyses of the crisis of 1494. However, the classic history of the French invasion and its aftermath, and a fundamental source for this book, is the sixteenth-century Florentine statesman Francesco Guicciardini's *History of Italy* written in his retirement in the 1530s. Francesco Guicciardini, *The History of Italy*, trans. Sidney Alexander, Princeton 1969, is a convenient selection from this vast work. Gilbert (note 5) contextualises Guicciardini's history.

9.　Guicciardini (note 8), pp. 76–85; Najemy (note 8), pp. 375–400; Gilbert (note 5), pp. 11–29.

10.　Lorenzo Polizzotto, *The Elect Nation: The Savonarolan Movement in Florence 1494–1545*, Oxford 1994; Lauro Martines, *Scourge and Fire: Savonarola and Renaissance Italy*, London 2006; Savonarola, *Compendio di revelatione dello inutile servo di Iesu Christo frate Hieronymo da Ferrara dello ordine de frati predicatori*, Florence, August 1495.

11.　See Pocock (note 8), pp. 103–13, on Savonarola and the myth of Venice.

12.　Savonarola's extremism in his later sermons is reported by the young Niccolò Machiavelli, in a letter dated 9 March 1498, in James B. Atkinson and David Sices, eds, *Machiavelli and His Friends: Their Personal Correspondence*, DeKalb, IL, 1996, pp. 8–10.

13.　Luca Landucci, *A Florentine Diary . . .*, trans. Alice de Rosen Jervis, London and New York 1927, pp. 142–3.

14. Isaiah Berlin, 'The Originality of Machiavelli', in *The Proper Study of Mankind: An Anthology of Essays*, London 1998, pp. 269–325, is a great introduction to Machiavelli's importance. Skinner, Gilbert and Pocock (notes 5, 6, 8) all offer detailed accounts of Machiavelli's thought. His correspondence, in Atkinson and Sices, eds (note 12), bring his world engagingly to life. Peter Constantine, *The Essential Writings of Machiavelli*, New York 2007, and Peter Bondanella and Mark Musa, *The Portable Machiavelli*, Harmondsworth 1979, are excellent selections from his writings, although neither contains the full text of the *Discourses*. For a precise translation of this work, which is key to understanding his republicanism, consult Niccolò Machiavelli, *Discourses on Livy*, trans. Harvey C. Mansfield and Nathan Tarcov, Chicago and London 1996. The thesis of 'Machiavellian intelligence' in chimpanzees is debated in Andrew Whiten and Richard W. Byrne, eds, *Machiavellian Intelligence II*, Cambridge 1997.

15. Christopher Marlowe, *The Jew of Malta, Prologue spoken by Machevil*, c. 1590, in Frank Romany and Robert Lindsey, eds, *Marlowe, The Complete Plays*, London 2003, pp. 248–9; William Shakespeare, *The Third Part of Henry the Sixth*, c. 1591, act 3, scene 2, in Shakespeare, *Complete Works*, ed. Jonathan Bate and Eric Rasmussen, Basingstoke 2007, p. 1269.

16. Luca Landucci, *Diario Fiorentino dal 1450 al 1516 . . .*, ed. Iodoco del Badia, Florence 1883, p. 254: '*E parve cosa molto nuova vedere abitare donne in Palagio.*'

17. Walter Pater, *The Renaissance: Studies in Art and Poetry* (1873), Oxford 1986, p. 73.

18. Vasari, p. 552.

19. Heidelberg, University Library, Incunabulum with handwritten comments, D7620 qt. INC, Cicero, *Epistolae ad familiares*, Bologna 1477, B1, 11a.

20. Vasari, p. 551.

21. *Ibid.*, p. 552.

22. Pliny the Elder, *Natural History: A Selection*, trans. John F. Healy, rev. edn, London 2004, p. 332. For a modern attempt to reconstruct Apelles' achievements see E. H. Gombrich, *The Heritage of Apelles*, London 1976, pp. 3–18.

23. J. Wilde, 'The Hall of the Great Council of Florence', *Journal of the Warburg and Courtauld Institutes*, 7 (1944), pp. 65–81.

308 THE LOST BATTLES

24. *Ibid.*, p. 76.

25. *Ibid.*, p. 78.

26. Landucci (note 16), p. 208: '. . . *e posesi alla porta de' Signori un Cristo di rilievo molto bello, come parve che noi volessimo dire "Non abbiamo altro re che Cristo". Credo fussi una permissione divina, come più volte aveva detto frate Girolamo, che Firenze non aveva altro re che Cristo.*'

27. Wilde (note 23), p. 77.

28. '*Discursus florentinarum rerum post mortem iunioris Laurentii Medices*', in Niccolò Machiavelli, *Opere*, vol. II, Turin 1986, pp. 216–17.

29. Giorgio Vasari, *Lives of the Painters, Sculptors and Architects*, full trans. of second edn of 1568 by Gaston de Vere, London 1996, pp. 555–7.

30. L. Beltrami, ed., *Documenti e memorie riguardanti la vita e le opere di Leonardo da Vinci*, Milan 1919, doc. 88.

31. *Ibid.*, doc. 130; Archivio di Stato, Florence, Signori e Collegi, Deliberazioni in Forza d'Ordinaria Autorità, 105, fol. 106 recto, 24 October 1503.

32. Richter 1, n. 669, pp. 348–9.

THREE: HEROICS

1. Condivi, p. 11.

2. *Ibid.*, p. 12.

3. E. H. Gombrich, 'The Early Medici as Patrons of Art', in *Norm and Form*, London 1966, pp. 56–7, debunks the 'legend' of Lorenzo's garden academy; Caroline Elam, 'Lorenzo de' Medici's Sculpture Garden', *Mitteilungen des Kunsthistorischen Institutees in Florenz*, 36 (1992), pp. 41–84, demonstrates its documented reality.

4. Carmen C. Bambach, ed., *Leonardo da Vinci: Master Draftsman*, New York, New Haven and London, 2003, p. 228.

5. Elam (note 3), p. 58.

6. Condivi, pp. 12–14.

7. *Rime*, 60, p. 109 (written 1532).

8. Condivi, pp. 15–16.

9. *Ibid.*, p. 62.

10. Michael Mallett, *The Borgias: The Rise and Fall of a Renaissance Dynasty*, London 1971, p. 95.

11. James B. Atkinson and David Sices, eds, *Machiavelli and His Friends: Their Personal Correspondence*, DeKalb, IL, 1996, letter 22, Agostino Vespucci to Niccolò Machiavelli, Rome, 16 July 1501, p. 38.

12. P. Barocchi and R. Ristori, *Il Carteggio di Michelangelo*, vol. 1, Florence 1965, no. i, pp. 1–2.

13. *M. Tulli Ciceronis Epistulae, Epistulae ad familiares*, VII. 23, Oxford 1979, vol. I, p. 203.

14. P. O. Kristeller, *The Philosophy of Marsilio Ficino*, New York 1942, pp. 308–9.

15. Arnold van Gennep, *The Rites of Passage*, London 1960. Initiation rites in ancient Greece are stressed in Pierre Vidal-Naquet, *The Black Hunter: Forms of Thought and Forms of Society in the Greek World*, trans. Andrew Szegedy-Maszak, Baltimore and London 1986, which is striking given Michelangelo's relationship with the classical heritage.

16. Condivi, p. 22, '. . . *suo grande amico . . .*'

17. Dale Kent, *Cosimo de' Medici and the Florentine Renaissance: The Patron's Oeuvre*, New Haven and London 2000.

18. *Rime*, p. 341.

19. King James Bible, 1 Samuel 17:38–40.

FOUR: STONING DAVID

1. The meeting is recorded in Archivio dell' Opera di Santa Maria del Fiore, Florence, Deliberazioni degli Operai, 1496–1507, published in Giovanni Gaye, *Carteggio inedito d'artisti dei secoli XIV, XV, e XVI*, Florence 1840, vol. 2, pp. 455–63. My translations use the Italian text in Charles Seymour, Jnr, *Michelangelo's David: A Search for Identity*, Pittsburgh 1967, appendix II-B, pp. 140–55, hereafter referred to as Transcript. The Herald's words are on pp. 142–4.

2. John M. Najemy, *A History of Florence*, Malden, Oxford and Victoria 2006, pp. 147–8.

3. Richter 1, nn. 468, 469, pp. 235–6.

4. Richter 2, n. 1525, p. 457.

5. Vasari, pp. 565–71.

6. See Peter Burke, *The Italian Renaissance*, rev. edn, Cambridge 1987, pp. 178–9, for the cult of clocks.

7. D. P. Walker, *Spiritual and Demonic Magic from Ficino to Campanella*, London 1958; Frances Yates, *Giordano Bruno and the Hermetic Tradition*, London 1964; Burke (note 6), pp. 178–88; Armando Maggi, *In the Company of Demons: Unnatural Beings, Love, and Identity in the Italian Renaissance*, Chicago 2006; Charles G. Nauert, *Humanism and the Culture of Renaissance Europe*, second edn, Cambridge 2006, pp. 71–4.

8. Norman Cohn, *Europe's Inner Demons*, St Albans 1976. The misogynist nature of this fantasy is clearly evident in the highly influential late fifteenth-century demonological treatise *Malleus maleficarum*, now available in English: Christopher S. Mackay, *The Hammer of Witches: A Complete Translation of the Malleus Maleficarum*, Cambridge 2009, esp. pp. 160–73. On the witch as old woman, see Lyndal Roper, *Witch Craze: Terror and Fantasy in Baroque Germany*, New Haven and London 2006, pp. 160–78.

9. S. A. Farmer, *Syncretism in the West: Pico's 900 Theses (1486) . . . with Text, Translation, and Commentary*, Tempe, AZ, 1998; P. O. Kristeller, 'Giovanni Pico della Mirandola and His Sources', in *L'opera e il pensiero di Giovanni Pico della Mirandola nella storia dell'umanismo*, Florence 1965; Yates (note 7), pp. 90–129.

10. Francis Ames-Lewis, *The Intellectual Life of the Early Renaissance Artist*, New Haven and London 2000, esp. pp. 22–3, 193–6.

11. Vasari, p. 477.

12. Royal Academy of Arts, *Sandro Botticelli: The Drawings for Dante's Divine Comedy*, exh. cat., London 2000.

13. E. H. Gombrich, 'Botticelli's Mythologies', in *Symbolic Images*, third edn, London 1985, pp. 31–81. Botticelli's *Venus and Mars* in the National Gallery, London, directly illustrates Lucretius, *On the Nature of the Universe*, trans. R. E. Latham, rev. John Godwin, London 1994, pp. 10–11.

14. Yates (note 7), p. 67.

15. Erwin Panofsky, *The Life and Art of Albrecht Dürer*, fourth edn, Princeton 1971, pp. 165–71; *idem* and F. Saxl, 'Dürer's Melencolia I', *Studien der Bibliothek Warburg*, 2 (1923).

16. Charles Dempsey, *The Portrayal of Love: Botticelli's Primavera and Humanist Culture at the Time of Lorenzo the Magnificent*, Princeton 1992, summarises some of the many interpretations of this painting, pp. 3–19.

17. Keith Thomas, *Religion and the Decline of Magic*, London 1971; Peter Burke, *Popular Culture in Early Modern Europe*, London 1978; Carlo

Ginzburg, *The Night Battles*, London 1983, and *Ecstasies: Deciphering the Witches' Sabbath*, London 1990.

18. The woodcut illustrates Savonarola's *Sermone della oratione*, c. 1495. See also Paul Joannides, 'Late Botticelli: Archaism and Ideology', in *Arte cristiana*, LXXXIII (1995), which recognises the connection and argues that Botticelli must have at the very least imitated the woodcut – 'and that the woodcut might have been his own'. Botticelli's painting *The Agony in the Garden* is in the Capilla de los Reyes, Granada, and is illustrated in Daniel Arasse *et al.*, *Botticelli: From Lorenzo the Magnificent to Savonarola*, Milan 2003, p. 159.

19. The gender-segregated crowd in the Cathedral is depicted in a woodcut in Savonarola's *Compendio de revelatione*, 1496. Women outnumber men in this image, reproduced in *The Metropolitan Museum of Art: The Renaissance in Italy and Spain*, New York 1987, p. 80.

20. Niccolò Machiavelli, *Discorsi sopra la prima deca di Tito Livio*, ed. Corrado Vivanti, Turin 2000, p. 39.

21. Transcript (see note 1), p. 146.

22. *Ibid.*, p. 144.

23. *Ibid.*, p. 144.

24. Condivi, pp. 22 and xxxii, where Caroline Elam argues that Michelangelo's later comment means he did not make the spiteful remark against Donatello, but was misunderstood or misrepresented by his biographer. In his correction, Michelangelo specifically says he meant the *Judith* when he spoke of Donatello's works being unfinished, which might suggest he was still revolving arguments about the *Judith* versus his own *David* in his mind nearly half a century after the 1504 meeting.

25. Vasari, p. 545.

26. Condivi, p. 8.

27. Transcript (note 1), p. 146.

28. *Ibid.*, pp. 146–8.

29. *Ibid.*, p. 148.

30. The *Malleus maleficarum* refers to widespread beliefs about the evil eye. See Mackay (note 8), p. 107.

31. Transcript (note 1), p. 150.

32. The translator George Bull shares my understanding of *ornamento decente* in his *Michelangelo*, Harmondsworth 1995, pp. 51–2.

33. Mackay (note 8), pp. 194–9.

34. Luca Landucci, *A Florentine Diary*, trans. Alice de Rosen Jervis, London and New York 1927, pp. 213–14.

35. *Ibid*. and p. 139 for his shock at hearing Savonarola's confession in the Great Council Hall.

36 Felix Gilbert, *Machiavelli and Guicciardini: Politics and History in Sixteenth Century Florence*, New York and London 1984, pp. 22–3, sees Landucci as typical of the non-elite citizens empowered by the Great Council.

FIVE: THE ASCENT OF ART

1. Luca Beltrami, ed., *Documeni e memorie riguardanti la vite e le opere di Leonardo da Vinci*, Milan 1919, doc. 140, p. 87.

2. *Ibid*., pp. 87–8.

3. *Ibid*., p. 88.

4. Vasari, p. 888.

5. The goldsmith Michelangelo Bandinelli suggested putting the *David* in the Great Council Hall. Transcript of the meeting of 25 January 1504 in Charles Seymour, Jnr, *Michelangelo's David: A Search for Identity*, Princeton 1967, p. 153.

6. Charles G. Nauert, *Humanism and the Culture of Renaissance Europe*, second edn, Cambridge 2006, and Quentin Skinner, *The Foundations of Modern Political Thought, Volume 1: The Renaissance*, Cambridge 1978, give succinct accounts of this movement at the heart of the Renaissance.

7. Dante, *Purgatorio*, Canto XI, ll. 94–6.

8. Richter 1, n. 498, p. 250.

9. *Ibid*., n. 495, p. 249.

10. Vasari, pp. 320–21.

11. Niccolò Machiavelli, *Florentine Histories*, trans. Laura F. Banfield and Harvey C. Mansfield, Jr, Princeton 1990, p. 7.

12. Vasari, p. 547.

13. Archivio di Stato, Florence, Ufficiali di Notte e Monasteri, Deliberazioni, Parte II, fol. 41r, 9 April 1476, in Pietro C. Marani, *Leonardo da Vinci: The Complete Paintings*, New York 2000, p. 342.

14. Niccolò Machiavelli, *Il Principe*, ed. Giorgio Inglese, Turin 1995, pp. 144–5.

15. Richter 2, n. 1340, pp. 395–7.
16. *Ibid.*, p. 398.
17. *Ibid.*, p. 398.
18. Carmen C. Bambach, ed., *Leonardo da Vinci: Master Draftsman*, New York 2003, p. 230.
19. RL 12357 recto and RL 12358 recto in the Royal Library, Windsor.
20. Leonardo da Vinci, Manuscript C, Institut de France, Paris, fol. 15 verso. See Richter 2, n. 720, p. 14.
21. Bambach (note 18), p. 232.
22. Richter 2, n. 721, p. 15.
23. Nigel Spivey, *Greek Art*, London 1997, pp. 97–9; Vitruvius, *Ten Books on Architecture*, ed. Ingrid D. Rowland and Thomas Noble Howe, Cambridge 1999, esp. pp. 47–8, 148.
24. This and the earlier reference to one of Galeazzo's horses in the paragraph can found in Richter 2, nn. 716, 717, p. 14.
25. Leonardo da Vinci, Codex Atlanticus, Ambrosiana, Milan, 147 recto old numbering/399 recto new numbering.
26. Madrid II, fol. 157 recto.
27. *Ibid.*, fol. 155 verso.
28. *Ibid.*, fol. 157 recto.
29. *Ibid.*, fol. 157 verso.
30. Matteo Bandello, *Tutte le opera*, ed. Francesco Flora, vol. 1, Milan 1935, p. 646.
31. Richter 2, n. 723, p. 15.
32. Vasari, pp. 545–6.
33. *Ibid.*, pp. 550–51.
34. James Strachey and Albert Dickson, eds, *Sigmund Freud 14: Art and Literature*, Harmondsworth 1990, pp. 151–231.
35. Bandello (note 30), p. 646.
36. Andrei Rublev, *The Saviour*, tempera on wood, early fifteenth century, Tretyakov Gallery, Moscow.

SIX: BLOODSTAINS

1. Poggio Bracciolini, *Historia Fiorentina*, Florence 1492, and Leonardo Bruni, 'Memoirs', in his *History of the Florentine People, Volume Three*, trans. James Hankins with D. J. W. Bradley, Cambridge, MA, and London 2007, p. 395, give contemporary accounts of the battle. Niccolò Machiavelli, *Florentine Histories*, trans. Laura F. Banfield and Harvey C. Mansfield, Jr, Princeton 1988, pp. 224–8, describes it dramatically, but for rhetorical reasons – he wants to stress the puniness of Italian warfare prior to the French invasion of 1494 – rejects the earlier historians' casualty figures. Bracciolini says many of Piccinino's men died and many more were captured, Bruni that he lost virtually his entire army, while more than 1,200 citizens of San Sepolcro were taken prisoner. The account compiled from chronicles for Leonardo by the Palazzo della Signoria in 1503 also portrays it as a bloody day; see Richter 1, n. 669, pp. 348–9.

2. Francesco Guicciardini, *History of Italy*, trans. and ed. Sydney Alexander, Princeton 1969, p. 44, and by Machiavelli, in *Discourses on Livy*, trans. Harvey C. Mansfield and Nathan Tarcov, Chicago and London 1998, p. 113.

3. Luca Landucci, *A Florentine Diary*, trans. Alice de Rosen Jervis, London and New York 1927, 29 July 1504, pp. 215–16.

4. Richter 1, n. 508, p. 254.

5. Niccolò Machiavelli, *Mandragola*, act 1, scene 2, in *Teatro*, ed. Guido Davico Bonino, new edn, Turin 2002, p. 77.

6. See Bruni (note 1). Another Humanist historian, Poggio Bracciolini, who narrates the Battle of Anghiari in his 1492 *Historia Fiorentina* (note 1), was responsible for rediscovering many lost classical texts.

7. Dante, *Inferno*, Canto XXXIII, l. 75.

8. *Ibid.*, Canto XXXIII, ll. 79–84.

9. Landucci (note 3), entries for the spring and summer of 1503, pp. 204–8.

10. Madrid II, fol. 7 verso. Leonardo's note: '*CASCINA qui è la veduta*' ('Cascina this is where the view is from').

11. Leonardo's on-the-spot sketches in Madrid II that chart his journey by the Arno that summer illuminate fols 15 recto, 16 recto and verso, 17 recto and verso, 18 recto and verso, 19 recto and verso, 20 recto

and verso, and 21 recto, with detailed maps of the river across 22 verso and 23 recto and across 52 verso and 53 recto.

12. Madrid II, fol. 1 verso.

13. *Ibid.*: '*Livello d'Arno fatto il dì della Madalena 1503*'. The day of the Magdalene falls on 22 July.

14. As witnessed by the author on a visit to the restoration laboratory of the Opificio delle Pietre Dure, Fortezza da Basso, Florence in 2006, forty years after the floods.

15. Carmen C. Bambach, ed., *Leonardo da Vinci: Master Draftsman*, New York 2003, pp. 473–4; Roger D. Masters, *Machiavelli, Leonardo and the Science of Power*, Notre Dame 1995; Denis Fachard, *Biagio Buonaccorsi: Sa vie, son temps, son oeuvre*, Bologna 1976.

16. Masters (note 15), and in his *Fortune Is a River*, New York 1999.

17. See note 13.

18. Leonardo da Vinci, *Codex Arundel 263 nella British Library*, Florence 1998, 271 verso/278 recto. See also 149 recto, 274 recto, and 275 verso.

19. Madrid II across 22 verso and 23 recto; RL 12279 recto in the Royal Library, Windsor.

20. Madrid II across 52 verso and 53 recto.

21. Luca Beltrami, ed., *Documenti e memorie riguardanti la vita e le opere di Leonardo da Vinci*, Milan 1919, doc. 127, p. 80.

22. Machiavelli, *Il Principe*, ed. Giorgio Inglese, new edn, Turin 1995, p. 5.

23. Beltrami (note 21), doc. 126, pp. 79–80.

24. Richter 1, nn. 601, 602, pp. 3013.

SEVEN: THE GENIUS IN HIS STUDY

1. Department of Prints and Drawings, British Museum, London, 1895-9-15-496. J. Wilde, *Italian Drawings in the Department of Prints and Drawings in the British Museum: Michelangelo and His Studio*, 2 vols, London 1953, 3 recto.

2. Leonardo Bruni, *History of the Florentine People*, ed. James Hankins, vol. 2, Cambridge, MA, and London 2004, p. 463 (my translation). The medieval chronicle by Giovanni Villani and family, *Cronica*, Turin 1979, p. 328, gives an alternative account of the Battle of Cascina.

3. Wilde (note 1), 3 verso.

4. Michelangelo, *A Battle Scene*, Ashmolean Museum, Oxford, 294 (cat. no. from K. T. Parker, *Catalogue of the Collection of Drawings in the Ashmolean Museum, vol. II, Italian Schools*, Oxford 1956).

5. See chap. 2 (note 31).

6. Luca Beltrami, ed., *Documenti e memorie riguardanti la vita e le opere di Leonardo da Vinci*, Milan 1919, docs 132 (16 December 1503), and 134 (8 January 1504), pp. 82–3.

7. The sheet in question is RL 19084 in the Royal Library, Windsor.

8. Giorgio Vasari, *Delle Vite de' piu eccellenti pittore . . .* (rev. second edn of *Lives*), Florence 1568, vol. 2, p. 6.

9. Leonardo da Vinci, *Treatise on Painting*, trans. and annotated A. P. McMahon, Princeton 1956, is the standard modern edition of Melzi's Codex Urbinas in the Vatican Library. Martin Kemp and Margaret Walker, *Leonardo on Painting*, New Haven and London 1989, combines Melzi's manuscript with other notes by Leonardo to create an enhanced version.

10. Another great edition is Edward MacCurdy, *The Notebooks of Leonardo da Vinci*, 2 vols, London 1938, which includes more scientific notes than Richter.

11. Madrid Codex II, fols 2 verso, 3 recto, and 3 verso.

12. Richter 2, n. 1469, pp. 442–5, gives the earlier list of his books. It contains fewer religious works than the list of books stored in the monastery in 1504.

13 Codice Ashburnham 361, Biblioteca Medicea Laurenziana, Florence.

14. In his Manuscript B, Institut de France, Paris. See also MacCurdy (note 10), pp. 810–33.

15. See note 11.

16. Richter 2, n. 1498, p. 451.

17. Madrid II, fol. 52 verso.

18. *Ibid.*, fol. 3 recto.

19. Beltrami (note 6), n. 136, 28 February 1504, p. 84.

20. Richter 1, n. 512, p. 257.

21. The woodcut appears in Savonarola's *Della Semplicita della vita christiana*, Florence 1496, and is reused in other Savonarolan pamphlets in the 1490s.

22. Richter 2, n. 1452, p. 436.

23. *Ibid.*, n. 1416, p. 428.

24. *Ibid.*, n. 1526, pp. 457–8.

25. *Ibid.*, n. 1548, p. 464.

26. See Cennino d'Andrea Cennini, *The Craftsman's Handbook*, trans. Daniel V. Thompson, Jnr, New Haven and London 1933, pp. 42–50.

27. Beltrami (note 6), n. 140, p. 88.

28. Madrid II, fol. 3 recto.

29. *Ibid.*, fol. 2 verso.

30. RL 12603 recto, Royal Library, Windsor; MacCurdy (note 10), p. 193.

31. Richter 2, n. 929, p. 179.

32. On the medieval image of the mounted knight, see Maurice Keen, *Chivalry*, New Haven and London 1984, esp. pp. 23–30; Robert Bartlett, *The Making of Europe: Conquest, Colonisation and Cultural Change 950–1350*, London 1993, pp. 60–63.

EIGHT: NAKED TRUTH

1. Richter 2, n. 1421, p. 429.

2. E. H. Gombrich, *Norm and Form: Gombrich on the Renaissance 1*, fourth edn, London 1985, p. 56.

3. Niccolò Machiavelli, *Mandragola*, act 1, scene 1, in *Teatro*, ed. Guido Davico Bonino, new edn, Turin 1979, pp. 75–6.

4. Kenneth Clark, *The Nude*, London 1956.

5. Michael Rocke, *Forbidden Friendships: Homosexuality and Male Culture in Renaissance Florence*, New York and Oxford 1996; Michel Foucault, *La Volonté de savoir*, Paris 1976; Sigmund Freud, 'Leonardo da Vinci and a Memory of His Childhood', in James Strachey and Albert Dickson, eds, *Sigmund Freud 14: Art and Literature*, Harmondsworth 1990, pp. 151–231; Leo Steinberg, *The Sexuality of Christ in Renaissance Art and Modern Oblivion*, second edn, Chicago and London 1996.

6. Compare Michael Hirst, *Michelangelo and His Drawings*, New Haven and London 1988, pp. 4–7.

7. Louvre, Paris, Inventaire 712. Paul Joannides, *Inventaire général des dessins italiens: Michel-Ange, élèves et copistes*, Paris 2003, pp. 78–80.

8. British Museum, London, 1887-5-2-116.

9. Steinberg (note 5), pp. 19–22.

10. Louvre, Inventaire 3897. Joannides (note 7), p. 67.

11. Richter 2, n. 1534, p. 460.

12. *Ibid.*, n. 1364, p. 414. See also Leonardo da Vinci, *Notebooks*, selected by Irma A. Richter, ed. Thereza Wells, Oxford 2008, p. 271.

13. Archivio di Stato, Florence, Ufficiali di Notte e Monasteri, Deliberazioni, Parte II, fol. 41 recto, 9 April 1476; and fol. 51 verso, 7 June 1476.

14. Rocke (note 5). The high proportion of unmarried males in Florence is revealed in David Herlihy and Christine Klapisch-Zuber, *Tuscans and Their Families*, New Haven and London 1985: 12.1 per cent of men were still single in their late forties and early fifties. Needless to say, Leonardo and Michelangelo belonged to that group.

15. P. C. Marani, *Leonardo da Vinci: The Complete Paintings*, New York 2000, p. 92.

16. Condivi, p. 62.

17. *Rime*, 58, dated 1532, p. 107.

18. RL 12337, Royal Library, Windsor.

19. British Museum, London, 1875-6-12-17.

20. Compare Steinberg (note 5).

21. Richter 2, n. 1293, p. 355.

22. Condivi, p. 8. Michelangelo's respectful letters to his father include one from Rome reassuring the old man that he does not carry money about the streets, but keeps it in the bank, and that he does not go about denouncing the Medici family: E. H. Ramsden, trans., ed. and annotated, *The Letters of Michelangelo*, London 1963, vol. 1, letter 85, pp. 81–2.

23. He protests in a letter written in 1531 (Ramsden [note 22], letter 185, p. 176) that he has always made sacrifices for his family.

24. Richter 1, n. 363, p. 190.

NINE: MASTER OF WAR

1. J. R. Hale, *War and Society in Renaissance Europe*, Stroud 1998, esp. pp. 15–16, on the 'new era' that began in 1494; Geoffrey Parker, *The Military Revolution: Military Innovation and the Rise of the West, 1500–1800*, rev. edn, Cambridge 2000, for a conceptualisation of the coming of artillery warfare; Andrew Cunningham and Ole Peter Grell, *The Four Horsemen of the Apocalypse: Religion, War, Famine and Death in Reformation Europe*, Cambridge 2000, chap. 3, 'The Red Horse: War, Weapons and Wounds', pp. 92–199, for the psychological consequences; Philip Bobbitt, *The Shield of Achilles: War, Peace and the Course of History*, London 2003, pp. 80–94, on the significance of 1494 for Machiavelli.

2. Francesco Guicciardini, *La Historia di Italia*, Florence 1561, p. 32: '*Ma i franzesi, fabricando pezzi molto più espediti né d'altro che di bronzo, i quali chiamavano cannoni, e usando palle di ferro, dove prima di pietra e senza comparazione più grosse e di peso gravissimo s'usavano, gli conducevano in sulle carrette, tirate non da buoi, come in Italia si costumava, ma di cavalli, con agilità tale d'uomini e di instrumenti deputati a questo servigio che quasi sempre al pari degli eserciti camminavano, e condotte alle muraglie erano piantate con prestezza incredibile . . .*'

3. RL 12652 verso, Royal Library, Windsor.

4. Or read Machiavelli's report on how to modernise them, 'The Account of a Visit Made to Fortify Florence', in Allan Gilbert, ed., *Machiavelli: The Chief Works and Others*, Durham and London 1989, vol. 2, pp. 727–34.

5. Leon Battista Alberti, *On The Art of Building*, trans. Joseph Rykwert, Neil Leach and Robert Tavernor, Cambridge, MA, and London 1991, esp. pp. 100, 104–5.

6. Compare Parker (note 1), and also 'The Artillery Fortress as an Engine of European Overseas Expansion, 1480–1750', in his *Empire, War and Faith in Early Modern Europe*, London 2002, pp. 194–218.

7. Ludwig H. Heydenreich, *Architecture in Italy 1400–1500*, rev. Paul Davies, New Haven and London 1996, pp. 148–51.

8. RL 12275, and RL 12337 verso, Royal Library, Windsor.

9. Madrid II, 36 verso.

10. *Ibid.*, 37 recto.

11. *Ibid.*, 45 verso.

12. Hale (note 1), pp. 206–8.

13. Leonardo transcribed Francesco di Giorgio Martini's writings on fortifications in Madrid Codex II, 86 recto–98 verso.

14. Edward MacCurdy, trans., *The Notebooks of Leonardo da Vinci*, London 1938, vol. 2, p. 835.

15. Madrid II, 39 recto.

16. Vasari, p. 553.

17. Walter Pater, *The Renaissance: Studies in Art and Poetry*, Oxford 1986, p. 81.

18. RL 12326 recto, Royal Library, Windsor.

19. Niccolò Machiavelli, *Discorsi sopra la prima deca di Tito Livio*, ed. Corrado Vivanti, Turin 2000, book II, chap. 2, p. 141.

20. Niccolò Machiavelli, *Il Principe*, ed. Giorgio Inglese, new edn, Turin 1995, chap. V, p. 31.

21. Manuscript B, Institut de France, 82 verso.

22. Edward McCurdy, *The Notebooks of Leonardo da Vinci*, London 1938, pp. 842–4.

23. Martin Kemp, *Leonardo da Vinci: The Marvellous Works of Nature and Man*, new edn, Oxford 2006, pp. 163–64, sees an element of satire in some of his military designs.

24. Nicholas Tartaglia, *Three Books of Colloquies Concerning the Art of Shooting in Great and Small Pieces of Artillerie . . .*, trans. Cyprian Lucar, gent., imprinted at London for John Harrison, 1588, Appendix, p. 93.

25. Richter 2, n. 1340, p. 397.

26. Manuscript B, Institut de France, 78 recto.

27. Venice, 1572.

28. Robertus Valturius, *De re militari*, Verona 1472.

29. Paolo Rossi, *The Birth of Modern Science*, Oxford and Malden, MA, 2001, p. 74; A. R. Hall, *Ballistics in the Seventeenth Century: A Study in the Relations of Art and War with Reference Principally to England*, Cambridge 1952.

30. RL 12570, Royal Library, Windsor.

31. Guicciardini (note 2), 1561, p. 234: '. . . *si ignegnarono con nuovo modo d'offendere i Pisani, tentando di fare passare il fiume d'Arno, che corre per Pisa, dalle torre della Fagiana vicina a Pisa, a cinque miglia per nuovo letto nello stagno, che è tra Pisa, e Livorno . . .*'

32. *Ibid.*: '*Ma questa opera cominciata con grandissima speranza, e seguitata con ispesa molto maggiore riusci vana: perche, come il piu delle volte accade, che simile*

cose, ben che con le misure habbino la dimonstratione quasi palpabile, si conoscano con l'esperientia fallaci (paragone certissimo, quanto sia disante il mettere in disegno al mettere in atto) . . .'

33. Francesco Soderini to Niccolò Machiavelli, 26 October 1504, in James B. Atkinson and David Sices, eds, *Machiavelli and His Friends: Their Personal Correspondence*, DeKalb, IL, 1996, pp. 106–7.

34. Niccolò Machiavelli, *Decennale*, Florence 1506.

35. Niccolò Machiavelli, *Libro della arte della guerra*, Florence 1521, 8 recto and verso.

36. *Parole da dirle sopra la provvisione del denaio*, see Atkinson and Sices, eds (note 33), p. 81.

TEN: THE RAID

1. Condivi, pp. 13–14.

2. Ovid, *Metamorphoses*, trans. and ed. Charles Martin, New York and London 2004, pp. 416–30.

3. 613 Er, Cabinet of Prints and Drawings, Uffizi, Florence.

4. In the Brera, Milan.

5. In the Royal Library, Windsor.

6. *Madonna del Cardellino (Madonna of the Goldfinch)*, c. 1506, Uffizi, Florence; *Madonna of the Meadow*, 1505–6, Kunsthistorisches Museum, Vienna; *Bridgewater Madonna*, c. 1507, National Gallery of Scotland, on loan from the Duke of Sutherland.

7. Translation by Thomas Hoby, London 1588.

8 Michelangelo's earliest extant verses are those on the Cascina drawing discussed at the start of chap. 7. Department of Prints and Drawings, British Museum, London, 1895-9-15-496; J. Wilde, *Italian Drawings in the Department of Prints and Drawings in the British Museum: Michelangelo and His Studio*, 2 vols, London 1953, 3 recto and verso.

9. C. Bambach, ed., *Leonardo da Vinci: Master Draftsman*, New York 2003, p. 235.

10. Richter 2, n. 1414, p. 427.

11. Niccolò Machiavelli, *Il Principe*, ed. Giorgio Inglese, new edn, Turin 1995, chap. XXV, pp. 166–7.

ELEVEN: THE GREAT SWAN

1. Uccelli, cover.
2. *Ibid.*, 18 verso.
3. Richter 2, n. 847, p. 131.
4. Leonardo da Vinci, *Notebooks*, selected by Irma A. Richter, edited by Thereza Wells, Oxford 2008, p. 354.
5. Richter 2, nn. 1521, 1519, p. 456.
6. Richter 1, n. 463, p. 233.
7. Richter 2, n. 1363, p. 414.
8. James Strachey and Albert Dickson, eds, *Sigmund Freud 14: Art and Literature*, Harmondsworth 1990, pp. 172–83.
9. *Ibid.*, p. 176.
10. Both images are in Richter 2, n. 1293, 'Of Dreaming', p. 355.
11. Pico della Mirandola, 'Oration on the Dignity of Man', as quoted in Jacob Burckhardt, *The Civilisation of the Renaissance in Italy*, trans. (1878) S. G. C. Middlemore, Harmondsworth 1990, p. 229.
12. King James Bible, Genesis 9, 2–3. See also Keith Thomas, *Man and the Natural World: Changing Attitudes in England 1500–1800*, Harmondsworth 1983.
13. Richter 2, n. 816, p. 118.
14. Richter 2, n. 817, p. 118.
15. RL 19102 recto, Royal Library, Windsor.
16. British Museum, London, 1857-1-10-1.
17. Vasari, p. 567. Compare the method of Leonardo and Piero di Cosimo with the interpretation of paleolithic art advanced in David Lewis-Williams, *The Mind in the Cave*, London 2002.
18. RL 12337, Royal Library, Windsor.
19. Uccelli, 6 recto.
20. *Ibid.*, 6 verso.
21. *Ibid.*, 15 recto.
22. *Ibid.*, 5 recto.
23. *Ibid.*, 16 recto.
24. *Ibid.*, 16 verso and and 17 recto; 7 recto; 6 verso.

TWELVE: HELL'S MOUTH

1. As he records it in Madrid II, 1 recto.
2. Szépmüvészeti Museum, Budapest, cat. no. 1775.
3. Ashmolean Museum, Oxford, 20 (cat. no. from K. T. Parker, *Catalogue of the Collection of Drawings in the Ashmolean Museum, vol. II, Italian Schools*, Oxford 1956).
4. Jacob Burckhardt, *The Civilisation of the Renaissance in Italy*, trans. S. G. C. Middlemore, Harmondsworth 1990, p. 204.
5. *Historie fiorentine di Niccolo Machiavelli cittadino, et segretaio fiorentino*, Florence 1532, 117 verso.
6. *Ibid.*, 149 recto.
7. Leonardo da Vinci, *Treatise on Painting, Codex Urbinas Latinus 1270*, Princeton 1956, vol. 2, Facsimile, 8 verso.
8. Niccolò Machiavelli, *Florentine Histories*, trans. Laura F. Banfield and Harvey C. Marshall, Jnr, Princeton 1988, p. 50.
9. Roberto Longhi, *Piero della Francesca*, London 1930, p. 66; J. R. Banker, *The Culture of San Sepolcro during the Youth of Piero della Francesca*, Ann Arbor, MI, 2003, p. 24, stresses the economic suffering of San Sepolcro as a result of the battle and the ransoming of 1,400 of its inhabitants from the victorious Florentines.
10. See J. V. Field, *Piero della Francesca: A Mathematical Art*, New Haven and London, 2005.
11. Vasari, pp. 337–8.
12. Richter 2, n. 1417, p. 428.
13. Bought by the collector Sir Hugh Lane and bequeathed by him in 1918, it is now in the National Gallery of Ireland, Dublin, NGI 778. It has a pendant, NGI 780, depicting the Florentine conquest of Pisa in 1406. Both are by the same anonymous artist.
14. Leonardo Bruni, 'Memoirs', in *History of the Florentine People*, vol. III, trans. James Hankins and D. J. W. Bradley, Cambridge, MA, 2007, p. 395.
15. Victoria and Albert Museum, London, inv. A.170-1910. On such early uses of art as historical evidence, see Francis Haskell, *History and Its Images: Art and the Interpretation of History*, New Haven and London 1993.
16. '. . . *un soldato vecchio con un berretton rosso* . . .' (Vasari, p. 553).
17. This was a world in which the fantastic intruded constantly on the

everyday. The early modern person resembled the rider surrounded by monstrous beings in a wild wood in Dürer's great print *Knight, Death and Devil*. The demonic qualities of Leonardo's battle painting connect it to the constant backdrop of myth and prodigy in Renaissance life, from peasants dressing as animals at Carnival time to werewolves haunting the forests. See Emmanuel Le Roy Ladurie, *Carnival in Romans*, London 2003; Caroline Oates, 'Metamorphosis and Lycanthropy in Franche-Comté, 1521–1643', in Michel Feher, ed., *Fragments for a History of the Human Body*, New York 1989, pp. 305–63; Richard Bernheimer, *Wild Men in the Middle Ages*, New York 1970.

18. *Nicholas Machiavel's Prince. Also, The Life of Castruccio Castracani of Lucca and The meanes Duke Valentino us'd to put to death Vitellozzo Vitelli, Oliverotto of Fermo . . . and the Duke of Gravina*, London 1640, pp. 304–5.

19. Richter 2, n. 1296, pp. 364–5.

20. For Lorenzo's ornate helmet, see Charles Dempsey, *The Portrayal of Love: Botticelli's Primavera and Humanist Culture at the Time of Lorenzo the Magnificent*, Princeton 1992, p. 80. On Leonardo's costumes for tournaments and masques, see Martin Clayton, *Leonardo da Vinci: The Divine and the Grotesque*, London 2002, pp. 157–81. Leonardo records his tournament costumes of '*uomini salvatici*' in Richter 2, n. 1458, p. 439.

21. Stuart W. Pyhrr and José-A. Godoy, *Heroic Armour of the Italian Renaissance: Filippo Negroli and His Contemporaries*, New York 1998.

22. In the Metropolitan Museum of Art, New York, purchased 1923, cat. 23.141.

23. Marble reliefs of antique warriors from Verrocchio's workshop are in the Louvre and the National Gallery of Art, Washington, DC. Leonardo's *Bust of a Warrior* is in the British Museum, Department of Prints and Drawings, 1895-9-15-474.

24. For example, a peak or hinged mask from a helmet, by the Negroli family, dated 1538, and in the Bargello Museum, Florence, M. 771, strongly resembles the armour in Leonardo's battle picture.

25. Edward McCurdy, *The Notebooks of Leonardo da Vinci*, London 1938, p. 312.

26. David Abulafia, *The Discovery of Mankind: Atlantic Encounters in the Age of Columbus*, New Haven and London 2008, pp. 241–61; Felipe Fernández-Armesto, *Amerigo*, London 2006.

27. Amerigo Vespucci, Letter to Soderini, in Mario Pozzi, ed., *Il Mondo*

Nuovo di Amerigo Vespucci: Vespucci Autentico e Apocrifo, Milan 1984, p. 139.

28. Richter 2, n. 1492, p. 450.

29. Richter 1, n. 602, p. 303. On the lateness of this part of Leonardo's battle text, see Carlo Pedretti, *Commentary on J. P. Richter, The Literary Works of Leonardo da Vinci*, Oxford 1977, p. 353, which dates it to c. 1510–11.

30. Dante, *Inferno*, Canto XXXII, ll. 125–9.

THIRTEEN: THE GOOD CITIZEN

1. The dialogue is as reported by Condivi, p. 35: '. . . *rispondendo lui: "Quando potrò", egli irato soggiunse: "Tu hai voglia ch'io ti faccia gittar giù di quel palco."'*

2. P. Barrocchi and Renzo Ristori, eds, *Il Carteggio di Michelangelo*, Vol. 1, Florence 1965, Michelangelo in Florence to Giuliano da Sangallo in Rome, 2 May 1506, p. 13.

3. Cellini stabbed to death the jeweller Pompeo de' Capitaneis, a rival for the patronage of Pope Clement VII. See Benvenuto Cellini, *Autobiography*, trans. George Bull, rev. edn, London 1998, p. 79, for the beginning of their animosity when Pompeo criticised Cellini's work to the pope, and p. 128 for its bloody conclusion. For Michelangelo's belief in Bramante's machinations against him, see Condivi, pp. 29, 34.

4. Compare Diarmaid MacCullough, *Reformation: Europe's House Divided 1490–1700*, London 2003, pp. 120–32.

5. Condivi, p. 26: '"*E voi direte al Papa che, se da qui inanzi mi vorrà, mi chercherà altrove.*"'

6. Codex Madrid II, 1 recto.

7. Vasari, p. 553.

8. Giovanni Villani and family, *Cronica*, Turin 1979, p. 328, says the commander was recovering from a fever and all too glad to lie down and let his men bathe without having prepared fortifications.

9. Titian's *Diana and Actaeon* is jointly owned by the National Gallery, London, and National Galleries of Scotland, Edinburgh. Peter Lely's *Nymphs by a Fountain* is in the Dulwich Picture Gallery, London.

10. In the British Museum, London, MLA 1888-02-15-1. It was made in Urbino and bears the arms of Cardinal Bembo.

11. Luca Landucci, *Diario Fiorentino dal 1450 al 1516* . . ., ed. Iodoco del Badia, Florence 1883, p. 273: '*E così fu tenuto la più bella cosa che si ordinassi mai per la città di Firenze.*'

12. Condivi, p. 27.

13. *Ibid.*, p. 28.

14. Attributed to Francesco Granacci and in the National Gallery, London.

15. '*Parole da dirle sopra la provvisione del dennaio*'. James B. Atkinson and David Sices, eds, *Machiavelli and His Friends: Their Personal Correspondence*, DeKalb, IL, 1996, p. 81.

16. Niccolò Machiavelli, *Art of War*, trans. Christopher Lynch, Chicago and London 2003, p. 29.

17. Condivi, p. 43.

18. Vasari, p. 550.

19. L. Beltrami, ed., *Documenti e memorie riguardanti la vita e le opere di Leonardo da Vinci*, Milan 1919, doc. no. 169.

20. Lucien Febvre, *The Problem of Unbelief in the Sixteenth Century: The Religion of Rabelais*, Cambridge, MA, and London 1982.

21. See Jacques Le Goff, *Medieval Civilisation 400–1500*, Malden, Oxford and Victoria, 1990, p. 57, on the early medieval Peace of God movements, and on attempts to reconcile Christianity and warfare; also Maurice Keen, *Chivalry*, New Haven and London 1984, esp. chap. III.

22. Margaret Mann Phillips, *Erasmus on His Times*, Cambridge 1967, p. 107.

23. Erasmus, *Bellum* . . ., Louvain 1527, ai.

24. *Ibid.*

25. Richter 1, n. 601, p. 303.

26. Richter 2, n. 1140, p. 286.

27. Condivi, pp. 27–8.

28. Atkinson and Sices, eds, letters 115, 117, 118 from Biagio Buonaccorsi to Niccolò Machiavelli, pp. 129–32.

29. The dialogue is as written down by Condivi, pp. 28–9.

30. Condivi, p. 29.

31. Aurelio Gotti, *Vita di Michelangelo*, 2 vols, Florence 1875, vol. 1, p. 54.

On Alidosi as intermediary, see Hugo Chapman, *Michelangelo Drawings: Closer to the Master*, London 2005, pp. 101–2.

32. Beltrami (note 19), doc. 180.

FOURTEEN: SCHOOL OF THE WORLD

1. P. Barocchi and R. Ristori, *Il Carteggio di Michelangelo*, Vol. 1, Florence 1965, no. cvi, p. 139.

2. John M. Najemy, *A History of Florence 1200–1575*, Malden, MA, Oxford and Victoria, 2006, p. 421.

3. Luca Landucci, *A Florentine Diary*, trans. Alice de Rosen Jervis, London and New York 1927, 12 December 1512, pp. 264–5.

4. L. Beltrami, ed., *Documenti e memorie riguardanti la vita e le opere di Leonardo da Vinci*, Milan 1919, doc. 216, pp. 136–7.

5. Benvenuto Cellini, *La Vita*, ed. Lorenzo Bellotto, Parma 1996, pp. 44–5.

6. Erwin Panofsky, *The Life and Art of Albrecht Dürer*, Princeton 1971, pp. 156–71.

7. Cellini (note 5), p. 45.

8. Vasari, p. 889.

9. Condivi, p. 28.

10. *Memoriale di molte statue et picture sono nella inclyta cipta di Florentia per mano di sculptori et picturi excellenti moderni et antiqui tracto dalla propria copia di Messer Francesco Albertini prete fiorentino anno domini 1510*, Florence 1510, 'al tempo dello illustrissimo Pietro Soderini . . .', reprint London 1909, p. 17.

11. Barrocchi and Ristori letter XLIX, p. 70.

12. *Ibid.*, Letter LIII, pp. 75–6.

13. Ashmolean Museum, Oxford, Parker II 535.

14. Vasari, p. 889.

15. Condivi, p. 28. On the Mannerist cult of 'artificiality', see John Shearman, *Mannerism*, Harmondsworth 1967, esp. pp. 37–8.

16. As late as 1899, tourists were told that a seventeenth-century work in the Uffizi collection was Leonardo's *Medusa*. See *Catalogue of the Royal Uffizi Gallery in Florence*, Florence 1899, '1159. LEONARDO DA VINCI. Head of Medusa. The head of the Gorgon is cut off and

turned upwards; the hair is changed into snakes, and other reptiles and monsters are scattered around it. This admirable painting formerly belonged to the collection of the duke Cosmus I' (pp. 211–12).

17. A suggestive example is a fountain in the Victoria and Albert Museum, London, with bronze masks of a Leonardesque Medusa/Piccinino attributed to Benedetto da Rovezzano, c. 1536, originally made for Cowdray House, Sussex. Benedetto cast similar Medusa/Piccinino masks for the altar of Santa Trinità, Florence.

18. Vasari. p. 889.

19. Vasari, *Vite . . .*, rev. second edn, Florence 1568, vol. III, p. 423.

FIFTEEN: PRISONERS

1. Benvenuto Cellini, *Autobiography*, trans. George Bull, rev. edn, London 1998, p. 75.

2. British Museum, London, 1895-9-15-519.

3. Machiavelli, 'The Account of a Visit Made to Fortify Florence', in *The Chief Works and Others*, trans. Allan Gilbert, Durham and London 1989, pp. 727–34.

4. In the collection of the Casa Buonarroti, Florence.

5. Benedetto Varchi, 'Della istoria fiorentina, Tomo primo', in *Thesaurus antiquitatem et historiarum Italiae*, 1723, a reprint of his sixteenth-century work, p. 294, says the 'young men of Florence competed with the soldiers' to build the bastions by torchlight.

6. James Strachey and Albert Dickson, eds, *Sigmund Freud 14: Art and Literature*, Harmondsworth 1990, p. 157.

7. Richter 2, nn. 1351, 1352, 1353, pp. 407–10.

8. *Ibid.*, p. 410.

9. Vasari, p. 547.

10. Richter 2, n. 1212, pp. 303–4.

11. Vasari, p. 554.

12. Varchi (note 5) p. 312, describes the soft earthen construction of Michelangelo's bastions in 1529. See also Renzo Manetti, *Michelangelo: Le Fortificazioni per l'assegio di Firenze*, Florence 1980; James S. Ackerman, *The Architecture of Michelangelo*, Harmondsworth 1970, p. 138.

13. Compare, for example, Leonardo's drawing of a tower haloed by

torqued radiating bastions in Madrid II, 37 recto, with the orotund ground plans of Michelangelo's gatehouse designs in the Casa Buonarroti. See further Pietro C. Marani, ed., *Disegni di fortifiazioni da Leonardo a Michelangelo*, Florence 1984.

14. See Leonardo's drawing RL 12355 in the Royal Library, Windsor.
15. Christopher Duffy, *Siege Warfare: The Fortress in the Early Modern World, 1494–1660*, London and New York 1996.
16. Vasari, p. 725.
17. John M. Najemy, *A History of Florence 1200–1575*, Malden, MA, Oxford and Victoria, 2006, p. 458.
18. Condivi, p. 41.
19. *Rime*, 247, p. 281.
20. In his spoken corrections to Condivi's biography that survive as anonymous handwritten notes in an extant copy, Michelangelo softens his earlier denunciations of Bramante. See Caroline Elam, 'Postille', in Condivi, p. xxxviii.

BIBLIOGRAPHY

David Abulafia, *The Discovery of Mankind: Atlantic Encounters in the Age of Columbus*, New Haven and London 2008

James S. Ackerman, *The Architecture of Michelangelo*, Harmondsworth 1970

Leon Battista Alberti, *On the Art of Building*, trans. Joseph Rykwert, Neil Leach and Robert Tavernor, Cambridge, MA, and London 1991

Daniel Arasse, Pierluigi de Vecchi and Parizia Nitti, eds, *Botticelli from Lorenzo the Magnificent to Savonarola*, Milan 2003

Giulio Carlo Argan and Bruno Contardi, *Michelangelo Architect*, Milan 2004

Ludovico Ariosto, *Orlando Furioso, Part One*, trans. Barbara Reynolds, Harmondsworth 1975

James B. Atkinson and David Sices, eds, *Machiavelli and His Friends: Their Personal Correspondence*, DeKalb, IL, 1996

Carmen C. Bambach, ed., *Leonardo da Vinci: Master Draftsman*, New York, New Haven and London, 2003

Matteo Bandello, *Tutte le opera*, ed. Francesco Flora, vol. I, Milan 1935

J. R. Banker, *The Culture of San Sepolcro during the Youth of Piero della Francesca*, Ann Arbor, MI, 2003

Paul Barolsky, *Michelangelo's Nose: A Myth and Its Maker*, University Park, PA, and London, 1990

Hans Baron, *The Crisis of the Early Italian Renaissance*, Princeton 1966

James Beck, Antonio Paolucci and Bruno Santi, *Michelangelo: The Medici Chapel*, London 1994

L. Beltrami, ed., *Documenti e memorie riguardanti la vita e le opere di Leonardo da Vinci*, Milan 1919

Isaiah Berlin, *The Proper Study of Mankind: An Anthology of Essays*, London 1998

Anthony Blunt, Carlo Pedretti and Kenneth Keele, *Leonardo da Vinci: Anatomical Drawings from the Royal Collection, Windsor Castle*, Florence 1979

William J. Bouwsma, *The Waning of the Renaissance 1550–1640*, New Haven and London 2002

Pinin Brambilla Barcilon and Pietro C. Marani, *Leonardo: The Last Supper*, trans. Harlow Tighe, Chicago and London 2001

Giovanni Boccaccio, *Decameron*, ed. Vittore Branca, Milan 1985

—, *The Decameron*, trans. G. H. McWilliam, Harmondsworth 1972

Poggio Bracciolini, *Historia Fiorentina*, Florence 1492

Gene Brucker, *Renaissance Florence*, suppl. edn, Berkeley, Los Angeles and London 1983

—, *The Civic World of Early Renaissance Florence*, Princeton 1977

Leonardo Bruni, *History of the Florentine People*, trans. James Hankins, 3 vols, Cambridge, MA, 2001–7

Michelangelo Buonarroti, *Il Carteggio di Michelangelo*, ed. P. Barocchi and R. Ristori, 5 vols, Florence 1965–83

—, *The Letters of Michelangelo*, trans. and annotated E. H. Ramsden, London 1963

—, *The Poetry of Michelangelo*, trans. and annotated James M. Saslow, parallel text, New Haven and London 1991

—, *Rime*, preface by Giovanni Testori, chronology, introduction and notes Ettore Barelli, sixth edn, Milan 1998

— and Ascanio Condivi, *Michelangelo: Life, Letters and Poetry*, trans. George Bull with Peter Porter, Oxford 1999

Jacob Burckhardt, *The Civilisation of the Renaissance in Italy*, trans. S. G. C. Middlemore, new intro. by Peter Burke and notes by Peter Murray, Harmondsworth 1990

Peter Burke, *The Historical Anthropology of Early Modern Italy: Essays on Perception and Communication*, Cambridge 1987

—, *The Italian Renaissance*, rev. edn, Cambridge 1987

Baldassare Castiglione, *The Book of the Courtier*, trans. with intro. by George Bull, London 2003

Benvenuto Cellini, *La Vita*, ed. Lorenzo Bellotto, Parma 1996

—, *Autobiography*, trans. George Bull, rev. edn, Harmondsworth 1998

Hugo Chapman, *Michelangelo Drawings: Closer to the Master*, London 2005

André Chastel, *L'illustre incomprise: Mona Lisa*, Paris 1988

Marcus Tullius Cicero, *Selected Letters*, trans. D. R. Shackleton Bailey, Harmondsworth 1982

Kenneth Clark, *Leonardo da Vinci*, new edn with intro. by Martin Kemp, Harmondsworth 1988

—, *The Nude*, London 1956

— and Carlo Pedretti, *The Drawings of Leonardo da Vinci in the Collection of Her Majesty the Queen at Windsor Castle*, rev. edn, London 1968–9

Martin Clayton, *Leonardo da Vinci: The Divine and the Grotesque*, London 2002

Ascanio Condivi, *Vita di Michelangelo Buonarroti*, ed. Giovanni Nencioni with M. Hirst and C. Elam, Florence 1998

Andrew Cunningham and Ole Peter Grell, *The Four Horsemen of the Apocalypse: Religion, War, Famine and Death in Reformation Europe*, Cambridge 2000

Dante, *Divine Comedy*, trans. and annotated Mark Musa, 3 vols, Harmondsworth 1984

—, *La Commedia secondo l'antica vulgata*, ed. Giorgio Petrocchi, 4 vols, Florence 1994

—, *Dante in English*, ed. with notes by Eric Griffiths and Matthew Reynolds, London 2005

Erasmus of Rotterdam, *Erasmus on His Times: A Shortened Version of The Adages of Erasmus*, ed. and trans. Margaret Mann Phillips, Cambridge 1967

James Fenton, 'Portrait of a Lady', 'Saturday Review', *Guardian*, 26 January 2008

Felipe Fernández-Armesto, *Amerigo*, London 2006

J. V. Field, *Piero della Francesca: A Mathematical Art*, New Haven and London, 2005

S. J. Freedberg, *Painting in Italy 1500–1600*, New Haven and London 1993

Carl Frey, ed., *Il Codice Magliabechiano cl. XVII. contenente notizie sopra l'arte degli antichi e quella de' fiorentini da Cimabue a Michelangelo Buonarroti, scritta da anonimo fiorentino*, Berlin 1892

Donato Giannotto, *Della repubblica fiorentina*, Venice 1721

Felix Gilbert, *Machiavelli and Guicciardini: Politics and History in Sixteenth Century Florence*, New York and London 1984

Goethe on Art, selected, ed. and trans. by John Gage, London 1980

Rona Goffen, *Renaissance Rivals*, New Haven and London 2002

Ludwig Goldscheider, *Michelangelo*, London 1998

Richard A. Goldthwaite, *The Building of Renaissance Florence*, Baltimore 1980

Andrew Graham-Dixon, *Michelangelo and the Sistine Chapel*, London 2009

Stephen Greenblatt, *Renaissance Self-Fashioning*, Chicago 1980

Francesco Guicciardini, *La Historia di Italia*, Florence 1561

—, *The History of Italy*, trans. Sidney Alexander, Princeton 1969

J. R. Hale, *War and Society in Renaissance Europe*, Stroud 1998

—, *Florence and the Medici: The Pattern of Control*, London 2001

—, *The Civilisation of Europe in the Renaissance*, London 2005

James Hall, *Michelangelo and the Reinvention of the Human Body*, London 2005

Marcia B. Hall, *Michelangelo and the Frescoes of the Sistine Chapel*, New York 2002

Francis Haskell, *History and Its Images: Art and the Interpretation of History*, New Haven and London 1993

David Herlihy and Christine Klapisch-Zuber, *Tuscans and Their Families*, New Haven and London 1985

Ludwig H. Heydenreich, *Architecture in Italy 1400–1500*, rev. Paul Davies, New Haven and London 1996

Howard Hibbard, *Michelangelo*, second edn, Harmondsworth 1995

Michael Hirst, *Michelangelo and His Drawings*, New Haven and London 1988

Thomas Hobbes, *Leviathan*, Harmondsworth 1981

Charles Hope, 'Can You Trust Vasari?', *New York Review of Books*, 42/15, 5 October 1995

Johan Huizinga, *The Waning of the Middle Ages*, trans. F. Hopman, Harmondsworth 1976

George Huppert, *After the Black Death: A Social History of Early Modern Europe*, Bloomington 1998

Paul Joannides, 'Late Botticelli: Archaism and Ideology', *Arte Cristiana*, LXXXIII (1995)

—, *Titian to 1518: The Assumption of Genius*, New Haven and London 2001

—, *Inventaire général des dessins italiens: Michel-Ange, élèves et copistes*, Paris 2003

Martin Kemp, *Leonardo da Vinci: The Marvellous Works of Nature and Man*, new edn, Oxford 2006

—, *Leonardo*, Oxford 2004

—, *The Science of Art: Optical Themes in Western Art from Brunelleschi to Seurat*, New Haven and London 2004

F. W. Kent, *Lorenzo de' Medici and the Art of Magnificence*, Baltimore and London 2004

P. O. Kristeller, *The Philosophy of Marsilio Ficino*, New York 1942

Luca Landucci, *Diario Fiorentino dal 1450 al 1516 . . .*, ed. Iodoco del Badia, Florence 1883

—, *A Florentine Diary*, trans. Alice de Rosen Jervis, London and New York 1927

Leonardo da Vinci, *A Treatise on Painting by Leonardo da Vinci*, trans. John Francis Rigaud, London 1802

—, *The Notebooks of Leonardo da Vinci*, trans. Edward MacCurdy, 2 vols, London 1938

—, *Treatise on Painting*, trans. and annotated A. P. McMahon, vol. 1: Translations, vol. 2: Facsimile, Princeton 1956

—, *Manuscript B, Institut de France, Paris*, facsimile edn, Grenoble 1960

—, *The Notebooks of Leonardo da Vinci*, ed. Jean-Paul Richter with commentary by Carlo Pedretti, Oxford 1977.

—, *Leonardo on Painting*, trans. Martin Kemp and Margaret Walker, selected Martin Kemp, New Haven and London 1989

—, *Codex Arundel 263 nella British Library*, facsimile edn, Florence 1998

—, *Codice Atlantico*, facsimile edn, Florence 2000

—, *Codex On the Flight of Birds (Sul Volo degli Uccelli)*, Biblioteca Reale, Turin, facsimile edn, Munich 2000

—, *Codices Madrid I and II*, facsimile edn, Antwerp 1974

—, *Notebooks*, selected by Irma A. Richter, edited by Thereza Wells, Oxford 2008

—, *Leonardo da Vinci on the Human Body*, trans. and commentary Charles D. O'Malley and J. B. de C. M. Saunders, New York 1983

Saul Levine, 'The Location of Michelangelo's David: The Meeting of January 25, 1504', *Arts Bulletin*, 54 (1974), pp. 31–41

David Lewis-Williams, *The Mind in the Cave*, London 2000

Ronald Lightbown, *Sandro Botticelli*, 2 vols, London 1978

Roberto Longhi, *Piero della Francesca*, London 1930

Wolfgang Lotz, *Architecture in Italy 1500–1600*, rev. Deborah Howard, New Haven and London 1995

Niccolò Machiavelli, *Decennale*, Florence 1506

—, *Libro della arte della guerra*, Florence 1521

—, *Opere*, 4 vols, Turin 1971–99

—, *The Essential Writings*, selected and trans. Peter Constantine, New York 2007

—, *The Portable Machiavelli*, ed. and trans. Peter Bondanella and Mark Musa, Harmondsworth 1979

—, *The Chief Works and Others*, trans. and ed. Allan Gilbert, 3 vols, Durham and London 1989

—, *Florentine Histories*, trans. Laura F. Banfield and Harvey C. Mansfield, Jr, Princeton 1990

—, *Il Principe*, ed. Giorgio Inglese, Turin 1995

—, *Discourses on Livy*, trans. Harvey C. Mansfield and Nathan Tarcov, Chicago and London 1996

—, *Discorsi sopra la prima deca di Tito Livio*, ed. Corrado Vivanti, Turin 2000

—, *Teatro*, ed. Guido Davico Bonino, new edn, Turin 2001

—, *Art of War*, trans. Christopher Lynch, Chicago and London 2003

Michael Mallett, *The Borgias: The Rise and Fall of a Renaissance Dynasty*, London 1971

Renzo Manetti, *Michelangelo: Le Fortificazioni per l'assegio di Firenze*, Florence 1980

Pietro C. Marani, *Leonardo da Vinci: The Complete Paintings*, New York 2000

—, ed., *Disegni di fortificazioni da Leonardo a Michelangelo*, Florence 1984

Lauro Martines, *Power and Imagination: City States in Renaissance Italy*, new edn, London 2002

—, *Scourge and Fire: Savonarola and Renaissance Italy*, London 2006

Adrienne Mayor, *Greek Fire, Poison Arrows and Scorpion Bombs: Biological and Chemical Warfare in the Ancient World*, Woodstock, NY, and London 2004

Jean-Pierre Mohen *et al.*, *Mona Lisa: Inside the Painting*, Paris and New York 2006

John M. Najemy, *A History of Florence 1200–1575*, Malden, Oxford and Victoria 2006

—, ed., *Italy in the Age of the Renaissance 1300–1550*, Oxford 2004

Charles G. Nauert, *Humanism and the Culture of Renaissance Europe*, second edn, Cambridge 2006

Diana Norman, *Siena and the Virgin: Art and Politics in a Late Medieval City State*, New Haven and London 1999

Geoffrey Parker, *The Military Revolution: Military Innovation and the Rise of the West, 1500–1800*, rev. edition, Cambridge 2000

—, *Empire, War and Faith in Early Modern Europe*, London 2002

—, ed., *The Cambridge History of Warfare*, Cambridge 2005

K. T. Parker, *Catalogue of the Collection of Drawings in the Ashmolean Museum, vol. II, Italian Schools*, Oxford 1956

Erwin Panofsky, *The Life and Art of Albrecht Dürer*, Princeton 1971

Randolph Parks, 'The Placement of Michelangelo's David: A Review of the Documents', *Art Bulletin*, 57, (1975), pp. 560–70

Walter Pater, *The Renaissance: Studies in Art and Poetry*, Oxford, 1986

Carlo Pedretti, *Leonardo: A Study in Chronology and Style*, London 1973

Filippo Pedrocco, *Titian: The Complete Paintings*, London and New York 2001

J. G. A. Pocock, *The Machiavellian Moment: Florentine Political Thought and the Atlantic Republican Tradition*, second edn, Princeton and Woodstock 2003

Angelo Poliziano, *Poesie italiane*, Milan 1998

Lorenzo Polizzotto, *The Elect Nation: The Savonarolan Movement in Florence 1494–1545*, Oxford 1994

John Pope-Hennessy, *An Introduction to Italian Sculpture*, 3 vols, London 2002

Luigi Pulci, *Morgante*, trans. Joseph Tusiani, Bloomington and Indianapolis 1998

Stuart W. Pyhrr and José-A. Godoy, *Heroic Armour of the Italian Renaissance: Filippo Negroli and His Contemporaries*, New York 1998

Paolo Rossi, *The Birth of Modern Science*, Oxford and Malden, MA, 2001

Royal Academy of Arts, *Sandro Botticelli: The Drawings for Dante's Divine Comedy*, London 2000

Patricia Lee Rubin, *Giorgio Vasari: Art and History*, New Haven and London, 1995

Nicolai Rubinstein, *The Government of Florence under the Medici 1434 to 1494*, Oxford 1966

—, 'Machiavelli and the Mural Decoration of the Hall of the Great Council of Florence', *Musagetes: Festschrift für Wolfram Prinz*, Berlin 1991

—, *The Palazzo Vecchio, 1298–1532*, Oxford 1995

Girolamo Savonarola, *Compendio di revelatione dello inutile servo di Iesu Christo frate Hieronymo da Ferrara* . . . Florence, 1495

Charles Seymour, Jnr, *Michelangelo's David: A Search for Identity*, Pittsburgh 1967

John Shearman, *Mannerism*, Harmondsworth 1967

Quentin Skinner, *The Foundations of Modern Political Thought, Volume One: The Renaissance*, Cambridge 1978

Charles L. Stinger, *The Renaissance in Rome*, Bloomington 1998

James Strachey and Albert Dickson, eds, *Sigmund Freud 14: Art and Literature*, Harmondsworth 1990

Bette Talvacchia, *Raphael*, London 2007

E. M. W. Tillyard, *The Elizabethan World Picture*, Harmondsworth 1972

Richard C. Trexler, *Public Life in Renaissance Florence*, Ithaca 1991

Roberto Valturio, *Le Macchine di Valturio*, Turin 1988

Robertus Valturius, *De re militari*, Verona 1472

Giorgio Vasari, *Le Vite de' più eccellenti architetti, pittori, et scultori italiani, de Cimabue insino a' tempi nostri*, ed. Luciano Bellosi and Aldo Rossi from first edn of 1550, Turin 1986

—, *Le Vite . . .* , second edn, 3 vols, Florence 1568

—, *Lives of the Painters, Sculptors and Architects*, trans. Gaston du C. de Vere, 2 vols (complete trans. of entire 1568 edn, originally published 1912), London 1996

Vegetius, *Epitome of Military Science*, trans. with notes and intro. by N. P. Milner, Liverpool 1993

Amerigo Vespucci, *Il Mondo nuovo di Amerigo Vespucci: Vespucci autentico e apocrifo*, a cura di Mario Pozzi, Milan 1984

Giovanni Villani and family, *Cronica*, Turin 1979

Vitruvius, *Ten Books on Architecture*, ed. Ingrid D. Rowland and Thomas Noble Howe, Cambridge 1999

D. P. Walker, *Spiritual and Demonic Magic from Ficino to Campanella*, London 1958

Daniel Whaley, *The Italian City-Republics*, third edn, Harlow 1988

Lynn White, Jnr, *Medieval Technology and Social Change*, Oxford 1962

J. Wilde, 'The Hall of the Great Council of Florence', *Journal of the Warburg and Courtauld Institutes*, 7 (1944)

—, *Italian Drawings in the Department of Prints and Drawings in the British Museum: Michelangelo and His Studio*, 2 vols, London 1953

Margot and Rudolf Wittkower, *Born Under Saturn: The Character and Conduct of Artists*, new edn with intro. by Joseph Connors, New York 2007

Rolf C. Witz, *Donatello*, Cologne 2000

Heinrich Wölfflin, *Classic Art*, trans. Peter and Linda Murray, fifth edn, London 1994

Jeremy Wood, *Rubens: Drawing on Italy*, Edinburgh 2002

Frances Yates, *Giordano Bruno and the Hermetic Tradition*, London 1964

Frank Zöllner with Johannes Nathan, *Leonardo da Vinci 1452–1519: The Complete Paintings and Drawings*, Cologne 2003

Frank Zöllner, Christof Thoenes and Thomas Popper, *Michelangelo 1475–1564: The Complete Works*, Cologne 2007

THE WORKS OF ART

This section gives essential information about works of art discussed in this book. All inventory and catalogue numbers are those used by the collections that hold the works in question.

WORKS BY LEONARDO DA VINCI

Paintings

Annunciation (early to mid-1470s)
Oil and tempera on poplar wood
Uffizi Gallery, Florence

Ginevra de' Benci (mid-1470s to c. 1480)
Oil and tempera on poplar wood
National Gallery of Art, Washington, DC

St Jerome (early 1480s)
Oil and tempera on walnut wood
Vatican Museums, Rome

The Adoration of the Magi (commissioned 1480, left unfinished c. 1482)
Oil and tempera on wood
Uffizi Gallery, Florence

Virgin of the Rocks (Paris version) (early to mid-1480s)
Oil on wood, transferred to canvas
Louvre Museum, Paris

Portrait of a Musician (mid-1480s)
Tempera and oil on wood
Pinacoteca Ambrosiana, Milan

Cecilia Gallerani (Lady with an Ermine) (c. 1490)
Oil on walnut
Czartoryski Collection, National Museum, Cracow

Virgin of the Rocks (London version) (probably begun 1490s, finished 1508)
Oil on wood
National Gallery, London

Last Supper (c. 1495–7)
Tempera on plaster
Refectory, Santa Maria delle Grazie, Milan

Mona Lisa (1503–6 and later)
Oil on poplar wood
Louvre Museum, Paris

Virgin and Child with Saint Anne
(begun 1500s, worked on until c.
1513)
Oil on poplar wood
Louvre Museum, Paris

Saint John the Baptist (c. 1513–16)
Oil on walnut wood
Louvre Museum, Paris

Drawings on Paper

Landscape, 5 August 1473
Pen and ink
Cabinet of Prints and Drawings,
Uffizi Gallery, Florence
Inventory number 436 E

Old Warrior (early 1470s)
Silverpoint
Department of Prints and
Drawings, British Museum,
London
Inventory number 1895-9-15-474

A Child Playing with Cat (late 1470s–
c. 1480)
Pen and ink
Department of Prints and
Drawings, British Museum,
London
Inventory number 1857-1-10-1,
recto and verso

Baroncelli Hanged (December 1479)
Pen and ink
Musée Bonnat, Bayonne
Inventory number 659

Designs for a 'tank' and scythed chariot
(1480s)
Pen and ink
Department of Prints and
Drawings, British Museum,
London

Designs for artillery weapons
(recto); a tower exploding and a hill
town being blown up (verso) (early
to mid-1480s)
Pen and dark brown ink over
leadpoint (recto); pen and ink on
blue paper (verso)
Royal Library, Windsor Castle
RL 12652

Study for the Sforza Monument (late
1480s)
Metalpoint on blue paper
Royal Library, Windsor Castle
RL 12357 recto

Study for the Sforza Monument (late
1480s)
Metalpoint on blue paper
Royal Library, Windsor Castle
RL 12358 recto

The Vitruvian Man (c. 1490)
Pen and ink over metalpoint
Accademia Gallery, Venice
Inventory number 228

*Study of the proportions of a horse's
foreleg* (c. 1485–90)
Pen and ink
Royal Library, Windsor Castle
RL 12294 recto

Study of the proportions of a horse (c. 1489)
Metalpoint on blue prepared paper
Royal Library, Windsor Castle
RL 12319 recto

The layers of the brain and scalp compared with the layers of an onion (early 1490s)
Pen, ink and red chalk
Royal Library, Windsor Castle
RL 12603 recto

Study for a Portrait of Isabella d'Este (c. 1499–1500)
Black and red chalk
Louvre Museum, Paris
MI 753

Studies of the Virgin and Child with Saint Anne (probably c. 1499–1500)
Pen and brown ink and wash over black chalk (recto); black chalk (verso)
Department of Prints and Drawings, British Museum, London
Inventory number 1875-6-12-17

Virgin and Child with Saint Anne and John the Baptist (cartoon) (c. 1499–1500)
Black chalk and touches of white chalk on joined sheets of paper mounted on canvas
National Gallery, London
NG6337

Map of the River Arno (probably 1503)
Charcoal or soft black chalk, reworked with pen and dark brown ink, and brush with brown and grey wash
Royal Library, Windsor
RL 12279

Michelangelo's *David* and other studies (c. 1504)
Pen and ink over black chalk
Royal Library, Windsor Castle
RL 12591 recto

Sketches for *The Battle of Anghiari* (autumn 1503–early 1504)
Pen and ink, brush and brown wash over traces of stylus
Accademia Gallery, Venice
Inventory number 215 A

Sketches for *The Battle of Anghiari* (autumn 1503–early 1504)
Pen and ink, over black chalk and traces of stylus
Accademia Gallery, Venice
Inventory number 215

Sketches for *The Battle of Anghiari* (autumn 1503–early 1504)
Pen and brown ink
Accademia Gallery, Venice
Inventory number 216

Studies of Charging Soldiers and Horses (1503–4)
Red chalk
Royal Library, Windsor Castle
RL 12340

Study of Soldiers and Horses (1503–4) on sheet with earlier studies of proportion
Anghiari studies in red chalk
Accademia Gallery, Venice
Inventory number 236

Rearing Horse (1503–4)
Red chalk with traces of pen and brown ink
Royal Library, Windsor Castle
RL 12336

Studies of Horsemen (1503–4)
Pen and ink
Department of Prints and Drawings, British Museum, London
Inventory number 1854-5-13-17

Horses and equine, leonine and human facial expressions (1503–4)
Pen, ink and wash with traces of black and red chalk
Royal Library, Windsor Castle
RL 12326 recto

Heads of Two Soldiers (1504–5)
Black and red chalk over metalpoint
Szépmüvészeti Múzeum, Budapest
Inventory number 1175 recto

Neptune and His Sea Horses (c. 1504)
Charcoal or soft black chalk
Royal Library, Windsor Castle
RL 12570

Rearing Horse and Rider; Leda and the Swan (recto); *Mortars bombarding a fortification* (verso) (c. 1504)
Charcoal or soft black chalk, details highlighted with pen and ink
Royal Library, Windsor Castle
RL 12337

A Row of Four Mortars Bombarding a Fortification (c. 1504)
Pen and brown ink and wash over traces of charcoal or soft black chalk
Royal Library, Windsor Castle
RL 12275

Study of a Spray of Blackberry (c. 1505)
Red chalk with white details
Royal Library, Windsor Castle
RL 12419 recto

Star of Bethlehem (flower study) (c. 1506–8)
Pen and ink, red chalk
Royal Library, Windsor Castle
RL 12424 recto

Job's Tears (flower study) (c. 1508–9)
Pen and ink, black chalk
Royal Library, Windsor Castle
RL 12429 recto

Studies of the Muscles of the Lips (c. 1506)
Pen and ink, black chalk
Royal Library, Windsor Castle
RL 19055 verso

Foetus in the Womb (c. 1510)
Pen and ink, wash, red chalk
Royal Library, Windsor Castle
RL 19102 recto

Studies for the Trivulzio Monument
(c. 1508–11)
Pen and ink
Royal Library, Windsor Castle
RL 12355 recto

Deluges, c. 1515
Black chalk
Royal Library, Windsor Castle
RL 12377, 12378, 12382, 12383,
12385, 12386

Angel Incarnate (c. 1513–15)
Charcoal
Private Collection

WORKS BY MICHELANGELO BUONARROTI

Paintings

Manchester Madonna (c. 1497)
Tempera on wood
National Gallery, London

Entombment (c. 1500–1501)
Oil on wood
National Gallery, London

Doni Tondo (c. 1504–7)
Tempera on wood
Uffizi Gallery, Florence

Sistine ceiling (1508–12)
Fresco
Sistine Chapel, Vatican, Rome

Architecture

New Sacristy (1519–34)
San Lorenzo, Florence

Laurentian Library (1523–33,
staircase completed 1555–8)
San Lorenzo, Florence

St Peter's Basilica (Michelangelo's
works 1546–64)
Vatican, Rome

Sculptures

Battle of the Centaurs (1492)
Marble
Casa Buonarroti, Florence

Saint Proculus (1494–5)
Marble
Basilica of San Domenico, Bologna

Saint Petronius (1494–5)
Marble
Basilica of San Domenico, Bologna

Bacchus (1496–7)
Marble
Bargello Museum, Florence

Pietà (1498–9)
Marble
St Peter's Basilica, Vatican, Rome

David (1501–4)
Marble
Accademia Gallery, Florence

Taddei Tondo (c. 1503–6)
Marble
Royal Academy of Arts, London

Bruges Madonna (c. 1503–4/5)
Marble
Notre Dame, Bruges

St Matthew (1506)
Marble
Accademia Gallery, Florence

Dying Prisoner and Rebellious Prisoner
(c. 1513–16)
Marble
Louvre Museum, Paris

Moses (c. 1513–16, reworked for its
current site 1542)
Marble
San Pietro in Vincoli, Rome

Boboli Prisoners (c. 1519–34)
Marble
Accademia Gallery, Florence

Victory (c. 1519–34)
Marble
Palazzo Vecchio, Florence

*Tombs of Lorenzo and Giuliano de'
Medici* (1519–34)
Marble
New Sacristy, San Lorenzo,
Florence

Brutus (c. 1542)
Marble
Bargello Museum, Florence

Drawings

Sketch for the Bronze *David* and
Other Studies (c. 1502)
Pen and ink
Louvre Museum, Paris
Inventory number 714

*Studies of Horses and a Sketch of a
Battle* (1504)
Pen and ink
Ashmolean Museum, Oxford
P. 293 recto

A Battle (1504)
Pen and ink
Ashmolean Museum, Oxford
P. 294 recto

A Battle Scene and Two Figures (recto);
Architectural sketches and poetry (verso)
(1504)
Pen and ink
British Museum, London
1895-9-15-496

Compositional Drawing for *The
Battle of Cascina* (1504–5)
Black chalk over stylus
Cabinet of Prints and Drawings,
Uffizi Gallery, Florence
Inventory number 613

Copy from Masaccio's *Adam and Eve*
(recto) (probably 1504); Figures for
The Battle of Cascina (verso)
Red chalk
Louvre Museum, Paris
3897

Figure for *The Battle of Cascina*
(1504–5)
Pen and ink, black chalk
Louvre Museum, Paris
712

A Seated Male Nude Twisting Around
(1504–5)
Pen and ink, wash, heightened with
lead white over leadpoint and stylus
British Museum, London
1887-5-2-116

A Male Nude (1504–5)
Black chalk heightened with
lead white
Teyler Museum, Haarlem
A 18

A Male Nude (1504–5)
Black chalk heightened with
lead white
Teyler Museum, Haarlem
A 19

Male Nude (1504–5)
Black chalk heightened with
lead white
Albertina, Vienna
Sc. R. 157r, 123

Designs for the Fortifications of Florence
(1528)
Mostly pen and ink and wash
Casa Buonarroti, Florence
Inventory numbers 11 to 30

Portrait of Andrea Quaratesi
(c. 1528–32)
Black chalk
British Museum, London
1895-9-15-519

WORKS BY OTHER ARTISTS

Bartolommeo Ammanati
Neptune Fountain (1560–75)
Bronze and marble
Piazza della Signoria, Florence

Antonello da Messina
Saint Jerome in His Study (c. 1475)
Oil on limewood
National Gallery, London

Fra Bartolommeo
*Madonna and Child with Saint Anne and
Other Saints* (1510–13)
Preliminary drawing on wood
Museum of San Marco, Florence

Battle of Anghiari (1460s)
Tempera on poplar wood
National Gallery of Ireland, Dublin

Bayeux Tapestry (c. 1070–80)
Wool embroidery on linen
Museum of the Bayeux Tapestry,
Bayeux

Bertoldo di Giovanni
A Battle (c. 1475)
Bronze
Bargello Museum, Florence

Bonnino da Campione (attributed)
*Equestrian Monument to Bernabò
Visconti* (before 1363)
Marble
Castello Sforzesco, Milan

Sandro Botticelli
The Discovery of the Body of Holofernes
and *The Return of Judith*
(both c. 1470–72)
Tempera on wood
Uffizi Gallery, Florence

Sandro Botticelli
Adoration of the Magi (c. 1475)
Tempera on wood
Uffizi Gallery, Florence

Sandro Botticelli
Saint Augustine in His Study (c. 1480)
Detached fresco
Ognissanti, Florence

Sandro Botticelli
Primavera (c. 1481–2)
Grease tempera on wood
Uffizi Gallery, Florence

Sandro Botticelli
Pallas and the Centaur (c. 1482)
Tempera on linen

Uffizi Gallery, Florence
Sandro Botticelli
Birth of Venus (c. 1484)
Tempera on linen
Uffizi Gallery, Florence

Sandro Botticelli
Venus and Mars (c. 1485)
Tempera and oil on poplar wood
National Gallery, London

Sandro Botticelli
Drawings for Dante's *Divine Comedy*
(1480s and 1490s)
Pen and ink and other media
Vatican Library, Rome, and
Kupferstichkabinett, Berlin

Sandro Botticelli
The Calumny of Apelles (c. 1495)
Tempera on wood
Uffizi Gallery, Florence

Sandro Botticelli
Agony in the Garden (1500–1504)
Tempera on wood
Capella de los Reyes, Granada

Sandro Botticelli
Mystic Nativity (1500)
Oil on canvas
National Gallery, London

Bronzino
Allegory with Venus and Cupid (c.
1540–50)
Oil on wood
National Gallery, London

Filippo Brunelleschi
Can Grande della Scala on Horseback
(fourteenth century)
Marble
Castelvecchio Museum, Verona

Filippo Brunelleschi
Sacrifice of Isaac (1402–3)
Bronze with gilding
Bargello Museum, Florence

Caravaggio
Medusa (c. 1598)
Oil on canvas on wooden shield
Uffizi Gallery, Florence

Caravaggio
Judith Beheading Holofernes (c. 1599)
Oil on canvas
Barberini Palace, Rome

Benvenuto Cellini
Perseus (1545–54)
Bronze
Loggia della Signoria, Florence

Lucas Cranach
Judith (c. 1530)
Oil on limewood
Kunsthistorisches Museum,
Vienna

Salvador Dalí
Study for *Spain* (1936)
Pencil and China ink on paper
Fundació Gala-Salvador Dalí,
Figueres

Salvador Dalí
Spain (1938)
Oil on canvas
Boijmans Van Beuningen Museum,
Rotterdam

Domus Aurea wall paintings
(first century AD)
Fresco
Domus Aurea, Esquiline, Rome

Donatello
*Equestrian Monument of Erasmo da
Narni, Known as Gattemalata*
(c. 1444–53)
Bronze
Piazza del Santo, Padua

Donatello
David (c. 1446–60)
Bronze
Bargello Museum, Florence

Donatello
Judith (c. 1446–60)
Bronze
Palazzo Vecchio, Florence

Albrecht Dürer
The Mens' Bathhouse (c. 1496–7)
Woodcut
Cleveland Museum of Art

Albrecht Dürer
Melancholia (Melencolia I) (1514)
Engraving
British Museum, London

Lorenzo Ghiberti
Sacrifice of Isaac (1402–3)
Bronze with gilding
Bargello Museum, Florence

Domenico Ghirlandaio
The Life of the Virgin (1485–90)
Fresco cycle
Capella Maggiore, Santa Maria
Novella, Florence

Domenico Ghirlandaio
An Old Man and His Grandson
(c. 1490)
Tempera on wood
Louvre Museum, Paris

Ridolfo Ghirlandaio
Christ on the Road to Calvary (c. 1505)
Oil on canvas, transferred from
wood
National Gallery, London

Giambologna
Model for *Florence Triumphant over
Pisa* (1565)
Gesso
Palazzo Vecchio, Florence

Giambologna
Rape of the Sabines (completed 1582)
Marble
Loggia della Signoria, Florence

Benozzo Gozzoli
Procession of the Magi (c. 1459)
Fresco
Chapel, Palazzo Medici-Riccardi,
Florence

Francesco Granacci (attributed)
Portrait of a Man in Armour (c. 1510)
Oil on wood
National Gallery, London

Gustav Klimt
Judith (1901)
Oil on canvas
Austrian Gallery, Belvedere,
Vienna

Frederic, Lord Leighton
*Cimabue's Celebrated Madonna Is
Carried in Procession through the Streets
of Florence* (1853–6)
Oil on canvas
National Gallery, London

Peter Lely
Nymphs by a Fountain (c. 1650)
Oil on canvas
Dulwich Picture Gallery, London

Leonardo da Vinci (copy of)
Leda and the Swan (c. 1505–7)
Oil on wood
Uffizi Gallery, Florence

Filippino Lippi
*Saint Philip Exorcising the Demon in the
Temple of Mars* (1487–1502)
Fresco
Santa Maria Novella, Florence

Filippino Lippi
*Triumph of Saint Thomas over the
Heretics* (1489–91)
Fresco
Santa Maria sopra Minerva, Rome

Filippo Lippi
The Annunciation (c. 1450–53)
Egg tempera on wooden panel
National Gallery, London

Ambrogio Lorenzetti
Allegory of Good Government (1338–9)
Fresco
Palazzo Pubblico, Siena

Lorenzo Lotto
Young Man before a White Curtain
(c. 1506–8)
Oil on canvas
Kunsthistorisches Museum, Vienna

Girolamo Machietti
Baths of Pozzuoli (1570–72)
Oil on slate
Studiolo of Francesco I, Palazzo
Vecchio, Florence

Magdeburg Rider (c. 1245–50)
Stone
Kuiturhistorisches Museum,
Magdeburg

Simone Martini
Maestà (1311–17, repaired 1321)
Fresco
Palazzo Pubblico, Siena

Masaccio, Masolino and Filippino
Lippi
Brancacci Chapel cycle (1420s,
finished by Lippi 1480s)
Fresco
Santa Maria del Carmine,
Florence

Michelangelo (copy of)
Leda and the Swan (after 1530)
Oil on canvas
National Gallery, London

Parthenon sculptures
(5th century BC)
Marble
British Museum, London

Pech Merle painted cave (pigments
dated to approximately 25,000
years ago)
Cabrerets, Lot

Pablo Picasso
Guernica (1937)
Oil on canvas
Reina Sofia Museum, Madrid

Piero della Francesca
The Legend of the True Cross (c. 1450s)
Fresco cycle
San Francesco, Arezzo

Piero della Francesca
Baptism of Christ (1450s)
Tempera on poplar wood
National Gallery, London

Piero di Cosimo
*The Battle between the Lapiths and
Centaurs* (c. 1500–1515)
Oil on wood
National Gallery, London

Piero di Cosimo
The Forest Fire (c. 1505)
Oil on wood
Ashmolean Museum, Oxford

Pisanello
Portrait Medal of Niccolò Piccinino
(c. 1439–92)
Cast bronze
Victoria and Albert Museum,
London
Inventory A.170 - 1910

Nicola Pisano
Pulpit (1260)
Marble
Baptistery, Pisa

Antonio del Pollaiuolo
Hercules and the Hydra and *Hercules
and Antaeus* (both c. 1460–c. 1475)
Tempera on wood
Uffizi Gallery, Florence

Antonio del Pollaiuolo
Hercules and Antaeus (probably 1470s)
Bronze
Bargello Museum, Florence

Antonio del Pollaiuolo
Battle of the Nudes (c. 1470)
Copperplate engraving
British Museum, London
Hind 1, 191.

Pontormo
Portrait of a Halberdier (1529–30)
Oil on wood, transferred to canvas
J. Paul Getty Museum, Los Angeles

Pontormo
*Portrait of a Young Man in a Red Cap
(Carlo Neroni)* (1530)
Oil on wood
Private collection

Pontormo
Martyrdom of the Ten Thousand
(1530)
Oil on wood
Pitti Palace, Florence

Raphael
The Marriage of the Virgin (1504)
Oil on wood
Brera Gallery, Milan

Raphael
Studies for the Trinity of S. Severo (c.
1505) with sketch of *The Battle of
Anghiari*
Silverpoint heightened with
bodycolour on paper
Ashmolean Museum, Oxford
P. II. 535

Raphael
Madonna of the Meadow
(c. 1505–6)
Oil on wood
Kunsthistorisches Museum, Vienna

Raphael
Madonna of the Goldfinch (c. 1506)
Oil on wood
Uffizi Gallery, Florence

Raphael
Portrait of Maddalena Strozzi Doni
and *Portrait of Agnolo Doni*
(both c. 1506–7)
Oil on wood
Pitti Palace, Florence

Raphael
Bridgewater Madonna (c. 1507)
Oil on canvas, transferred from
wood
Duke of Sutherland Collection, on
loan to National Galleries of
Scotland

Raphael
Entombment (1507)
Oil on wood
Borghese Gallery, Rome

Raphael
The School of Athens (1509–10)
Fresco
Stanza della Segnatura, Vatican
Museums, Rome

Raphael
Portrait of Pope Julius II (1511)
Oil on poplar wood
National Gallery, London

Raphael
The Triumph of Galatea (1511–12)
Fresco
Villa Farnesina, Rome

Raphael
Sistine Tapestry Cartoons (1515–16)
Gouache on paper mounted on
canvas
Victoria and Albert Museum,
London

Raphael
The Fire in the Borgo (c. 1516–17)
Fresco
Stanza dell'Incendio, Vatican
Museums, Rome

Raphael
Stufetta of Cardinal Bibbiena (1516)
Fresco and marble
Vatican Palace, Rome

Giulio Romano
Battle of Constantine (1521)
Fresco
Sala di Constantino, Vatican
Museums, Rome

Giulio Romano
Sala dei Giganti (1532–4)
Fresco
Mantua

Francesco Rosselli (attributed)
Execution of Savonarola (c. 1498)
Tempera on wood
Museum of San Marco, Florence

Vincenzo de' Rossi
Labours of Hercules (begun 1568)
Marble
Palazzo Vecchio, Florence

Rosso Fiorentino (or early copyist)
Moses and the Daughters of Jephron
(1523–4)
Oil on linen
Uffizi Gallery, Florence

Peter Paul Rubens
The Fight for the Standard (reworked
from a sixteenth-century copy)
(c. 1600–1615)
Chalk, pen and ink, washes and
gouache on two joined sheets of
paper
Louvre Museum, Paris

Peter Paul Rubens
The Fight for the Standard, after
The Battle of Anghiari (c. 1600s)
Chalk and wash on paper
British Museum, London

Peter Paul Rubens
Minerva Protects Pax from Mars
(1629–30)
Oil on canvas
National Gallery, London

Peter Paul Rubens
The Horrors of War (1637–8)
Oil on canvas
Pitti Palace, Florence

Andrei Rublev
The Saviour (early fifteenth century)
Tempera on wood
Tretyakov Gallery, Moscow

Aristotile da Sangallo
Copy of Michelangelo's *Battle of
Cascina* (c. 1542)
Oil on wood
Holkham Hall, Norfolk, Collection
of the Earl of Leicester

Giovanni Stradano
The Siege of Florence (c. 1560)
Fresco
Palazzo Vecchio, Florence

Tintoretto
Susanna and the Elders (1555–6)
Oil on canvas
Kunsthistorisches Museum, Vienna

Titian
Decorations for the Fondaco dei Tedesci
(1509)
Frescoes
Accademia Gallery, Venice

Titian
Allegory of the Three Ages of Man
(c. 1515)
Oil on canvas
National Galleries of Scotland,
Edinburgh

Titian
Bacchanal of the Andrians (c. 1523–5)
Oil on canvas
Prado Museum, Madrid

Titian
Diana and Actaeon (1556–9)
Oil on canvas
Jointly owned by National Gallery,
London, and National Galleries of
Scotland, Edinburgh

Paolo Uccello
Sir John Hawkwood (1436)
Fresco, transferred to canvas
Cathedral, Florence

Paolo Uccello
The Battle of San Romano (probably
c. 1438–40)
Tempera on poplar wood
Three panels in the Uffizi Gallery,
Florence, Louvre Museum, Paris,
and National Gallery, London

Paolo Uccello
Deluge (c. 1445–c. 1450)
Fresco
Green Cloister, Santa Maria
Novella, Florence

Standard of Ur (c. 2600–2400 BC)
Shell, red limestone and lapis lazuli
British Museum, London

Giorgio Vasari and assistants
Decorations of former Great
Council Hall (1563–5)
Fresco and other media
Palazzo Vecchio, Florence

Andrea del Verrocchio and
assistants, including Leonardo
da Vinci
The Baptism of Christ (1470–75)
Tempera and oil on wood
Uffizi Gallery, Florence

Andrea del Verrocchio (cast by
Alessandro Leopardi)
*Equestrian Monument to Bartolommeo
Colleoni* (c. 1481–96)
Campo SS Giovanni e Paolo,
Venice

Workshop of Andrea del
Verrocchio
Tobias and the Angel (1470s)
Tempera on poplar wood
National Gallery, London

Workshop of Andrea del
Verrocchio
Scipio (1470s–c. 1480)
Marble
Louvre Museum, Paris

Workshop of Andrea del
Verrocchio
Alexander (1470s–c. 1480)
Marble
National Gallery of Art,
Washington DC

ACKNOWLEDGEMENTS

The prints and drawings rooms of the Teyler Museum, Haarlem; the Uffizi Gallery, Florence; the Ashmolean Museum, Oxford; and the British Museum, London, all kindly let me look at works in their collections. Martin Clayton at the Royal Library, Windsor, was especially helpful and welcoming in making it possible for me to study Leonardo da Vinci's drawings in the Royal Collection and discussing them. I have also enjoyed opportunities to talk about the Renaissance with Martin Kemp, Sarah Dunant, Matthew Kieran, James Hall, Thereza Wells, Marta Ajmar-Wollheim and Jerry Brotton. All these chats were tangential to the book's arguments. I owe a great deal to the *Guardian* newspaper. Among editors there, Clare Margetson, Dan Glaister, Phil Daoust, Helen Oldfield, Katharine Viner, Charlie English and Mark Brown have at different times and in different ways helped this book. I would like to thank Mike Jones, my editor at Simon and Schuster, for his sensitive comments on the manuscript; Andrea Belloli for meticulous copy-editing; Rory Scarfe and Ben Ball. I have a terrific agent in Will Francis. My parents, Eric and Margaret Lewis Jones, first took me to Florence as a child and have always encouraged my writing. I'd also like to thank Deb Jones for that Vasari book, and Angela and Graham Currie for sharing their love of Italian culture and food. But no one has contributed as much to this book or to my life as Sarah, my intellectual companion and best friend.

INDEX

Alberti, Leon Battista 134, 137, 139, 171, 202, 293
Albertini, Francesco: *Memorial of Statues and Works of Art in Florence* 270, 272, 279
Alexander VI (Rodrigo Borgia), Pope 37, 60–1, 202, 233
Alidosi, Francesco 262
Altdorfer, Albrecht 259
Amboise, Charles d' 263
Ammanati, Bartolommeo: *Neptune Fountain* 48
Anghiari, Battle of 54, 118–19, 225–6, 228–32
Anonimo Magliabechiano 20, 26, 159
Antonello da Messina: *Saint Jerome in His Study* 140–1
Apelles 47–8, 91
 Calumny 77
Archimedes 139, 229
architecture 73, 138, 171–2, 202–3, 284–5, 292–3, 301
Ariosto 247
artistic personality 194–5
astrology 82–3
Athens 12, 113, 158, 186
Attavante 73

Baglioni, Gianpaglo 124
Bandello, Matteo 17, 19, 109, 113
Bandinelli, Baccio 276, 278, 297
Bandinelli, Michelangelo 73
Baroncelli, Bernardo de Bandino 14
Bartoli, Cosimo 182
Bartolommeo, Fra 178, 270
bastions 171, 173–5, 285
Battista della Palla 284, 286, 295
Bayeux Tapestry 99
Bellini, Giovanni 52
Bernardo di Marco della Cecca 73, 85
Bertoldo di Giovanni 151
Berughetta, Alonzo 276
Beyazit, Sultan 232–3
Biagio d'Antonio Tucci 73, 85
Biringuccio, Vannuccio 181
Boccaccio, Giovanni: *Decameron* 17, 19, 24
Bologna 27, 29, 60, 159, 171, 202, 261–2
Borgia, Cesare (Duke Valentino) 15, 124, 126, 180, 229, 232, 233–4, 253
Botticelli, Sandro 44, 63, 73, 76, 77–81, 84, 216
 Adoration of the Magi 77
 The Agony in the Garden 80

Birth of Venus 78–9
The Mystic Nativity 80
Primavera 79
Saint Augustine in his Study 141–2
Venus and Mars 78, 155
Braccio di Montone 225–6
Bracciolini, Poggio 227, 231, 240
Bramante, Donato 101, 113, 181, 192, 202–4, 249–50, 300, 301
Bronzino 277
 Allegory with Venus and Cupid 275–6
Brueghel, Pieter 259
Brunelleschi, Filippo 94, 171, 194
Bruni, Leonardo: *History of Florence* 119, 122–3, 131–2, 187, 227, 230, 231
Bruno, Giordano 288
Buonaccorsi, Biaggio 261
Burckhardt, Jacob 5, 225

Can Grande della Scala 99
cannibalism 241–2
cannon 170–1, 283
Caravaggio
 Judith Beheading Holofernes 76
 Medusa 277–8
Cardiere 60
Cascina, Battle of 92, 131–2
Castiglione, Baldassare 193–4
Cataneo, Girolamo 181
Cavalieri, Tommaso 59, 160, 161, 166
cave paintings 214–16
Cellini, Benvenuto 20, 249, 267, 268, 269, 274, 275, 282
 Perseus 48
Cellini, Giovanni 73
Cézanne 292
Charles I of England 299
Charles V 282
Chimenti del Tasso 73
Christianity 62, 177, 250, 258, 289
Cicero 47–8, 62
 Familiar Letters 45
Cimabue 26
cities and city states 34–5
Clement VII, Pope (Giulio de' Medici) 51, 281–2, 295
Codex Urbinas 25
Colleoni, Bartolommeo 98, 100
Colonna, Vittoria 161

Columbus, Christopher 239
communal bathhouses 150–1
competition 93–6
Condivi, Ascanio: *Life of Michelangelo* 28–9, 59, 67, 82, 83, 160, 247, 250, 254, 260, 262, 276, 279
condottiere 225
Constable, John 125
Constantine, Battle of 228–9
Cornuola, Giovanni 73
Correggio, Antonio Allegri da 63
Corsali, Andrea 208
Corsini, Marietta 41
Costa, Lorenzo 52
Cranach, Lucas 76
Credi, Lorenzo di 73

Daedalus 220
Dalí, Salvador: *Spain* 299
Dante
 Divine Comedy 77, 93, 123, 126, 242
 Inferno 235
Darwin, Charles 210, 211
Domenico da Pescia, Fra 50
Dominic, St 134
Donatello 95–6, 105
 David 34, 68, 82, 155
 Erasmo da Narni statue 100
 Judith 33, 34, 35, 68, 71–2, 75–6, 78, 82, 88
Doni, Agnolo 44
Duchamp, Marcel 53
Dürer, Albrecht 150–1
 Melencolia I 268–9, 292

Egypt, ancient 74, 98, 209
equestrian statuary 98–101
Erasmus: *'Dulce bellum inexpertis'* 258–9, 299
Este, Ercole d' 109
Este, Isabella d' 52, 159

Febvre, Lucien 258
Federico da Montefeltro 225
Ferrara defences 285
Ferretti, Francesco 182
Ficino, Marsilio 64, 74, 160, 268
Florence 5–6, 23–4, 34
 Accademia Gallery 56, 292
 adoration of the Virgin 165
 artistic rivalry 93–6
 Borgia threat 15
 Brancacci Chapel 157
 citizen militia 185–6, 253–6, 282–4
 creation of Gonfalonier 40–1
 David and public identity 89
 equestrian statuary 99–100
 Great Council
 created 36–7, 50
 reinstated (1527) 281
 Great Council Hall 49–51, 178, 255
 busyness 145, 263
 competition 5, 92–3, 144, 186, 192–8, 251–2, 257, 267–78, 287
 competition display 5, 269–72
 opening 50
 Leonardo's commission 5, 47–8, 53–4, 130

Leonardo's wall painting 201, 221, 243, 251, 257, 294–5, 297–8, 299–300
Machiavelli's anti-piety ambitions 177, 178
Michelangelo's commission 5, 92–3, 131
Michelangelo's 'public space' ambitions 187, 188
post-Medici cleansing 281
ravaging 266, 280
Soderini's sublime ambitions 114
symbolic importance 51, 266
transfiguration 297–8
homosexuality 158–9
insult obsession 24
intellectual revolution 138
Laurentian Library 5, 138, 200, 284–5, 292–3
Leonardo's fame 46–7, 52–3, 207
Leonardo's loss of popularity 251–2, 256–7, 263–4
loss of Pisa 36, 71, 122
Medici fall (1494) 35, 39, 50, 68, 169
Medici fall (1527) 281, 282
Medici restoration (1512) 265–6, 272, 280
Medici restoration (1529) 286, 295–6
meeting to site *David* 71–6, 81–2, 84–7, 92, 176
Michelangelo gains popularity 256, 257, 261, 262–4
Michelangelo's fortification 282–7, 291–2, 295
Palace of the Podestà (Bargello Museum) 14, 94, 194
Palazzo della Signoria (Palazzo Vecchio) 5, 23, 31–2, 35, 41, 48–9, 71, 90, 133, 188, 223, 277, 287, 297
Palazzo Spini 20, 21–2, 25–7, 31, 87, 111
Piazza della Signoria 31, 37–8, 75, 81, 83, 88, 124, 188, 221, 254, 255, 259
political history 35–41
portraits revered 52
pratiche 72
public nudity 151–2
public torture 23
Santa Maria Novella 53, 57, 133–5, 140–5, 154, 167, 192, 195, 198–9, 269, 271, 279, 293, 298
siege and fall (1529–30) 286, 293–4, 295
Strozzi Palace 73
superstition 79, 80
Tornaquinci 22–3
Uffizi Gallery 96, 125, 189, 190, 277, 297
war with Pisa 38, 49, 75, 122–9, 169, 173, 176, 254
 Arno diversion 125–9, 176, 180, 183–5
 see also Anghiari, Battle of; Cascina, Battle of
Florence Cathedral 36, 77, 80, 81, 84, 99–100, 132, 192, 197, 220
 dome 23–4, 89, 122, 171
 Opera del Duomo 72
 workshop 55–6, 65, 72
Francesco di Giorgio 138, 139, 174, 181
Franciabigio 276
François I 287
French Invasion (1494) 36, 38, 109, 120, 169–70
Freud, Sigmund 75, 110–11, 149, 209, 287

Gaddi, Agnolo 99–100
Galileo Galilei 182, 288

Gallieno 73
Ghiberti, Lorenzo 93–4, 194
Ghirlandaio, Davide 73
Ghirlandaio, Domenico 28, 52, 57–8, 135
Ghirlandaio, Ridolfo 276
 Christ on the Road to Calvary 298
Ghuiducci, Francisco 129
Giambologna 48, 297
Ginevra de' Benci 12–13
Giocondo, Francesco del 43, 45
Giocondo, Lisa Gherardini del 43–5, 45–6, 53, 167, 168
Giorgione 252
Giotto 19, 220
Goethe, Johann Wolfgang von 22
Gozzoli, Benozzo: *Procession of the Magi* 33
Granacci, Francesco 58, 73, 276
 soldier in front of *David* (attrib.) 255, 283
Greece, ancient 4–5, 58, 62, 99, 100, 138, 155
Guasparre di Simone 73
Guelf/Ghibelline factions 34, 123
Guicciardini, Francesco: *History of Italy* 170, 184, 227, 265, 295

Habsburg Empire 282, 286
Hawkwood, John 99–100, 101, 132, 225
Henry VIII of England 180
Hermes Trismegistus 74
Hermeticism 77
High Renaissance 3, 5, 290–1
Hobbbes, Thomas 237
Holy Roman Empire 34
human uniqueness 210–11
Humanism 93, 138–9, 227, 231
Hundred Years' War 185

Il Riccio, Andrea 73, 85, 86, 88

Jacopo d'Appiano 169, 173
Jewish Kabbalah 77
Julius II (Giuliano della Rovere), Pope 27, 28, 201–2, 203–5, 233, 247–50, 254, 260–2, 265, 274–5, 282, 292

Klimt, Gustav: *Judith* 75

Landucci, Luca 23, 41, 51, 88, 89, 254
Leighton, Lord 26
Lely, Peter 252
Leo X (Giovanni de' Medici), Pope 29, 282, 289
Leonardo da Vinci 3
 Adoration of the Magi 103, 142, 242–3
 anatomical dissections and drawings 1–2, 4, 146–7, 211–12, 287, 292
 Annunciation 11, 13, 212–13
 Annunziata cartoon 46–7, 163–4, 165, 199, 267
 apprenticeship with Verrocchio 18, 25, 95
 outstrips Verrocchio 96–7
 architectural drawings 172, 293
 and armour 235–7
 and Arno diversion plan 125–9, 176, 180
 aspirations as a painter 11
 Battle of Anghiari
 battle sketches 117–18, 119–20, 130, 133
 cartoon 145, 175, 195, 197–8, 221–2
 cartoon destruction 279
 cartoon on display 269–72
 comes to life 294–5
 commission 5, 47–8, 53–4, 130
 heresy 257, 259–60, 288, 291
 historical research 226–7, 229–32
 horse studies 145–6, 147–9, 175, 207, 213, 215, 216–17, 232
 imaginary reconstruction 300
 ill omens 221, 251
 influence 272, 273, 275–6, 276–7, 294, 298–9
 new contract with Machiavelli 90–1
 old warrior's head study 223–5
 protective cage 266
 propaganda purpose 176–8
 savagery of war 175–6, 221–2, 222–5, 240–2, 243
 wall painting 201, 221, 243, 251, 257, 294–5, 297–8, 299–300
 book collection 137–40, 171
 bronze horse project 46, 104–11, 114, 197
 childhood 17–18, 208–9
 clothing inventory 9–10, 15–16, 21
 'covered chariot' 178–9
 and *David* 70, 71, 81, 85–7, 153, 223–5
 death 18–19, 287
 Deluges 287
 drapery painting 11–15
 drawing prowess 154
 dreams 210
 emigration to France 290, 291
 exploding tower drawing 170
 fame in Florence 27, 46–7, 52–3
 'family' 166–7
 flying machine 207, 218–20, 287
 and fossilisation 236–7
 heresy 288–90, 291
 heavenly pedigree 82–3
 'How to Paint a Battle' 130, 241, 259
 human-cow uterus drawing 6, 212
 illegitimacy 24–5
 inability to finish work 91, 110–11, 196–7
 imagery from stains on a wall 121, 188, 216
 kite encounter 209–10, 293
 landscape drawings 124–5
 Last Supper 13–14, 19, 22, 46, 53, 109, 111–13, 114, 135, 144–5, 203, 231, 235, 256
 Leda 162–3, 192, 206–7, 217, 288
 London cartoon 46, 167, 267–8
 loses popularity with Florentine government 251–2, 256–7, 263–4
 and Lorenzo's sculpture garden 59, 159
 Medusa 277
 as mercenary 232–3
 and Michelangelo
 antagonism 30, 31, 153, 167
 bastardy/beast insults 24–5
 'bronze horse' insult 20–1, 25–7, 96, 97, 111
 comparable development 97–8
 current of intimacy 291–2
 Great Council Hall competition 5, 92–3, 144, 186, 192–8, 251–2, 257, 267–78, 287

head-to-head comparison 5, 269–72
intellectual opposition 201, 290
meeting ground 292–3, 301
rivalry 4–5, 19–20, 31, 163–8
symbiosis 113–14
microcosm and macrocosm 146
in Milan 13, 18, 19, 46, 97, 101–13, 138,
 172, 181, 202–3, 219, 225, 235, 256–7,
 263, 287
military science and engineering 102–3, 138,
 173–6, 179–83, 291–2
Mona Lisa 41–8, 52–3, 125, 167, 168, 192,
 287, 288
'monster' shield 17–18, 236, 277
and the natural world 206–13, 217–18, 220
Neptune and his Sea Horses 183
notebooks 72–3, 135–7, 142, 196, 287, 289,
 290
 Codex Arundel 127, 140
 Codex Atlanticus 136–7, 140, 209
 Madrid Codex II 9, 21, 24, 108–9, 125,
 127, 128, 129, 140, 174
 Manuscript B 136, 172, 178–9, 181
 On the Flight of Birds 207, 217–20
 Royal Collection 70, 127, 135–6, 140, 148,
 149, 211
old warrior drawing 236
pink and purple clothes 11, 21, 72
Piombino defences 169, 173–6, 252, 291
portrait of Cecilia Gallerini 52, 53, 213
portrait of an executed criminal 14
in Rome 288
Santa Maria Novella rooms 53, 133–5,
 140–5, 154, 167, 192, 195, 269, 271
self-reminder to visit bathhouse 150
sexuality 153, 158–60
sodomy accusation 158
Treatise on Painting 288
Trivulzio Monument 287, 292
The Virgin and Child with Saint Anne 12, 13,
 192, 213, 288
The Virgin on the Rocks 12, 160, 268
Vasari's first 'modern' artist 94
vegetarianism 143, 207–8, 211
Vitruvian man 70–1
Lippi, Filippino 51, 54, 73, 93, 135, 176, 270,
 289
 Annunciation 33
 Saint Philip Exorcising the Demon 198–200
Lippi, Filippo 19
Lorenzetti, Ambrogio: *Allegory of Good Government*
 34–5
Lorenzetto 276
Lotto, Lorenzo 10
Lucar, Cyprian 180–1
Lucretius 240, 241
Ludovico 73
Luther, Martin 250

Machiavelli, Niccolò 39–40, 41, 45, 51, 53, 80,
 88, 90–1, 102, 126, 130, 169–70, 176–8,
 184–6, 204, 205, 227, 228, 233, 253–6,
 260, 261, 265, 282–3, 285
 The Art of War 155, 284
 'Decannale' 185, 254–5
 The Discourses 39, 40, 177

Florentine Histories 96, 226
Mandragola 22, 122, 151
The Prince 39, 40, 129, 178
Machietti, Girolamo 151
Mafia 39
Magdeburg Rider 99
magic 74, 75–6, 77, 78, 80, 85, 86–7, 210
Malaspina, Argentina 41
Malleus maleficarum 87
Mannerism 275–8
Marcus Aurelius 98
Marcus Fabius Gallus 62
Marlowe, Christopher: *The Jew of Malta* 39–40
Martini, Simone 54
Masaccio 94, 135, 157, 298
Maturino 276
Medici, Allesandro de' 296
Medici, Cosimo de' ('Pater Patriae') 77, 34, 35,
 77, 134
 townhouse 33–4
Medici, Cosimo I 296, 297
Medici, Francesco de' 151, 277
Medici, Giuliano de' (1453-1478) 14, 19, 77
Medici, Giuliano de' (1579-1516) 208, 265–6,
 288, 291, 294, 296
Medici, Lorenzo de' (the Magnificent) 14, 28,
 29, 33, 36, 52, 58–60, 74, 76–7, 104,
 151, 159, 223
Medici, Piero 36, 60, 77
Medici family 34, 35, 39, 49, 50, 68, 169, 272,
 277, 286, 292, 296, 297
 fall (1494) 35, 39, 50, 68, 169
 fall (1527) 281, 282
 restoration (1512) 265–6, 272, 280
 restoration (1529) 286, 295–6
 see also Clement VI; Leo X
Melzi, Francesco 25, 136, 137, 287
Mesopotamia 98
Messer Francesco 71–2, 74–5, 82
Michelangelo Buonarroti
 apprenticeship with Ghirlandaio 28, 57–8
 attachment to family 166
 Bacchus 28, 61–5, 66, 155, 204
 Battle of Cascina (*The Bathers*) (cartoon) 5,
 187–8, 195, 197, 250
 bacchic allusion to Leonardo 252–3
 commission 5, 92–3, 131
 Cellini's reverence 267
 destruction 278–9
 on display 269–72
 first battle designs 131, 132–3
 grotesque freedom 198, 200
 horse drawing attempt 149
 ideal citizen-soldiers 256, 257, 282
 imaginary reconstruction 300
 influence 272–3, 273–4, 275, 276, 277, 294
 as recruiting poster 253, 254
 nude sketches 156, 190–1
 Battle of the Centaurs 188–90
 bronze *David* 67–8, 93
 Bruges Madonna 192
 commissions Condivi's *Life* 28–9
 damning of Donatello 82
 David 28, 55–7, 65, 66–7, 68–9, 83–7, 98,
 114, 155, 187, 188, 192, 223–5, 281
 emasculation 71, 88–9, 153

journey to Piazza della Signoria 87–8
Leonardo and 70, 71, 81, 85–7, 153, 223–5
meeting to site 71–6, 81–2, 84–7, 92, 176
as ideal citizen soldier 255, 282
drawings 154–5
emotional self-disclosure 29–30
faith 290, 291
Florence fortifications 282–7, 291–2, 295
and Florentine public space 89, 188
and the grotesque 200
heavenly pedigree 83
The Holy Family (Doni Tondo) 150–1, 165–6, 167
and Julius II
aborted Bologna trip 260–1
bronze statue 262
pardon 261–2
row and flight from Rome 248–50, 254
tomb commission 204–5, 247–8, 292
and Leonardo
antagonism 30, 31, 153, 167
bastardy/beast insults 24–5
'bronze horse' insult 20–1, 25–7, 96, 97, 111
comparable development 97–8
current of intimacy 291–2
Great Council Hall competition 5, 92–3, 144, 186, 192–8, 251–2, 257, 267–78, 287
head-to-head comparison 269–72
intellectual opposition 290
meeting ground 292–3, 301
rivalry 4–5, 19–20, 31, 163–8
symbiosis 113–14
Laurentian Library 5, 200, 284–5, 292–3
Leda and the Swan 293
and Lorenzo's sculpture garden 28, 58–9
in Lorenzo's household 59–60
male nudes 150, 152, 155–6, 157–8, 161–2, 167–8, 190–1, 198
Medici tombs 281–2, 294, 295–6
New Sacristy 276, 284–5
patriotism 256
Pietà 28, 65–6, 114, 204
poetry 59, 131, 133, 160–1, 196, 281, 290, 292, 295–6
popularity with Florentine government 256, 257, 261, 262–4
portrait of Andrea Quaratesi 284
Raphael's portrayal 27–8
and risk 157
in Rome 60–6, 67, 204–5, 265
emigration 296
sexuality 153, 157–8, 160–1, 284
Sistine ceiling 2–3, 4, 27, 28, 247, 274–5, 289, 290
Slaves 292
Sleeping Cupid 61
St Matthew 192, 197
St Peter's basilica 300–1
St Petronius 171
St Proculus self-portrait 27, 29–30
Taddei Tondo 164–5, 167, 193
Vasari's ultimate artist 28, 94
Victory 297
Michelotto, Don 253

Michelozzo 33, 165
Milan 18, 35, 46, 97, 99, 101–13, 136, 138, 140, 172, 181, 202–3, 219, 225, 235, 256–7, 263, 287
Santa Maria della Grazie 13, 19, 109, 112, 135, 203
see also Anghiari, Battle of
military science and architecture 102–3, 138, 173–6, 179–83, 282–7, 291–2, 295
Monciatto, Francesco 81
Mussolini 39

Negroli family 236
Nero 199
New World 238–9, 241
Newton, Isaac 182–3
Northern Europe 34, 101, 250, 281
art 12, 259

Ovid: *Metamorphoses* 189, 240

pacifism 258–9, 299
Pacioli, Luca 101, 105, 139, 229
Padua 95, 100
Papacy 34, 54, 282
Pater, Walter 43, 175
Paulo de Leonardo 159
Peche Merle caves 213–14
Perino del Vaga 276
Perugino, Pietro 73, 95, 191
Pesello, Giuliano 99–100
Picasso: *Guernica* 118
Piccinino, Niccolò 118–19, 225–6, 228, 229, 230–2, 233, 234–5, 237, 240, 275, 277, 291, 298
Pico della Mirandola 77, 210, 211
Pierfrancesco de' Medici, Lorenzo di 61
Piero della Francesca
Baptism of Christ 229, 230
The Legend of the True Cross 228–9
Piero di Cosimo 73–4, 216
Battle between the Lapiths and Centaurs 239–40
The Forest Fire 240
Piombino 169, 173–6, 183, 252, 291
Pisanello 231–2
Pisano, Andrea 220
Pisano, Nicola 157
Plato 64, 139
Symposium 160
Pliny the Elder 47, 210
Natural History 19, 137
Poliziano, Angelo 59, 77, 188–9
Pollaiuolo, Antonio del 104–5
Battle of the Nudes 189–90
Hercules 33
Hercules and Antaeus 189–90
Pollaiuolo, Simone del 73
Pollaiuolo brothers 73, 155
Pontormo, Jacopo da 276–7, 298
Martyrdom of the Ten Thousand 293–4
portrait of Carlo Neroni 283, 284
portrait of Francesco Guardi 283–4
Prato, Sack of 265, 280

Raphael 44, 151, 168, 191–4, 250, 272–4, 276, 290, 301

The Battle of Anghiari (copy) 272
Bridgewater Madonna 193
Entombment 272
The Fire in the Borgo 273
frescoes 289–90
Madonna of the Goldfinch 192–3
Madonna of the Meadow 193
The Marriage of the Virgin 191–2, 203
Portrait of Pope Julius II 01, 204
The School of Athens 27–8, 272–3
Sistine tapestry cartoons 273
The Triumph of Galatea 273
Reformation 250, 281, 288
republicanism 34, 35, 36, 40, 68, 178, 185–6, 257, 281, 282–3
Riario, Raffaele (Cardinal San Giorgio) 61
Richter, Jean-Paul: *The Literary Works of Leonardo da Vinci* 137, 196
Robbia, Andrea della 73
Romano, Giuglio
 Battle of Constantine 277
 Sala dei Giganti 277
Romantic Age 26
Rome 60–6, 67, 76, 113, 151, 164, 202, 233, 247–50, 289–90, 296
 Belvedere Palace 203–4, 288
 Bramante's Tempietto 203, 301
 Julius' tomb 204–5, 247–8
 sack of 282
 Sistine Chapel 2–3, 4, 27, 28, 247, 273, 274–5, 290
 St Peter's 249–50, 300–1
Rome, ancient 4–5, 19, 27, 47–8, 58, 62, 98, 99, 100, 138, 151, 155, 171, 176–7, 199, 226, 249
Rosselli, Cosimo 73, 84
Rosso Fiorentino 276
 Moses and the Daughters of Jephron 277
Rubens, Peter Paul 298–9
 The Battle of Anghiari 175, 298
 The Horrors of War 299
Rublev, Andrei 113
Ruccellai, Giovanni 134
Ruccellai family 134
Ruscelli, Girolamo: *Precepts of Modern Warfare* 181, 182

Salaì 10–11, 15, 143, 158, 159, 166–7, 233, 287, 291
Salvestro 73
Sangallo, Antonio da 73, 87, 171, 204, 250, 292, 301
Sangallo, Aristotile da 276
Sangallo, Giuliano da 73, 84, 87, 171, 204, 248
Sansovino, Jacopo 276
Sarto, Andrea del 276, 295
Savonarola 36–7, 39, 50–1, 54, 60, 65, 79–80, 85, 89, 141, 178, 270, 280
self, birth of modern 5–6
Ser Piero da Vinci 17–18, 24–5
Sforza, Francesco 101, 102, 104, 107, 225, 226
Sforza, Ludovico 18, 101, 102–3, 105, 109, 169, 179, 202, 213, 234
Shakespeare 17, 40, 235
Siena 34–5, 49, 54, 196

Sixtus IV, Pope 104, 202
Soderini, Cardinal Francesco 184, 261
Soderini, Piero 5, 39, 40–1, 47, 51, 53, 54, 67–8, 81–2, 88, 89, 92, 114, 126, 130, 238, 250, 254, 257, 262–4, 265, 266, 270, 283
storytelling culture 17, 19
Strozzi Doni, Maddalena 44, 168

Tartaglia, Nicholas 180–1
Thomas Aquinas 289
Tintoretto 191
Titian 63, 191
 Bacchanal of the Andrians 252
Torrigiani, Pietro 157
Tribolo 276
Trivulzio Monument 287, 292
Tuscany 34, 36, 49, 52–3, 123

Uccello, Paolo 94
 The Battle of San Romano 33, 227–8
 Deluge 135
 Sir John Hawkwood 100
Ugolini, Luca 45
Ugolino, Count 123, 242
Umbria 44, 73, 118, 191

Valturio: *De re militari* 38, 182
Vasari, Giorgio
 architecture 296–7
 'Life of Botticelli' 77, 79
 'Life of Leonardo da Vinci' 17–19, 45–6, 46–7, 82–3, 95–6, 106, 110, 277
 'Life of Michelangelo' 28, 269, 278–9
 The Lives of the Architects, Painters and Sculptors 16–17, 20, 26, 28, 43–4, 58, 92, 94, 136, 175, 178, 216, 289
 transfiguration of Great Council Hall 297–8
Venice 37, 40, 98, 100, 101, 119, 130, 179, 231, 232, 252, 286
 Accademia Gallery 117, 299
Verrocchio, Andrea del 12, 18, 98, 95, 100, 105, 159, 213, 236
 Baptism of Christ 96–7
Vesalius 2
Vespucci, Agostino 45, 47, 48, 54, 61, 91, 142, 227, 239
Vespucci, Amerigo 238–40, 241
Vespucci family 142
Victoria, Queen 26
Villani, Giovanni 132
Vinci 17, 208–9
Visconti, Bernabò 99
Visconti family 35
Vitelli, Vitellozzo 229, 233–4
Vitruvius 70–1, 106, 113, 171
Volpaia, Lorenzo della 85
 Clock of the Planets 74

women
 inequality 22, 41, 75
 in Leonardo's portraits 12–13
 male fears 75–6
 support for Savonarola 37
 training for beauty 44–5